CAMBRIDGE STUDIES IN THE HISTORY OF ART

*Power and display in
the seventeenth
century*

CAMBRIDGE STUDIES IN THE HISTORY OF ART

Edited by FRANCIS HASKELL

Professor in the History of Art, University of Oxford

and NICHOLAS PENNY

Keeper of Western Art, Ashmolean Museum, Oxford

Cambridge Studies in the History of Art will develop as a series of carefully-selected original monographs and more general publications, aimed primarily at professional art historians, their students, and scholars in related subjects. The series is likely to embrace a broad range of topics from all branches of art history, and to demonstrate a wide variety of approaches and methods.

Titles in the Series:

El Greco and his Patrons: Three Major Projects
RICHARD G. MANN

A Bibliography of Salon Criticism in Second Empire Paris
Compiled by CHRISTOPHER PARSONS and MARTHA WARD

Giotto and the Language of Gesture
MOSHE BARASCH

The Oriental Obsession: Islamic Inspiration in British and American Art and Architecture 1500–1920
JOHN SWEETMAN

Power and Display in the Seventeenth Century: The Arts and their Patrons in Modena and Ferrara
JANET SOUTHORN

Power and display in the seventeenth century

The arts and their patrons in Modena and Ferrara

Janet Southorn

The right of the
University of Cambridge
to print and sell
all manner of books
was granted by
Henry VIII in 1534.
The University has printed
and published continuously
since 1584.

Cambridge University Press

Cambridge
New York New Rochelle
Melbourne Sydney

Published by the Press Syndicate of the University of Cambridge
The Pitt Building, Trumpington Street, Cambridge CB2 1RP
32 East 57th Street, New York, NY 10022, USA
10 Stamford Road, Oakleigh, Melbourne 3166, Australia

© Cambridge University Press 1988

First published 1988

Printed in Great Britain by BAS Printers Limited, Over Wallop, Hampshire

British Library cataloguing in publication data

Southorn, Janet
Power and display in the seventeenth century: the arts and their patrons in Modena and
Ferrara – (Cambridge studies in the history of art).
1. Art patronage – Italy – Emilia Romagna – History – 17th century
I. Title
707'.9 N5273

Library of Congress cataloguing in publication data

Southorn, Janet
Power and display in the seventeenth century: the arts and their patrons in Modena and
Ferrara / Janet Southorn.
 p. Oc. – (Cambridge studies in the history of art).
Revision of thesis (PhD)
Bibliography
Includes index.
ISBN 0 521 34563 4
1. Art, Italian – Italy – Modena. 2. Art, Modern – 17th–18th centuries – Italy – Modena.
3. Art – Collectors and collecting – Italy – Modena. 4. Art patronage – Italy – Modena. 5.
Art and society – Italy – Modena. 6. Art, Italian – Italy – Ferrara. 7. Art, Modern – 17th–18th
centuries – Italy – Ferrara. 8. Art – Collectors and collecting – Italy – Ferrara. 9. Art patronage
– Italy – Ferrara. 10. Art and society – Italy – Ferrara. 11. Modena (Italy) – Nobility. 12.
Ferrara (Italy) – Nobility. I. Title. II. Series.
N6921.F4S68 1988
709'.45'42—oc19 87–35421 CIP

ISBN 0 521 34563 4

BA

For my family

Contents

Plates

(Where not otherwise stated, photographs have been taken by the author and printed by Sky Photographic Services, High Holborn, London.)

Preface

This book began as a PhD thesis and now, no less than then, my deepest thanks are due to Jennifer Fletcher of the Courtauld Institute, who advised me during the preparation of the thesis and who has continued to draw my attention to matters relevant to Modena and Ferrara of which I would otherwise have remained unaware. Now, however, I can also express my very great thanks to the editors of *Cambridge Studies in the History of Art*, Professor Francis Haskell and Dr Nicholas Penny, and to William Davies and Karen Horowitz of the Cambridge University Press, for their advice and encouragement and their faith in this book. Among friends who have commented on the text, I must record, in particular, my gratitude to Robert Oresko, Alex Gordon and Michael Kaye.

I have drawn heavily upon both archival sources and published material and therefore I wish to record my special thanks to the kind and helpful staff of the Archivio Segreto Vaticano, the Archivio di Stato, Modena, the Archivio di Stato, Ferrara, the Archivio Arcivescovile, Ferrara (with particular thanks to Don Enrico Peverada), the Biblioteca Comunale Ariostea, Ferrara, the Biblioteca Estense, Modena and the Accademia Militare in Modena. My thanks are also due to all institutions named in the List of Plates for the prompt supply of the photographs without which this book would be so much the poorer. I am very grateful to Signor Prisco Bagni for helping me obtain a number of these.

As for the book itself, it began as a study of Este patronage in Modena but grew to become rather wider in scope, with all the attendant risks of generalisation, over-simplification and inconsequentiality. I hope I have avoided those risks, but in any case it has not been my aim to replace existing studies of narrower focus or hinder further research. My aim has been to bring personalities, ideas and works of art to life in the hope that readers, specialist and general, will find them as interesting, even fascinating, as I have done.

Introduction

At the heart of Ferrara, where the medieval city meets the Renaissance town plan, is the Castello Estense (Plates 1 and 2), and around the walls of its courtyard were once portraits in chiaroscuro of the princes of the House of Este. But Alfonso II d'Este, fifth Duke of Ferrara, had had his portrait erased, not wishing while living to be numbered with the dead.[1] Probably no one knew better what his death would mean. Alfonso died on 27 October 1597. Three months and one day later, on 28 January 1598, the Duchy of Ferrara disappeared within the States of the Church.[2]

Since the early thirteenth century, the histories of Ferrara and the Este had been so closely linked as to make their names synonymous. By the sixteenth century there was also an Este residence in Venice (later the Fondaco dei Turchi), and on the Quirinal Hill in Rome and at Tivoli in the Roman Campagna the Este cardinals were creating beautiful gardens,[3] but Ferrara was the family home, the setting for a Renaissance court whose poetry and music, pastoral plays, palaces and paintings had captured the imagination of Europe. It was an effort to remember that though they behaved as free princes and hereditary rulers, the Este in Ferrara owed allegiance to the Pope.[4] Since the ninth century at least, Ferrara had been regarded as a papal fief and from 1243 the Este had ruled it in almost unbroken succession as papal vicars, paying an annual tribute to Rome. The popes had raised Ferrara from a marquisate to a duchy and confirmed Este princes in the succession, but tradition was no guarantee of papal favour – in 1510 Pope Julius II had anathematised and excommunicated Alfonso I d'Este, and in 1571, when Alfonso II took his claim to grand-ducal status to the Imperial, and not the Papal, Court, the saintly Pope Pius V had replied by dropping 'Duke of Ferrara' from Alfonso's existing titles.[5]

When Alfonso II's brother, the Cardinal Luigi d'Este, died in 1586 the Villa d'Este at Tivoli passed out of the family's hands for lack of an Este prelate. It seemed, in retrospect, a rehearsal for the loss of Ferrara itself, for lack of an acceptable heir. Alfonso had married three times, but despite the reassuring predictions of Nostradamus he died without issue, and the heir he had finally named was his cousin Cesare.[6] The descent was direct, for Cesare's father Don Alfonso was a son of the great Alfonso I, but he was, or was believed to be, a bastard son and here was a cause for concern for the Este in Ferrara, because Pope Pius V had ruled that an illegitimate line could not succeed to a papal fief. When Pius was dead Alfonso II negotiated with his successors and one, Gregory XIV Sfondrato, had at least wavered before endorsing the rule. But in 1597 the pope was Clement VIII Aldobrandini, who had already threatened Alfonso with excommunication for building a fort and was prepared neither to accept Cesare nor to debate the issue with him.[7] 'Most ardent in the resolution of war, with the adherence of the

College, which incited him in every way to persist and carry out his proposal', Clement raised a loan of 600,000 *scudi*, mustered an army under the command of his nephew the Cardinal Pietro Aldobrandini, placed Ferrara under interdict and excommunicated Cesare, who first defied, then hesitated and finally gave in.[8] By the treaty signed on 13 January 1598 in the Sala delle Stelle of the Palazzo del Popolo in Faenza, Ferrara devolved to the Pope.[9]

Devolution meant humiliation for the Este, but it could have been worse. Within months they were reconciled with the Pope, in token of which Cesare's half-brother Alessandro became a cardinal in 1599, and unlike other deposed princes they had somewhere to go. West of Ferrara lay the duchies of Modena and Reggio (now Reggio Emilia), Imperial fiefs which they had ruled since the late thirteenth century and which they would continue to rule, for the Emperor Rudolph II, less fastidious than the popes, had agreed, at a price, that Alfonso II might nominate his heir as he wished.[10] Modena was the larger and the nearer city and thus it was to Modena, and to the old Castello of San Pietro, once the city governor's residence, that Cesare moved in January 1598.[11]

Ferrara too had been lucky. Since there had been no war the city had escaped such destruction as Mantua (sacked by Imperial troops in 1629) and Castro (razed by order of Pope Innocent X in 1649) would suffer, and when *Ferraria Recuperata* replaced *Non Prevalabunt* on the papal coinage Ferrara was wooed with concessions.[12] To the spiritual gifts of a jubilee (to show the Pope's 'great feeling of paternal benevolence' to 'his most delightful people of Ferrara') and plenary indulgence were added gifts of bread, money and reduced taxes – 'the Pope is more mild to his subjects', noted the English traveller Fynes Moryson, 'than any other prince in Italy'.[13] Then in May the city which had played host in 1438 to an ecumenical council of East and West was again the capital of Christendom when the Pope, accompanied by cardinals, bishops, the papal treasurer and the Sistine tapestries designed by Raphael, arrived in Ferrara for a visit which lasted six months and cost a reported 150,000 *scudi*.[14] The Pope in Ferrara was in a holiday mood, residing in the Castello Estense and, during the late summer heat, at the *delizia* of Belriguardo, sailing down the Po to the Adriatic port of Comacchio, presiding over services in selected churches, receiving the homage of princes and the Spanish ambassador, and solemnising in the cathedral of Ferrara a double wedding of Habsburg princes – Philip of Spain (the future Philip III, represented in Ferrara by proxy) to Margaret of Austria and the Infanta Isabella (also represented by proxy) to the Archduke Albert.[15] 'Ferrara Regained' was Clement's triumph and it was commemorated in Ferrara by inscriptions, celebrations and a portrait bust on the cathedral façade, and in Rome by prints, medals and, later, sculpture on the papal tomb in the church of Sta Maria Maggiore.[16]

Devolution was also the making of Pietro Aldobrandini, who now emerged from the shadows to rival the other Cardinal Nephew, Cinzio Aldobrandini, and to become the Papal Legate to Ferrara.[17] No less than the Pope his uncle, Pietro Aldobrandini enjoyed his stay in Ferrara. He too visited Comacchio and then travelled incognito to Venice (where the Este palace on the Grand Canal became for a time Aldobrandini property). He also became the owner of Ferrarese art. Aldobrandini had formed an unexpected (some thought extraordinary) friendship with Lucrezia d'Este, Duchess of Urbino, who as Cesare's cousin but bitter enemy had represented the family's interests at Faenza. On 4 February 1598 Lucrezia made her will in favour of Aldobrandini, and when she died just over a week later (a coincidence upon which no one appeared to comment) he inherited the island palace of Belvedere on the Po di Ferrara

and Lucrezia's collection of paintings.[18] It was perhaps this latter bequest which encouraged Aldobrandini to look with more interest at art in Ferrara, and by the end of the year he had acquired a number of other Este pictures, among them the famous *Bacchanals* begun by Giovanni Bellini and completed by Titian for Alfonso I.[19]

The *Bacchanals* had hung in the rooms of the Via Coperta connecting the Castello with the apartments of the Corte Vecchia which, as the possession of the family as distinct from the state, was still Este property but had been placed at the disposal of the Legate's retinue. The paintings were stolen, but theft became gift, and in the same way the devolution of Ferrara itself seemed to pass off quietly. It did not go unnoticed – as Fynes Moryson observed, 'it were superfluous to speak of the minor princes of Italy, now that the Dukedom of Ferrara is fallen into the Pope's hands' – but it was a local upheaval in which other Italian states and European powers had chosen not to intervene.[20] It is for the Peace of Vervins, the Edict of Nantes, the creation of the Archduchy of Flanders and the death of Philip II that 1598 is remembered, not for the devolution of Ferrara. Yet devolution signalled, no less perhaps than the death of the King of Spain, the end of an age. A change in the political geography meant a change in the character of cities and the patterns of life within them, and the needs of art and artists changed too as the Este in Modena and the Papal State of Ferrara entered the new century.

Between the Po to the north and the Reno to the south, Ferrara was a low-lying fertile land, and in the opinion of the seventeenth-century Ferrarese writer Alberto Penna this fact alone accounted for the quiet complacency of a leisure-loving people.[21] Certainly the lie of the land had helped to create the architects of Ferrara. Since stone was not readily available (Verona was the nearest source), the Ferrarese had become specialists in brick – 'or, as we say, stone', explained another Ferrarese writer, Antonio Libanori.[22] They were also expert in hydraulic engineering, the subject of a treatise, the *Idrologia*, by one of Ferrara's greatest architects, G. B. Aleotti of Argenta, and in a land of some forty rivers and canals the 'science and art of regulating water' was perhaps the most essential part of an architect's skill. But Aleotti was also a military engineer and a designer of festive decorations and stage machines, and these skills he had developed as the servant of the Court. In the creation of architects as all things Ferrarese, local conditions combined with, and sometimes ceded to, the influence of the Este.

As the course of the Po had moved away from Ferrara, the Court had become the city's reason for being. The Este had shaped the character of Ferrara. From their founding of the Studio, or university, in the fourteenth century to the patronage of the poets Ariosto, Tasso and Guarini in the sixteenth, they were responsible for the intellectual culture of Ferrara. Poetry, music (upon which Alfonso II spent 14,000 *scudi* a year, only a little less than the 15,000 allotted to the diplomatic service[23]) and the theatre had flourished under their protection, and if painting had lagged somewhat behind, nevertheless the Este had created, from Cosmè Tura to Dosso and on to Ippolito Scarsellino towards the end of the sixteenth century, a succession of painters individual in character yet dependent upon the particular atmosphere of the Court. They had also given Ferrara some of its finest buildings, including the Castello, founded in 1385, the monastery of the Certosa and Biagio Rossetti's Palazzo dei Diamanti, and with the extension northwards of Ercole I's *Addizione Erculea*, and the creation of a ring of suburban palaces and parks encircling the defensive walls, they had determined the city's very shape.

Court influence had permeated life, compounding any inborn complacency with a love of splendour. 'In this city are many fine houses', ran a report submitted to the Pope in 1598, 'and many splendid famiſes rich in possessions, but for the most part burdened with great debts.'[24] Living up to the Court could mean living beyond one's means, and because trade was beneath this nobility, and their lands were entailed, some at least looked to the state revenues for profits – in which they were not discouraged by Alfonso II, who was quite as gracious as Montaigne described him in 1581, and who managed his squabbling courtiers with skill, but who took little part in the practical business of government.[25] Looking up to the nobility were the citizens of Ferrara, and in the opinion of a Florentine visitor of 1589, Orazio della Rena, nowhere were their pretensions more patently revealed than in their portraits, 'which if I had not been told otherwise I would have taken to be the image of an Achilles or Hector, so ornamented in gold is the armour painted by Dosso'.[26] Ferrara seemed to della Rena a pleasure-loving, self-satisfied city where everyone wished to be noble and nobody wanted to work. As a Florentine, he was almost certainly biased, but that consumers might indeed outnumber producers in Ferrara was also implied in the report, mentioned above, of 1598, in which it was noted that artisans, the *minuto popolo*, were in the minority in Ferrara. Silk was the city's staple commodity, but in Ferrara as elsewhere in Italy the silk industry was on the edge of decline, and Alfonso II's neglect of the tapestry workshops in which his father Ercole II had taken so keen an interest seemed only to endorse the trend. It was, perhaps, high time for a change of government, and the Ferrarese appeared to think so, for they offered Cesare little support in his brief stand against the Pope. But after three centuries of dependence it was by no means certain that Ferrara could survive without the Este.

As long as the Pope was in Ferrara it seemed that the city had simply exchanged one festive court for another, but in 1599, when the Pope and the glamour had gone, it was clear that conditions had changed. Population had fallen, the *Monte di Pietà* was suffering the first of many bankruptcies, and crime was being punished with an exceptional severity, the stamp of the new, disciplinarian, regime.[27] Vandals in the Aldobrandini entourage had reduced their borrowed apartments to ruins, the *Bacchanals* had left Ferrara for Rome, and the Belvedere palace was now demolished to make way for a fortress.[28] The interest of the Aldobrandini in Ferrara had been of a passing and purely acquisitive nature, and Ferrara was the poorer for their presence. Some thirty years later the Ferrarese chronicler Cesare Ubaldini would conclude that devolution had been, after all, 'not dissimilar to a sack, not hostile, but civil and domestic'.[29] One of the bitterest of local historians (his chronicle, not surprisingly, remained in manuscript), Ubaldini found fault with the Ferrarese but most of all he blamed the papal government for the shabbiness of Ferrara. Yet he was not entirely just. The first Papal Legate had set depressing precedents of despoliation and destruction, but his successors were not bound to follow his example.

Forty miles west of Ferrara, in the southern stretches of Lombardy, the Este had entered another world. Modena had been ruled for centuries by a governor appointed in Ferrara (in the fifteenth century Ercole d'Este had governed the city on behalf of his brother Duke Borso), but it had also enjoyed a considerable degree of autonomy. By 1598 its character was as fully-formed as its shape – the 'little circular city' built round the Romanesque cathedral (Plates 3 and 4) and the Ghirlandina tower, criss-crossed by canals and cut through by the Via Aemilia,

the ancient Roman highway from Piacenza to Rimini.[30] Modena had grown from the Roman *Mutina*, and the loss of its classical relics to the antiquarian collections of sixteenth-century Ferrara was still a source of grievance in the 1660s, when the historian Lodovico Vedriani was writing the history of his city and the biographies of its famous sons.[31] From centuries of destruction and renewal Modena had emerged an efficient, competitive and prosperous city (its rivalry with Bologna was well-known), the market town of a fertile countryside and a busy commercial and industrial centre. It was, for example, Modenese craftsmen who made the masks for Court masquerades and other entertainments in Ferrara.[32] The Florentine Orazio della Rena in 1589 saw the difference in character between this city and Ferrara. Where the Ferrarese were lethargic, the Modenese were industrious, 'subtle men', aggressive and devoted to trade.[33] The seventeenth-century poet Alessandro Tassoni, author of the famous *La Secchia Rapita*, was himself Modenese and in his collection of *Pensieri Diversi* he confirmed the commercial talent of his countrymen by observing that they had found a way, despite the 'laws of Mahomet', of selling Trebbiano wines to the Turk.[34] Commerce was not, however, their sole talent. In the sixteenth century Modena had produced other poets, including F. M. Molza and Jacopo Sadoleto (who was also a cardinal), the rhetorician Lodovico Castelvetro and the scientist Gabriele Falloppio. Lancilotti and, at the turn of the century, G. B. Spaccini, represented the local chronicle-writing tradition. If Modena nevertheless lacked a name for letters and learning, it was due not to the Modenese themselves but to the proximity of Ferrara, for Modenese students were obliged, by order of the Este, to attend the Studio of Ferrara, while Modena's university periodically foundered for lack of funds.[35]

Modena's artistic history was uneven, which may help to explain why the city was never famous for its beauty. From the sculptures by Wiligelmo on the cathedral to the altarpieces by Dosso and Correggio in the churches, Modenese patronage had brought fine works of art into being. Even so, Modena could not compete with Reggio, the 'smiling' city of Ariosto further north on the Via Aemilia, whose artistic wealth included altarpieces by Correggio and, more recently, Annibale Carracci. At the end of the sixteenth century Reggio was enjoying a new advantage over its neighbour as a result of the discovery, in 1596, of the miracle-working image of the Madonna della Ghiara, which attracted first pilgrims, and income, and then artists to decorate the new pilgrimage church.[36] Modena had produced some exceptional artists, most notably the sculptors Guido Mazzoni and Antonio Begarelli and the painter Nicolo dell'Abate. Modenese artists were also known abroad. The painter Tommaso da Modena, for example, may have worked in Prague in the fourteenth century, while in the sixteenth century a 'Niccolo of Modena', or Nicholas Bellin, had worked at the Court of Henry VIII in England and more famously Nicolo dell'Abate had left Italy for France.[37] In 1598 Modenese artists could be found in Rome, Bologna and Parma, but art in Modena itself was best represented by the unexciting Ercole Abate (or 'Abbati'), grandson of the greater Nicolo.[38] It was not that artistic interest was lacking – the chronicler Spaccini, for example, was himself a draughtsman and would-be connoisseur who recorded the movements of art and artists as keenly as he noted other events in his journal of daily life in Modena.[39] All it needed perhaps, was the kind of sustained patronage which could offer encouragement and direction to Modenese art as to other aspects of Modenese culture. When the Este settled in Modena in 1598 it might be supposed that such patronage would follow, but much would depend upon the character of the prince, his tastes and the value he placed upon art.

Between Este Modena and Papal Ferrara moved an old territorial nobility which included families scarcely less eminent than the Este themselves.[40] Among the richest were the Rangone, whose family tombs in Reggio Cathedral seemed a pivot between their fiefs of Spilamberto near Modena and Roccabianca in the Farnese Duchy of Parma. Among the most powerful were the Pio, feudal subjects but traditional enemies of the Este, with whom they had exchanged their old fief of Carpi for that of Sassuolo, which they still ruled in 1598. With such peers as the Bevilacqua, Montecuccoli, Obizzi and Pepoli, these families had been courtiers in Ferrara but semi-autonomous lords on their feudal estates, and devolution was bound to encroach upon their freedoms and to demand declarations of allegiance in return for the renewal of privileges. The Court in Modena offered the nobleman traditional ties and an established order. The Pope in Ferrara was more subtle, seeking to replace former loyalties with dependence upon Rome by means of careers in the Church and the papal service and a seemingly enhanced rôle in communal government. Merchants and artisans had a place on Ferrara's new elective Council of One Hundred, but more influential were the noblemen, representatives of the twenty-seven noble families of Ferrara named on a list compiled by Rome which gave Ferrara the semblance of the Golden Books of the patrician republics of Genoa and Venice.[41] In time, the nobility would have to choose where its best interest lay, but in 1598 devolution appeared to offer new opportunies for the adventurous, chief among whom were the Bentivoglio.

Rulers of Bologna until 1506 (and still, noted Orazio della Rena, regarded as newcomers in Ferrara in 1589), the Bentivoglio family had suffered its own upheaval and the experience may have left its members readier than most to adapt and to exploit every opportunity offered for the advancement of family interest and the expression of personal ability. They were discerning, imaginative and appreciative of new talent, and wherever they went patronage followed. It was not, however, only as patrons that the Bentivoglio were known but also as art agents and entrepreneurs, which made their dealings in art especially interesting, and was not altogether dissociated from their increasingly desperate need of money. Between the Este in Modena restoring a reputation, and the uneasy alliance of cardinals and noblemen seeking a new rationale for Ferrara, the Bentivoglio pursued their own interests and their own tastes in art. It is with the needs and the achievements of these three kinds of patrons and users of art that this book will be concerned.

Part I

*The Este in Modena
(1598–1658)*

1 *Reactions*

(i)

The Duke of Modena, observed a papal correspondent in 1607, 'is a prince of good and pleasing nature, who leans more than anything towards the effeminate', by which the writer must have meant 'gentle', for he also observed the Duke's attachment to his female cousin Bradamante d'Este.[1] Cesare d'Este (Plate 5) had not always been so gentle. In 1602 his punishment of a nobleman had seemed so unreasonably severe that his half-brother, the Cardinal Alessandro d'Este, had had to explain that it was 'the office of a good prince not only to administer but also to moderate justice' and from princes 'one expects a manner more agreeable and pleasing'.[2] Yet now it seemed that Cesare had slipped into a passive docility which, if compared with the style of his peers, with the splendour of his old friend Vincenzo Gonzaga, for example, or the stern single-mindedness of Ranuccio I Farnese, was not impressive.[3] Nor, for that matter, was the behaviour of the Cardinal d'Este (Plate 6). He avoids Rome, wrote the same papal correspondent, 'partly because he lacks the means to stay there, and partly because he does not know how to leave Modena', where he 'passes his time in literary things, and has great talents if he wished or were able to use them'. Alessandro was also romantically entangled in Modena, the object of the affections of Cesare's daughter Giulia, a lady of 'great beauty', added the reporter, and 'incredible charm'. By contrast with these placid princes, it was the Este women who seemed to have inherited the family's strength of nerve: Marfisa d'Este, who lived on in the Palazzina in Ferrara until her death in 1608, and Cesare's sister Eleonora, Princess of Venosa, the second wife of the composer Carlo Gesualdo (he had murdered his first) and the 'woman of great spirit' who had spread stirring reports of her brother's readiness to 'die a thousand times before he surrendered Ferrara'.[4] Cesare, however, could not live up to her loyal propaganda.

Cesare was ambitious but he lacked the necessary will, and all too easily ambition dissolved into compromise, or whine. He surrendered Ferrara, but once in Modena he began to comb the archives for legal loopholes whereby he might regain the Duchy, or at least the Valleys of Comacchio. Quite possibly the intensive archival research which he thus set in motion gave new direction to historical thought in Modena and paved the way for the work, a century later, of L. A. Muratori, librarian to the Este and historian. As far as the recovery of Ferrara was concerned, however, it was wasted effort. Cesare was no more decisive in 1599, when the fief of Sassuolo fell to him on the death in Modena, by murder, of Marco Pio. The Pio accused Cesare of complicity and Cesare complained of injustice, but it was not his laments,

– – – – denotes illegitimacy

(Adapted from Archivio di Stato di Modena, *Archivio Segreto Estense*, Rome, 1953, tables III and IV)

Figure 1. Family tree of the House of Este (ruling branch), *c.* 1500–*c.* 1700

but the clever advocacy of Paolo Brusantini, one of his courtiers, which persuaded the Imperial Court to reverse its first decision and award Sassuolo to the Este.[5]

From his father Alfonso, from the Cardinal Luigi and finally from Alfonso II, one by one the legacies of Ferrara had fallen to Cesare, but he had never been sure, not until Alfonso II was dying, that he would inherit the duchy. Thus the chronicler Cesare Ubaldini was right to believe that Cesare acted as a private gentleman to whom great gifts had come by chance. According to Ubaldini, who despised him, Cesare in Ferrara had lived a life of 'uncorrected error', an assertion to which his friendship with Vincenzo Gonzaga lent colour.[6] In 1586 he had married Virginia de' Medici, daughter of the Grand-Duke Cosimo I of Tuscany and his second wife Cammilla Martelli, and although Virginia's importance as the child of this morganatic marriage was not great, Cesare's father Alfonso had no doubt hoped to ensure influential support for his son in the event of his succession. No one, however, seemed to have prepared Cesare for government, and hence, maybe, the uncertainty of his first actions. The true focus of Cesare's world in Ferrara had been not the great Castello but the Palazzo dei Diamanti, inherited from the Cardinal Luigi, which in the early 1590s was decorated with a newly-commissioned series of ceiling paintings and friezes by painters of Ferrara (including Scarsellino) and Bologna.[7] The best-known of these paintings are the *Venus*, *Flora*, *Pluto* and *Galatea* by Annibale, Agostino and Lodovico Carracci (Plates 7, 8, 9, 10), and they convey far better than words the atmosphere of the world Cesare left behind.

Shortage of money hampered the attempt to adjust. In 1597 Cesare had inherited Alfonso II's treasury ('money unlimited' by one report, over six million *scudi* by another), but more valuable had been the regular incomes and these were slashed by devolution.[8] Ferrara had contributed 225,000 of Alfonso's annual budget of 450,000 *scudi* in 1589, but from 28 January 1598 the figure shrank to the 40,000 *scudi* a year Cesare received from his personal patrimony in Ferrara.[9] 'The Duke of Modena pays his servants better than any prince in Italy' wrote the loyal Modenese chronicler G. B. Spaccini in 1599, but in the same year there was talk among Cesare's advisers of moving the Court from Modena to Carpi in order to reduce costs, and in 1603 Cesare was obliged to make savings; the salary of his secretary, or *intimo*, G. B. Laderchi, for example, fell from 600 to 400 *scudi* a year.[10] To the costs of running a court were added such extraordinary outgoings as the 215,000 *ducatoni* determined by the Imperial Court as appropriate compensation to the Pio for the loss of Sassuolo. There were certain remedies open to Cesare. By 1599 he had formed an alliance with Spain which would earn him membership of the Order of the Golden Fleece and promised the Cardinal d'Este, as protector of Spanish affairs in Rome, a more useful 6,000 *scudi* a year to add to the 14,000 which he received from the Abbey of Pomposa and Pieve di Bondeno (his continuing *giuspatronato* of these benefices had been confirmed in 1599). With the approval of Pope Paul V Borghese, Cesare, like the Farnese before him, also had recourse to the papal method of raising loans, and in 1612 erected a *Mont' Estense*.[11] But money was never plentiful in Modena.

Obstantia Solvet was the motto of Cesare's *impresa* but to believe it was an act of faith.[12] In 1592, as heir to the Cardinal Luigi, he owned statues in the Este gardens on the Quirinal Hill in Rome which could not, however, be brought to Ferrara for fear of annoying the Pope.[13] It was a foretaste of the kind of compromise with which Cesare, as Duke of Modena, would be obliged to live. By article 4 of the Treaty of Faenza, he was allowed to have brought to Modena two of the four cannon cast by Alfonso I (he took *Regina* and *Spazzacampagna*, leaving

11

Diavolo and *Terremoto* to the Pope), such archives as did not concern the papal government, and all jewels, silver and other precious goods, including paintings and sculpture, which he possessed in Ferrara. Article 13 added that any goods not removed by 28 January 1598 could be taken at his leisure thereafter.[14] As the largest wholesale removal of its kind in decades, perhaps centuries, the amount saved was remarkable. Paintings by Titian, Giulio Romano, the Dossi, Garofalo and Girolamo da Carpi; tapestries designed by Giulio and the Dossi; antique and Renaissance sculpture and medals (including sculpture by Antonio Lombardi and medals by Il Antico); books and precious manuscripts, including the illuminated *Bible* of Borso d'Este: all this and more would in time be carried to Modena. But there were also losses of art.

Within months of the signing of the Treaty of Faenza, the Aldobrandini had shown that with the help of keys and deliberately vague inventories its terms could easily be flouted. In 1608 it was the turn of Scipione Borghese to help himself to Este art when, in a case almost as notorious as the theft of the *Bacchanals*, he acquired first a series of frieze paintings by Dosso from the *Camerino d'Alabastro* of Alfonso I and then, unexpectedly, a number of ceiling paintings by the same artist from other rooms in the Via Coperta.[15] Acting for the Cardinal were the Marchese Ippolito Bentivoglio in Modena and his half-brother Enzo in Ferrara and they made a formidable team, but in this and other cases of loss from the Este collections there was also inefficiency.

It was obvious that the accumulation of centuries could not be rehoused at once in the old Castello of San Pietro in Modena – books certainly suffered, stacked in damp rooms until rescued, or appropriated, by such devoted booklovers as the ducal secretary Count Laderchi.[16] Art therefore waited in Ferrara, either in the Castello and adjoining buildings, or in the Palazzo dei Diamanti, which had become a storehouse of art in transit. Responsible for Cesare's possessions in Ferrara was the Ducal Agent Count Giustiniano Masdoni, to whom reported one Lodovico Borgo, custodian of the Diamanti. Given the speed of events in Ferrara, they could sometimes act swiftly, as in 1603, when a vase was snatched, 'not without some difficulty', from the ruins of the Belvedere palace.[17] But at other times their knowledge of the whereabouts of art was confused. In July 1598, for example, the sculptor Francesco Casella had discovered twelve classical busts and a *Spinario* figure belonging to the Este, and having restored them he had handed them over to Borgo for safekeeping. But in 1604 Masdoni had to report that the busts were not in the Diamanti and Borgo had no idea where they were, though he wondered, mistakenly, if they were by chance in Modena.[18] In 1608 it was Masdoni's own confusion which allowed Enzo Bentivoglio to take the ceiling paintings by Dosso out of store and pack them off to Rome. But it was not Masdoni's fault that these paintings had been left at risk in Ferrara. Twice he had reminded Cesare of their existence, once in 1605, when he had at last gained access to the Via Coperta, and again in 1607, when he had had them removed and replaced by copies on hearing of a plot to steal them.[19] Two warnings should have been sufficient, but only in 1608 did Cesare appear to want these paintings, and by then it was too late. Cesare acted quickly to have the pictures returned, but in the end he compromised and agreed to divide them with Borghese.

The forced and the voluntary gift of art had their place in Cesare's policy. In 1604 he presented 'twelve Caesars by the hand of Annibale Carracci, excellent painter, copied from Titian', to the Count of Fuentes, Spanish Governor of Milan, and the gift was probably inspired if not by the new Spanish alliance then by Fuentes' personal importance as arbiter in the minor

wars which periodically flared between Cesare and the Republic of Lucca along the shared border in Garfagnana.[20] Fuentes was an art collector, but not in the same league as the Emperor Rudolph II, Cesare's feudal lord, and it was Rudolph who proved the greediest recipient of Este art. In 1599 Cesare sent to Prague gifts of pictures by Raphael and Titian, including the latter's portrait of Cesare's grandmother Laura Dianti, with which he perhaps calculated to both meet the Emperor's known taste for Titian and enlist his support for the disputed Este succession.[21] At the end of 1603 the Imperial painter Hans von Aachen arrived in Modena as part of his tour of Italy to paint portraits of princesses with whom Rudolph kept up a diplomatic courtship (his subject in Modena was Cesare's daughter Giulia), and when he returned to Prague in 1604 he took with him Este gifts including a gold chain for himself and jewels, medals and pictures for the Emperor – who would, wrote the painter, like more, and especially a bas-relief by Giovanni Bologna (von Aachen was evidently an efficient spy), and in June more duly arrived.[22] How useful such gifts really were is not easy to say, but whether or not they served their purpose was, in the circumstances, immaterial, for Cesare had no option but to give. He had, in any case, more immediate needs to attend to than the preservation of the Este collections.

Cesare and Virginia de' Medici had nine children, the last of whom was born in 1607. In the following year the eldest son and heir Alfonso married Isabella of Savoy, daughter of the great Charles Emmanuel I, and their first child was born in 1609. Making the Castello of S Pietro comfortable and fit for a growing family was a practical necessity.

By March 1598, less than two months after the arrival of the Este, the Commune of Modena was asked to pay for the enclosure of the Castello grounds, and soon new gardens began to take shape to afford the Court a degree of privacy and recreation (there was a fish-pond by 1602, a tennis-court by 1603) and a setting for such festivities as those which attended the wedding of Cesare's daughter Laura to Alessandro I Pico della Mirandola in 1604.[23] Meanwhile, the Castello itself was undergoing renovation. While paintings awaited transport, 'ornaments from the doors of rooms brought from the Palazzo dei Diamanti' did arrive in Modena in 1605 and as early as September 1598 building workers from Ferrara had joined others from Carpi at work on the Castello walls.[24] Tapestries had also been brought from Ferrara, presumably because they were more useful than paintings in years of cold winters, and in time they also served members of the family abroad. A *Scipione* and a *Hercules* series, designed by Giulio Romano, were sent, for example, to the apartments of the Cardinal d'Este when in residence in Rome, and on his death in 1624 they returned to Modena for reallocation to Cesare's son Luigi, then resident in Venice, to whom had also been given six other tapestries 'made in Ferrara'.[25] Making-do might be one description of Cesare's domestic arrangements, but as far as the Castello works were concerned, his improvements seemed to one observer 'most judicious', transforming 'what was once barely adequate for the Governor into a comfortable residence for six princely courts'.[26]

A number of Cesare's executants had accompanied him from Ferrara, gardeners and herbalists, for example, and the architects and engineers Pasio di Passi, the Sienese Cosimo Pugliani (who soon drifted back to Tuscany) and, the most useful of all, Antonio Vacchi, architect, surveyor and designer for ceremonial occasions, including the funeral of the Duchess Virginia de'Medici in 1615.[27] Ferrarese painters had remained in Ferrara, and Cesare's dealings with Scarsellino, Giulio Belloni and others were managed by the Ducal Agent Masdoni. Cesare

13

therefore made use of local resources, including Spaccini, who was soon giving drawing lessons in perspective and fortifications (and perhaps portraiture, in which, wrote Tiraboschi in the eighteenth century, Spaccini had some ability) to the Duke's sons.[28] By 1602 Cesare had also employed in the Castello a number of minor local artists on decorative work.[29] In the same year, however, Cesare became the patron of the finest local artist of the day, Bartolomeo Schedoni.[30]

Cesare may have borrowed Schedoni from Parma, where the painter's father Giulio made masks for the Farnese Court, or he may have discovered him in Modena, where in 1599 Schedoni had painted an altarpiece for the church of Sant'Eufemia. However the introduction was made, the subsequent patronage revealed Cesare's interest in, and need of, a young and promising painter, 24 years old, who could work regularly for the Court. His demands of Schedoni were interesting. Within a very few years the painter's name would be associated almost exclusively in art critics' and collectors' minds with variations on the theme of the *Madonna and Child* (often thought to be derived, and occasionally copied, from Correggio) and in 1606 Cesare ordered a painting of this kind for his new private chapel in the Castello: the *Holy Family with the Infant St John* now in Dresden (Plate 11) may be Cesare's painting. Yet either because he cared little for artistic specialisation or, more probably, because he expected rather more of a painter trained by Federico Zuccaro in Rome, Cesare also ordered portraits and decorative pictures for the Castello from Schedoni who, for his part, did not appear to find the work uncongenial. Cesare's patronage kept Schedoni in Modena for some four years, bringing a degree of continuity, and sanity, to a career which until 1602 had seemed a series of brawls, imprisonments and a few finished paintings. It may be that Schedoni was indeed unable to leave: in 1605 Cesare's continuing demands prevented him from beginning a commission accepted in 1604 from the Commune of Modena, despite the pleas of the *Conservatori*. In Cesare's patronage of Schedoni, and in the series of paintings ordered from him on the subject of *Hercules*, a hero of sixteenth-century Este imagery, were hints that there was, after all, something of the old pride and autocratic style of the Este in Cesare.

On 30 April 1605 the Commune of Modena, appointed godfather to Cesare's new-born son Borso, instituted an annual horse-race on the boy's baptismal day. On 25 July Spaccini recorded Cesare's formal entry into Sassuolo to cries of 'Viva Casa Estense' from the people.[31] Thus 1605 seemed a year of celebration for Cesare, and in this mood of optimism he had already embarked, in March, on his most ambitious act as a patron of art. He had commissioned for the Rosary Chapel of the church of S Domenico adjoining the Castello altarpieces not from any easily accessible painter but from painters in Rome, from Annibale Carracci, whose reputation in 1605 stood rather higher than it had at the time of the Palazzo dei Diamanti commission, and from the already notorious Caravaggio.[32]

It was an imaginative commission for which the Cardinal d'Este may have been more responsible than Cesare, for Alessandro was better acquainted with contemporary Roman painting and would have known, for example, the Cerasi Chapel in Sta Maria del Popolo where paintings by Carracci and Caravaggio could be seen side by side. But Cesare was passionately committed to the commission and, to an extent, his hopes were unreasonable. The paintings were wanted by the Feast of the Virgin on 8 September, but certain measurements were not supplied to Carracci until June. Nevertheless, the Ducal Resident in Rome, Fabio Masetti, visited Carracci's studio in the Palazzo Riario and confirmed that the artist 'worked every day' on a painting

of the *Nativity of the Virgin* which is almost certainly to be identified with the painting now in the Louvre. Caravaggio, naturally, was more difficult to deal with, but Masetti made the down-payment and hoped for progress on a painting which may have been the *Madonna of the Rosary* now in Vienna, for though the price of 50 *scudi* agreed with Caravaggio would seem too small for this painting, the Rosary theme corresponds perfectly with Cesare's commission. By August 1605 Masetti was forced to observe that 'the greater the desire His Highness shows for these paintings, the greater his displeasure at seeing that it is impossible', and in the event Cesare celebrated the Feast of the Virgin that year in his palace chapel, thrown open for the occasion to the public.[33] He did not, however, give up hope just yet, but though Masetti enlisted the help of influential agents (the Cardinal Francesco Maria Del Monte for Caravaggio and the Cardinal Odoardo Farnese for Carracci), neither painting would ever arrive in Modena. In 1607 the commissions were quietly abandoned.

By now Cesare's disappointments were noticeably gathering. Most serious, perhaps, was the illness of the Duchess Virginia de' Medici, diagnosed to be in need of exorcism, which marred the celebrations for the wedding of their son Alfonso to Isabella of Savoy.[34] The defection of artists was less dramatic, but significant nevertheless. In 1606 Cesare had given Schedoni leave to take up the commission from the Commune of Modena, but in 1607 Schedoni left Modena, that work unfinished, and settled in Parma, a path which Cesare's mint master, Paolo Selvatico, would also follow.[35] It was as if Schedoni had worked as a journeyman for Cesare but chosen to settle for a career elsewhere. Cesare retained his interest in Schedoni, but it was to Schedoni as Farnese court painter that he would send a protégé, Bernardino Cervi, to be trained in 1614.[36] For the wedding decorations of 1608, Cesare looked to Ferrara to supply him with painters (and musicians, servants and borrowed silver) whose presence in Modena coincided with that of Bolognese artists, including Leonello Spada, drawn to the city for this most important occasion.[37]

From this point it becomes ever more difficult to disentangle Cesare's influence, on policy in general as much as art patronage, from that of his immediate family. The Prince Alfonso, Isabella of Savoy and the Cardinal d'Este all tended to eclipse the Duke himself and thereby endorsed the prevailing opinion that his character was weak. A new public image of Duke Cesare d'Este was however taking shape which would be drawn in part from this very weakness, or from the 'good and pleasing nature' which the papal correspondent of 1607 had observed. On Cesare's death, on 11 December 1628, a funeral oration was composed which translated his mildness, or weakness, into a 'heroic docility' and enduring patience, and fifty years later the name of Cesare in Este history would be synonymous with the virtue of clemency.[38] It was indeed so interpreted, with heavy irony, by Alessandro Tassoni in Cesare's lifetime. The 'benignity' of this 'new Caesar' could, wrote Tassoni, 'give certainty of grace and favour to his enemies as much as to such natural and devoted subjects as myself'.[39] But Tassoni was possibly referring obliquely to what, in his opinion, was Cesare's favouritism, as a result of which he had lost a court case. The Venetian painter Sante Peranda would have testified more readily to Cesare's patience.

From 1609 Peranda was regularly on loan to the Este Court from Alessandro I Pico della Mirandola, to whom he was Court Painter. He painted devotional pictures and most frequently portraits, and though Peranda was not an outstanding artist, his portraits at least were of reasonable quality. But his first visit to Modena had ended abruptly with his angry departure, 15

and Carlo Ridolfi's tale of a courtier who criticised a portrait by Peranda which did not resemble the sitter refers to this incident. As the chronicler Spaccini fairly observed, 'If they want other painters, though he is so good, they would not only have to pay well but they would also have to wait, for others would not return so quickly as he.' But however impatient other members of the Este Court may have been with the second-best, Cesare, according to Ridolfi, 'much appreciated the ability of Sante, and paid him as he deserved'. (In fact, Peranda and the Duke seemed to establish a quite harmonious relationship, for when in 1620 even Cesare had to say that a portrait of Giulia d'Este, while it was good, was not very like, Peranda agreed and undertook to paint another.)[40]

To the clemency and heroic patience in Cesare's character, piety made a natural third. Public demonstrations of piety were to be expected, and soon after the arrival of the Este in Modena in 1598 notices were posted reinforcing popular faith with threatened punishments: a vandal who defaced an image of the saints risked the galleys or loss of a hand, while defacing an image of the Virgin, Christ or God the Father was a capital offence.[41] There was no obvious sign then, however, of any out-of-the-ordinary religious feeling in Cesare. It was in later years that he was seen to be taking part more often in public services and processions, outward shows of an apparently deepening piety which might be attributed to several influences, not least the Jesuits in Modena (who provided the Court with confessors and tutors and whose new church of S Bartolomeo was founded in 1607 with ducal, but not popular, approval), but which might also be regarded as a natural consequence, in a mild-mannered man, of repeated disappointment.

In time, Cesare's piety too would be enshrined in Este history and his Court would be likened to that of a Christian Lycurgus. It was, however, the poet Giambattista Marino who broadcast the image of the pious Duke of Modena, in the madrigal dedicated to him in *La Galeria*, 'Non fuggo e non pavento'.[42] Not weakness nor fear, proposed Marino, but piety and obedience had persuaded Cesare to surrender Ferrara to the Pope in 1597, for better humiliation than sacrilege, and Cesare had had no wish to own that which rightly belonged to God. Though perhaps no more than a gloss, by 1615, when *La Galeria* was published, the picture of Cesare it presented seemed not far from the truth, and the movement towards a deeper devotional feeling was reflected also in Cesare's art.

In 1620 Cesare had a corridor built connecting the Castello with the church of S Domenico, for which he had ordered some years before an altarpiece of the *Virgin and St Catherine* from Sante Peranda. In 1626 his sister Eleonora founded a Chapel of Sta Barbara in S Domenico, commissioned an altarpiece for it from the Ferrarese painter Carlo Bononi, and made provision there for the burial of Cesare's younger sons.[43] Cesare would himself be buried in S Domenico, a church which was clearly close to his heart. But it was the private chapel he had had built within the Castello of S Pietro which testified most eloquently to his faith.

In June 1615 Cesare ordered for this chapel a new altarpiece of the *Holy Family with Sts Barbara and Carlo Borromeo* (Plate 12), painted for him by the now elderly Ferrarese artist Scarsellino.[44] It was not the most straightforward of commissions. When Cesare asked for speedy completion Scarsellino replied, with some dignity, that he was not accustomed to rushing paintings for princes. Nor would he discuss yet the suggested price of 50 *scudi* (he was at the time withholding a delivery of another altarpiece, for the chapel of Cesare's father, pending final payment). A sketch was sent from Modena not, he was assured, to dictate the appear-

16

ance of the finished work but to 'give information on what is desired'. How far Scarsellino let himself be guided by this sketch is not known, but he asserted his professional independence by demanding more precise information on intended location and lighting. But the fact that he, and not the regular stand-by Peranda, had been chosen to paint this altarpiece implies that it was a commission of especial importance to the patron, and Scarsellino lived up to expectations by delivering, in just four months, a painting which by virtue of the composition was very grave in character and by virtue of light intensely reverent in mood. The presence of San Carlo may be accounted for by his enhanced popularity everywhere in the years immediately following his canonisation in 1610 (Peranda painted two images of San Carlo for the Court), and special prayers may have been offered to San Carlo in Modena in 1615, when a virulent smallpox outbreak claimed two thousand babies in two months.[45] The protection of St Barbara might be invoked against sudden death (though usually of a more violent kind than smallpox), and her presence may also refer to the epidemic, or more specifically to deaths within the Este family – Cesare's wife Virginia de' Medici died in 1615 as did his grandson Alessandro, born the same year to Alfonso and Isabella. But St Barbara was also a protectress of Ferrara (in this painting her attribute of a tower looks very like one of the corner towers of the Castello Estense), and this alone may explain her presence in an Este painting.

The *Holy Family with Sts Barbara and Carlo Borromeo* complemented the two paintings which already decorated the private chapel. One was the *Holy Family* which Bartolomeo Schedoni had painted for Cesare in 1606. The other was a painting by Titian of an importance to Cesare which was revealed in 1612, when the chapel was robbed of its gold cross and candlesticks and he feared, mistakenly, the Titian too. This painting must have been the *The Tribute Money* (Plate 13), originally painted for Alfonso I d'Este and probably the finest work of art to be salvaged from Ferrara after devolution. According to Ridolfi, when an Imperial ambassador saw *The Tribute Money* in the ducal chapel he was amazed, for he had believed that no painter could surpass Albrecht Durer in the painting of truth-to-life.[46] It was hardly less amazing that Rudolph II had not demanded the painting as a gift. The fame of *The Tribute Money* was almost legendary. In the opinion of Alessandro Tassoni, it proved the superiority of contemporary painters over the ancients in the rendering of human psychology and the divine spirit: 'no one will say that that countenance represents a being other than divine, so shining are the signs of heroic virtue and supernatural majesty, combined with such exquisiteness of colour and grace that the pen cannot describe so well as the brush.'[47] Cesare may have seen only the artistry, but if his contemporaries looked also for psychological insight, so perhaps did he. Whatever the meaning of *The Tribute Money* for its patron Alfonso I, 'Render unto Caesar' may have seemed particularly relevant to Cesare, and no less appropriate the lesson it afforded in divine patience and self-control in the face of malice.

Much that Cesare planned failed to materialise and much that he did would later be destroyed. Thus he is remembered as the man who let what he had slip from his grasp, from the *Bacchanals* to paintings by Caravaggio and Annibale Carracci and to the Duchy of Ferrara itself. When there is so little left to show for a reign of thirty years it is possible to emphasise unduly the introspective in Cesare's character. His love of gardens must not be forgotten, and one of the most fascinating documents of his reign is a discourse composed for him with recommendations for a new park 'with little expense and much beauty', where 'artifice would

17

surpass but not alter nature'.[48] The intended site was perhaps Sassuolo and the particular beauty of the materials (tufa, pumice and chalk, shells, chestnut and fruit trees, juniper and bryony bushes, mountain and meadow flowers) was that so many could be found locally, without cost, for the unnamed writer of the discourse realised that outside Modena the Este possessed a countryside rich in natural resources. But if the park was ever created it was soon destroyed and probably it never took shape. The form if not the content would have derived directly from the *delizie* of Ferrara, and the palace of Isola, built by Cesare's father beside the Po at Pontelagoscuro, was mentioned by name. But thus the charming *Discourse* was just another reminder of all that had been lost, for Cesare alone was banned from entering the Papal States and revisiting his possessions.[49] When due allowance has been made for what was or might have been, the thoughts return to Cesare's losses. To look from the silent, contemplative art of his private chapel to the paintings which had decorated his Palazzo dei Diamanti ignores their vastly differing purposes but does not, perhaps, misrepresent the change in Cesare's world. He did not travel now and the festivities he must from time to time arrange for visiting princes were a source of worry about costs as much as entertainment. In letters to the Cardinal d'Este he would describe briefly a joust performed or a comedy seen, but never did the world of Modena seem so narrow and so dull as when letters arrived from the Cardinal abroad.

(ii)

Alessandro's position was enviable, all that Cesare's was not, and he at least had been free, in 1603, to revisit the *delizia* of Isola and receive the local nobility who, much to the annoyance of the papal government, flocked to greet him.[50] Alessandro did not enjoy his duties. His education had encouraged his literary interests, and he would always be more at home in a literary academy than in the College of Cardinals. He had taken orders for the sake of the family, become a cardinal in 1599 and Bishop of Reggio in 1621, but he would never be a force in conclaves and never remotely *papabile*. The Court of Rome wearied Alessandro: 'believe me', he wrote in 1612, 'these ceremonies are boring, and I long for the freedom of Modena'.[51] He loved 'humanity' in people, had no taste at all for Roman double-dealing, and as late as 1621 the hypocrisy of the Cardinal Montalto, whom he had considered a friend, could draw from him expressions of shocked innocence.[52] A chronic shortage of money made it difficult for the Cardinal d'Este to keep up appearances in Rome. In 1602, with debts already standing at 8,000 *scudi* and expected to rise to 14,000, Alessandro begged Cesare for help so that he might remain 'with some honour', and not 'flee with much shame, from the which, to speak freely to Your Highness, we are not very far'.[53] But there were compensations. For diplomatic reasons Alessandro travelled to Bavaria and Bohemia in 1604 and to Spain via Chambéry, Lyon and Avignon (an interesting route) in 1614, and new sights relieved the negotiations. He saw much that made him laugh (the heavy drinkers of Bohemia, for example) but he was drawn above all to the beautiful. In August 1604, having first visited Prague, Alessandro was invited to Rudolph II's summer palace at Brandeis on the Elbe (it was, he wrote to Cesare, *superbella*), where the Emperor showed him his leopards and secret gardens, vases, statues

and clocks, and paintings 'wonderful for the quantity and the quality.'[54] Nearer home, in 1608 Alessandro was guided by the Grand-Duke Ferdinand I de' Medici about the city of Florence, 'truly a miracle of beauty'.[55] The inventory of Alessandro's collection, drawn up on his death in 1624, suggested that he acquired art on his travels.[56] His volumes of *grotesques* for goldsmithery by one of the Jamnitzer family, for example, might have been purchased in Bavaria or Prague, and Alessandro looked with an expert eye at work of this kind, being himself a prolific draughtsman.

Among the several boxes of drawings in the Cardinal d'Este's collection were two containing his own work, including his copies after works by the Bolognese artist Bartolomeo Passarotti. Alessandro's talent cannot now be judged, but he possessed an exquisite set of drawing tools: silver pen and inkwell, silver boxes for pigments, silver pencils and a silver phial for oil.[57] He also employed a draughtsman, the German Emanuele Sbaigher (*Il Todeschino*), who drew for him sheets of fantasy designs for moustaches and for glassware, and some of the latter group may have been produced, for in addition to a 'large goblet, of beautiful workmanship, bearing the Cardinal's arms', Alessandro owned some 150 goblets *a capriccio*.[58] He had a decided liking for the bizarre and capricious, and a light-heartedness which was revealed also in his library, where Latin and Greek classics, the proceedings of the Council of Trent and the annals of the Este stood alongside pastoral fables and descriptions of jousts in Ferrara.[59] His collection of art was equally varied.

It was a large collection in which the old masters were well-represented – a *Deposition* by the Bolognese painter Francia, for example, hung over the door to the Cardinal's *studio*, which may have been a place of honour. But this was not one of the priceless collections of the day (in 1624 it was valued at just 3,000 *scudi*) but rather an assembly of contemporary art more interesting than precious. In Alessandro's houschold lists of 1611 was provision for a staff painter, and this post would bc filled by Annibale Mancini, an artist known to Marino and mentioned in *La Galeria*. Mancini painted *caprices* and *bagatelles* for the Cardinal and any number of portraits, including a series of 'literary men' such as the Cardinal Bessarion and Giovanni Argyropoulos. Alessandro also collected the likenesses of living writers, asking the poet G. B. Guarini, for example, for a copy of his portrait.[60] Literary interests may also have inspired his acquisition, or commission, of pictures by Alessandro Tiarini and Sisto Badalocchio illustrating stories from Ariosto and Tasso, but it was perhaps the Cardinal's sense of humour that was reflected in his two paintings, the *Soldier with a Glass* and *Soldier with a Flask* (both are now in the Galleria Estense, Modena), by Bartolomeo Manfredi. In the inventory of 1624 both men were described as Germans, and they may have reminded Alessandro of his travels in northern Europe. But the interest which the collection revealed above all was an interest in artistic style.

Alessandro would be remembered as a patron in the writings of Ridolfi, Malvasia and Giulio Mancini, reflecting a range of artistic interests from Venice through Bologna to Rome. Early seventeenth-century Venice was the least exciting of these, but Alessandro, as many other visitors, had his portrait painted by Leandro Bassano on a visit to a city where he found, as he told Cesare in 1609, 'an incredibly loving feeling . . . for our father and for all our House'.[61] In Rome Giulio Mancini recorded Alessandro's patronage of the Bolognese artist Lavinia Fontana, for whom he provided accommodation.[62] It was probably Bolognese painting which most attracted Alessandro. In his will he bequeathed paintings by Guido Reni to Cesare

and to the Cardinals Scipione Borghese and Guido Bentivoglio, which might be taken as a mark of his high regard for that artist. He himself received gifts of Bolognese art, such as a painting and the dedication of a print after Parmigianino's *San Rocco* in Bologna by Francesco Brizio (Plate 14), and in 1622 *The Genius of Fame* by Annibale Carracci (Plate 15).[63] (In 1619 he had also received the intriguing offer of an unfinished altarpiece by Agostino Carracci, which Reni might 'retouch' if Alessandro wished.[64]) But there were two painters in particular who seemed to interest the Cardinal. One was Leonello Spada, by whom he came to own some eighteen pictures, including Spada's self-portrait. The presence of such themes as the *Prodigal Son*, *Herodias* and the *Buona Ventura* in his Spada collection suggests that Alessandro liked the Caravaggesque manner in this painter, and he may indeed have encouraged it. He certainly encouraged Spada's career by showing his paintings to other prospective patrons and in 1620 the painter wrote from Parma to thank him. Eighteen pictures by Spada compared with just two by Tiarini, implying a preference for, to use Malvasia's terms, the 'bizarre and strong in colour' before the 'correct and profound in design'.[65] It was probably the same preference which led Alessandro to acquire paintings by Guercino, including the *Four Evangelists* (Plates 16, 17, 18, 19), a series whose unusualness of conception would have appealed to the Cardinal's eye. The connection with Guercino, probably formed while the artist was in Cento, may have continued in Rome, where from 1621 to 1623 Guercino and the Cardinal lived in the same parish of San Lorenzo in Lucina. By 1624 Guercino was in any case sufficiently sure of the favour of Alessandro to propose themes for paintings – on this occasion he suggested the elegant, if not particularly original, subject of *Alexander and Bucephalus*, drawing upon an analogy already explored by Marino in *La Galeria* to show Alessandro like Alexander the Great in the 'happy possession of heroic virtue'.[66]

According to Spaccini, the Cardinal d'Este was also appreciative of 'the ingenious Modenese, eminent in all things'.[67] But in Modena he figured more importantly as an arbiter than as a patron of art. Alessandro was protector of the Theatine Order in Modena, for whose temporary home in the new church of the Paradiso an altarpiece of the *Visitation* by Palma Giovane arrived in 1611.[68] In 1620 altarpieces commissioned for S Bartolomeo of the Jesuits from Cristoforo Roncalli (Il Pomarancio) in Rome (including the *Crucifixion* now in the Galleria Estense, Modena), had to be submitted to Alessandro for approval.[69] The following year, 1621, the Canon Fabrizio Manzuoli consulted the Cardinal about a suitable painter for the new Chapel of the Resurrection in Modena's Cathedral. Manzuoli had Guido Reni in mind and Reni was eventually commissioned to paint the *Risen Christ*, but on this occasion Alessandro had proposed another Bolognese, Lucio Massari, an odd recommendation which might be explained by an undertaking to help Massari's career.[70] More fitting to Alessandro's memory and more in keeping with his taste was the *Assumption of the Virgin* painted by Reni in the 1630s for a confraternity in Spilamberto, near Modena, which was paid for, indirectly, by means of a legacy from him to the Theatine Order.[71]

The principal reason, temperament apart, why Alessandro's early years as a cardinal in Rome were so acutely uncomfortable was that he not only lacked money but also a permanent home. He rented accommodation, moving about the palaces of the Colonna, Salviati and Peretti before settling at last in the Palazzo de Cupis in Piazza Navona, where he arranged his pictures, books and glassware and where, in May 1624, he would die.[72] The Este gardens on the Quirinal Hill had been sold, in part, in 1609 to make way for extensions to the papal palace

grounds, and therefore when Alessandro was invited, as he was in 1620, to attend concerts at the Borghese *vigna*, he could not return the compliment in Rome.[73] In the same year, however, he was able to play host at a restored Villa d'Este at Tivoli.

Restoration had been under way at the 'palace and garden' at Tivoli since 1606, Alessandro's first executant being the Modenese Giovanni Guerra, to whom had succeeded by 1611 Francesco Peperelli, a former pupil of Girolamo Rainaldi. In 1615 Peperelli was working to save the palace from what he believed to be 'the imminent danger of ruin' to the brickwork, gutters and paving, but basic repair apart, little was done to the building.[74] A painting of the *Madonna della Ghiara* in the palace chapel was a sign of a new age, but it was the gardens which were changing. The 'fountain-maker' allowed for in Alessandro's budgets of 1611 had been at work by July 1612, when as the Roman *avvisi* reported the Cardinal d'Este had invited his friend the Cardinal Ferdinando Gonzaga (later the Duke of Mantua) to Tivoli 'to enjoy the delights of that garden'. 'Truly', wrote Alessandro to Cesare, 'it is more beautiful than ever.'[75] Statuary had been moved to new locations and some old features of the gardens had been altered. A *tempietto*, for example, now graced the famous Water Organ. In the process of restoration the iconography of the Cardinal Ippolito II's original scheme was destroyed in ways which were surely unwitting, for it was Alessandro's *mastro di casa* Raselli who supervised the work, and he was probably not aware of the various esoteric meanings which the design of the gardens had held. In any case, the Cardinal Ippolito's highly personal imagery, though no doubt satisfying still to unravel, was out of keeping with this new age of Tivoli, with which the Eagles and Lilies of the Este coat-of-arms which now appeared in the Lane of One Hundred Fountains and on the crest of the Water Organ were much more in tune. In 1620 the new Tivoli came fully into its own. Alessandro returned to Modena by way of Florence and Caprarola, then transferred from Rome to Tivoli to prepare a welcome in late June and early July for Prince Tommaso of Savoy. The Cardinal Borghese was a guest at these festivities and he returned to Tivoli in the autumn, when Pope Paul V himself visited the Villa d'Este. In August the *avvisi* had reported that the Pope was granting Alessandro, like Cardinals Ippolito I and Ippolito II before him, the governorship of Tivoli for life. The Este were moreover promised absolute possession of the Villa, 'which has need of continual expense and care to maintain', and in 1621 Pope Gregory XV would issue the papal brief which made the Villa the property in perpetuity of the Este.[76]

The poet Fulvio Testi visited Tivoli in October 1620 and reported to Cesare.[77] The hospitality, he wrote, was 'grand' but not 'ambitious', and guests included a different foreign prelate every day and always 'rare literary talents'. The day began with prayers, then discourse, study, reading, games and walks through ever-changing garden vistas – 'the woods are immense', added Testi, 'but the *scherzi* of water are infinite'. Music was made at Tivoli (by Frescobaldi as well as Alessandro's regular musicians) and new epic poems were written, or at least begun – the Cardinal's secretary Ridolfo Arlotti began a poem on the conquest of Granada and Testi embarked upon his own, unfinished, pastoral epic, the *Arsinda*.[78] The *locus amoenus* had been restored, and Tivoli was again the haunt of beauty, poetry and the recreation of the spirit.

As the reports came back to Modena, Cesare could only hope that Alessandro 'did not lose completely the memory of we who have little novelty to hand'.[79] But he did not begrudge him his 'delicious solitude' nor, it seemed, the 26,000 *scudi* spent on restoration. To see why Tivoli had enjoyed such priority at a time of financial stringency it is only necessary to remem-

21

ber the prestige of the site. But Tivoli was also close to the heart of Cesare. Once, in the old Ferrara days, he had visited the Villa d'Este, entering by the *Porta da basso*, from which the view was most breathtaking, 'and though so many years have passed and I may have forgotten some details, the memory of that first truly marvellous entry remains vivid in my mind'.[80] Cesare would not see Tivoli again, but in Modena, with time on his hands, there may have been a compensating sweetness in nostalgia and pleasure in this one former glory restored.

(iii)

It could never be said of Alfonso d'Este, as it was of his father Cesare, that he behaved as a private gentleman. Whether as Prince Alfonso, as Duke Alfonso III, or as the Padre Giobatta d'Este ('P. G. B.' in despatches), his bearing was always consciously exemplary. As the heir to the throne he had neglected no occupation becoming to a prince. He fought in Modena's border wars with Lucca and in 1619 at least contemplated taking part in the religious wars of northern Europe. He was a scholar and when the university of Modena was closed for lack of funds, he formed his own philosophical academy and presided over its debates. He was also an accomplished horseman who displayed his skill both in the formal ballets, such as those held in Turin in 1608 at the time of his wedding, and in the wild hunting chases he would lead across the Modenese state.[81] Alfonso could be ruthless. When Ercole Pepoli was murdered in Ferrara in 1617 (it happened across the road from the Palazzo dei Diamanti) and the Este confiscated his Modenese estates, Alfonso as Cesare before him was accused of complicity, but instead of complaining he countered attempts on his life with a reward on the head of the murdered man's relative, Filippo Pepoli, dead or alive.[82] Life was precarious for Alfonso's courtiers. Pio Enea degli Obizzi, for example, was imprisoned, quite unjustly he claimed in his *Atestio*, and Fulvio Testi was never sure if he was in favour or out.[83] It seemed indeed to Testi that Cesare and Alfonso between them had created a court which resembled a well – as one bucket rose, another fell, but the bucket ascending was usually lighter than that which was on the way down.[84]

Yet there was a more attractive side to Alfonso. He was a poet who liked to have such poets and *litterati* as Obizzi and Testi about him. According to Spaccini, he was also a talented draughtsman who excelled in perspectives, figures and landscapes – it was perhaps not surprising that relations between Alfonso and his uncle the Cardinal d'Este seemed rather more cordial than those between Alfonso and Cesare.[85] His own skill and the training of hand and eye had made Alfonso also a collector of drawings: examples by, or at least attributed to, Raphael and Giulio Romano, Titian, Parmigianino and the Carracci came into his possession.[86] In the 1620s he was a patron of altarpieces by the Bolognese painter Alessandro Tiarini and took an interest also in Lorenzo Garbieri – an artist whose career not only Alfonso but other members of the Court seemed almost pledged to support, particularly with regard to commissions for the pilgrimage church of Reggio.[87] Alfonso turned his hand also to architectural design, asking in 1620 for the loan of the model of the Palazzo Bentivoglio at Gualtieri (designed by G. B. Aleotti) to help form 'the design of the building of the Castello'. How seriously rebuilding schemes were being debated in the early 1620s is not clear, but when Alfonso was Duke

of Modena the old tower of the Castello would be pulled down and work begun on a new façade.[88]

No one was more acutely aware than Alfonso of the many talents and virtues he possessed. Among his papers survives a document amounting to a testimonial to a prince in whom the ancestral virtues of his house were gathered: a master of hunting, arms and learning, strong of soul, mature in judgement, swift to act, benign to his subjects and obedient to God.[89] This 'Nestor and Achilles' united was, the document implied, about to have a Homer to sing his praises, and therefore it had perhaps been prepared for a poem, and if Alfonso had not actually written it, he had supervised its contents. The proper organisation of his life was a matter of deep concern to Alfonso, who drew up the rules for the regulation of his days: the hours for sleep and the time of rising, the hours for recreation (hunting, sports and chess) and for entertaining his wife Isabella, to whom he was devoted, and the hours for study. In the evening, for example, accounting and history were allowed thirty minutes each, reading and translating Plutarch occupied one hour and a third hour was given over to studying fortifications with the engineer Passi. When Alfonso prayed he gave thanks for the Creation and the creation of mankind, for human redemption and for his own birth as a prince.[90] Self-discipline, not the example before him, was shaping Alfonso for his future duties. But there was a weakness, an instability, in his character which was perhaps inherited from his parents and aggravated by the upheavals of his childhood, and which showed in the very self-conscious zeal with which he applied himself to work. Everyone, especially Fulvio Testi, knew that Alfonso's humours were changeable, but no one seemed to have predicted the turn of events which followed upon the death, in August 1626, of the Infanta Isabella of Savoy.

The daughter of Charles Emmanuel I, Duke of Savoy, Isabella was better-born than her husband. Her character was as strong as his own and rather more stable. Isabella had been brought up in the manner of a Spanish princess in Turin, where the painter Zuccaro had observed in 1606 her grace and her gravity of expression.[91] From the moment of her arrival in the spring of 1608 she had assumed far more easily than the retiring Virginia de' Medici the rôle of a first lady, but she devoted her considerable energies to three principal passions: the House of Savoy (she sent family portraits by Peranda and paintings by Guido Reni (including a *Holy Family*) to her father and brothers); her own children (she and Alfonso had fourteen, nine of whom survived childhood); and her profound faith in God.[92] Where it was customary for the Este princesses to celebrate the Mass in private, Isabella asked and obtained Cesare's permission to join the congregations in the churches of Modena, and thus, it is said, she encouraged the Modenese to repair and improve their buildings so that she and her companions might worship in some comfort.[93] (Her initiative was timely, to judge by the complaints of the Augustinians, the sacristy of whose church of Sant'Agostino was being used as a pig market at the turn of the century.[94]) In 1621 Isabella founded a new Confraternity of the Suffragi in the church of S Sebastiano, an act which was later commemorated in a portrait, in which she holds a sketch of St Sebastian (Plate 20).[95] She also shared with the Cardinal d'Este patronage of the Theatines in Modena, and it was thanks to a legacy from Isabella that their new church of S Vincenzo founded in 1617, would eventually receive its High Altar tabernacle, framed by statues of San Contardo d'Este and the Blessed Amadeus of Savoy.[96]

Isabella's importance can hardly be overstated. She set an example to the city and she steeled the rather passive piety of Cesare and the easy-going Cardinal d'Este with an energy which

23

generated activity. Alfonso had once threatened a courtier who talked of princes being ruled by their wives, but she was certainly his constant support and her death was a devastating blow.[97] For eighteen years they seemed to have divided patronal duties, Isabella assuming the devotional and Alfonso, though necessarily concerned with the city's pious institutions, lending his special protection to the arts and learning. But in January 1627 he wrote of a sorrow which was still so fresh in his mind that it destroyed his taste for old pastimes.[98] He continued Isabella's protection of the Theatine Order, and in 1627 enabled the Congregation of the Blessed Virgin and San Carlo, formed under Theatine auspices, to build their own oratory of S Carlo Rotondo.[99] In 1628 Alfonso was ill and he attributed his eventual recovery solely to the intervention of the prayers of the community of Sestola in Garfagnana.[100] In December 1628, at the age of 37, Alfonso succeeded to the Duchy of Modena. The usual inventories were made and new initiatives were taken, including work on the Castello, essential repairs at Tivoli and new defences for the state.[101] But on 27 July 1629 Alfonso III abdicated to become a member of the Capuchins, most rigorous of the reformed religious orders.

By rights Alfonso, or the Padre Giobatta d'Este as he was henceforth to be known, should have no further place in Este patronage in Modena. That he has, and that his influence cannot indeed be ignored, is due partly to the advice which he continually gave to his son Francesco I, and partly to the way in which he as a Capuchin friar turned the principles of princely patronage inside out but retained the exemplary style. He described his abdication as a death which had orphaned his sons and his entry into the Capuchin Order as a rebirth in the faith.[102] Pope Urban VIII Barberini found it most edifying, 'and not without extraordinary effect, for while the cardinals commonly renounced the biretta for the title of prince (Ferdinando Gonzaga was a case in living memory) the Duke renounced his title to make himself a humble Capuchin'.[103] But very soon the Barberini and the princes of Savoy were sympathising with the young Duke Francesco I, who was exasperated by his father's interference.[104] The Padre was never humble.

Letters which were truly small booklets of advice would arrive in Modena from the monastery of Merano in the Tyrol where the Padre took orders, from Innsbruck and later from Castelnuovo di Garfagnana, where the Padre in 1634 founded a new Capuchin outpost in the mountains (Plate 21). Or, if the Padre were in Modena, messages sounding a subtle note of criticism would issue from his cell – he would regret, for example, that he had not seen Francesco that day because the latter was playing tennis, or perhaps watching a play.[105] In 1631 the Padre understood that his son planned to build a 'vast fabric' in place of the Castello, and he wished that he content himself with completing the façade already begun and invest the savings in grain, artillery and gunpowder, for the French, believed the Padre, were returning to Italy, and he feared war. Therefore he composed a new *libretto* of advice. 'Guard yourself against every outlay that is excessive and not absolutely necessary, such as clothing your wife too sumptuously, gambling, spending on jousts and tournaments, and above all on building which, as the proverb says, impoverishes the man.'[106] However galling to receive, the Padre's advice was usually sound and there were times when Francesco was obliged to consult him, as happened in 1632, when the young Duke was wondering how best to put to the Modenese his plan to build a fortress in Modena. Explain first, replied the Padre, the urgent necessity of repairing the existing defences and allay fears by adding that the recent plague (Modena had suffered the plague in 1630 and 1631) was caused by contagion, not

bad air. Get the groundwork done and as soon as the men are on site, announce that you have changed your mind in favour of a fortress, providing greater security at less expense and promising cleaner air.[107] It was impossible to ignore an adviser as wise as this.

The Padre d'Este was equally devious when it came to proposing new devotional campaigns and pious foundations. In 1629, for example, he demonstrated how easily a site marked out for new defences could be adapted to allow room for a Capuchin convent.[108] For his own foundation at Castelnuovo, he asked his son not only for wood and iron but also for certain pious legacies which he knew existed and had not yet been used.[109] Often he found his own resources (in 1639 he enlisted fugitive soldiers as cheap building labour at Castelnuovo), but when the need arose, when it seemed, for example, that a printer's charity had been tried too often, he applied to Francesco, for this was work 'in the public good'.[110] In 1642 the Padre had a Capuchin craftsman ready to carve the ornaments of three altars at Castelnuovo, but he required the services of the ducal architects to make the drawings. At Carpi (where, in 1636, the year after the notorious Loudon case, the Padre had exorcised the Convent of Sta Chiara), he organised in 1641 a general communion service and borrowed the ducal Superintendent of Fabbriche, to design the structure and lighting, and the ducal Wardrobe stock for use in the procession.[111] The Padre apologised for any inconvenience caused, but not humbly, because, as he explained to his son, these functions were directed ultimately towards the well-being of the Duke, the House, the State and the Universal Peace. These were very large claims but the Padre believed them to be true, for he saw himself now as the spiritual leader of his people.

The palace and the fortress had become the monastery and the mendicant hostel, and energies once absorbed by the hunt and the joust were now expended in the communion service or the conversion of the Jewish community. Poets had been replaced by friars, and in particular the Padre Sestola, the most faithful companion; in October 1634 it was he who was sent to select the site and 'plant the Cross' in Castelnuovo.[112] In 1629 Alfonso had renounced his own poetry (if it could not be adapted to devotional use it must be destroyed), and his eloquence now poured into sermons which, it was said, won over the doubting. Some years later, a painting in the Room of Este Virtue at Francesco's country palace of Sassuolo would picture the Padre d'Este, like a latter-day John the Baptist, preaching to the people amid a rocky landscape. The collection of drawings he had once formed was 'bequeathed' to his second son Obizzo.[113] Connoisseurship of art had become the contemplation of images in the life of the Padre d'Este.

The account of the Padre's preparations for death, on 24 May 1644, at the monastery in Garfagnana revealed the value to him of devotional art. As he waited

> the fervent Religious Prince knew no better company than the dead, who speak through books and still more through pictures, for by seeing them their patience enters the heart, their unspeakable torments inspire the soul of the suffering, and their glory makes him yearn for Paradise. These holy images offer consolation and speak to the heart as much and as often as is wished. Therefore he ordered that in the infirmary . . . was placed a Crucifix at the head of the bed, a *St Mary Magdalen*, at the foot the *Padre Gioseppe da Leonessa*, who lives in glory, and at one side the *Blessed Felice* (of Cantalice), both Capuchins.[114]

No mention was made of artists or artistic quality. These were, perhaps, images of an intense

but unsophisticated kind, for Simplicity, and Poverty, was the Rule of the Order which the Padre (who was said to observe as closely as possible the example of St Francis) had asked his son to respect when, in 1630, Francesco presented an expensive chasuble to the monastery at Merano.[115] But the Padre d'Este had not closed his eyes to art. In 1641 altarpieces of *St Francis* and the *Madonna and Child with the Blessed Felice* (Plate 22) were ordered on his behalf for the monastery church at Castelnuovo, and they were ordered from Guercino, by now one of the most celebrated painters of the day. At a cost all told of over 600 *scudi*, these were not humble commissions.[116]

The terms of the commissions are not known, but since the downpayment was brought to the artist in Cento by the Padre Sestola (the preacher who, in 1641, delivered such impassioned sermons in the church of S Biagio in Cento that the Forty Hour Oration was revived in the town and a new confraternity was founded), it is likely that he, acting on his own or the Padre d'Este's behalf, discussed what was required with Guercino.[117] The result, in the case of the *Madonna and Child with the Blessed Felice*, was a strangely absorbing painting. It shows the moment when the humble Felix of Cantalice, whose custom it was to pray for mercy for benefactors upon his return from the begging of alms, was granted a vision of the Madonna and Child, and these three figures form a self-contained group, bound together by the composition and the mood of silent reverence. But on the right kneels an angel, holding what must be the Capuchin's sack of alms, and though he is only an onlooker, directing the eye to the principal group, he attracts attention in his own right, and the sweep of his wings brings a physical, almost sensual, richness to the painting. He recalls the angel who accompanies San Filippo Neri in paintings by Reni and sculpture by Algardi, or even perhaps Michelangelo's *Angel bearing a candlestick* on the Arca di S Domenico in Bologna (the commissions for the Padre d'Este did in fact cross the period of Guercino's move from Cento to Bologna). There is simplicity in Guercino's painting, but there is also an artistry not inappropriate to a patron who was a Capuchin prince, listed in the painter's account book as 'the Most Serene Padre'.

The Padre d'Este had retained the Prince Alfonso's tendency to self-dramatisation. On the way to Merano in 1629 he had travelled as 'Marco Bevilacqua', and unless the plan to abdicate had only gradually taken shape, there had been a deliberate drama too in waiting until he was the Duke of Modena before announcing his decision. He probably wished to ensure that the affairs of state were in order, but abdication also ensured the greatest publicity. He missed no opportunity for the instruction of the people: 'The death of the great', observed the abdication notice, 'is a book wherein more than anywhere else one may learn to despise the world'.[118] Every detail of the new identity had been considered: letters, for example, were sealed with the sign of a Capuchin at a prayer before an altar with a Crucifix. But perhaps the most striking contribution to this new propaganda programme was made by portraits.

Portraits recorded the various stages of the Padre's new life from the time of his ordination at Merano, and as the pictorial equivalents of the sermons they employed all means to instruct. 'Come and see what God has wrought in my soul' called the inscription on one portrait of 1630, while in another engraved by the Reggio artist Bernardino Curti the Padre's hand pointed simply but eloquently to the Cross (Plate 23).[119] Printed portraits of this kind were perhaps distributed at the Padre's communion services and processions, while the painted

portraits would have been studied by visitors and, no doubt, by the Padre himself. Most remarkable of all was the full-length portrait of 1635 (Plate 24).

The artist was Matthew Lowes, an English painter who had assisted Guercino when that artist was summoned to Modena by Francesco I in 1632.[120] But for all that Lowes contributed to this portrait he might as well be anonymous, for the presentation must have followed the dictates of the Padre. The portrait commemorates a particular day, 7 October 1635, and a particular age, 44 years in the world, 6 years in faith. All the paraphernalia of government, war, scholarship and recreation, all that Alfonso had cultivated so carefully in another life, surrounds him here as the temporal world he has renounced to take up the Cross to which he points. The lesson continues literally in the Bible, which is open at St Paul's Epistle to the Philippians, Chapter 3, verses 1 to 9 of which carried especial meaning for the Padre d'Este: 'Finally, my brethren, rejoice in the Lord . . . If any other man thinketh that he hath whereof he might trust in the flesh, I more . . . But what things were gain to me, those I counted loss for Christ . . . for whom I have suffered the loss of all things.'

Alfonso, like Cesare, had withdrawn from the world, but how different, and aggressive, was his style. The Padre d'Este was still the exemplar, the pattern for others to follow, and it hardly discredits his faith to see that he still possessed and exploited the prince's and the politician's understanding of what art could do for a patron. As Duke of Modena he might have been a most interesting and informed patron of art. As it was, he brought the first thirty years of the Este in Modena to a close when he stepped down in July 1629.

2 *Restoring the ancient splendour*

'The Duke Francesco is not Duke Cesare', announced Fulvio Testi, now ducal secretary, in Rome in 1635, by which he meant the Pope to understand that Francesco would not waver in his intention of founding a fortress in Modena.[1] Nor was he Alfonso III, for though Francesco probably learned more from his father than he would have cared to admit, he by no means saw eye to eye with that extraordinary man. The memory of the first thirty years of the Este in Modena began to fade in the presence of the first Duke of Modena to be born in the city and brought up to rule. The dust of devolution settled and by 1646 it was possible for the French ambassador in Venice to say that in the person of Francesco I, the 'ancient splendour' had returned to the Most Serene House of Este.[2]

(i)

Francesco was a traveller, and at once the world of Modena seemed more open and alive. In 1628 he had travelled for education, visiting his mother's family in Turin and thence via Switzerland to Flanders and the Court in Brussels of his great-aunt, and Philip II's favourite daughter, the Archduchess Isabella.[3] In 1633 he waited upon the Cardinal-Infante Ferdinand (a cousin once removed) in Milan.[4] In 1645 he seemed to contemplate a journey for the faith, having enquiries made about ships and interpreters in Venice which suggested a pilgrimage, perhaps in response to Pope Innocent X's call for a new crusade.[5] But he certainly travelled for political reasons, never to Vienna (though he had learned German in his youth and was the subject of the Emperor) nor to Rome (a visit was often planned, but either the Pope or his own ministers would raise objections), but to the most important political capitals of the day, Madrid in 1638 and Paris in 1656. Most frequently, Francesco travelled for pleasure, to the neighbouring courts of Parma and Florence, for example, and as often as he could to Venice.

Wherever Francesco went he was welcome. Turin was charmed by his manners and his horsemanship in 1628, the Milanese were still demanding copies of his portrait in 1634, and in 1656 he left in the Cardinal Mazarin (whom he had already met some twenty years before), as in all the French Court, the wish to see him again, for 'his rare qualities, which can kindle the love and esteem of everyone'.[6] When he visited Spain, travelling via Genoa in September 1638, he was fortunate in that his arrival coincided with the birth of the Infanta Maria Teresa (the future Queen of France) and the Spanish victory at Fuenterrabía. The welcome, therefore,

was especially warm. Among the honours he received were some, such as appointment to the Council of State and the Order of the Golden Fleece, and the invitation to stand as godfather to the new Infanta, which might have been prescribed for any visiting prince. But the quite unexpected decision to divide the command of the Spanish Main so that he might share the title with Mattias de' Medici was the result of Francesco's charm. The Florentine ambassador Riccardi noted also that King Philip IV called Francesco 'sobrino, which means nephew' and was taken as a sign of especial affection. Francesco was lodged in the Buen Retiro and visited the other royal residences of Aranjuez and the Torre de la Parada, but the signal mark of royal approval was the visit to the lonely Escorial, where Philip IV himself and alone guided Francesco through the palace, room by room, then down to the 'subterranean Pantheon' with the tombs of the Spanish Habsburgs.[7]

Francesco was young, handsome and charming. The Florentine Riccardi described his appearance in Spain: 'Truly he is handsome, tall, with a cheerful, affable countenance, and a vivacious, open manner'.[8] It was perhaps the portrait painted by Guercino in 1632 (now known only by copies) which most closely resembled this description – though no portrait would ever reveal the light-heartedness in Francesco's character.[9] In Madrid his portrait was painted by Velázquez (Plate 25), the painting which survives today in Modena serving as a preliminary to the equestrian portrait (now lost) on which the artist was working, slowly, in 1639.[10] Since Velázquez would have looked particularly closely at his sitter, it was not surprising that he portrayed a rather shrewder young man than Riccardi described.

'This Prince applies himself with much prudence to his affairs', observed the Cardinal Giulio Sacchetti, Papal Legate to Ferrara, in 1629, and he was perhaps the first to see that there was more to Francesco than charm.[11] Velázquez saw a politician in 1638, and so did the English ambassador to Madrid, Arthur Hopton: 'Here is much made of him', reported Hopton, 'as truly his bearing deserves none less, especially from this Crown, whereunto he so wholly applies himself as he neglects everybody else'.[12] No one had understood quite why Francesco had come to Madrid, but concluded that he was simply confirming his allegiance to Spain. In fact the Duke of Modena had withheld that allegiance until he was sure of obtaining certain advantages, such as money to build the citadel in Modena and Spanish support for his claim to the vacant Imperial fief of Correggio.[13] Thus Francesco renegotiated the hitherto useless Spanish alliance he had inherited from the reign of Cesare. His policy towards Cesare's children was not dissimilar.

In August 1629, just a month after his accession, Francesco issued an ultimatum to his aunts and uncles whereby, wrote the agent of the absent Luigi d'Este, 'many are seen to be perplexed'.[14] They might keep their rooms but without linen and cooking facilities, and they would be required to pay for new kitchens on sites allotted to them. In keeping with her character and her dignity, the first to leave was Eleonora, Princess of Venosa, who would eventually retire to the convent of Sant'Eufemia in Modena. Of Cesare's children, Giulia and Ippolito elected to live alone, while Nicolo, Borso and Foresto decided to share accommodation.[15] Economy, not hostility, had prompted Francesco's actions, but among these relations were some who were undeniably a cause of concern and embarrassment – most notably Borso, who was a good soldier but who also ran up bills with jewellers and tailors in Venice and Milan and whose style of living (he first cohabited with, then married, his niece Ippolita, herself an illegitimate child) obliged Francesco to banish him temporarily from Court.[16] Only Luigi d'Este, still

29

a commander in the Venetian service, proved consistently useful, and in 1643 Francesco rewarded him with the marquisate of Scandiano.[17]

Francesco could exercise more direct control over his brothers. Obizzo, second eldest, was 'dour and melancholic' in the opinion even of his father the Padre d'Este, who worried about his soul. A cardinalate had been planned for Obizzo, but for 'personal caprice' or some other reason he had refused to take orders in 1639, though by the following year he appeared to have stepped back into line, being appointed then to the bishopric of Modena.[18] But already Obizzo had been replaced as the senior Este prelate by his younger brother Rinaldo. He had been brought up to follow a military career but 'being of a more compliant nature' as Francesco put it, had been redirected towards the Church. He became a cardinal in 1641 and ten years later, as the Cardinal Alessandro before him, he was appointed to the bishopric of Reggio.[19] The Padre d'Este was not so easily managed, but he could be snubbed. Francesco dropped negotiations opened by his father on his behalf in 1626 for a marriage to the Neapolitan Anna Caraffa, Princess of Stigliano. Instead, 'with the connivance of love and a large dowry', Francesco in 1631 married Maria Farnese, sister of the Duke Odoardo of Parma, and seen here with Francesco and their eldest children, Alfonso and Isabella (Plate 26). Far away in distant Gorizia, the Padre had to ask if he might know the name of his daughter-in-law.[20] By 1634, however, he had accepted the fact and rejoiced at the birth of the heir Alfonso (the future Alfonso IV, Plate 27), which he attributed to the intercession of St Francis, St Francis Xavier and, most important, St Joseph.[21]

Cesare had had his complement in Alessandro, Alfonso in Isabella of Savoy. Francesco, however, was alone. The Cardinal Rinaldo (Plate 28) would not emerge as a personality in his own right during Francesco's lifetime, and though it was said of him that he was devious, and flattered his ambitious brother, it is difficult to see what such cleverness had achieved, for as the deputy and agent, never the principal, he was forever foregoing his own interests to serve those of the Duke.[22] Even so, he perhaps did well by comparison with the Duke of Modena's wife. When Maria Farnese died in 1646, Francesco two years later married her sister Vittoria and lastly, on Vittoria's death, he married Lucrezia Barberini, who outlived him. Yet not one of these three Duchesses of Modena left any mark of strong and individual character, only a name for quiet piety.[23] Between the powerful personalities of Isabella of Savoy and Laura Martinozzi, the wife of Alfonso IV, there was silence from the ladies of the Este Court. Partly, perhaps, this was due to the fact that the moral climate in general was noticeably cooler as far as women were concerned. As Fulvio Testi observed in a preface of 1644, 'the time was past when Erminia, Angelica and Fiordiligi could wander unaccompanied without scandalising public opinion', and no very high opinion of women could be deduced from the praise Francesco received for his unassailable chastity.[24] (The disappearance of the dotted line of illegitimacy, in the ruling line at least, distinguishes the seventeenth-century Este from their predecessors on the family tree.) Where respectability was all-important, piety was perhaps the only outlet, though Isabella of Savoy had shown that faith need not mean oblivion. The truth was that at the Court of Francesco I there was a proper place for quiet wives, and for complaisant brothers, but no room for rivals.

When the plague came to Modena in 1629 Francesco, unlike Alfonso II in Ferrara in 1570, and unlike Ferdinand II of Tuscany, Francesco's immediate contemporary, did not remain in his city to oversee in person the arrangements for nursing the sick and burying the dead,

but moved to the countryside. He neglected to keep the city informed of his whereabouts, which drew from the representatives of the Commune, in August 1630, a hint of criticism of his conduct. Francesco, however, was not disposed to placate them. As with the family, so with the duchies, his object was to rule, and gradually both the capital Modena and the second city Reggio would lose by means of central laws and taxes their former measure of self-government and their traditional freedoms.[25]

Over every facet of political and household management, from the annual budgets to the price of postage and not forgetting, as he appeared to think they might, the wearing of appropriate mourning by his diplomatic staff abroad on the death of the Archduchess Isabella of Flanders, Francesco would exercise the closest personal control.[26] He was hard-working to a fault, to judge by the concern expressed by the Count Duke Olivares, in conversation with Fulvio Testi, about the Duke of Modena's health.[27] One should, advised Olivares, 'take breath and amuse oneself from time to time', but in 1642 it was the turn of the Duke of Parma to express concern about his brother-in-law's tendency to overwork.[28] Francesco, however, was about to demonstrate that he was not only a careful administrator but also a soldier, the grandson of Charles Emmanuel I of Savoy and the true heir of Alfonso I d'Este.

'I fight for the defence of my states and my personal reputation' announced Francesco in 1643 as he joined with Venice, the Medici and the Farnese in the League against the Pope in the first war of Castro.[29] With the help of his subject Raimondo Montecuccoli (who would become one of the most respected Imperial commanders in the war against the Turk), he came very close to achieving his personal ambition of regaining Ferrara for the Este and though he failed, the emergence of Francesco as a commander of men completed the picture of the Duke of Modena as probably the most exciting prince of the day in Italy. But, inevitably, there were limits to how much an Italian prince, however charming, prudent, industrious and brave, might achieve. The poets Tassoni, whom Francesco summoned to Court in 1632, and Fulvio Testi had written of an independent Italy, free of foreign influence, and conceivably Francesco shared their dream, but in practice he, and they, were realists.[30] On the whole, Francesco's ambitions were realisable; some immediately, such as confirmation of the legitimacy of the Este ruling line which he obtained within months of his accession from the Emperor Ferdinand II; others after years of diplomacy, such as full possession of the state of Correggio, achieved in 1649.[31] Foreign policy was reviewed in the light of changing times and in 1646 Francesco abandoned the Spanish alliance in favour of France. Rinaldo became Protector of French affairs in Rome and Francesco, once 'Supreme General of His Catholic Majesty in the One and the Other Ocean', became in 1656 'Supreme General of the Army in Italy of the Most Christian King', a post which he held at the time of his death on campaign in Piedmont on 14 October 1658.[32] There remained the ambition of a royal marriage for at least one of his children.

In Madrid in 1638 the ambassador Arthur Hopton had been asked, most discreetly, to give his opinion on a possible match between Francesco's son Alfonso and a daughter of Charles I.[33] At the time the whole notion was dismissed as a 'caprice', but a generation later it would become reality when Alfonso's daughter Maria Beatrice d'Este married James, Duke of York and became, if only briefly and unhappily, Queen of England, 'Mary of Modena'. In the meantime, Francesco had turned his attention to France and proposed one of his daughters as a bride for the young Louis XIV. The Cardinal Mazarin kept the two portraits which were sent

him and they were later listed in his collection with other portraits of the Este family.[34] He did not, however, accept an Este for the King of France and Francesco had to be content with the marriage, in 1656, of Alfonso and Laura Martinozzi, one of the many nieces of Mazarin.[35] It was by no means a failure, for Laura Martinozzi possessed a strong character (when Alfonso died in 1662 she ruled as Regent until 1673) and her morals were impeccable, yet it was a compromise. Policy could only do so much for a prince of Francesco's rank, but patronage might achieve what policy alone could not. In 1651 a *festa* given in his honour in Florence compared Francesco with his ancestor Alfonso I, but he himself may have had a still more august ancestral exemplar in mind. In the early 1640s Francesco had commissioned from Fulvio Testi an epic on the life of the Emperor Constantine, the Roman and Christian hero whose wars with Maxentius had, incidentally, destroyed in passing a former Modena. The poem was never finished, but Testi had been sure that he could show, 'without the distortion of adulation', a Constantinian thread in Francesco's lineage.[36] When Girolamo Graziani, Testi's successor as Court poet and ducal secretary, published in 1650 his epic of *Il Conquisto di Granata*, he was on far firmer ground, for Francesco's descent from Ferdinand of Aragon was beyond question.[37] But perhaps no poem, and no ancestral parallel, served the policy or the memory of Francesco I so well as his portrait bust, carved (from paintings) by Gianlorenzo Bernini in 1650 and 1651 (Plate 29).[38] Last and most enduring of the great portraits of this Duke of Modena, it established his image as a martial hero and supreme prince. Francesco never met Bernini and therefore had no direct say in the making of this work of art, but he knew the value of patronage.

(ii)

'One needs economy', wrote Francesco to Rinaldo in 1645, 'but one also needs splendour, and economy without lustre is for private gentlemen, not princes'.[39] As a policy for art patronage, it was in sharp contrast to that pursued by Cesare, or advocated by the Padre d'Este.

'I wish that Your Highness would show a little more enthusiasm for pious works', wrote the Padre from Innsbruck in 1632, and he regretted that his son did not, 'as many cardinals and princes are wont to do', visit church and monastery building sites from time to time. In particular, the Padre was disturbed by the thought that 'the body of my dear companion, the Infanta of Savoy, lies in a wretched repository . . . please attend to the building of the chapel and make it as honourable as possible'.[40] Thus Francesco was placed in a rather unattractive light, but he was not indifferent towards devotional works. He continued his mother's patronage of the Theatine Order (in 1645 he petitioned Pope Innocent X for the canonisation of Gaetano Thiene and Andrea Avellino for 'the particular devotion that I must bear to the one and the other'), and the first major painting he commissioned as Duke of Modena was the *Madonna with Sts John the Evangelist and Gregory Thaumaturge* by Guercino (Plate 30), painted in the plague years 1629 and 1630 and destined for a chapel in the Theatine church of S Vincenzo.[41] It was, indeed, Francesco's wish that the vow made by the Commune of Modena as the plague spread through the city should be fulfilled by the completion of

S Vincenzo. But the Commune wished otherwise, and between a recalcitrant city on the one hand and the Padre (who had other pious building plans for Francesco) on the other, it was one battle which Francesco had to concede, with the result that the Commune built its own votive church, the Madonna del Voto, or Chiesa Nuova.[42] Francesco's argument had been that a new church would drain the city's finances, but almost certainly he had been hoping that the city would relieve him of the cost of completing San Vincenzo. Many devotional works were begun or continued by Francesco I, some minor and others of major importance, such as the new sanctuary church of the Madonna at Fiorano. But a sizeable number of the repairs, rebuildings and redecorations he ordered were less pious initiatives than compensation for church buildings demolished and altarpieces removed. He would support the request of a Modenese patron for an altarpiece by Guercino, but in his own programme of patronage the devotional was now subordinate to the secular – to the staging of spectacular *feste*, the building and decoration of new palaces, and the creation of a gallery of paintings.[43]

By 1635 work had begun on a new city palace, a new country palace and the much-debated citadel of Modena (demolished in the late eighteenth century), finally sited on the northern edge of the city. There were many false starts. The citadel had to be pulled down and begun again, what was painted in the Castello of S Pietro was painted out, what was planted in the gardens was dug up, and progress on the new city palace hung fire as the plans were reconsidered: 'this making and unmaking is nothing but foolishness', grumbled the now elderly chronicler Spaccini.[44] In fact the palace would be subject to many changes of both plan and detail and by the time of Francesco's death it was far from complete (Plate 31). Yet nothing, perhaps, so revealed the intentions of Francesco I as the successive stages whereby, between 1629 and 1634, the Castello of Modena became, in plan at least, the Palazzo Ducale. The first schemes were little more than extensions of earlier, piecemeal, projects. The next brought geometric order to the gardens and a degree of regular planning to the building. But the decisive plans were those of 1634, in which the building was reoriented towards the city and the asymmetry of the Castello gave way to the logic of a regular square plan.[45] It was as if, each time, the patron had stepped back to take a longer look at his building, dissatisfied until the scale and the form matched his idea. The Palazzo Ducale of Modena was the first official residence and seat of government (as distinct from a pleasure palace) which the Este had founded since Niccolo II's Castello Estense in Ferrara of 1385, and the two buildings offer an interesting contrast, the one a reminder of the age of the fortified castle, the other a monument to centralised, absolute authority.

Although they seemed to be under way at once, the building works, in fact, were staggered, the fortress and then the country palace at Sassuolo (built on the foundations of the old Rocca) taking precedence over the Palazzo Ducale. Francesco was less reckless than the Padre d'Este had feared and common sense informed his actions. If statuary were 'to serve in a garden, it is enough that it looks well from afar, and I am not bothered that it is especially beautiful'.[46] In 1654 the price of 100 *ducatoni* each for eight silver vases to decorate a carriage seemed exorbitant: 'after all, this is a reconditioned carriage, not new'.[47] But the gilded studs, numbering some 1,100, for this and for a second carriage, each one bearing either the Este Lily for the town or the Este Eagle for the country (a fine distinction quite lost upon the fitters in Modena, who mixed them up), were designed for Francesco in Rome by the sculptor Alessandro Algardi.[48] There was nothing petty about Francesco's taste. He cared for both quality and

33

appearances and understood that they could be costly. Never was this more true than when, in 1651, he had to pay Bernini for the carving of the marble portrait bust. Francesco had thought of perhaps 400 *scudi* (generous enough when an Algardi portrait might cost 150), but the Cardinal d'Este, more familiar with Bernini's prices, soon disillusioned him. In the end, as is well-known, Francesco paid 3,000 *scudi*, that is, the same sum that Pope Innocent X had paid Bernini for the Four Rivers Fountain in Piazza Navona and, no less telling perhaps, the same sum which, by Rinaldo's reckoning, it would take *per annum* to keep a friendly cardinal in the papal faction. Francesco was in fact rather proud of his outlay – when a courtier suggested that 600 *scudi* would have been appropriate, Francesco, in 'sweet reproof', had asked if 'such an amount would sufficiently have recognised the *virtù* of the artist'. He understood, and explained to Rinaldo, that 'by contenting Bernini, I will preserve my reputation of respecting *virtù* and the virtuosi'.[49]

'Better well-made than made quickly' Francesco had written while the portrait bust was in progress, but the eagerness with which he asked for news rather belied this dictum. On the whole, he preferred to give to his patronage the same minute attention he gave to other affairs of state, and if he could not be present in person, he sent the most detailed instructions. Subject to particular scrutiny were the Court *feste*, astronomically expensive but critically important forms of entertainment and propaganda. The most celebrated of the open-air festivities of Francesco's reign were the *Alcina* of 1635, which welcomed his uncle the Cardinal Maurizio of Savoy to Modena, and *La Gara delle Stagioni* of 1652, with which he greeted the Habsburg Archduke Ferdinand Karl, his wife Anna de' Medici and his brother Sigismund Franz. *La Gara* was subsequently commemorated in a series of etchings by Stefano della Bella (Plate 33). These *feste* served their purpose admirably, the *Alcina* being discussed with respect in Rome and news of *La Gara* filtering through to Spain.[50] Francesco was naturally the principal participant in the *feste* (in *La Gara delle Stagioni* he led one of the four squadrons of knights representing the Seasons), and increasingly he was also their director. How he controlled, even from a distance, the content and standards of performance was revealed in the prelude to the relatively modest spectacle which celebrated his marriage to Vittoria Farnese at Carnival time in 1648.[51]

Early in January, when Francesco himself was absent on campaign, his son Alfonso researched themes with the erudite Padre Zambotti. They proposed, and Francesco approved, the *Ship Vittoria*. Since time was short, spectacular machines had to be ruled out but, wrote Francesco, it 'was not fitting that a lance was not thrown on this occasion. Therefore I am resolved upon a quintain, which will satisfy everyone and not invite embarrassment about machines.' Each participant must wear a mask of his own invention and funds could be provided to help the needy with the costs. As his brother's deputy, it was for the Cardinal Rinaldo to invite those he judged suitable, but, added Francesco, 'I desire that the quintain is numerous', so Rinaldo must not forget the noblemen of Reggio, who could form a separate squadron. Lists must be built by the stables, the knights must rehearse, and a sample of crimson leather with silver lamé must be sent to Francesco for approval – but the lamé must be false, 'remembering that the liveries for such functions must make a great show, and thus the work does not need to be minute'. Next Rinaldo must ensure that the ballet would be 'well-organised, neatly and gracefully danced', and search among the Court pages if no other capable young men could be found. 'I would not wish', added Francesco, in the knowledge that the Farnese

were preparing their own celebrations in Parma, 'that we were in any way inferior, at least in the grace of invention, and the good order of the dance.' 'Meanwhile', he continued, 'for the service of this ballet, and for other occasions that will occur . . . apply yourself to putting together a good band of musicians, that must have no less than twelve instruments, that is, violins and violas'. It would be wrong to assume, from the explicitness of his instructions, that the Duke of Modena was surrounded by fools. But his Court was still young and comparatively inexperienced and all decisions, whether they determined the form of the *feste*, the plan of a palace, or the use of pastels in portraits (not approved in 1656), flowed from his will.[52]

It must have disturbed the Padre d'Este to see that while his son left the churches to fend for themselves, once his palace of Sassuolo was under way his visits were many and they galvanised the work (Plate 32). Sassuolo had been a place of resort for the Este since Duke Borso had held picnics there in the fifteenth century and in 1629 Alfonso III had retired to the Rocca of Sassuolo to prepare for abdication. For Francesco and his family Sassuolo was the country retreat, the place for sports, family celebrations and recreation in favourite rooms.[53] Yet this was also a working palace where state business was conducted and official visitors (Queen Christina in 1658) were entertained, and under the patronage of Francesco the walls and ceilings of rooms were decorated with scenes from Este history and Este poetry as well as classical mythology and legend. Over the years Sassuolo evolved from a hunting box into a palace. Many influences may have contributed to its form – the *delizie* of Ferrara, for example (known only by reputation to Francesco), or, among places he had visited, the Palazzo del Giardino of Parma, the villas of the Medici, the Valentino in Piedmont and the Buen Retiro in Spain. But Sassuolo would not be quite like any of these, because it reflected the changing tastes and aspirations of its patron. Sassuolo was close to the heart of Francesco and when he was away he would demand reports and order improvements. From the fortifications of Brescello, for example, he wrote in 1648 asking that 'a little lamp of glass globes was hung above the door of the *Sala*' and Rinaldo must see to it immediately.[54] The cares of patronage merged with pleasure at Sassuolo.

Francesco derived from the creation and the contemplation of art a pleasure which corresponded with the genuine charm of his personality. In 1650 he saw, for the first time, Alfonso II d'Este's palace of Mesola on the Po di Goro (not far from the border between Ferrara and Venice), and thought it 'lovely and bizarre', though not quite as beautiful as he had been led to believe. On a visit to the Medici in January 1652 he visited Livorno and wrote to Rinaldo of the lovely buildings, impressive defences and the famous port. He also acquired a painting in this city of free trade and art shipments to northern Europe, but the letter from one 'Thurin Giuberti' (a member of the protected Jewish community) which acknowledged his payment gave no clue as to the work.[55] The city Francesco loved most was Venice.

In 1650 the Duke of Modena took his son Alfonso, aged 16, on a brief holiday to Venice to show him, as the Este Resident informed the Doge, 'the splendours of the city because they delighted in paintings and in the architecture of churches and palaces'. The Republic responded by opening for them, as for all its distinguished visitors, the Arsenale and the *Tesoro* of St Mark's. Though the air of Venice was not, he admitted, very good for his eyes, like any other visitor Francesco lingered in the Piazza S Marco, leaning against a column to watch 'the amazing concourse of well-adorned people'. While Alfonso found his own entertainments (including

masquerades, in which Francesco did not take part), his father probably consulted the copy of Carlo Ridolfi's *Le Maraviglie della Pittura* sent to him in 1649. He certainly wished to see pictures (he wrote as much to Rinaldo), and the gallery to which he went seemed to be that of the Flemish artist and dealer Nicolas Regnier. Francesco later confessed to Rinaldo that he could not help but spend money, 500 *ducatoni*, on three paintings. One was a *Holy Family* by Tintoretto. The second was the *St Jerome* by Rubens (Plate 34); a painting of that description was noted by Ridolfi as being in the possession of Regnier. Francesco may have been introduced to the work of Rubens in Brussels in 1628 (though Rubens himself would then have been absent on his diplomatic mission to Spain and England) and already owned a portrait by him of the Archduchess Isabella of Flanders, to which in his letter to Rinaldo he compared the size of his new acquisition. The *St Jerome*, thought Francesco, was 'one of the best things he ever did . . . with a lovely landscape'. The third picture he described as a work by Veronese (Plate 35):

> a beautiful landscape (with) two beautiful figures which represents the *Parable of the Samaritan* . . . almost completely nude and excellent . . . there is the usual dog . . . and a poor mule . . . (and) there are the Rabbis walking in the distance, little figures, who have left charity to its own devices.[56]

Perhaps this was not sophisticated art criticism, but the candour of Francesco's character was conveyed here, as he responded to the appearance of a painting, and entered into the spirit of its narrative, as warmly as the Padre d'Este before a devotional image.

Art was perhaps such a form of relaxation as the Count Duke Olivares had recommended, offering a pleasure akin to that of the hunt, which gave Francesco 'incredible serenity of mind', but required an alert intelligence. As a child his daily lessons had been preceded by riding in the morning, relieved by visits to Modena's churches in the afternoon, and followed by drawing in the evening, 'for a measure of solace'.[57] His son Alfonso apparently showed proficiency as a draughtsman, but no one appeared to comment on Francesco's ability, perhaps because he had none, or because it was not important.[58] Francesco's pleasure derived from looking at art, and in this connection it is worth stressing that the erotic had no part in that pleasure. He shared with certain contemporaries (and notably the Cardinal Barberini, who worried in 1637 about propriety in the *Bacchus and Ariadne* by Guido Reni intended for Henrietta Maria of England) an almost obsessive concern for decency.[59] When a *Bath of Diana* by Francesco Albani was acquired for Francesco in Bologna in 1639 (Plate 36), the agent reassured him: 'I would not wish', he wrote, 'that it fell under the same contempt as my *Hermaphrodite* by reason of its beauty, and I assure Your Highness that there is no obscenity, indeed, everything is modestly covered.'[60] No art open to suggestive interpretation appeared to enter the Este collection in Francesco's time, and few female nudes for that matter. A rare exception is the Venus whose hand rests on a quiver bearing the Este Eagle in Guercino's *Venus, Mars and Cupid* of 1634, a remarkable painting in any case, with its unusually direct appeal to the observer (Plate 37). It was possibly not the result of Francesco's own patronage, for though paid for by a member of the ducal Wardrobe staff, according to the *Life* of Guercino by Malvasia, it was ordered as a gift to the Duke, who is presumably the beholder at whom Venus is pointing and Cupid aims his arrow. The relevance of this painting to Francesco is not immediately obvious and it may perhaps allude to his virtues by reference to the customary

allegorical significance of these deities (as Beauty and Valour, for example). What is, at least, quite certain is that this Venus was not intended to seduce.[61]

New acquisitions, and anticipated acquisitions, were an undoubted source of pleasure. In 1650 Francesco was hoping to acquire the altarpiece of the *Madonna del Foligno* by Raphael and, as he explained to the Cardinal d'Este, 'just the thought of being able to have the Raphael gives me the greatest pleasure'. But when he wrote that the Raphael 'would certainly be a most appropriate painting for me', his interest in art seemed to shade back from pleasure to serious purpose.[62] Francesco's collecting was governed by policy. From the early 1640s a succession of masterpieces of sixteenth-century painting entered his collection – by Andrea del Sarto, Giulio Romano, Correggio, Parmigianino, Veronese and even Hans Holbein – so that by the 1650s paintings acquired and paintings inherited amounted to a collection which was comparatively small by contemporary standards but outstanding for its quality and (since many works of art had been acquired from their original homes or the heirs of their original owners) for its authenticity. It lacked only a great work of art by Raphael, which was why the Duke of Modena's agents (including Monsignor Giulio degli Oddi, whose ancestors had commissioned Raphael's *Assumption of the Virgin* in Perugia) scoured the Papal States for paintings to be had in return for gifts and patient negotiation.[63] The great Raphael never arrived. Even so, 'the rarest of most excellent paintings in the world are collected in the gallery of Your Highness', said the Grand-Duke Ferdinand of Tuscany, which was the kind of compliment the Duke of Modena would wish to receive from his peers.[64]

Francesco was a thoughtful collector, choosing frames, for example, with care. When a painting of *Silvio and Dorinda* by Guercino (now in Dresden) passed through Modena on its way to the Gonzaga of Novellara in 1647, he took note of its Bolognese gilded frame, and soon Rinaldo was asked to order similar frames for a series of four large canvases by Veronese and, as he did so, consider a frame of 'a different, softer, kind' for Giulio Romano's *Madonna of the Washbasin*.[65] The arrangement of paintings was also considered and, according to Pietro Gherardi, curator of the Este collections a century later, Francesco had introduced 'symmetry, form and order' to his pictures, gathering them together and displaying them 'in tiers, hung from the walls of attractive spacious places and kept in good order. To so lovely and delightful a union of paintings was given the name of Gallery.'[66] Perhaps the most curious evidence of art at Francesco's Court is given in his eulogy of 1659, *L'Idea d'un prencipe et eroe Christiano* (Plate 38), or rather in the illustrations which accompany the written exposition of Francesco's many virtues.[67] Among these are a number of domestic interiors showing paintings, and though none can be identified with certainty, their very inclusion, in so offhand a manner, suggests that if the artist was not concerned with documentary record, he was at least sketching in what he knew to be there. Thus he left a very general impression of pictures on the walls of the Duke of Modena's residence.

But there is a more detailed word-picture of the arrangement of certain pictures, and this is given in another book, *Il Microcosmo della Pittura*, published in 1657 by the physician, art critic and connoisseur from Forlì, Francesco Scannelli, How Scannelli became acquainted with the Este Court is not clear, but he may have been introduced by another Forlivese, Marco Uccellini, who directed instrumental music at Court from 1641.[68] By the 1650s Scannelli knew the Este collection very well indeed, and referred to it often in the *Microcosmo*, sometimes to help expound a particular theory (the inspiring effects of appreciative patronage, for example,

on which Scannelli was led to speculate by the *Portrait of the Painter's Mistress* presented by Titian to Alfonso I d'Este), sometimes simply to praise its high proportion of authenticated originals and the well-lit, spacious conditions (critical to connoisseurship) in which they were displayed.[69] Yet one room in this 'singular', 'stupendous' and 'extraordinary' gallery attracted Scannelli's particular attention and most superlative praise. This was the principal *Sala* in which, by the later 1650s, had been assembled a number of outstanding sixteenth-century paintings, some inherited, such as paintings by Titian, Dosso and the Carracci, and others acquired by Francesco. Among the latter were *The Sacrifice of Abraham* by Andrea del Sarto and *The Madonna of Casalmaggiore* by Parmigianino (Plates 39 and 40); *The Adoration of the Magi* and *The Marriage at Cana* by Veronese (Plates 41 and 42); and *The Madonna of San Giorgio, The Madonna of San Sebastiano* and *The Adoration of the Shepherds* (or *La Notte*) by Correggio (Plates 43, 44, 45). As another visitor, understandably overwhelmed, exclaimed in 1658: 'This is a Paradise.'[70]

The new Este gallery of paintings may have been Francesco's most imaginative and far-reaching act of art patronage, using the term in its widest sense as protection of, or dedication to, the cause of art. A number of pictures salvaged from Ferrara, the rump of former family collections, had been combined with new acquisitions in the creation of something new, whole and complete, and the arrangement of the principal *Sala* in the 1650s had a particularly interesting sequel. The ducal gallery of Modena provided Francesco Scannelli not only with examples to cite as evidence but also the idea, the underlying thesis, of the *Microcosmo della Pittura*. It was here that he formed his aesthetic theory, discovering, as he explained in the book, a 'species of the most beautiful' and 'in the face of a new idea' forming his 'particular composition'.[71] It was here that he saw that of the three schools of sixteenth-century painting as defined by contemporary critics, the greatest was not the Roman (or Florentine-Roman) School of Raphael, founded on drawing, nor the Venetian School of Titian, synonymous with vivid naturalism, but the Lombard School of Correggio who, through a fusion of *disegno* and truth-to-life, a sympathetic presentation of human feelings and a *sfumato* treatment of colour, had introduced a third quality to art, a sentimental, emotional truth which appealed to the heart of the observer and carried him closer to the apprehension of divine beauty, which, to Scannelli, was the true end of connoisseurship. It was the grouping of paintings in the *Sala* of the Palazzo Ducale in Modena which allowed this highly impressionable observer to feel the cumulative effect of Correggio's art, bringing him gradually to the 'stupendously divine' *La Notte*, a painting which, wrote Scannelli, nobody could see 'without loss of senses'.[72] Publication of *Il Microcosmo della Pittura* made the Este gallery in Modena the home of the Lombard School of painting in the minds of art-lovers throughout Europe and spread the name of Francesco I as the collector whose 'heroic magnanimity' to art had brought these paintings together. Scannelli praised Francesco's connoisseurship and dedicated the *Microcosmo* to him. In the frontispiece, designed by Guercino, the *putto* who supports the Este coat-of-arms also carries the inscription *Otium Regium*; 'Royal Leisure', which defines very well the nature of Francesco's interest in art.

At the request of Alfonso IV, it was the Jesuit Father Domenico Gamberti who composed the eulogy for Francesco I, *L'Idea d'un prencipe et eroe Christiano*, a somewhat ponderous volume which fulfils a number of tasks. In part, it is a recapitulation of Francesco's life, episodes selected to reveal his several virtues, each one of which is then traced back to an ancestor. In part,

it is a description of the service of commemoration held for him in the church of Sant'Agostino on 2 May 1659, of the three-storey temporary façade designed for the occasion by the Bolognese artist Andrea Seghizzi, and of the interior decorations designed by Gaspare Vigarani.[73] (So extensive were these, and similar decorations for the service in 1662 for Alfonso IV, that the Regent Laura Martinozzi decided to make good the damage by having the church rebuilt as an Este 'Pantheon'.) In part, *L'Idea* is also a rewriting of Este history from the new perspective on the past made possible by the thirty years of Francesco's reign. The humiliation of devolution was smoothed over and Cesare and the Padre d'Este were given their places within the family tradition. On palace façades and in paintings, on carriages and in prints, on silverware and on the title-pages of new books of poetry and art criticism, the presence of the Este Eagle testified to the part art had played in restoring the ancient splendour and confirming the continuity of the dynasty. In thirty years Francesco had created the essential components of a seventeenth-century Court. That he had done so was not remarkable, for his motives were clear enough and comparable, if more urgent, to those of any prince. How he had done so, however, was remarkable.

3 *Ways and means*

(i)

Modena was a commercial city but not an art market, and if Modenese merchants traded abroad they had not, it seemed, established the kind of connections which led to trade in art and artists. Francesco's contacts with the artistic world outside therefore depended upon his own foreign service. Ducal Residents (usually clerics) represented his interests in Rome and Venice, Milan and Naples, Spain, France and Vienna. There was no regular diplomatic link with Protestant Europe (though there were contacts with English ambassadors in Madrid and Venice), nor, more surprisingly, with the Spanish Netherlands. Informal agencies protected Francesco's interests in Genoa and the Papal States and he was represented at the courts of Florence, Mantua, Parma and Turin. The foreign service reflected political interests and the place of art in its work can be exaggerated. Nevertheless, for Francesco as for other princely patrons and collectors, the agencies abroad were a useful extension of the catchment area for art – and in the case of the Duke of Modena, they were probably essential.

Not all agencies were equal. Vienna, for example, was never a source of importance beyond the occasional painting or item of news. Nor was France, despite the increasing popularity of French fashions in dress and manners at Court in the 1650s and the temporary presence of Pierre Mignard, sent by Mazarin in 1653 to paint portraits of prospective brides for Louis XIV.[1] From Genoa came slate for Sassuolo, lists of paintings on sale and information on the Republic's new defensive walls, but the real value of Genoa lay in its bankers, including the Balbi and Airolo to whom Francesco more than once applied for loans.[2] Among the court cities of Italy, Mantua was not the city it had been before the sale of 1627 and the sack of 1629, and the new Gonzaga line had its own work of restoration and artistic patronage to do.[3] Parma and Turin, however, supplied Francesco with architects.

In 1629 the Count Carlo Castellamonte, head of a Torinese dynasty of architect–engineers, had visited Modena with the ambassador of Savoy and had been given a jewel worth 250 *ducatoni* by Francesco. Six years later he was remembered, and Francesco asked Duke Victor Amadeus of Savoy if he might borrow 'for four or five days the person of the Count Carlo Castellamonte', for advice on the new citadel of Modena.[4] But when, in May 1631, Francesco needed a civil architect to advise on plans for the Palazzo Ducale, he turned instead to the Farnese of Parma, and borrowed Girolamo Rainaldi, who returned in 1632 and was consulted again in 1641.[5] But loans such as these were temporary solutions at best (neither Savoy nor the Farnese would let their architects be absent for long) and Francesco did better to find

40

his own staff. He could never hope, however, to create in Modena the artistic resources of the Medici in Florence.

Between the Medici and the Este in the seventeenth century was a difference which showed, for example, in 1645, when the Cardinal Gio. Carlo de' Medici arrived in Rome in splendour to find his Palazzo Madama residence furnished in advance, while the Cardinal Rinaldo, his finances overstretched, was reported in the *avvisi* to be begging his brother for leave to return to Modena.[6] The difference showed also in the atmosphere of the Court. There was a seriousness, a moral rectitude amounting almost to prudishness, about Francesco and his Court which made the Medici seem decadent. But the cultural resources which they and their predecessors had created in Florence only emphasised the poverty of Modena.

Francesco subscribed to the Tuscan intellectual tradition of which the Medici were still the patrons. In 1651, for example, he ordered a copy of the dictionary of the *della Crusca* academy, and in 1653 he requested a report on Valerio Chimentelli, Professor of Greek Literature at Pisa, as a possible tutor for his younger son Almerigo.[7] Military architects either born or based in Florence were famous, and Francesco obtained reports in 1633 on Remigio Cantagallina and Alfonso Parigi among others.[8] In November 1645, news arrived in Modena of the grand-ducal ante-chamber in the Palazzo Pitti 'made beautiful' by Pietro da Cortona, who, added the report, 'is considered very worthy in the profession of painting *a guazzo*', and reports such as this must have stirred Francesco's own schemes for decoration at Sassuolo.[9] Florence could supply Francesco with plants and bulbs for his new gardens (he bought them also in Milan, Naples and Venice) and gold leaf for the 'Stuccoed Rooms' at Sassuolo.[10] But its unique value in the mid-seventeenth century lay in the Court portrait painter Sustermans, the graphic artist Stefano della Bella, and the artistic workshops for tapestries, furniture and *pietre dure*.

Francesco's agent in Florence in the 1650s was his subject Tommaso Guidoni, a nobleman who was also an artist ('of good taste and good execution' in the opinion of Filippo Baldinucci), an organiser of *feste* in Florence, and Gentleman-in-Waiting to the Grand-Duke and the Cardinal Gio. Carlo, in which capacity he had rooms in the Palazzo Vecchio, a horse (and a stall for it in the ducal stables) and among other incomes 8 *ducatoni* a month as the Cardinal's 'copier'.[11] Not only was Guidoni well-placed to be the perfect art agent, but he was well-qualified. Tapestries offered for sale in 1652 were, he advised Francesco, worked 'with much finesse, and fine colours, but of ugly design, and the sample enclosed is not the worst'.[12] On good terms with the *pietre commesse* craftsmen, he could provide full details of materials, designs and prices so that Francesco might decide both the kind of 'picture in mosaic' he wanted and, most important with this highly expensive craft, could readily afford.[13] He could also act on his own initiative, as he did on a visit to Rome in 1655, when he thoughtfully obtained and sent to Prince Alfonso a copy of Leonardo da Vinci's *Trattato*.[14] Guidoni was the means whereby Francesco was able to borrow Sustermans whenever a portrait, or series of portraits, of importance was required – two of the portraits used by Bernini as models for the portrait bust were painted by Sustermans. By the 1650s a visit by the artist to Modena had become almost an annual event, Guidoni first asking Sustermans, then applying to the Grand-Duke for permission.[15] It was also Guidoni who arranged Francesco's commissions to Stefano della Bella, or 'Stefanino'. Many sheets of his drawings came to Modena, among them designs for carriage decorations incorporating the Este Eagle.[16] (If these were intended for the same

41

carriages as those adorned with gilded studs designed by Algardi, those vehicles would have been a particularly fine example of proxy patronage.) In June 1652, three months after the staging of *La Gara delle Stagioni* in Modena, Francesco had the poet Graziani send drawings and printed descriptions of the *festa* to Florence so that della Bella could record the performance for posterity. It took time (Stefanino, explained Guidoni, was finding the task more difficult than he had imagined) but in October 1653, after a trial printing, the eleven copper plates were finally despatched to Modena, where they soon took their place, like the Bible of Borso d'Este, as a fragment of Este history on display in the cabinets of curios.[17] In one of the most sophisticated of art capitals, Guidoni was an efficient and valuable agent. How valuable might be gauged by comparison with artistic dealings in a city where the part of art agent was necessarily combined with that of official Resident.

Spain could be as much as four months by post from Modena (and the seas were often unsafe), which put the onus upon the Duke of Modena's Resident to allocate his budget with care. In 1640 the Resident was the Padre Ippolito Camillo Guidi, a Dominican who had been Francesco's confessor in Spain and had then been appointed 'Preacher to His Catholic Majesty', a title not purely honorific, for Guidi did occasionally preach in the Royal Chapel.[18] Guidi's political ability was as well-known as his talent as a preacher, and he became an interesting commentator upon the state of Spain. He had seen the country before in 1620, and in 1641 he was shocked to see the pitiful results of Olivares' policies. The inflation of the *vellon* currency had jumped to 235% by March 1642 and Guidi saw ruin about him: 'the misery and poverty of this country, which once was all gold, is unimaginable', he wrote, and it may have been with some satisfaction that he composed his *Fall of the Count Olivares* in 1644.[19]

Nevertheless, Guidi was Francesco's agent and he was not blind to a bargain. Since silverware and jewellery was, for the time, priced in silver, he decided to 'invest this *vellon* money in tapestries, pictures or whatever is of taste to Your Highness'.[20] As for guidance to Francesco's taste: 'I remember that Your Highness charged me with the purchase of some pictures by Rubens', wrote Guidi, and he reported on a find of a set of tapestries on the life of *Theseus*, owned by the Admiral of Castile, which possessed 'such fineness of . . . figures, landscapes and colours' but in particular 'that which endears them to me most, the design, which was by Rubens'. Guidi accordingly asked the Princess of Carignano (wife of Francesco's uncle Tommaso of Savoy) if the tapestries were sufficiently 'princely', then negotiated a price of 2,000 *ducatoni*.[21] But Rubens apart, Guidi was on his own.

Rarity became his criterion: 'I would not take pictures or *galanterie* which I imagine could be found in Italy.'[22] As a result, he bought a set of furnishings from the estate of the Count of Lemos because there were only two such sets in Spain (and the other was in the Buen Retiro), and a set of Mexican tapestries because 'I know there is nothing like it in Italy'.[23] When the collection of the Flemish Duke of Aerschot came on the market (it contained some 2,000 pictures and 18,000 medals, cameos and vases, and Tassoni had made reference to it in the *Pensieri Diversi*), Guidi took note of a group of hunting scenes by the Flemish painter Pieter de Vos which he thought 'would have been new in Italy' and ideal for a gallery at Sassuolo. But now Guidi was bidding in a very competitive market (other bidders for the Aerschot collection included the omnivorous Marquis of Leganes) and on the advice of Velázquez among others, he finally rejected the hunting pictures because the price was too high.[24]

Guidi had to balance on one hand the desire 'not to lose something which appears to me likely to please Your Highness, and on the other the desire to spend your money with such circumspection and prudence that no criticism would follow'.[25] He was a highly conscientious agent. But not only had he entered a complex and rapidly changing world of art collecting and trading in Madrid, he also could not always accurately predict Francesco's taste. One set of tapestries at least did not please when it arrived in Modena. Offering to take it, and exchange it for 'good pictures', was the Resident in Milan, the Abate Roberto Fontana.[26]

Fontana had grown up in the Este service (he had served as secretary to the Cardinal Alessandro d'Este) and from 1625 he had grown old as the Este Resident in Milan, a charge which had consumed, as he put it, 'a good part of the complexion, and the life (and) more than 24,000 scudi'.[27] The Fontana family was part Modenese and part Milanese, which gave the Abate a useful foothold in a city of considerable political importance to Francesco while he was formally allied to Spain (a suggestion that Francesco might become governor of Milan, or commander of the Spanish troops there, was at least considered by Spain in 1637[28]). Milan was also a centre for various goods and commodities, among them silverware and rock crystal, fabrics, furnishings and tapestries, and thanks to two successive Archbishops, Federico Borromeo and Cesare Monti, it was also a city of art collections and connoisseurship with a pride in its local and imported (from Leonardo to Procaccini) artistic traditions.[29] Fontana had entered into the spirit of this world and developed his own taste for art. In 1644 he was appointed to the bishopric of Modena and 'gave many proofs of his piety', but he also contrived to obtain a statue of the *Magdalen* by Begarelli from the church of S Biagio, for 'he delighted in such works and paintings'.[30] His memorial in the cathedral of Modena, designed apparently by Ercole Ferrata, does not suggest a modest or retiring man and in fact Fontana was confident of his abilities as prelate, diplomat and art agent (Plate 46).[31] To an extent, he was right to be so.

Fontana could be an excellent researcher. In November 1639 he was asked to trace (though why is not clear) the painter of a *St Sebastian* which he had acquired some years before for Francesco: 'it would be dear to us', ran the instruction, 'if you could make diligence to know where he is, and advise us as quickly as you can'. Within a week Fontana had located the painter, who must have been Francesco del Cairo and was then to be found at home in Varese, 'dealing more in rentals than painting'. For good measure, Fontana added his own critique of del Cairo: 'he is considered a beautiful colourist but a poor draughtsman, and I understand that so he was always regarded in Turin'; he is proud but has painted 'singular things' and being young he wished to study.[32] Fontana also liked to display upon occasion his own artistic sensibilities. In February 1634 he reported his decision to change the decoration proposed for a bedhead commissioned in Milan for the cradle of the newly-born Alfonso. It should be, thought Fontana, 'more novel, more noble and more comely' than the 'trivial and ordinary' design supplied from Modena. So he devised an *impresa* of a child in a cradle with a sword to cut the Gordian Knot (thus would Alfonso, he explained, cut through life's problems), and because 'the motto is the soul of an *impresa*, and when it is not so peculiar to the emblem that it should apply to no other, then it is unsatisfactory', he composed his own, *Estensis ad Regnum*.[33] His advice on the rather more mundane matter of disguising defects in a piece of second-hand furniture was no less interesting.[34]

But though Fontana could supply 'beautiful and bizarre' items, the vases he sent in 1638 43

(which were probably intended to be taken as gifts to Spain later that year) could, he was told, have been better, and his judgement of paintings was not unflawed.[35] The consignment of pictures he sent in 1635, including del Cairo's *St Sebastian*, a huge *Rape of Helen* by Giulio Cesare Procaccini and paintings by Morazzone, was itself well-received, but the carrier had to collect other pictures and bring them back, rejected, to Milan.[36] At 4 *ducatoni*, the cost of returning unwanted pictures was not excessive, but it was annoying and could have been avoided.

In October 1634 an attempt had been made to lay down basic criteria for proxy collecting. In reply to a letter from Fontana too vague to be useful, he was asked to supply an inventory, with details of artists, size and such other information

> 'as, for example, if the figures are whole or half, if one or more, and every other more precise particular, and if they are originals, and from the brushes you tell us, we will consider taking them in whole or in part without seeing them, provided however the price is such as we know to be to our advantage'.[37]

But by the later 1630s Francesco had accepted his need for a professional art assessor, and found one in Gabriele Balestrieri of Parma. Balestrieri was a painter but he was better known for his devotion to sixteenth-century art (he also advised Paolo Coccapani, Rinaldo's predecessor as Bishop of Reggio and a notable collector), and both his training and his passion had made him a sensitive picture restorer. When he seemed to be taking inordinate pains with a Pordenone in 1644, he explained that 'to reproduce the colours in imitation of the old masters' must inevitably take time.[38] Balestrieri was the perfect man to send when, in the same year, the Abate Fontana reported a new artistic find.

Fontana had located, in the possession of a Bergamesque dealer, a portrait attributed to Sebastiano del Piombo and a *Mystic Marriage of St Catherine* by, it appeared, Raphael – Milanese painters confirmed the attributions, added Fontana, having checked the portrait at least against paintings by Sebastiano in the collection of Cardinal Monti. Other collectors were interested, and in particular the Count Giulio Aresi, and Francesco must decide soon for the sale could not be further delayed. In fairness to Fontana, he did suggest that a painter, the Modenese Lodovico Lana, might inspect the pictures for Francesco. But Francesco sent Balestrieri, with authority to buy if he judged the paintings originals. Balestrieri, however, rejected both and for good measure upset Milanese pride by 'showing little respect for various works by Procaccini and Cerano, and even by Luini and Bramante, etc., works which are held most precious here'. Yet his reasons for rejecting the Raphael at least were cogent. Balestrieri followed Vasari in attributing three 'manners' to Raphael, the first influenced by Perugino, the second by Leonardo and the third by Michelangelo. The painting in Milan was patently, in the judgement of Balestrieri, not of the second or third, and to claim as the Milanese did that it belonged to the first was, he thought, ridiculous, because certain figures were painted, badly, in imitation of figures in later Raphael paintings of unshakeable authenticity, including the *Santa Cecilia* in Bologna. Thus, concluded Balestrieri, the Milanese picture must belong to a 'fourth manner . . . that is, that practised by Raphael after his death, as it was as likely that he had painted it in his life as after his death'.[39]

Balestrieri was equally outspoken on the subject of English connoisseurship. When, in 1645, the English collector in exile Thomas Howard, Lord Arundel, raised doubts about the

authenticity of an Este painting attributed to Andrea del Sarto, Balestrieri, while disclaiming knowledge of this particular work, expressed his utter contempt of the English ability to see superficialities of manner but never to look any deeper.[40] When the newly-acquired *Madonna of Casalmaggiore* by Parmigianino was discussed at Court in 1647, it was understood that Balestrieri, 'to whose sentence there is no appeal, will decide in due course'.[41] He was an eccentric but invaluable asset and when he died in 1648 Francesco was saddened, for 'as I had singular respect for his merit, so I learn with extreme dismay of his loss'.[42] He was replaced by other specialists, among them the Franciscan Fra Bonaventura Bisi, a miniaturist and draughtsman in Bologna who was also a friend of Guercino, whose light-hearted portrait sketch of Bisi survives (Plate 47). In 1651 Bisi wrote to the Este Court offering 'those few talents that he had', though in fact, in the opinion of Francesco's assistant Geminiano Poggi, the Franciscan possessed 'the best taste and not a little understanding of what is good in art'. He sent art, in particular drawings, to Modena together with examples of his own work. His value was perhaps somewhat compromised by the fact that he offered similar services to the Medici, but by the 1650s Francesco's dependence upon professional services may have been reduced by a new keenness of connoisseurship among his permanent staff.[43] In any case, the value of foreign agencies which might once have profited most from expert advice had now dwindled to almost nothing. In 1651 the Duke of Modena's new envoy to Madrid was the Count Francesco Ottonelli, formerly the representative in Naples and distantly related to the Jesuit Padre Ottonelli who collaborated with Pietro da Cortona on the *Trattato della Pittura* of 1651. But though the political task was difficult enough (a brief attempt at a new alliance with Spain while France was preoccupied with the Fronde), Ottonelli needed no more artistic sense than it took to explain that Francesco was not in a position to give Correggio's *La Notte* to Philip IV, and to give his opinion on performances staged at the Buen Retiro, 'because here, not being used to it, they tend to admire every little thing'.[44] The importance of Milan too had declined.[45] But the importance to Francesco of Venice and Rome seemed ever to increase.

Family ties reinforced the diplomatic presence of the Este in both cities. Until the 1650s Luigi d'Este was still semi-resident in Venice, and Francesco's son Almerigo followed Luigi into the Venetian military service, only to die in Crete in 1660 and be awarded a tomb, at the Republic's expense, in the church of the Frari in Venice.[46] There was still no permanent Este residence in Rome, but now and then Francesco would consider the advantages of a palace, such as the Palazzo Bentivoglio (the modern Palazzo Rospigliosi), which the Pope, however, judged would be too near the Quirinal Palace for comfort, and the much-rented Palazzo de Cupis in Piazza Navona and Palazzo Riario on the Lungara.[47] Each time the idea was dropped on grounds of cost, size or site, which naturally affected the Cardinal Rinaldo, no better placed in Rome than his great-uncle Alessandro. From another temporary residence, in the old Barberini palace in Via dei Giubbonari, Rinaldo in 1653 begged pardon for importunity, 'but extreme has been the discomfort I have experienced on my return'.[48] (The correspondence about buildings lent authenticity to the architectural code the brothers once adopted when the cyphers were being changed: 'what are your designs', asked Francesco with reference to the protection of French affairs in Rome, 'what the model and the foundation of the building, and how do you intend to build it?'[49]) Even Tivoli suffered, occasionally repaired and periodically tidied but lacking the continual care (Rinaldo could only go 'skirmishing'

to Tivoli) which alone could maintain good order.[50] To Francesco, the importance of Tivoli and still more of Rome and Venice lay in the services they could supply to Modena. The values of Rome and Venice occasionally overlapped. Administrative models, for example, were obtained in both cities, Fulvio Testi in Rome in 1634 gathering details of the 'Archivio Urbano' to assist in the planning of the Modenese public archive, and the Resident Scalabrini in Venice in 1637 sending an analysis of the political and notarial archives of the Republic.[51] But each city had its individual strengths.

The resources of Venice seemed infinite: building materials (from lead to coral and even Carrara marble) for Francesco's palaces; furniture, crystal and glass (including spectacles); amber, musk and civet; beaver hats and ostrich feathers; printing presses (in 1643 Rinaldo suggested Venetian printers for the *Ragioni* setting out Francesco's case for war against the Pope) and, of course, books.[52] Maps and atlases from Amsterdam and Antwerp, local classics (including Alvise Cornaro's treatise on the Venetian Lagoon), missals and breviaries – these and many other publications were obtained for Francesco by the Residents in Venice, who made themselves quickly familiar with booksellers and librarians and also read new books, especially histories, for mentions of the Este.[53] In April 1650 Francesco decided that for the sake of the Modenese Carnival he must consider a 'theatre for comedies' in the city, a plan that was realised in the Teatro della Speltà, and he looked to Venice for help: the Resident Gio. Pietro Codebò was instructed to get details of 'the design and measurements of those theatres for comedies' in Venice, and duly sent plans of the theatres of S Moisè, S Cassiano, S Luca and SS Giovanni e Paolo.[54]

Rome, meanwhile, was the city for antique and fake antique statuary: in 1654 Rinaldo inspected fake statues by one of Bernini's pupils at an address given him by the master.[55] News of art sales was also available in Rome: in 1647 Rinaldo again obtained a list of pictures to be sold in Genoa from the Admiral of Castile's collection, and in 1650 he viewed the paintings of the Savelli put up for sale in Rome.[56] But despatches to and from Rome turned more often upon contemporary art and artists, and here was the essential difference between that city and Venice. Rome was the capital of contemporary art fashions, Venice of old master paintings.

There were, of course, still artists in Venice, Venetian artists and foreigners, such as the Flemish painter Nicolas Regnier and the Bolognese sculptor Clemente Molli. Yet it was noticeable that while Francesco was a patron of Regnier as a painter in 1638 (and of his half-brother Michele Desubleo in 1654), his interest turned increasingly to Regnier's other career as an art dealer, and from Molli he expected advice on paintings but never, apparently, a work of sculpture.[57] Venice was now, above all, a city of art dealers and, in person or through agents, of competitive collectors, among whom were the Genoese, most notably Gio. Filippo Spinola, foreign residents, such as Jan Reynst, and Leopoldo de' Medici, represented since 1640 by the Florentine Paolo del Sera who was himself a collector.[58] By the early 1640s the Duke of Modena had joined this group. When his assistant Geminiano Poggi went to Venice on a mission, he had to find time to talk to an 'antiquary' and to another 'who makes pictures his profession and who has promised to obtain for His Highness a picture by Giorgione'.[59] This was in 1644, the same year in which Francesco on a visit to Venice had seen four canvases painted by Veronese in the 1570s for the Coccinà family, and opened negotiations with Count Anton Maria Coccinà for the acquisition of all four: the *Adoration of the Magi*, the *Marriage at Cana*, the *Road to Calvary* and the *Madonna of the Coccinà* family. It was a complex negotiation, not

completed until 1645, and it involved the whole agency service in Venice, from the diplomats, secretaries and messengers to Balestrieri, hung between hope and despair, Regnier, who finally detached and packed the paintings, and local allies who obtained the export licence.[60]

Given the complexity of art dealing in Venice, and its competitiveness, it was interesting to see that Francesco's Residents were experienced men who had served in other embassies – and given that some, such as the Abate Scalabrini and the Padre Guidi, died in office, it seemed that Venice might be the last posting of a diplomatic career. Experience certainly helped. In 1650 Francesco had agreed to buy a set of tapestry cartoons of the *Life of Jason* designed in the sixteenth century by Giuseppe Porta (also known as Giuseppe Salviati) but had left the negotiations to his Resident Codebò. 'I who have a little experience in the world have made a grand show of 500 *ducatoni* down', reported Codebò, 'and then left the Devil to work.' After some protestation, the offer was accepted and the *Jason* cartoons were bought for the equivalent of 887 *ducats* – which was just as well for Codebò, because he was working to a limit of 900 *ducats* recouped from a debtor named 'Keglovich' (a member, probably, of the Hungarian Keglevich family) and set aside for the cartoons.[61] But even so worldy-wise a negotiator as Codebò learned to work with the professionals. The 'broker' for this transaction had been Marco Boschini, the Venetian artist and writer, and he had also proposed the method of folding the frame to which the cartoons were nailed, while the designer of the 'Noah's Ark' in which they were shipped to Modena was Clemente Molli.

In the 1650s it was Molli who most regularly inspected pictures for Francesco, including a *Judith* owned by Regnier and attributed to Veronese, and paintings by, or said to be by, Giorgione, Paris Bordone, Veronese, Tintoretto, Jacopo Bassano and, a rare modern, the Genoese painter in Venice Bernardo Strozzi, all brought to Francesco's attention by Gio. Battista Franceschi. Molli's advice was as useful, and rather briefer, than that of Balestrieri before him. For the provenance of a Palma Giovane seen in 1653 he referred Francesco to his copy of Ridolfi's *Le Maraviglie*. A *Madonna and Child with Sts Peter, Paul, John the Baptist, Augustine, Catherine and Columba* was, decided Molli, a genuine original by Tintoretto, but damaged and not, he felt, one of that artist's finest works (Plate 48).[62] Yet, on this occasion, Francesco did not act on his agent's recommendation but bought this rather disturbing Tintoretto painting. Provided it was genuine, sixteenth-century Venetian painting never lost its appeal for Francesco and his Court – and his son Alfonso's passion for Veronese in particular would later be commemorated in a poem by Boschini.[63] And as it happened, Venetian paintings would also be Francesco's last acquisition (one which he would never see), in the form of a group of rare mythological scenes by Tintoretto, bought in Venice in October 1658 and destined to decorate the ceiling of the second 'Chamber of Parade' in the Palazzo Ducale of Modena.[64]

Rome was another world, a world of artists, of fountain-makers and engineers who might be useful for Sassuolo, of gardeners recommended by the papal gardener, of silversmiths who might be enticed to Modena (though the terms one demanded in 1647 were unacceptable), and of the papal medallist Gaspare Moroni, much too busy to leave Rome but prepared to consider commissions.[65] The agents too were different in kind. It was the opinion of Fulvio Testi that a cleric was not suited to be a diplomat in Rome, where his loyalties, presumably, might be suspect.[66] Therefore, in 1633, Testi had nominated as Resident the Count Tiburzio Masdoni (in whose family ran a tradition of Este service) and as Ducal Agent Francesco Mantovani, and, however excellently Masdoni may have served, it was Mantovani who attracted

attention, being perhaps the most useful and troublesome of Francesco's agents abroad.[67]

Mantovani was a journalist with a quicksilver mind whose *avvisi* were famous, or notorious, in Rome and such essential reading in Modena that he had to beg for discretion in their circulation, for though they were not scurrilous they carried a fairly *gustoso* kind of street and Apostolic Chamber gossip, which often landed their author in trouble. 'The Spanish fleet has arrived in Naples and Mantovani is imprisoned in Rome', reported the Cardinal d'Este in 1648: one seemed as inevitable as the other.[68] Rinaldo could not risk employing Mantovani himself, but Francesco was more tolerant, admitting that 'the pen of Mantovani usually runs with a little licence and freedom', but knowing no one better for inside information and news.[69] Mantovani reported on art as part of everyday Roman life – on the doings of Bernini, for instance, or a Pamphili dinner-party with table decorations by Algardi, an exhibition of art visited by the papal family, or such a crazy commission as that of the Duke of Bracciano, who ordered a picture to commemorate the stocking of his lake with fish quite regardless of the fact that all the fish had died.[70] But in 1640, when his newsletters had temporarily ceased for lack of a trustworthy copyist, Mantovani became an agent for art patronage, handling an order for pictures which made use of his many contacts and brought him suddenly closer to the business of painting in Rome.[71]

After discussions with Francesco about the decoration of Sassuolo, Fulvio Testi had asked Mantovani, perhaps in 1639 or early 1640, to obtain sketches of seascapes by 'some Neapolitan' (that is, Filippo Napoletano) in the Bentivoglio palace in Rome.[72] This, it seems, was the beginning of a commission, or series of commissions, which would introduce Francesco to a range of contemporary landscape painters in Rome from the conservative Bolognese Gio. Francesco Grimaldi through the Bentveughels to the anti-establishment fringe. But since no one in Modena appeared to be in charge, it may be that Roman patrons took this opportunity to bring their protégés to Este attention through the medium of Mantovani. According to Testi, the Ducal Agent had employed 'young men' on his 'sketches' and they had charged extraordinarily high prices. These men were perhaps Herman van Swanevelt and Salvator Rosa, and certainly some time before September 1640 two paintings, one by the Fleming and one by Rosa, which may have been the *Landscape with Erminia* (Plate 49), had arrived in Modena. In September, four more paintings arrived, a genre scene by Swanevelt, a *Galatea* by the Frenchman François Perrier, and two paintings by Rosa, of which one was the *Harbour Scene* (Plate 50) which displays the Este coat-of-arms above the doorway of the ruined building.[73] It was as Testi sent these pictures on to Francesco at Sassuolo that he reminded the Duke of the earlier discussions. Mantovani had not relied upon his own judgement in obtaining these paintings, and of his two advisers in Rome, the most eminent was the Cardinal Guido Bentivoglio. In 1640 Mantovani was on terms amounting almost to friendship with Bentivoglio and reported sympathetically upon his ill health and financial distress. It would have been surprising if he had not consulted the Cardinal about copies of paintings in his palace on the Quirinal Hill. But it was at this time that Bentivoglio was hoping to sell his palace to Francesco and was offering him the gift of a group of Flemish landscapes.[74] Bentivoglio should perhaps be regarded as the principal agent of the entire commission, and it was certainly Bentivoglio who, according to Mantovani, commissioned him to send to Modena in September 1640 the pictures by Perrier and Swanevelt.[75] Mantovani's second adviser was the lesser-known Abate Nicolo Musso, of whose collection of paintings Geminiano Poggi would write dismissively

in 1652 but who, as well as being a notable preacher, carried influence with the young Salvator Rosa. In 1639, soon after the artist's return from Naples, Musso was the director of Rosa's 'comedies' at a *vigna* near Porta del Popolo which made fun, remembered G. B. Passeri (who had been present), of the artistic 'establishment' represented by Bernini and Romanelli.[76] In 1640, it was thanks to Musso, wrote Mantovani, that Francesco received two pictures by Rosa, whose '*sfumato* air' had pleased rather more than the style of Swanevelt.

The next consignment of paintings, arriving in October 1640, appeared to reflect a decline in standards: a *David playing the harp* by a Fleming named 'Giusto', an *Amphion at the building of Thebes* by Grimaldi, but three paintings by artists described merely as 'various hands'. The reason may have been that whereas some if not all of the earlier pictures appear to have been gifts, Francesco was now paying for his Roman landscapes. Once this new consignment had been accepted, Mantovani admitted that he might have gone to better figure painters at least.[77] (The landscape commission of the late 1630s for the Buen Retiro, including pictures by Poussin and Claude, might be regarded as a yardstick of quality.) But, as Mantovani explained, better painters would have charged more and taken longer, as was demonstrated in 1641 when Francesco ordered one final landscape. He asked for the painter of 'the ships and the rocks', remembering the style if not the name of Salvator Rosa, but Rosa was by then in Florence. Mantovani, collaborating again with Musso, therefore chose Perrier, but since he was currently engaged on paintings for the French ambassador Annibale d'Estrées, Marquis de Coeuvres, he took months to complete Francesco's picture. But 'the painters of consequence have so much to do', wrote Mantovani, 'that one needs patience before one has entire satisfaction of them', and he suggested such sweeteners as payment in advance.[78]

By the end of 1641 Francesco had some twelve landscapes and seascapes to set in stucco frames at Sassuolo, and in Mantovani he had an agent now skilled in dealing with the painters of Rome. Yet the commission (or commissions) led nowhere. Mantovani returned to his newsletters and Francesco found other ways of decorating the walls of Sassuolo. The next time Salvator Rosa featured, this time by name, in Este despatches may not have been until October 1658, when he was referred to as a famous artist whose pictures, like those of Cerquozzi, Borgognone and Mola, decorated fashionable apartments and whose services were much in demand. The reference was made in connection with a projected new decorative scheme to be imported, again, from Rome, but this time worked out in advance.[79]

By the 1650s, the Roman art world had changed and with it the Este agency. The Cardinal Rinaldo had become Francesco's principal agent and increasingly familiar with artists and their patrons – at the conclave of 1655, for example, he discussed Andrea Sacchi with Sacchi's protector, the Cardinal Barberini.[80] Dealings with artists had become more delicate and more respectful, and the well-known report of 1661 by Rinaldo's minister G. B. Muzzarelli reflects most perfectly the new spirit. The subject of the report was the best artist to choose for ceiling paintings. Salvator Rosa, wrote Muzzarelli, was a 'fine painter', inventive and intellectual, but accustomed to working in oil on a small scale not easily transferrable to a modern ceiling. Bernini was rich in ideas, but Pietro da Cortona was 'superior in the manner that is called heroic'. Cortona was just then unwell, but it was unthinkable that he and Bernini might collaborate for both were 'virtuosi', and Muzzarelli did not wish to upset Cortona by even hinting at collaboration.[81] The analysis was informed, the attitude sensitive and the tone almost hushed. It was perhaps necessary to look beyond Mantovani and his crash-course in contemporary

art patronage to Cesare's Resident chasing the outlaw Caravaggio for refund of a down-payment to see how much society, the art world and the agency in Rome had changed.

(ii)

The foreign agencies were invaluable to Francesco, but he had need of a good staff team. When Cesare had lacked artists, he had looked to Ferrara for help, but by the 1630s there was little in Ferrarese art which was likely to be of service to Francesco. Nor was he especially interested in local artists, and the case of Lodovico Lana, Ferrarese by birth but settled in Modena, illustrates both points.[82] Lana worked for Francesco, painting portraits and copy portraits and pictures for Sassuolo, and he also painted at least one altarpiece, destined for Ferrara, for a member of Francesco's Court. But decorations painted by Lana in the Castello would be painted out as soon as Francesco found artists more to his liking. Lack of interest in local artists was suggested also by the case of the Modenese Francesco Manzuoli. In 1646 Manzuoli was anxious to study in Rome and had friends who hoped to place him in the household of the Cardinal d'Este, 'given the risks of employing a painter at random or a studio hand'. But, wrote Rinaldo to Geminiano Poggi, 'I find it difficult to believe that he would be entirely suited to my needs'. Yet Manzuoli contrived to reach Rome and work there and in 1653 sent paintings to the Court which were intended, it seems, to help him obtain a pardon for murder. But in October 1658 a new attempt was made to help him to patronage. It was Manzuoli who compiled the report on decorative painting in Rome as represented by Rosa, Borgognone, Cerquozzi, Pier Francesco Mola and Mario dei Fiori, and pointed out the high prices they charged, the time they took (both excessive in the case of Rosa), and their other pressing commitments. It was left to the covering letter from Giulio Cavazza (a member of Rinaldo's staff since 1646 and therefore, perhaps, Manzuoli's sponsor from the start) to explain that there was really no need to employ these artists because Manzuoli was available, skilled in all genres and vouched for by the famous. Consideration of this report coincided with Francesco's death and Alfonso IV did indeed summon Manzuoli to Court, but by a sad irony within a few months the painter was dead.[83] Alfonso IV may well have taken a greater interest than his father in the state of local painting, for he appointed the Modenese Francesco Stringa Court Painter in 1661.[84] Francesco, however, had looked to Bologna, where he found, in 1638, the Frenchman Jean Boulanger.[85]

Boulanger had been trained by and worked with Guido Reni until the age of 32, when he joined Francesco's staff in April 1638 at a salary of about 30 *scudi* a month, which had risen to some 40 *scudi* by the 1650s. But payment was usually months in arrears and as Boulanger observed, he wasted much time in waiting for his money in the antechambers of the ducal treasury.[86] From the early 1640s, Boulanger's principal occupation was the decoration of Sassuolo, working steadily forwards from the small apartments of the wings to the main rooms of the front block of the palace. He led a varied and ever-growing team of assistants: Pier Francesco Cittadini from Milan; a Pietro Galuzzi from Urbino; an expert in architectural perspectives who was perhaps a late disciple of the Rosa of Brescia; his own nephew, Olivier Dauphin, from France; and three local painters, Sigismondo Caula of Modena,

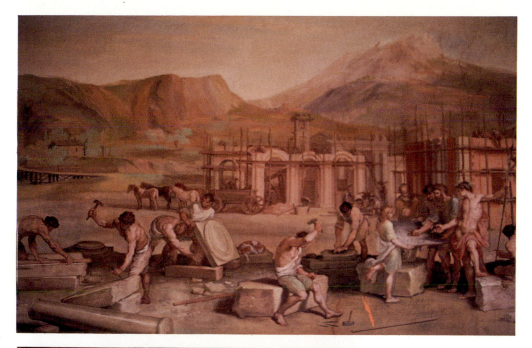

Colour plate 1. Jean Boulanger and assistants: *The Building of the City of Nysa*

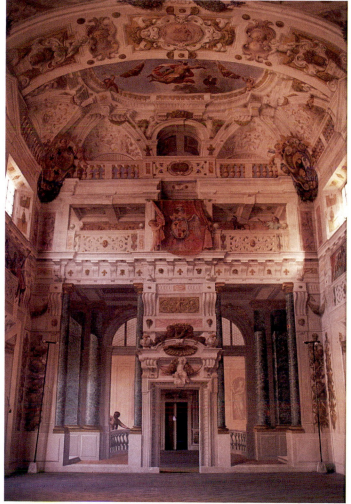

Colour plate 2. M. Colonna and A. Mitelli: *Detail of frescoes in the Salone della Guardie, Palazzo Ducale, Sassuolo*

Colour plate 3. Jean Boulanger and assistants: *Gallery of Bacchus*

Colour plate 4. Antonio Raggi after Bernini: *Sea-god with Dolphin*

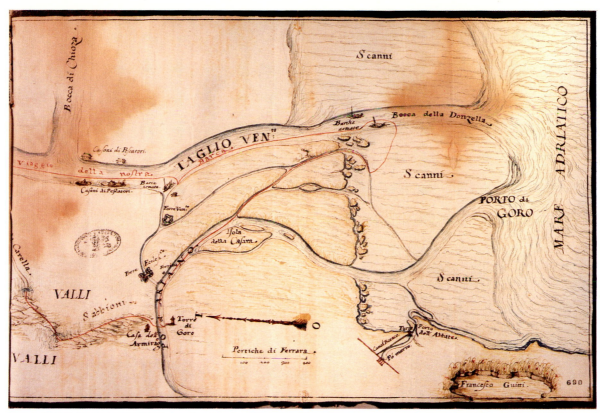

Colour plate 5. Francesco Guitti: *Reconnaissance map of the 'Taglio Veneto'*

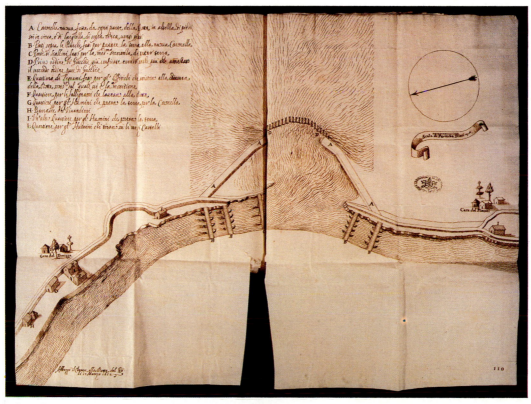

Colour plate 6. Luca Danese: *Sketch of flood repair work on the river Po*

Colour plate 7. Comacchio: *Granary and loggia*

Colour plate 8. Comacchio: *Trepponti (Ponte Pallotta)*

Tommaso Costa of Sassuolo and Sebastiano Sansone of Scandiano.[87] For all that Boulanger, at the head of this team, managed to achieve, he deserved rather better treatment.

'What is "Volans"' (he was usually just the *francese*) 'doing there?' demanded the Maggiordomo Maggiore Francesco Montecuccoli of an official at Sassuolo in 1643, 'what is his work?'[88] But the alternative to his ignorance was supervision of the closest kind. Boulanger's subject-matter at Sassuolo varied in the demands it made of him. An instruction of 1643 concerning family portraits in the Room of Enchantments (where Ariosto's enchantress Melissa would present the Este succession to Bradamante) was easy enough to follow if only the portraits to copy could be sent from Modena, but a year later two were still awaited. In June 1644 Boulanger began the ceiling of the Room of Painting, and here he had Cesare Ripa's classic, the *Iconologia*, to guide him (Plate 51).[89] But what was he to make of the proposals of 1646 and 1647 for the Room of Fountains?[90] One fountain had to appear icy at midday, red-hot at night; another was to be shown as sweet, salt and bitter by degrees; and another was to run clear when man was silent, but torbid when he argued or approached by stealth. Erudition at Court had conjured up from Antiquity fountains which could be described in words, perhaps produced as stage-effects, but were virtually beyond the reach of painting. Of the eight proposed, Boulanger felt that only the Fountain of Jove at Dodona, which doused burning torches and rekindled the spent, would readily lend itself to pictorial treatment. Yet he must have found solutions (the paintings of this room have, regrettably, not survived) for his work here was reported to be well-advanced by September 1647.

The narratives drawn from history, myth, poetry and legend chosen for other rooms at Sassuolo would have been perhaps easier to compose, but the demands made upon Boulanger's inventive power and versatility were nonetheless daunting. It may have been because Francesco understood the limitations of Boulanger's pictorial vocabulary that in 1644 he had sent him, on salary, to Rome, where for eighteen months he worked for the Cardinal d'Este and researched ideas for Sassuolo. (On the eve of his departure from Rome in 1646, Boulanger was copying a *Battle of Constantine and Maxentius* in the Vatican (presumably Giulio Romano's painting in the *Sala del Constantino*) 'to use as the need arises'.[91] This may have been the *Constantine at the Ponte Molle* attributed to Giulio Romano in an Este inventory of 1743, when it was displayed as part of a series by Giulio salvaged from Ferrara and illustrating the *Life of the Emperor Titus*.)[92] Paintings still to be seen at Sassuolo may reflect the extent of Boulanger's study. The *Fall of Phaëthon* (Plate 52) he painted in the later 1640s for the ceiling of the Room of Phaëthon (in which, incidentally, Salvator Rosa's landscapes were displayed by the late 1670s) is a strikingly adventurous composition (though, admittedly, on a somewhat small scale) encouraged, perhaps, by exposure to Roman ceiling decoration. When, in 1650, Boulanger and his assistants began work in the Gallery of Bacchus it would seem to have been the work of one particular artist, Domenichino, that he found most helpful. The scenes from the *Life of Bacchus* (including a *Bacchus and Ariadne on Naxos* (Plate 53) in complete contrast to Titian's tumultuous treatment of the subject (now in the National Gallery, London) for Francesco's ancestor Alfonso I) are set in fictive tapestry settings reminiscent of those which frame Domenichino's frescoes (now also in the National Gallery, London) for the Villa Aldobrandini at Frascati, Boulanger's cherubs playing the part of the Aldobrandini dwarf, and in composing the scenes of Bacchus at the *Building of the city of Nysa* (Colour plate 1) and *Raising a column on the banks of the Ganges*, Boulanger perhaps had in mind a comparable

51

painting by Domenichino in the Chapel of St Nilus at the Abbey of Grottaferrata in which the fall of a column during the building of the abbey is miraculously averted.

Thus the experience of Rome introduced Boulanger to new ways of narrating logically, sometimes wittily, the stories which his patron, and his patron's literary-minded advisers, had chosen. Nobody, perhaps, would have thought of asking more than clear exposition from Boulanger. (The Court poet and secretary Girolamo Graziani certainly revealed no great faith in the power of art to convey meaning unaided when he proposed that the figures of Bacchus and Ariadne to be painted on the ceiling of the Gallery of Bacchus should carry explanatory *cartelli*.[93]) When more inventive flights of fancy were desired, and a showier style which would not so much tell stories as cover spaces and seemingly extend them, they were commissioned not from Boulanger but from the specialists, that is, the *quadraturisti* painters of Bologna.

By August 1631 Francesco had become a patron of the figure painter Michelangelo Colonna who, with his older partner Girolamo Curti, *Il Dentone*, as painter of perspectives, was then and throughout 1632 at work in the old Castello of Modena. Then Curti fell ill and soon died, and Colonna was unhappy in Modena.[94] But Francesco (who put a ducal carriage at the disposal of both artists) had made a most important connection. He was drawn in particular, wrote Malvasia, to Colonna's style of figure-painting but he also liked the perspectives, for in 1638 Colonna's new partner Agostino Mitelli was paid for work in Modena.[95] In 1645, he summoned both artists to Sassuolo, 'not deeming complete that rich and delightful palace if it was not seen to be painted by their hands'.[96] The *quadratura* painting of Colonna and Mitelli, and their assistants including Giovanni Paderna, Giangiacomo Monti and Bartolomeo Bianchi, transformed the palace of Sassuolo, opening up vast imaginary spaces on the external walls of the courtyard and loggia, and peopling the staircase hall and principal *Sala* or *Salone delle Guardie* (Plate 54, Colour plate 2) with fantasy scenes of Court life. So much did Francesco need them, that it became difficult for the painters to honour other commitments, but his feudatories Cornelio Malvasia and Odoardo Pepoli at least gave in to his demands and let their own commissions wait.[97] Once, according to Malvasia, Francesco had 'not disdained' to visit Colonna at work. Now he required that Colonna should on no account move from Sassuolo until he had arrived and spoken with the artist.[98] In return for their services, Colonna and Mitelli reportedly received 3,000 *scudi*, which placed them in a rather higher bracket than Boulanger.[99] Yet the *quadraturisti* did not replace the staff painter, and in 1650, in the Gallery of Bacchus, the two teams of decorators met.

The decision that Boulanger, Cittadini and Dauphin should collaborate with Monti and Bianchi in the Gallery was perhaps taken on grounds of expediency, but it proved highly imaginative. The absence of Colonna and Mitelli themselves may have helped to ensure that no style took precedence over the other – even the salaries were balanced at around 35 *scudi* a month for Boulanger, Monti and Bianchi.[100] Boulanger and Dauphin painted the narratives in the fictive tapestries along the walls and in the shields in the ceiling coves, telling at rather unusual length the story of Bacchus. Monti and Bianchi painted the fantasy architecture, within which the trailing branches, animals, birds, vases of flowers and garlands of fruit by Cittadini made pretty frames for the narrative and softened the edges of the painted architecture (Colour plate 3). Every surface in this comparatively small and narrow room was either gilded or covered with colour (some details were added *a secco*) and the result was a decorative ensemble to confuse and enchant the eye. The staff painters were very far from being the

most notable artists employed by Francesco, but when it was completed in 1652 their work made the Gallery of Bacchus one of the most original and sophisticated creations of his reign.

Francesco's need of sculptors took time to mature. At first they were easily met by, for example, the Pacchioni family of Reggio, including Prospero, who in 1630 was employed on chapels in S Vincenzo and S Carlo Rotondo and, in 1631, turned his hand to the restoration of seven antique marble statues, under the supervision of Spaccini.[101] By the time the palace and gardens of Sassuolo were under way, Francesco had secured the services, under contract, of Tommaso Luraghi of Como, who worked 'much to our satisfaction' on all projects requiring the locating, quarrying, fetching, cutting and carving of stone.[102] But in the later 1640s, when sculptural work of a more delicate kind was required at Sassuolo, Francesco sought the services of the Tuscans Domenico Guidi and Francesco Baratta.[103] He could not, however, always be certain of these sculptors, for whom there was a greater demand in Rome – in 1651, for example, Baratta wrote regretting that he was unavoidably detained in Rome, and sweetened his apology with the gift of a bas-relief in marble, a 'spiritual sculpture'.[104] It was at moments such as this that the distance of provincial Modena from the capital of the art world told most heavily. In the circumstances, the agreement reached in 1653 with the sculptor Antonio Raggi represented a major coup.[105]

Towards the end of 1652, Geminiano Poggi, on a visit to Rome, discovered a *Lorenese* sculptor (that is, Claude Poussin) who had worked under Bernini's direction on the Four Rivers Fountain (his was the figure of *Ganges*). He notified Francesco, in case he should ever need such a sculptor. Very quickly, Francesco decided that he did, and one who was 'good now, and could become better in time'. But instead of the *Lorenese*, he was interested in a *Milanese* of whom he had received, perhaps from the Cardinal d'Este, rather better reports. This sculptor had also worked on the fountain in Piazza Navona and at the church of St John Lateran, and he was Antonio Raggi. Poggi made enquiries, Bernini gave his opinion, and Francesco, 'ever more excited', offered a salary of 60 *ducatoni* a month (Poggi thought this excessive). The salary was accepted, and Raggi arrived in Modena just after Carnival in 1653, to be 'seen by the Duke with particular pleasure', noted Poggi, and given a comfortable house to work in and his 'handsome', even 'perfumed', salary. How long Raggi stayed is not certain – indeed, the whole question of his presence in Modena is complicated by that also of the little-known sculptor Lattanzio Maschio, who made the stucco sculptures after Raggi's terracotta models.[106] Raggi remained long enough, however, to model such figures as the *Neptune* and *Galatea* which brought a Roman glamour to Francesco's palace of Sassuolo. And behind Raggi stood Bernini, from whose drawings, followed by Raggi's models, was made the group of the *Sea-god with Dolphin* which sits amid the frescoes by Colonna and Mitelli, and in a niche made for another statue, in the courtyard at Sassuolo (Colour plate 4).

As a patron of architecture, Francesco had a regard for the advice of consultant architects matched only by his faith in his own judgement. It was 'to give form to some of my ideas' that he had borrowed Girolamo Rainaldi in 1631, and Francesco had been pleased to find that Rainaldi, unknowingly, had come to the same conclusions as himself about the form of the Palazzo Ducale (whereupon Rainaldi had received 25 *doppie* (*c.* 75 *scudi*) for his five days of advice). It may therefore be that both were responsible for deciding upon the 'great tower' which would endure throughout the subsequent changes of plan and architect as the

landmark of ducal Modena, distinct from the old Ghirlandina tower in the civic centre. Twenty years later, in 1651, Francesco was studying, with varying degrees of impatience, yet more consultants' reports on the Palazzo Ducale, submitted this time by Borromini, Pietro da Cortona and, of course, Bernini. Caught between the experts and the patron was Francesco's own 'civil architect', the Roman Bartolomeo Avanzini.[107]

Avanzini, son of a painter, may have arrived in Modena through the agency of Rainaldi or, perhaps, Francesco Peperelli. He joined in April 1634 at a salary of 10 *ducatoni* a month, which rose by stages to *22 ducatoni* in the 1650s but was never sufficient, for Avanzini had relatives to support in Rome. In 1651, for example, it seemed that he would have to sell possessions including architectural books and tools in order to help his sister, but on this occasion, as on others, the Cardinal d'Este intervened to assist him.[108] The civil architect's life was far from enviable. In letters he expressed himself humbly, ready to learn from his betters and grateful to have, in the Duke and the Cardinal, patrons of 'intelligence and good taste'.[109] But he could never be meek. Avanzini had a mind, and a pride, of his own and since Francesco was not dissimilar, it was likely that they would clash.

Within months of Avanzini's arrival, in August 1634, orders were issued for building materials for the Palazzo Ducale.[110] In 1635 he was sent, together with the mason Cesare Biavardi, to Sassuolo to lay out Francesco's 'New Garden'.[111] But in 1636, when attention had turned to the fortress, Avanzini was asking for work, unhappy to be idle, he explained, while others laboured.[112] By the early 1640s, however, he may have longed for those days of leisure. From 1642 Avanzini lived on site at Sassuolo (as he did still in 1651, when the 10 *scudi* rent he paid for his house consumed nearly half his monthly salary). He provided models and instructions for all building work there, from the levelling of the courtyard to the form of the new stone staircase (made by Luraghi), and from window-sills and thresholds to the cutting of the canal which would link the palace to the capital. He supervised the *capomaestri* on site and compiled lists of others who could be called upon as necessary.[113] All this, of course, was to be expected of the staff architect, but Francesco was a demanding patron. In March 1650 Avanzini was enjoying a rare visit to Rome, where he inspected potential residences for Rinaldo, consulted with his peers and refreshed his memory of Roman palaces. But, wrote Francesco, 'Yesterday I went to Sassuolo and found that Avanzini indeed has to come most promptly, for the drawings he has left are incomplete and those at Sassuolo cannot follow them and are confused.' Avanzini had, in fact, omitted to give any indication of scale on his drawings.[114] However, he managed to remain in Rome until May, when he returned to a new round of problems.

'Being we in need of continuing this our Palace of Modena' ran the promulgation of May 1650, new orders for materials were issued and the palace plans were reconsidered. By July Francesco could have reported fair progress to Rinaldo, had it not been for Avanzini, who 'made me lose my temper because he came to me to propose demolishing the wings and enlarging . . . the guard-room already built'. But the moral victory was the architect's, for Francesco

knew that he spoke the truth, and it will improve greatly the façade and other aspects of the palace and therefore I believe that I shall have to resolve to do it, since it is not possible to content oneself with doing something one way when one knows one could do it better.[115]

One year later, however, the argument was continued, which was why new consultants'

reports were requested in the spring of 1651. Francesco thought only of consulting Bernini and it appears to have been Avanzini who took opinion also from Borromini and Pietro da Cortona.[116] When the reports arrived, it was not difficult to see why. All three members of this illustrious trio had suggested cosmetic improvements: the main portal, for example, could be more grand, and the decoration of the windows on the main façade could be more *svelte* and majestic. But Borromini and Cortona had suggested also that the existing lower storey could be raised to provide a full basement and the basement window-sills without which, to Roman eyes, the palace was incomplete. Bernini's proposals were considerably less drastic. He suggested structural alterations to the courtyard (a reduction in the width of the arched bays and the use of more slender columns in the interests of 'svelteness' and 'uniformity'), but no more extensive rebuilding, in which connection it is interesting to note his observation some fifteen years later in Paris that to create 'a grand and majestic building without demolishing what already exists is worthy of greater praise'.[117] In 1651, Bernini's proposals certainly appealed to Francesco, to whom the improvements recommended by his other consultants seemed such major surgery that 'one would have to lose all that already exists of the old fabric, and meanwhile wait a long time before one could enjoy a little comfort'.[118]

Avanzini, however, was reasonably content with the reports. He thought, justifiably, that the consultants might have supplied 'some little sketch of their ideas', and he defended his own proposals for window ornaments, explaining in a letter to the Cardinal d'Este that he had taken into account both the site and the view from a distance.[119] But most satisfying was the support that two of the great men were giving to the structural alteration which he, if not Francesco, believed could be made without undue disturbance. 'I am sure', he wrote to Rinaldo, 'that if Your Eminence had been there you would have been more successful in persuading the Lord Duke'.[120] There is no evidence, however, that Rinaldo even tried and the appearance of the palace suggests that Francesco preferred his own judgement. Certain features of the building today may be traced back to the reports of 1651, including window pediments of the *piano nobile* as recommended in the fragmentary report attributed to Borromini (Plate 55). But the basement storey was never raised and its offending windows still sink sill-less into the ground.

The palaces apart, Avanzini provided designs for many other Este building projects: the dome and tabernacle (made by Luraghi) of S Vincenzo of the Theatines, for example, alterations to Rinaldo's episcopal palace in Reggio, and temporary theatres for festive shows and jousts.[121] He may not always have chosen his priorities wisely. In September 1652 Francesco asked Rinaldo to ensure that the architect came as promised to Sassuolo, and 'not take himself off to look at some other work elsewhere', and as far as Rinaldo's works in Reggio were concerned, Francesco proposed that he should find a local builder who could work to Avanzini's instructions.[122] (In the same year, Avanzini in fact referred to an assistant, 'my young Roman, skilled and experienced', but his identity is not known.[123]) At times it seemed a continual struggle between patron and architect, but Avanzini remained in Francesco's service and gave, as Francesco once confirmed, 'satisfaction'.[124] When he died in July 1658, only three months before Francesco himself, the news was conveyed to Francesco by Geminiano Poggi, who observed that 'the loss is considered by all as most grave and Your Highness would be very lucky if you could repair the damage by finding another to give such good service, but one cannot be sure of this, given the scarcity everywhere today of excellent men'.[125] It was a

55

kind and a just epitaph for a man who was not an architect of distinction but who was able to cope. Avanzini had brought Sassuolo into being, a competent if not a beautiful building, and he had made a start on the Palazzo Ducale, interpreting the opinions of consultants from Rainaldi to Bernini and ensuring that Francesco's ideas for his palace would take a form less Roman than the architect wanted, but Roman enough for the patron.

It was probably Francesco's interest in Roman architecture which saw that local architects, no more than local painters, would not enjoy the encouragement of his particular patronage. Indeed, the Este if not Francesco himself even appeared to throw away one potential genius to hand. This was Guarino Guarini, the godson of the Court Wardrobe Master, Marcello Querenghi, and later a member of the Theatine Order protected by the Este. In the 1650s Guarini supervised building works at S Vincenzo, yet so far from encouraging his talent, the Este, at a time when Francesco may have been absent and for reasons which are not clear, seem to have been responsible for Guarini's exile from Modena and therefore for the travels which led him to Paris, Lisbon and finally Turin.[126] It would be from Turin, as a visiting consultant on loan from Savoy, that Guarini would arrive in the 1670s to give his opinion on the Palazzo Ducale of Modena. Perhaps there had been no place for such an individual genius as Guarini was to become within the scope of Francesco's patronage. Besides, he already had the services of Gaspare Vigarani, and, as he wrote, 'for ingenuity and for art, I could have need of no other than he'.[127] Vigarani of Reggio was the only local man to enjoy high prestige as a creative artist at Francesco's Court, and he may well have been a genius.[128]

How or why Vigarani, a member of a noble banking family of Reggio, became an architect and engineer is not known, but in 1619 he and his brother Giacomo were responsible for the decorations accompanying the translation of the image of the Madonna della Ghiara to its new shrine, and a contemporary report praised the talent of these 'ingenious young men' (Vigarani was then 31). By the early 1630s he was involved in Francesco's various palace and garden schemes, working with the regular staff, including Antonio Vacchi, Cesare's architect who was still undertaking building and surveying work at Court, and Francesco Vacchi, who may have been his son – it was over the heads of these men that Avanzini would be appointed in 1634.[129] By 1635 Vigarani was Francesco's 'Superintendent General' of all building and engineering works, and later 'Superintendent General of Fabrics and Festivities and Principal Engineer of the Waters and the Streets of the State', an unwieldy title covering a multitude of duties, though Vigarani seemed able to combine them with responsibilities in the Ducal Treasury.

Vigarani was highly respected. When Avanzini, Boulanger and the rest must rush, Vigarani must not travel in the heat of summer, wrote Francesco, since 'it is not convenient that he risk his life without necessity'.[130] In 1645 Rinaldo was lucky enough to secure his services temporarily in Rome, and set out the list of tasks for him to do:

> He must apply himself to . . . the design of a livery and a silver safe, the plan of the palace and garden of Tivoli, and the proposals for works and repairs there, the plan of sites leased out on Montecavallo, a country carriage, the furnishings of the house, and what other commissions will arise, for he works with such love, principle, industry and diligence that with him I am completely satisfied.[131]

56 In 1650 Vigarani was given the task of remodelling for Prince Alfonso the country house

near Modena of Pentetorri, and Alfonso was equally delighted with him: 'in the building of my Casino', he wrote to the Cardinal, 'his work is so much to my satisfaction that I cannot express it to Your Eminence'.[132] (As a result, Alfonso recommended Vigarani's son for the archdiaconate of Reggio.)

The Casino of Pentetorri, which from 1654 was decorated by the same team of Boulanger, Monti and Bianchi as had created the Gallery of Bacchus at Sassuolo, no longer exists save in photographs.[133] The little Palazzetto in the gardens of the Palazzo Ducale in Modena, built in the 1630s, is not truly comparable and may owe much to Girolamo Rainaldi (Plate 56). It gives, none the less, an idea of the character of Vigarani's architecture. The Palazzetto seems comprised of parts fitted together in a manner which suggests a formal, intellectual exercise. No less experimental but perhaps more happily integrated are the new churches he designed for Reggio (Sant'Agostino and S Girolamo among them) and the fascinating S Giorgio in Modena, begun in the later 1640s in the form of a Greek cross within a square marked out by a colonnade which creates corridors below and balconies above and exciting vistas from every angle (Plate 57).[134] Yet the churches, perhaps Vigarani's finest works, are only indirectly attributable to Francesco's patronage, which expected other skills of Vigarani.

In 1645 Francesco had summoned Vigarani from Rome 'particularly and urgently for the fortress'.[135] In the campaigns of 1648, when Francesco himself 'worked like a dog' and the 'marches were confused', the obedience minimal, 'nothing was more important' than the despatch of Vigarani (who, for once, must hurry) to supervise repairs to the fortress of Brescello.[136] Fortifications design was necessarily of paramount importance to Francesco (it attracted a number of stray engineers briefly to his service, including in 1648 an ingenious bridge-builder who was, apparently, a Scot) and it was Vigarani's principal occupation.[137] He was also the civil engineer, responsible for the construction of canals and bridges, for repairs in the wake of floods and for the fountains at Sassuolo. But second only in importance to his work as a military engineer was Vigarani's work for the theatre. A new theatre was built at Carpi in 1640 to the 'personal plan' of Vigarani, and in 1654, armed perhaps with the plans of Venetian theatres obtained in 1650, he began Francesco's *Teatro della Speltà*, which would seat 3,000 spectators. Vigarani was the scenic designer of the House of Este. He contrived the machines and decorations for Carnival shows and for the Padre d'Este's processions. He designed a Carnival spectacular for the Cardinal d'Este in Rome and the machines and stage effects for Francesco's *feste* in Modena. Finally he designed, in collaboration with the Bolognese designer and painter Andrea Seghizzi, the decorations for Francesco's memorial ceremony in Sant'Agostino in 1659.[138] It was for his theatres and stage design that Vigarani's name became known and when, in 1651, Duke Carlo II Gonzaga of Mantua requested his help in the rebuilding of a theatre, Francesco, so often the borrower of artistic services, at last became a lender. After Francesco's death, the Cardinal Mazarin, counting upon the goodwill of his niece Laura Martinozzi, now Duchess of Modena, called Vigarani to Paris in 1659, an opportunity to which he responded by designing the great *Salle des Machines*, much criticised by Bernini but famous for its scenery and stage effects.[139] In 1652, however, the Duke of Mirandola had requested Vigarani's advice not on theatre but on palace design, which raised an interesting question, for apart from his work on garden buildings and the casino, Vigarani's part in the great palace building schemes of Francesco's reign seemed to be administrative, occasionally supervisory, but not creative.

57

Vigarani was a gentleman architect and a mathematician who, like Alberti and many another before him, needed practical builders to realise his schemes – the Commune architect Cristoforo Malagola built his S Giorgio in Modena and Girolamo Beltrami (a *capomaestro* at Sassuolo in 1653) worked with him in Reggio.[140] Vigarani's interest possibly lay in devising plans and solving problems rather than seeing a building through to completion, in which case the many-sided part he played at Francesco's Court was best suited to his kind of genius. When his patrons were so unstinting in their praise, it seems silly to carp at the quality of patronage that Vigarani enjoyed. Yet his years in Paris notwithstanding, he has never attracted the attention he deserves. In the eighteenth century the historian Girolamo Tiraboschi wrote of Vigarani as an architect of fertile invention and majestic and noble ideas whose name, however, had been sadly neglected, and the same could be written today.[141] One reason would be that so little survives – the theatres have been destroyed and the *feste* live only in prints and written descriptions. But what does survive suggests that Vigarani might have risen to a grander challenge had it been offered him in Modena – or in Rome, had he been allowed to stay there. Este patronage may not have made the most of Vigarani. Rather, it made of him, as of Boulanger and Avanzini, what it wanted. The Duke of Modena's needs of his artists were always more imperative than their needs of him.

(iii)

Within a week of his accession in July 1629, Francesco had restructured his Court. Out with the aunts and the uncles went the Gentlemen of the Chamber who dined and slept at Court, and far away in the Tyrol the Padre d'Este worried that his son should keep by him only the one assistant.[142] The Court complement at which Francesco finally arrived numbered some 130, including 18 cavaliers, a confessor, a preacher, chaplains and pages, and by comparison with the three hundred who had eaten at Alfonso II's table, or even the 123 mouths the Cardinal Alessandro had budgeted to feed, it was a modest number.[143] The Court included noblemen, such as the Marchese Massimiliano Montecuccoli, summoned to Francesco's service from Ferrara in 1631 and by 1646 receiving a salary of 6,000 *scudi* a year (not to mention such gifts as a diamond belt worth some 2,000 *scudi*).[144] But later at least it was said of Francesco that he maintained a balance between nobles and commons in his state, preventing the former from crushing the latter, and whether or not this was true, some of the most influential members of the Court were not of patrician rank by birth. As for the moral tone of this Court, according to the *Idea of the Christian Prince and Hero*, its most cultivated virtues were chastity and obedience to God. Another was austerity, and a frugal diet was in any case imposed upon Francesco by the state of his health, though in the end it would be a kidney stone which would kill him.[145] A fourth virtue was usefulness.

What is interesting in the scene which illustrates the princely virtue of Knowledge (*Scienze*) in *The Idea of a Christian Prince and Hero* is the kind of learning it portrays (Plate 58). Through the archway is a garden, the place of leisure and contemplation, but the virtuosi portrayed here are not dreamers lost in abstractions. Everyone is working, discussing fortifications, consulting maps or, in a tribute to Bernini, carving an inscription on the plinth of the portrait

bust. No one is playing music, though of necessity there were musicians at Court, and no one is conducting an experiment. In the ducal collection of curiosities, inventoried in 1662, were two microscopes, one large and cased in bone and the other small and set in silver, and in the person of Giannantonio Rocca of Reggio Francesco had to hand an experimental scientist, a disciple of Evangelista Torricelli.[146] But whatever speculative amusement the microscopes may have afforded, Rocca at least was put to practical use, assisting Vigarani when the Panaro river flooded. Only the author presenting the book hints at the contemplative life in this illustration, but his book might be a new history of the Este, a treatise on artillery or fortifications, or propaganda in poetry.

'The Most Serene House of Este', wrote Fulvio Testi in 1644, 'stands alone in the possession of fine poets', and Este patronage of literature, including the poetry of Ariosto, Tasso and Guarini, was the theme of the ceiling decorations by Colonna and Mitelli in the principal *Sala* at Sassuolo.[147] Francesco himself, however, was not an avid student of poetry – when Testi in 1634 told Urban VIII that the Duke had admired the Pope's Latin poems he lied, and since Mazarin would shortly be visiting Modena and could check, Testi hastily told Francesco where a copy might be found.[148] But in his youth Francesco had learned to recite the *Dialogo* of the House of Este and he would have learned from his father of the value of poetry to a prince. His poets Tassoni and Testi were themselves ready to admit that the time for delicious but wasteful *ozio* was past and to urge both poets and princes to action.[149] These opinions found their way into the education of Francesco's son Alfonso, who would have shared with the Court pages instruction in dancing, riding, fencing and other knightly skills, but whose future responsibilities required especial preparation.[150] At the request of Francesco, and with the help, perhaps, of the Tassoni manuscripts in his possession, Testi in 1641 proposed a simple curriculum. Grammar, rhetoric and dialectic were not needed and modern languages were to be preferred to the dead. Tacitus, Macchiavelli and Bodin were banned, but moral and political philosophy must be taught in the interests of state and self-government. All recondite studies were ruled out, leaving only the study of poetry in order to recognise genius and potentially useful publicists, and the study of fortifications design, architecture and art.[151] Where art appreciation was looked for in a prince, art management was necessarily expected of the staff.

The *Maggiordomo Maggiore* was a post for a nobleman. Like the English Lord Chamberlain, he presided over the management of the Household (including the Court musicians, actors and artists), supervised building works and their staffing, arranged contracts and the payment of bills passed to Vigarani and the Ducal Factors. Day-to-day administration of specific projects was delegated to individuals, usually clerics, such as the Theatine Don Siro, in charge of the chapel of which Francesco was patron in S Vincenzo; Don Antonio Ferri, manager of works at Prince Alfonso's Casino of Pentetorri; and, most overworked of all, the Provost Sebastiano Marinelli, in effect the Clerk of Works at Sassuolo.[152] Marinelli had carried some responsibility for management at Sassuolo since 1640 if not before but a formal appointment was made in 1646 in order 'that the building would rise quickly'. He would be remembered (in Tiraboschi) as an 'excellent and wise pastor', but how much time he now had for his pastoral duties is open to question, for Sassuolo appeared to absorb his energies. Until his death in 1649, Marinelli struggled to ensure orderly progress in the simultaneous building, decoration and plantation of Sassuolo – getting the models from Avanzini, for example, so that Luraghi could cut the stone, or getting sculptors to work in the *Sala* so that the painters could then make

a start, and always reviewing at Francesco's request the most urgent of tasks to be done in both the palace and the gardens.[153]

There were two Keepers of the ducal Wardrobe, or *Guardarobieri Maggiori*, one to take charge of furnishings, costumes and festive decorations and the other responsible for jewels, precious metals and paintings (this latter post was held by Guarino Guarini's godfather Count Marcello Querenghi in the 1630s).[154] But more interesting, perhaps, than the masters was the assistant Cesare Cavazza, who was a member of the Wardrobe staff in 1631, travelled in Francesco's retinue to Spain in 1638 and in 1650 was still employed in the Wardrobe. Cavazza seems to have assumed particular responsibility for paintings, given that his name appears in the account book of Guercino with reference to ducal (and perhaps certain private) commissions, and his nomination in 1637 as the intermediary between Guercino and a prospective patron in Modena wishing to order an altarpiece suggests a good relationship with the artist.[155] Cavazza's son Giulio was the promoter in Rome of the interests of the painter Francesco Manzuoli, and father and son together may represent an intriguing undercurrent in Court patronage.

At one remove, or so it appeared, from the business of patronage were the ducal secretaries and chancellors, but it was in this group, rather than in the Household, that perhaps the most imaginative, and influential, art advisers and administrators were found. When Francesco restructured his Court he appointed eight secretaries, four for political affairs and four for social business. It was said that he showed the same impartiality here as in his treatment of nobles and commoners and had no favourites. But as far as the outside world was concerned the Duke of Modena's 'favourite' (the English ambassador Hopton used the term in despatches from Spain) was Fulvio Testi.[156]

Testi was seventeen years older than Francesco and, as the son of a Ferrarese Court official who had transferred with Cesare in 1598, he had grown up in the changeable world of Cesare and the future Alfonso III. The uncertainties of those years had left a mark upon him no less than upon the prince his contemporary, but where Alfonso turned to the faith, Testi seemed to lean towards scepticism – at least, according to Alfonso, speaking as the Padre d'Este, Testi had gone unconfessed for years.[157] Testi became Francesco's secretary in 1628 and was confirmed in the post after the succession. In 1634 Francesco ennobled him, and with his fief of Busanello in the state of Reggio and his coat-of-arms (a quartered design of human and equine heads with the Este Eagle at the centre), Testi was happier now than he had been in the previous reign. But he had carried over a tendency to complain – of overwork, lack of recognition and poverty. Quite possibly his complaints had substance, but if Testi was not exactly a malcontent, he was prey to a dissatisfied restlessness which would eventually ruin him. But first, and for some fifteen years, he had fashioned policy.

Testi composed Court *feste*, such *L'Isola d'Alcina*, given in 1631 on the wedding of Francesco and Maria Farnese. He was most valuable, however, as the secretary whose official letters and confidential despatches were models of brevity and style, and who possessed the knack of summarising succinctly the essence of an atmosphere, a person, a place or an age: 'this is the century of *stravaganza*', and 'the century of the soldiers'.[158] He represented Francesco's interests, as envoy or ambassador extraordinary, in Mantua, Rome, Vienna and Madrid. Francesco's visit to Spain in 1638 (postponed from 1637) was almost entirely of Testi's making, and he regarded its success as a personal and vindicating triumph over his many critics, among whom the Padre d'Este was probably the loudest.[159] Testi thrived on negotiation, intrigue

and the politics of courts. In particular, he thrived in Rome, which he loved in spite, or perhaps because, of the dissimulation and double-dealing he observed at the Barberini Court.[160] By contrast with Rome, Modena seemed despicably mean to Testi: how could one compare, for example, Modena's Canal Grande with the Ripa and Ripetta of the Tiber, or the Este secretaries trailing to Court with the cardinals in consistory?[161]

In 1632 the Duke of Modena's Ambassador Extraordinary entered with enthusiasm into the pleasures of Roman life, falling in love (as almost every man did, it seems) with the singer Leonora Baroni, taking part in literary gatherings and making the acquaintance of Bernini.[162] Testi was especially proud of this acquaintance, which soon became a friendship, with the 'Michelangelo of our century' who directed satires at which 'whoever has knowledge of the Court dies of laughter' and who 'is enamoured of me and I of him'. In 1633 Bernini apparently painted a portrait of Testi which he then intended to carve. Testi proposed to bring the painted portrait back with him to Modena, to add presumably to the portrait painted many years before by Bartolomeo Schedoni.[163] There is now no trace of Bernini's portrait of Testi (nor of Schedoni's) but it is not impossible that some knowledge of it lies behind the portrait (in two versions) attributed to Francesco del Cairo, for something of Testi's vitality, so clearly expressed in his letters, is conveyed in this painting (Plate 59) and it brings to mind Testi's comment on Bernini's portrait of the Cardinal Borghese: 'truly it lives and breathes'.[164] The letter in which Testi described most fully the pleasures of Rome was sent not to the Duke but to a friend, with the request (apparently ignored) that it be destroyed. Perhaps Testi rather liked this kind of drama, but it may be that he knew he was enjoying himself too much away from Court. Yet he was not neglecting his duties.

Testi advised on everything, from diplomatic policy and appointments to the best choice of singers, and in doing so he helped inculcate the precept of *da principe*, the princely style, in the young Duke of Modena. In 1633 Testi in Rome, like the Abate Fontana in Milan, took it upon himself to redesign finials, in the form of vases, to be made in silver for the decoration of a bedstead for the Duchess Maria:

> The drawings that Your Highness has sent me . . . are not appropriate, for not only is the form of the vases not the most beautiful in the world, the workmanship is too trite . . . and since it is to be placed on high, it must be such that the eye can perfectly discern and enjoy.

So Testi devised a more 'solid' design of Eagles and Lilies (the Lily standing on this occasion for the Farnese) interlaced, and soon 'my vases' were being made by the Roman silversmith Fantino Taglietti. Then Testi considered a gift for the Duchess, and described a *tazza* decorated with trailing ivy and the figure of Orpheus playing the harp among animals and beside a stream.[165] It is not clear whether Testi was imagining the *tazza* or describing a model or sketch he had seen, but the taste he showed was the taste of contemporary Rome. Poussin, for example, could have painted such a scene, and François Duquesnoy could have carved or modelled it, and Duquesnoy was very possibly the 'Fleming', considered second only to Bernini, who would shortly be working on figurines intended for the *tazza*.[166]

Thus Testi became Francesco's guide to artistic fashion in Rome. It might be expected that he would also offer guidance on art appreciation. In this respect, however, Testi can be disappointing. In a poem he wrote after the death of Schedoni in 1615, he took up the conventional theme of art's triumph over nature – 'by comparison with your art, nature is worthless (*vile*)'.[167]

In a poem of 1644 addressed to Salvator Rosa, he treated of Rosa's Stoic philosophy but did not connect it with his art.[168] Elsewhere, it may be possible to detect in Testi a bias towards *disegno*. In 1637 he was concerned with, and may well have suggested, a commission to Bernini. Painting, not sculpture, was wanted but Bernini had undertaken to draw a composition for another artist to colour, and Testi, reassuringly, explained to Francesco that perspective was the 'principal point' of art. In his recommendations of 1641 for the education of Prince Alfonso, Testi proposed the study of geometry because it enabled the appreciation of painting and sculpture, which are, he added, 'nothing other than a union of proportions and symmetries well-composed'.[169] Testi's somewhat, and surprisingly, dry opinions may have found their way not only into the *Sala* at Sassuolo, where personifications of Painting, Sculpture, Architecture and Geometry formed part of the decorations, but also into the Room of Painting, where Boulanger's pictures of the early-to-mid-1640s illustrated by reference to Classical painters the five principles of Painting: *disegno*, decorum, proportion, ideal beauty and the expression of the *affetti*.[170]

It was while these pictures were being painted that Testi was trying to adjust to a new mood at Court. His poetry did not fit. He was quite prepared to compose, as he admitted, for 'political rather than poetical' ends at times, but he was a master of the lyric and of the analysis of mental states; in the eighteenth century Tiraboschi, with customary sensitivity, would write that for vivacity of imagery and fervour of fantasy Testi was unsurpassed.[171] But Francesco wanted epics and Testi's Muse was never Heroic. In 1640 Testi, like Ariosto before him, had gone to Garfagnana to govern the border province and, as he had explained when requesting the post, to write. But once there, as everywhere, he soon made enemies and complained of his difficulties – the Padre d'Este, also in Garfagnana, now became Testi's ally and sent letters to Francesco which glowed with praise of the poet's loyalty and faithful service.[172] Testi began his *Constantine* epic, borrowing the Court's history books and atlases and proposing different approaches to the theme – he was perhaps just stalling for time. By April 1642 he was back at Court and presumably unable to concentrate on the epic. In 1643 he followed Francesco to war, but what he saw was not heroic glory but the pitiful destruction of lands which had once been beautiful.[173] His restlessness returned and when the Cardinal d'Este was offered the French protectorate Testi thought of a new posting in Rome. But Francesco now wanted faithful servants more than roving representatives and he had his former secretary arrested. By a sad irony, Testi was imprisoned in the fortress of Modena, the foundation of which he had once challenged the Pope to oppose, and he died there in August 1646.[174] His downfall came as no surprise to other courtiers, especially those who disliked him, but it served as a reminder that Francesco could be ruthless. Testi had outlived his time.

He was succeeded as Court poet and propagandist and later secretary by Girolamo Graziani, born near Urbino and the son of a member of one of Francesco's courts of law.[175] Graziani's past was not unflawed. In 1628 he had been secretary to the younger sons of Alfonso III and in 1632 secretary to the difficult Obizzo, in which capacity he was accused of complicity in Obizzo's attempts to challenge Francesco's authority. For this, and for a fight with another courtier, Graziani was banished from Court, but from his return in 1647 his loyalty and obedience were never to be in doubt. Louis XIV of France admired Graziani's poetry and granted him a pension, but there was no suspicion that he would enter the service of the French king. Graziani accompanied Francesco on campaign (he was present at Mortara in Piedmont when

the Duke died), composed *feste* and contributed proposals for decorative programmes at Sassuolo. Therefore he took an interest in artistic affairs. But among the younger administrators at the Court of Modena, no one performed so essential a service to art patronage and collecting as the modest Geminiano Poggi.

Assistant to the Prince Francesco in 1624, Poggi remained when others were expelled and in January 1631 he was appointed *Aiutante da Camera*. He then undertook various diplomatic and administrative duties but not, surprisingly, until 1654 was he formally declared a ducal secretary, at which announcement, it was reported, both the Court and the city of Modena were glad.[176] Poggi was popular with everyone. There was a friendship between him and Testi, eight years his senior, to whom he was in 1636 the 'Poggino mio' whose letters were 'dearer than Ursuline confessions to the Jesuits'. Yet Poggi and Testi were essentially different. Poggi, for example, was Modenese, not from Ferrara. He was also exceptionally unambitious and uncomplaining, making light of his ill health and when travelling always refusing the offered carriage and taking only a horse. At work he would hum the *Nunc Dimittis*, the Song of Simeon, faithful servant of the Lord.[177] The Este princes thought highly of Poggi: Francesco made up for an uncharacteristic show of temper with the surprise gift of a house; Rinaldo was concerned for his health; and the young Alfonso turned immediately to Poggi for sympathy when the first son born to him and Laura Martinozzi died in 1658.[178] Poggi's good nature found its way into Malvasia's *Felsina Pittrice*, in the mention of the secretary's sorrow at the death in Modena of the Bolognese painter Flaminio Torre.[179] In his will of 1662, Poggi left provision for a chapel in the church of S Sebastiano and for masses for his own soul but more particularly for souls in Purgatory for whom there was no one to pray.[180] And where Testi perforce died without ceremony, Poggi wished to do so.

Poggi's duties and abilities were legion. Francesco Scannelli mentioned mathematical skills, an oblique reference perhaps to the talent for deciphering codes which forestalled an attack by Spanish troops on the fortress of Brescello in 1653. He organised Carnival entertainments, compiled the Court gazette, undertook historical research (into the deeds, for example, of Francesco Maria della Rovere, Duke of Urbino, to whom Francesco could claim a distant relationship), and was trusted with confidential matters from mooted marriage alliances to the making of a time bomb to blow up Spanish munition stores at Sabioneta in 1657.[181] He undertook Francesco's missions in Parma, Venice, Genoa, Rome and other Italian cities, and it was notable that so many were made under the cover of art. 'It came into my mind', he wrote from Ferrara in January 1639, 'to say . . . that Your Highness had understood that the heirs of Roberto Canonici had dispensation to sell the paintings, and that Your Highness had particularly commanded me to speak with the Canonici.' It seemed a very extensive cover, for Poggi viewed the paintings in this best-known of Ferrarese collections of the time, and consulted with Guercino, who happened also to be in Ferrara – it was perhaps no coincidence that on the day Poggi wrote to Francesco, a payment for the *Decollation of the Baptist* by Guercino for the Duke was entered in the painter's account book.[182] In Rome in 1652 Poggi negotiated with the Pamphili while rumour ran of an alliance with the Barberini: 'Now see, your Highness', he wrote, 'if painting has such a great prerogative in making one talk of that which was never thought.'[183] Poggi's language gave his cover away, for in truth art mattered to him quite as much as politics. In Rome in 1636 he had been glad of the success of his mission (it concerned Francesco's uncle, the Cardinal Maurizio of Savoy), but he had also been sad,

for 'I have seen here miracles of painting, and I know that I must leave discontented, because I will leave with only the memory of these treasures.'[184]

Poggi stood on good terms with artists in Modena, where he at least took an interest in Lodovico Lana,[185] and in Rome, where he would speak with the most famous, such as Bernini or Pietro da Cortona. On one occasion in Rome he also talked with Mattia Preti: 'The Cavalier Calabrese has been to find me', he reported, 'and with terms of great courtesy has taken me to various places to see paintings.' This meeting took place in November 1652, and it is not impossible that Poggi played some part in Preti's arrival in Modena, perhaps in 1653, to paint the frescoes (now destroyed) in the cathedral and the astonishing frescoes which still survive in the church of S Biagio of the Carmelites (rebuilt from 1649 and thus ready, as Poggi would have known, for decoration).[186] He was equally well-acquainted with the art experts, such as Pier Fabrizio Mattei, the Medici agent in Rome, and it was perhaps Poggi who had introduced Gabriele Balestrieri to Francesco in the late 1630s, for there was certainly a friendship between the two men.[187] It was possibly Balestrieri who helped to make Poggi the discerning art critic he became.

Poggi was Francesco's most reliable pair of eyes, able to make whatever he described come to life on the page. In Rome he saw and described for Francesco the beautiful 'idea' of Bernini's *Truth and Time* and Algardi's *Leo and Attila* relief for St Peter's, of a 'manner very tender and well-designed'.[188] At the same time, Francesco had asked him to inspect one particular painting, and Poggi had been taken by Gualdo Priorato to see it in the palace on the Quirinal Hill which had belonged to the Bentivoglio but was now the property of Mazarin.[189] It was said to be a work by an 'English painter' and, wrote Poggi, it 'is most beautiful'. The painting was a life-size, half-length portrait of a proud man, with a long beard and a costume in the Persian style and a head-dress which resembled but was not precisely a turban. (It is tempting to associate this picture in some way with the portraits of Sir Robert and Lady Shirley painted in Rome some thirty years earlier by Van Dyck on Shirley's return from Persia, and in Van Dyck's Italian sketchbook is a drawing resembling the man Poggi described.) In Poggi's opinion, this portrait was 'most fine, and unbelievably soft, the tones so well-balanced one against the other that the figure seems to project from the painting, and the design corresponds to the other perfections'. It remained in Poggi's mind 'as if it were before the eyes', and this was perhaps the effect of his description upon Francesco.

Poggi was undoubtedly the man to supervise artistic tasks, from the selection of pictures for Sassuolo (in the mid-1640s he selected from the collection paintings by Dosso and Garofalo to fit the spaces available) to the provision of sketches of the Bernini portrait bust requested by Leopoldo de' Medici.[190] He visited art collections on Francesco's behalf and in Rome visited also the Academy of St Luke, where the state of Raphael's *Madonna of St Luke*, (which Francesco was secretly hoping to acquire) filled him with rage and contempt for those who could have allowed it to so deteriorate.[191] He would also have inspected the collection of Francesco Angeloni, had Angeloni not died the day before Poggi knocked on his door.[192] Art entering the collection in Modena was viewed by Poggi, including in 1651 a 'painting from Pavia' which was not, he concluded, by Titian but fit to be hung 'among the best'. Two pictures sent from Venice in the same year were judged by Poggi to be suitable instead for a cabinet: one was a 'landscape by Civetta, to discern the whole of which one needs sharp eyesight

or a good pair of glasses', and the other a 'German manner' scene of *putti* and 'little invention'.[193] Poggi also kept the ducal collection in order. 'I have adjusted the paintings in the gallery', he wrote in 1645, 'in the manner ordered by Your Highness', and at the same time he made sure the paintings received a 'good cleaning'.[194] When Velázquez visited Modena in 1650, it was Poggi who made sure that the painter, as Philip IV's agent, was kept out of the gallery on the pretext that the warder with the keys was absent.[195] Poggi acquired a number of pictures on his own account, but he was as devoted to Francesco's gallery as he was to Francesco himself. In 1652 he described Raphael's *Madonna del Foligno* with such passion that the Duke had to ask for restraint. But Poggi replied that his enthusiasm 'deserves to be excused and pitied, because since I cannot tepidly wish to see in the Gallery of His Highness the last word in the marvels of painting, so I must ... declare my passions with some vehemence'.[196]

Running through Poggi's passion for art was the thread of a particular taste. Contemporary painting was not greatly to his liking. Paintings by Federico Barocci, however, earned his respect, and 'truly for moderns are a great deal better than those of Guercino or Reni'.[197] But even Barocci 'could not be mixed among those of the first class', and guided by a sense of 'the good one knows and one seeks', Poggi went back further into the sixteenth century. When he travelled through the Papal States in 1652, he saw the 'dryness' of Perugino and of early 'first manner' paintings by Raphael. But the *Madonna del Foligno* amazed him, seeming the most excellent of Raphael's paintings, better than the *Santa Cecilia of Bologna* or the *San Sisto of Piacenza* (the *Sistine Madonna*) because 'it has of the exquisite in its design, and moreover a softness (*morbidezza*) that one does not see in his other works'.[198] Then he added that the *Madonna del Foligno* was 'so tender it appeared to be by Correggio', and so he revealed the true heart of his love of painting. Poggi admired Raphael and Titian, saw 'good taste' in Veronese and 'spirit' in Bassano, but he belonged to the Lombard School. One contemporary artist for whom he did have time was the Bolognese Mastelletta, in which connection it was interesting that, according to Scannelli, in his later career Mastelletta had been particularly influenced by the Lombard Parmigianino.[199] But first in Poggi's artistic hierarchy was Correggio and his altarpiece of *La Notte*, 'the painting that exceeds all others in the world in excellence of art and sublimity of idea'.[200] When Poggi wished to distinguish early and late paintings by Raphael, he compared them with Correggio's altarpieces, and when he wished to give a character to the Court of Rome, he drew upon Lombard imagery:

> As for these courtiers, I assure Your Lordship that they do not surprise me ... the study of their stratagems renders them lacking in good colour, too finely drawn, and the Lombard manner, even at its most coarse, is more tender, and more natural.[201]

Rarely, maybe, can a taste in art and attitude to life, each one, perhaps, influencing the other, have run so happily together. Francesco Scannelli knew Poggi well and when in Rome once longed for the chance to confer and talk with him.[202] If anyone at the Court of Modena helped Scannelli to form the theory upon which the *Microcosmo della Pittura* is based, and which put Modena on the cultural map of Europe, it was Poggi. They shared a dismissive attitude towards most contemporary artists and they shared a passion for Correggio and the Lombard

School. There was a special place in the *Microcosmo* for the secretary of 'extraordinary talents and great intelligence in the matter of painting'.[203]

(iv)

Last, but inevitably not least, was always the question of money. When Francesco reformed his Court he also reformed his treasury, demanding exact accounts from paymasters and establishing annual income and expenditure.[204] Regular incomes were estimated at 500,000 *scudi* a year and irregular incomes (from such sources as mines and confiscations) at 50,000 *scudi*. The annual expenditure of the Court was fixed at 350,000 *scudi*. Perhaps this was, as was said, a 'calculation that proved very true', but it is very difficult to believe that at a time of war and famine any budget could remain that stable, and in practice finances fluctuated. In 1650, for example, when Francesco was prevented by civil unrest in France from campaigning in Italy, monetary stock seemed high in Modena and the production of the mint reached heroic levels – thousands of silver *ducatoni*, some 478,999 *doppie* and 114,000 *ungari*.[205] In the same year Francesco himself drew up a balance sheet for Court expenditure under the headings of Salaries (the costliest item), Soldiery, Household spending (the *Spenderia*, including food and drink, fuel, grain, alms and lighting), the Wardrobe, and the embassies, stables, fortresses, building repairs, salt, paper and books, ships and *bucintori*, gifts, Sassuolo, Extraordinary (under which Nicolas Regnier had been paid in 1638) and the catch-all *Causa nota*. His estimates showed a healthy surplus for that year.[206] But in other years resources were more thinly stretched. Francesco's reign was punctuated by a series of extraordinary expenses: a payment in 1629 to keep Imperial troops from quartering in the Modenese state, the costs of the war of Castro and subsequent wars in Lombardy, and not least the visit to Spain, which by one estimate cost Francesco a staggering 800,000 *scudi*; the figure may be exaggerated, but with new liveries, precious gifts and chestfuls of money to spend and largesse to distribute the true cost cannot have been much less.[207] And since there was not one year of abundant harvests in Francesco's reign but several years of shortage, sometimes desperate, there was also from time to time a need for special purchases of grain.[208]

For Francesco as for Cesare, foreign subsidies were one means of augmenting the regular revenues. The 1630s, for example, were the decade when Spanish money circulated in Modena (Guercino was paid by Francesco in Spanish *doppie* in 1634) and helped to pay for the fortress. But foreign subsidies were not reliable. Nor was Cesare's other stand-by, the Mont'Estense, for papal policy towards non-papal *monti* hardened in the 1630s – it was negotiations about the interest payments on the *Mont'Estense* that first brought Rinaldo, in 1645, into contact with Poussin's former patron Cassiano dal Pozzo, one of the deputies appointed to supervise the payments.[209] Francesco turned instead to the bankers of Genoa for loans. Expenditure affecting the well-being of the state, such as the payment which bought off the Imperial troops, was raised by a levy on each community of the state. Domestic expenditure could sometimes be managed by setting off new expenses against old debts: in 1647, for instance, Francesco told a hopeful Rinaldo that he might (though of course he did not) negotiate the purchase of the Palazzo Riario in Rome by means of a Riario family legacy to which he had acquired

the rights.[210] Finally, Francesco was prepared at least to consider such means of creating wealth as the *arbitrio economico praticabile* for increasing state revenues proposed to Rinaldo in 1650 (but then shown to be a fraud), and the science of alchemy – a doubting Poggi watched 'chemical operations' in Modena in 1646 and thought them as foolish as all other attempts to make gold.[211] It was with a not dissimilar range of alternatives to direct payment that Francesco approached the business of art patronage and collecting.

There was value for money in art. If an unsolicited dedication in a book (Pompilio Totti's volume of 'illustrious men', or *Ritratti et elogii di capitani illustri*, published in 1635 and indeed dedicated to Francesco), was thought worthy of a gift of 100 *scudi*, Gaspare Moroni's charging of the same amount for a medal, which fulfilled a similar function but possibly demanded more skill, made artistry seem cheap.[212] Nevertheless the price of art added up to a sizeable sum. The 50 Roman *scudi* paid for a landscape by François Perrier in 1641 could have paid Mantovani's rent for five months. In 1639, 400 *scudi* had been agreed as the price for the portrait of Francesco by Velázquez – 'he is dear', admitted Testi, 'but he is good'.[213] So was Guercino, who received 630 *scudi* for his portraits of 1632 and 600 *scudi* in 1634 for a painting of *Christ and the Moneychangers in the Temple* for Francesco.[214] Nicolas Regnier did not discuss prices with princes, reported the Resident Scalabrini from Venice in 1639 (Regnier was then working slowly on a portrait of Luigi d'Este), but preferred to wait until the work was done.[215] When Francesco wished to order a painting from Pietro da Cortona in 1652, it was accepted that the artist would determine the size and the subject (he chose *Coriolanus*, but gout may have prevented Cortona from making any further progress), while Francesco 'followed the road to generosity which one must always take with Pietro'.[216] It all made the prices for portraits by Justus Sustermans seem extremely reasonable (25 *scudi* for a 'head', 30 to 35 *scudi* for a half-length, and 50 *scudi* for a full-length with landscape background), but Sustermans enjoyed the relative security of a Court appointment.[217] Materials incvitably added to the price of workmanship. A matching set of Crucifix and candlesticks in silver cost 2,500 *scudi* in Rome in 1633, and a single picture in *pietre dure* could cost the same amount (in Florentine coin) in 1635.[218] But the patron also paid for the art: of the 300 *scudi* charged by Stefano della Bella for the eleven engraved plates of *La Gara delle Stagioni*, the copper accounted for just 30 *scudi*.[219]

Art collecting could cost as much, if not more. The *Rape of Helen* by G. C. Procaccini sent from Milan with other pictures in 1635 alone cost 300 *ducatoni* (which compared with the 300 *scudi* a year received by the poet Tassoni as Francesco's Gentleman of Letters). But this consignment of pictures also revealed the hidden costs of collecting, for when all duties, tolls, packing and haulage costs and carriers' subsistence had been taken into account, they amounted to 122 *ducatoni*, which could have purchased another picture, or two horses, or thirty more sacks of wheat in a year when the severe shortage of grain made it necessary to buy extra.[220] In 1649 the collections of the Muselli and Curtoni in Verona were inspected on Francesco's behalf and had he been able, as he wished, to buy one, it would have cost him upwards of 20,000 *ducats*.[221] At this point, the cost of collecting began to approach that of building and festive art. In 1653 one Sassuolo building contract alone quoted 3,500 *scudi*, which compared interestingly with the compensation payment of 2,700 *lire* (say, 540 *scudi*) for two homes demolished in 1646 to make way for the works at Sassuolo.[222] The full cost of this palace and garden was given as 100,000 *scudi*, which seems a conservative figure.

Meanwhile, the *Alcina festa* of 1635 had apparently cost Francesco an amazing 200,000 *scudi*. *La Gara delle Stagioni* of 1652 cost a more modest, but still, by comparison, considerable, 50,000 *scudi*.[223] When the costs of art ran as high as this, they bid fair to compete with the costs of war.

Careful management helped control them. If the difference in cost between the *Alcina* and *La Gara* was truly so great, it may have been because in 1635 the *festa* was staged for Francesco by the noble entrepreneur Pio Enea II degli Obizzi, while in 1652 Francesco had his own team of poets, musicians and artists and knew by experience how to contain costs. Gifts and exchanges also helped to offset expenditure. Quite why Francesco exchanged, in 1649, a *St Veronica* for a *Magdalen* with the Marchese Alfonso Molza is not easy to explain, for Poggi had had to choose 'I will not say the best, but the least bad' from Molza's collection.[224] But in the same year he exchanged with the Medici a *Rest on the Flight* by Correggio for the *Sacrifice of Abraham* by Andrea del Sarto and made a notable addition to his gallery. In 1650 he made another exchange with the Medici, receiving a *St Catherine* by Leonardo da Vinci in return for a portrait by Titian.[225] Gifts of art could be received from subjects, among them a Lelio Orsi, a Sisto Badalocchio and, more notably, the portrait by Hans Holbein of *Charles de Solier, Sieur de Morette* (Plate 60), a painting presented by Massimiliano Montecuccoli and noted by Scannelli for its rarity and 'beautiful naturalism'.[226] From Ferrante Gonzaga, Duke of Guastalla, who married Francesco's sister Margherita in 1647, he received the *Madonna of the Washbasin* by Giulio Romano (Plate 61), a painting which, thought Scannelli, possessed a grace unusual in Giulio's art. In 1650 arrived the gift of a *St Jerome* by Durer from the 'Count Lesles' in Vienna: this donor was possibly Walter Leslie, the Scot who took part in the assassination of Wallenstein in 1634 and was ennobled by the Emperor in 1637.[227] Sculpture too could be offered as a gift. In 1652 Aurelio Calcagnini in Reggio wrote asking Francesco to accept, 'for the ornament of Sassuolo', the sixteenth-century statues of *Hercules* and *Lepidus* which, when they finally arrived in Modena, would be set into niches on the façade of the Palazzo Ducale.[228]

A number of gifts were directly or indirectly encouraged. In 1646, for example, Francesco's brother Cesare was more or less expected to surrender what pictures he owned so that they might decorate Sassuolo. Rather more graceful was Tommaso Guidoni's mention to the Cardinal de' Medici that Francesco would appreciate a work by Bronzino, to which the Cardinal responded with the gift of a portrait.[229] But Francesco did not always expect a gift. When he saw the four Coccinà canvases by Veronese, he had offered to buy two and had refused a gift. But when Coccinà, who was by no means a fool, offered all four and named as his price a fief in the Modenese worth 10,000 *scudi*, Francesco, after some hesitation, agreed. It was neither the first nor the most spectacular example of payment for art by fief, but it was memorable enough to be recorded by Marco Boschini in his poem on the death of Francesco's son Alfonso IV, *Funeral fato da la Pitura Venetiana per el passazo del . . . Serenissimo de Modena*: for your paintings, ran the lines addressed to Veronese, the 'Duke Francesco Maecenas gave counties'.[230] In effect, the costs of art collecting had been transferred to the state, and there were other ways in which this might be done.

By the time Francesco became a collector of art, the acquisition of old master paintings from churches had become a commonplace of collecting, though still capable of arousing protest. In 1630, for example, the Modenese Cardinal Campori had sharply reminded the provost of a church in Viadana from which a Parmigianino altarpiece was missing that 'that which

has once been dedicated to the divine worship cannot be converted to secular use', and he had called upon the Duke of Parma for help in a matter 'which concerns the service of the Lord God and the honour of the Blessed Virgin'.[231] Yet when Francesco acquired the *Madonna of Casalmaggiore* by Parmigianino in the 1640s there appeared to be no extraordinary fuss, perhaps because the authorities of Sto Stefano in Casalmaggiore were content to give it in exchange for an undertaking to increase the status of their church.[232] But when Francesco had begun to acquire paintings by Correggio from churches in Correggio and his own states, there had been a notable outcry. In 1638 Jean Boulanger and a Franciscan friar removed from S Francesco in Correggio the painting of the *Rest on the Flight* later to be given to the Medici, and the protest reached as far as Rome. In May Mantovani reported that one Quirico Mozzani of Correggio, who happened to be an Adjutant to the Papal Chamber, had asked if he 'knew what had occurred about a painting that had been robbed from the church of the Conventual Fathers in Correggio' and Mozzani had not accepted Mantovani's denial. 'In short he replied that under cover of making a copy in Your Highness's name, the painter and a friar have stolen it . . . and that you intended to send it as a gift to the Catholic King.'[233] It was perhaps the popular protest which dissuaded Francesco from giving away this painting, but having found this cheap means of collecting he was not prepared to give it up. The *Madonna of San Francesco* from the same church in Correggio followed the *Rest on the Flight* into the ducal collection. In 1640 came *La Notte*, 'stolen at night' from S Prospero in Reggio. In 1647 Correggio's *Madonna and Child with Sts Mary Magdalen and Lucy* was removed from the church of Albinea 'in the time of the archpriest's absence' (the absence was forced), and in 1649 the Modenese Confraternity of St Peter Martyr was persuaded to give up its *Madonna of San Giorgio* by Correggio (in return for an altarpiece by Guercino which took, however, some twenty years to arrive). Within a few years the Confraternity of San Sebastiano had also given up its *Madonna of San Sebastiano* to the Duke.[234]

Parishioners complained, but had little option other than to accept the compensation which was always scrupulously offered but which never, when it arrived, approached the value of the loss. Had the *Madonna of San Giorgio*, for example, been saleable, it would have cost Francesco at least 10,000 *ducats*, the value estimated by Tassoni in the early seventeenth century and possibly far below the market value in the 1640s.[235] The copies by Boulanger which replaced most of the removed Correggio altarpieces were, of course, very cheap to Francesco. By the 1660s, if not before, Este collecting had brought Modena and Reggio into line with other more famous artistic centres and art exports were monitored. As Alfonso IV, with the help of Poggi, acquired altarpieces by Annibale Carracci from the churches of Reggio (finding the vendors rather cannier now perhaps than in the days of Francesco), an attempt to sell the *Assumption of the Virgin* by Guido Reni to enable the community of Spilamberto to pay off its debts met with much bitterness of feeling at Court.[236]

The art of Modena and Reggio belonged, it seemed, to the Este, and so did all building materials and labour. In August 1634, feudatories and provincial governors received orders to send quantities of lime, stone and brick to Modena for use in the new Palazzo Ducale, and brickmakers were forbidden, 'under pain of what will appear just to His Highness, pecuniary or corporal', to sell or export their products.[237] Once work was under way at Sassuolo, assignments were made from state revenues (Sassuolo taxes, duties on oil and fish at Reggio, incomes from Scandiano and its windmill, etc.) to meet the monthly estimates of expenditure.[238] But

69

before the building and the decoration of palaces could begin, there was a need for manual labour. For Francesco as for the Padre d'Este, the prisons were one source of labour. But far more important were the communities of the state – for Sassuolo, the thirteen neighbouring communes, for the Palazzo Ducale, the duchy as a whole.

The Este administration pressed into service the old '*bovateria* of the state' system whereby each community undertook to transport cartloads of materials commensurate with the number of pairs of oxen it possessed: thus under an agreement, or *comparto*, of 1652 for the carriage of 33,335 stones for Sassuolo, assuming 285 stones per pair of oxen, Sassuolo, with 25 pairs, carried 2,925 stones, while Fiorano, with 38 pairs, transported 4,446. Agreements were made as the need arose for lime, gesso and other materials, but labour required a slightly different method. When digging was needed in the gardens or in the repair of the banks of the Secchia, the spadework due from each commune was calculated anew. Sassuolo, for example, must contribute '2 works' of carriage, '2 works' of the spade, Fiorano 2 of the carriage and 5 of the spade, while Magredo was for the moment kept in reserve for work on the *Casiglia*.[239]

Not surprisingly, the system was highly unpopular (harvesting was interrupted) and inefficient.[240] In 1651 all thirteen Sassolese communes must have shirked their duties, for they were rebuked for having carried only 138 of the 579 loads of gesso needed (these were years in which, according to one supervisor, 'the building devours quantities of gesso every day'), while in Modena cartloads of materials from a recalcitrant Reggio were long overdue.[241] In 1656 one exasperated official at Sassuolo, Francesco Buzzalini, had to report that only one woman and a boy had turned up for the '10 works' of labour ordered for that day; 'I was angry', he added.[242] The communes, however, grumbled too. Their manual labour might reasonably be expected for defence works, but when in 1653 the community of S Felice protested against the requirement that they assist at Sassuolo, they pointedly observed of the palace that it was 'made for the recreation of Your Highness'.[243]

It is not impossible that these forced contributions from the communes were not merely a means of obtaining cheap, or free, labour but a calculated attempt to weld the state into one by means of such 'national service', and such an interpretation might also be read into the selection of master masons (two from Carpi and three each from Modena and Reggio), and into the summoning, in 1653, of plants from all parts of the state for the gardens of Sassuolo.[244] There is, however, no firm evidence of any such intention influencing these public works. Labour and materials were the most important contributions the duchies could make, besides money, to Francesco's programme of building and patronage, yet the system probably hindered rather than assisted progress. It seemed, in the end, a rather primitive foundation on which to build, reminiscent of the old feudal *fieldwerk* and *handwerk*, and at odds with the increasingly sophisticated methods of proxy patronage and collecting, purchasing and commissioning, information-gathering and consultancy, art inspection and art appreciation which had developed so rapidly under Francesco I. In September 1652 Francesco wrote to Rinaldo of two drawings he had just received from Bernini, one most appropriate he thought, the other needing consideration – these were probably the observations on Francesco's palaces which, said Poggi to Bernini in Rome, had enjoyed the respect they merited in Modena. But it might have been at the very moment that these drawings from the most famous artist in Europe arrived in Modena that an undated memorandum was sent reporting that the community of Castelarano had let its load of clay slide into the canal of Modena.[245] At times,

it must have seemed unlikely that anything would get done at all. That it was done, and so quickly, was due to the determination of Francesco d'Este to restore the prestige of his House and establish the Este in Modena.

Part II

*The Bentivoglio
(1598–1660)*

4 *Patrons, agents and entrepreneurs*

The Bentivoglio bore the Imperial Eagle on their coat-of-arms and traced, or claimed to trace, their lineage back to kings, namely Enzio, King of Sardinia and a natural son of the Emperor Frederick II, the *Stupor Mundi* of the Middle Ages. A third distinction they shared with the Este was that of being deposed by a Pope. Julius II had expelled the Bentivoglio from the lordship of Bologna in 1506 and the family had divided. There remained a Bentivoglio presence in Bologna in the seventeenth century, and the old Castello on the canal from Bologna to Ferrara still carried the family name (John Evelyn noticed it as he sailed past in 1644), but leadership of the family had passed to the branch which had settled in Ferrara. The Bentivoglio in Ferrara did not forget the past. The gallery of their palace by the church of S Domenico displayed, in 1685, a picture of the *Guasto Bentivoglio*, a reminder of the palace of Sante Bentivoglio in Bologna razed by Julius II. But Ferrara was now their home and to the seventeenth-century chroniclers the Bentivoglio were Ferrarese.[1]

Cornelio I Bentivoglio had refounded the family fortunes, obtaining from Alfonso II d'Este the fief of Gualtieri near the border between Reggio and Mantua (it became a marquisate in 1570), draining the surrounding marshes and planning a small town around a massive family palace.[2] Cornelio's architect was G. B. Aleotti, whose career probably owed more to Bentivoglio's patronage (acting either for himself or as Alfonso II's lieutenant and unofficial master of ceremonies) than to the Este themselves. Aleotti may have contributed to the design of the new palace in Ferrara which Cornelio was building in the early 1580s and with which the names of Pirro Ligorio and the sculptor Alessandro Vittoria are also sometimes associated.[3] Alfonso II, it was said, found Cornelio increasingly intolerable in later years, which was probably due to his authoritarian manner but may also have had something to do with the ease with which Cornelio produced heirs. Cornelio married twice, first Leonarda d'Este and second Isabella Bendidei (a member of the famous *concerto delle dame* at Alfonso's Court), and had some twelve children, most of them sons. When Cornelio died in 1585 he was able to leave to his eldest son Ippolito I an array of feudal estates, including Magliano in the Maremma of Siena as well as Gualtieri, and a reasonable inheritance. But devolution then divided the family again. Ippolito followed the Este to Modena where he settled with his son Ferrante and Ferrante's children by his first wife, Beatrice d'Este of the San Martino line, and second, Leonora Mattei. Of Cornelio's other sons, some left for the wars in the Netherlands, one moved to Rome to follow a career in the Church, and another stayed, for the moment, in Ferrara. Thus, in 1616 one might find the Marchese Ippolito managing Duke Cesare d'Este's fortifications and artillery, Monsignor Guido returning from his nunciature in Flanders then leaving again for France, and the Signor Enzo, on behalf of Ferrara, greeting the incoming Cardinal

Giovanni II
1463–1506

Annibale *m* Lucrezia d'Este, natural
daughter of Duke Ercole I

Costanzo *m* Costanza Rangone

CORNELIO I *m* 1. 1539, Leonarda d'Este, daughter
?1519–85 of Scipione, Marchese d'Este
 2. 1573, Isabella Bendidei (*d* 1619)

| Scipione *d* 1547 | Ottavio | Margherita *m* Alfonso Turchi, Co. of Ariano | Annibale *d* 1595 in Flanders | Giovanni 1576–1610 |

Annibale *d* 1569 — Lucrezia (*d* 1602) *m* Ugo Pepoli — Ginevra *m* 1. Pio Torelli 2. Marcantonio Martinengo — Alessandro *d* 1600 in Flanders — Guido 1577–1644 *Cardinal*

IPPOLITO I *m* Vittoria Cibò (*d* 1587), daughter
d 1619 of Alberigo of Massa-Carrara

FERRANTE *m* 1. 1601, Beatrice d'Este, daughter of
d 1619 Filiberto d'Este of San Martino
 2. 1616, Leonora Mattei,* daughter of
 Asdrubale Mattei, Marchese di Giove

Giulia (*d* 1629) *m* Cesare Pepoli — Giovanni *d* in Spain — Alessandro *d* in Spain — Cornelio *d* 1600 in Flanders

Francesco *d* 1609 — Isabella (*d* 1641) *m* Paolo Sforza — Beatrice *m* Giacomo Boschetti — Vittoria *m* Guido Rangone — Matilda 1604–83

ENZO *m* 1602, Caterina Martinengo
?1575–1639

Annibale *d* 1669 *m* Semidea Leni (*d* 1627) then entered the Church — Guido (1624–76) (*Theatine*) — Beatrice *m* 1627, Ascanio Pio — Giovanni 1611–94 (*Abbot*) — Ermes *d* 1655

Francesco *d* 1655 — Anna (*Nun*) — Isabella *m* 1624, Cesare Estense-Mosti — Margherita (*Nun*)

CORNELIO II *m*. 1. Anna Strozzi (*d* 1636)
1606–63 2. 1637, Costanza Sforza

IPPOLITO II *m* Lucrezia Pio, daughter of
1630–85 Ascanio Pio — Ferrante 1635–95 (*Abbot*)

Matilda 1671–1711 — Maria Teresa — Beatrice 1661–1718 — Cornelio 1668–1732 *Cardinal*

Ascanio 1673–1719 — LUIGI *m* Marianna Pepoli 1666–1744 — Isabella *b* 1665

* Remarried (1621) Ascanio Pio di Savoia

Adapted from Litta, *Celebri Famiglie Italiane*, vol. III

Figure 2. Family tree of the Bentivoglio of Ferrara, *c*.1550–*c*.1750

Legate and organising a *festa* in his honour. There was buoyancy in the Bentivoglio character, and among many talents was the ability to adapt and make themselves indispensable.

(i)

Of all the Bentivoglio brothers, Ippolito is the most elusive. Guido Bentivoglio once explained his half-brother's adherence to the Este in 1598 by the fact that Ippolito was a soldier, which may, perhaps, suggest that he lacked the psychological complexity, and agility, of the other Bentivoglio.[4] Yet he was not insignificant. He had fought for the Spanish Habsburgs in Portugal and Flanders (in 1607 he received Letters Patent as a councillor of war to the Archdukes of Flanders). In 1597 it had been Ippolito who, with the ducal secretary Laderchi, had urged Cesare to fight.[5] Now in Modena he was Cesare's Lieutenant-General, conducting the wars against Lucca, for example, and Cesare left all decisions to Ippolito, from the number of cannon to be commissioned to the method of paying the foundryman.[6] (Even the long-suffering Cesare appeared, however, to find Ippolito as overbearing as Alfonso II had found Cornelio, for on Ippolito's death in 1619 Cesare proposed to divide and diminish the duties of his post.) Ippolito was also a patron of art and architects.

According to a rather biased Aleotti, Ippolito was the 'Hero of our times' who had quadrupled the incomes of his estates by completing, with Aleotti's help, the land reclamation scheme (or *bonificazione*) at Gualtieri and thus creating what 'one can justly call . . . the Tempe of Lombardy'.[7] The family palace was already complete, but under Ippolito's patronage he now laid out the square and porticoed piazza before the palace and the church of Sant'Andrea was built on one side. In later years, supervision of building and engineering at Gualtieri was entrusted to Antonio Vacchi, who was Cesare's architect but who, if not engaged on defence works under Ippolito's direction, would probably have been under-employed in Modena.[8] But painters to decorate the palace were not so easy to find. An inventory of the palace taken in 1619 recorded hundreds of pictures on the walls (and a promising 'Room of Painting'), but they were listed in anonymous blocks – 172 'various' in the *Galleria Grande*, for example, 60 Este portraits, 54 Bentivoglio portraits and so on.[9] Bartolomeo Schedoni was apparently persuaded to stop at Gualtieri on his way to Parma in October 1607 and decorated a room.[10] Six years later, the painters Sisto Badalocchio and the Brescian Tommaso Sandrini were at work there, or at least they were expected to be, though Sandrini in Ferrara was uncertain how to answer the summons to Gualtieri and Sisto, it seemed, preferred to remain in Reggio.[11] Sisto Badalocchio would, in fact, paint a *Fame* and a *Hercules* series for Gualtieri, but the relative isolation of this little town would always hamper patronage there, and perhaps affect the attitude of the Bentivoglio themselves towards their fief.

In Modena, Bentivoglio patronage complemented that of the Court. Soon after the transfer from Ferrara, a Bentivoglio garden, with pergolas and a labyrinth, appeared by the walls near Sant'Agostino.[12] A palace near the Castello was purchased from the Rangone, repaired and decorated with tapestries, landscape paintings, histories and portraits of the Este and Bentivoglio (all, again, unattributed), of which the most impressive must have been the large, full-length portrait of the late Marchese Cornelio which hung in Ippolito's apartments.[13] The

77

palace wardrobes were stocked with costumes for the joust and the quintain, and the palace itself had become a venue for other entertainments. In February 1605, the Este princes were taken by their tutor to the Bentivoglio palace to see a play about 'a peasant driven mad by love, in verse and the native tongue', and had it not been for another 'very good and delightful' performance (by a group of local scholars) there in 1606, that Carnival would have been still bleaker than the chronicler G. B. Spaccini found it.[14] The Bentivoglio were also setting an example in devotional patronage. From 1602 Ippolito was the Cardinal Alessandro's deputy as protector of the new church of the Paradiso, and from 1605 his soldier son Ferrante participated in the particular devotions of the Capuchin, Carmelite and Servite communities in Modena.[15] Then Ippolito became one of the first private patrons of the new Jesuit church of S Bartolomeo, where he founded the Chapel of the Annunciation. (Ippolito was, perhaps, especially devoted to the Annunciation, for another painting of the subject was sent to him, at Gualtieri, from Florence in 1607.[16]) The altarpiece was ordered from the Veronese painter in Florence Jacomo Ligozzi (Ippolito approved its composition in 1612), but the additional paintings of the *Life of the Virgin* were commissioned in 1613 from Lorenzo Garbieri, the Bolognese painter who within a few years would be enlisting Este help in obtaining work in Reggio.[17] In S Bartolomeo, Ippolito's patronage coincided closely with the interests of the Este, and he seemed to respect the mood of devotion encouraged by Cesare and Isabella of Savoy, for the carved initials 'H. B.' on the pilaster bases of his chapel announced his patronage very quietly.

But within weeks of Ippolito's death on 29 November 1619 came news, on 14 December, from Graz in Styria of the death of his son Ferrante, and thus the Modenese branch of the Bentivoglio came to an end, for all surviving children of Ferrante's two marriages were daughters.[18] All elder sons of Cornelio I having died, leadership of the family now passed to Enzo Bentivoglio.

(ii)

Enzo Bentivoglio became head of his House by a process of elimination, but as he was named after its supposed founder, he seemed somehow destined for fame. He was not altogether pleasant. His brother Guido in Flanders was left for months with neither news nor allowance, and Leonora Mattei and her daughters and step-daughters in Modena complained of cavalier if not criminal treatment from Enzo. In 1622, Matilda, the eldest daughter of Ferrante, petitioned Cesare d'Este for justice, claiming that her great-uncle had falsified the inventories of the Modenese inheritance, deducting large sums for creditors, without showing that any creditors existed, and undervaluing some goods by at least 50% while entering no values at all against others, including tapestries and paintings.[19] Enzo was also so slow in honouring Ippolito's pious bequests that Prince Alfonso, in 1627, had to write and ask him to do so.[20] In 1630 Fulvio Testi could not understand how it was that Enzo could both sell and confiscate the same property, and this to a sick and elderly member of the Bentivoglio family.[21] On this occasion, thought Testi, a means should be found of restricting Enzo's influence with the courts, but this was never easy for Enzo's influence, thanks to his contacts, was considerable, and

so were his means of persuasion. According to his son-in-law Ascanio Pio, Enzo's means of persuasion included the 'almost violent', and so keenly did he remember the day, in 1632, when Enzo arrived at the Pio palace unannounced and bullied Ascanio into standing guarantor to some scheme, that he drew up a codicil to his will binding his sons never to advance money to anyone other than a brother, and calling upon Pope, Legate and princes to make sure that they never did.[22] Yet, for all that, Enzo was a 'knight of vast talent' and tireless energy without whom the world was a duller place.[23] His activity was ceaseless and protean – now he was a patron with an almost compulsive urge to build, change and improve, now an agent with an eye for a talented artist or a good painting, now a clearing-house for artistic goods and services, and now a consultant and entrepreneur, undertaking for other patrons schemes as diverse as canal construction and festive entertainments. Enzo might be found in Ferrara, Parma or Rome, perhaps in Modena or Venice, or perhaps out in the country supervising the reclamation of land from water, running up cottages or laying out fortifications. 'Truly', sighed Pope Urban VIII in 1634, 'he is a great cavalier', but he wished that Enzo would settle into a fief in the Papal States and become a proper subject of the Church.[24] In Ferrara and the Romagna, of course, he was, but he was also the subject of the Este (at Gualtieri) and the Medici (at Magliano), a landowner in Spanish Lombardy and inscribed, with other members of his branch of the Bentivoglio, in the *Libro d'Oro* of Venice. In 1629 the Cardinal Bishop of Ferrara, Lorenzo Magalotti, thanked God that in Enzo's brother Guido and two of Enzo's sons in orders the Church held 'hostages' whereby such a 'suspect subject' could be restrained.[25] But if Magalotti associated Enzo with, on this occasion, the Este, the Este associated him with Rome. Enzo's mobility was unsettling and his loyalties were uncertain but he retained his freedom to act.

In 1620 Enzo became Marchese di Gualtieri and a citizen of Modena, but he did not settle in the city. Instead, that part of Ippolito's portable property which was not sold straightaway was dispersed among other Bentivoglio residences. Pictures, for example, were sent to Gualtieri, where Enzo would soon, in 1623, commission new decorations from the Centese artist Pier Francesco Battistelli.[26] The portrait of Cornelio I, however, came to the family home in Ferrara. Under Enzo's management, the Palazzo Bentivoglio in Ferrara had been completed and decorated by artists including, perhaps, Tommaso Sandrini, who may have painted there in 1613 the ceiling decorations recorded by Ridolfi.[27] Enzo, like Ippolito in Modena, had also become a leading patron of pious works. The family already possessed chapels in S Domenico and Sta Maria degli Angeli, where Cornelio I had been buried, and in 1612 Enzo added a third institution when he became patron of the new church of S Maurelio of the Capuchins, (Plate 64), a plain, brick building which Aleotti may have designed for Enzo.[28] Then in 1625, as 'principal patron' of the Theatines in Ferrara, Enzo was offering to pay for the site and façade of the Order's new church in return for the display of his coat-of-arms.[29] The patronage of S Maurelio, said the Cardinal Bishop of the day, Gio. Battista Leni, was an act 'of great charity, for which you will have merit with God'.[30] But good works and intentions notwithstanding, it was a mistake to think, as Leni hoped, that Enzo had done with the world.

Never slow to exploit an opportunity (to apply for ferry rights across the Po, for example), Enzo had embarked upon a new land reclamation scheme at Trecenta, a family possession since 1562. The *bonificazione* of this thirty-mile stretch of land near the borders with Mantua and Venice was sanctioned by Rome in 1609 and substantially finished by 1612.[31] It seemed

miraculous: an area 'before uncultivated and submerged in water, now under cultivation, quickly filled with people who may enjoy air which is good, where before it was bad and infected'.[32] By 1636, there were over 200 people and 45 new houses at Trecenta, new grain supplies for Ferrara and new souls for the Church – among whom, apparently, were a number who had slipped across the border from Venetian soil, 'since the subjects of the Church are so much better treated than those of the Republic'.[33]

The reclamation at Trecenta had been achieved by the time-honoured techniques of drying, digging and embanking the land, then building drainage tunnels, aqueducts and sluice gates. Enzo had kept strict control of his work-force (his *contadini* labourers could not be levied for military service, the food he bought them was exempt from tax, and no one else might sell them food or wine on pain of a fine). His engineer seems to have been Antonio Vacchi, borrowed from the Duke of Modena, probably with Ippolito Bentivoglio's help, in 1609 and 1615 and no doubt more frequently.[34] Enzo was not the sole party (one Alessandro Nappi was his partner in the undertaking), but as Alberto Penna would later write, since Enzo 'had the greater part in conceiving and producing it, bringing it to completion and spending money upon it, so it carries his surname'.[35] As far as the costs were concerned, though limits to Enzo's liability had been written into the agreement of 1608 (he would pay compensation to owners of cultivated land, but not owners of reclaimed land), by 1611 the bill already amounted to some 80,000 *scudi*, of which the sluices and dykes accounted for the greater part, the gifts to Aleotti, Vacchi and the Legate's secretary the most judicious.[36] But money, for the moment, hardly appeared to matter. In 1612, with the reclamation almost complete and the offer to build S Maurelio made, Enzo was also proposing to pay half the costs of a new theatre in Ferrara, thereby revealing his most passionate interest.[37]

The theatrical productions of Enzo Bentivoglio had acquired a semi-legendary fame. When Fulvio Testi needed a metaphor for his lyric *Che le miserie consistono in apparenza*, he found it in Enzo's theatre: how true, and alive, seemed the images of the infernal regions, the sighs and groans, the flames and fumes, yet they were only semblances, and thus, reasoned Testi, human sorrows too were no more than imagination.[38] The poem was addressed to the Cardinal Guido Bentivoglio, but in fact Guido had been somewhat uneasy about his brother's passion for shows, once advising him against ostentation and 'the tournaments that Your Lordship has in mind to hold, and other such things as come into your head without occasion'.[39] But it was difficult to stop Enzo, especially when his services as a theatrical entrepreneur were so much in demand.

Enzo had been a founder member of the Ferrarese Academy of the *Intrepidi*, formed by the nobility with the support of Clement VIII and a small subsidy from the Commune for the continued encouragement of letters in Ferrara. In 1606 Enzo was also the motive force behind the building, to the design of Aleotti, of the *Teatro degli Intrepidi* in an old Este granary near the church of S Lorenzo. But more important, perhaps, was the theatre in the *Sala delle Commedie* (or *Sala Grande*) of the Corte Vecchia which he, as current *Principe* of the *Intrepidi*, and Aleotti created in 1612 to give permanent form to the kind of proscenium stage with changeable scenery that entrepreneur and architect had developed.[40] Enzo, in fact, acquired a proprietorial interest in this theatre which by means of successive investitures by the Este (the Academy's landlords in the Corte Vecchia) would pass to succeeding generations of the Bentivoglio.

Until 1617, when the Cardinal Legate Giacomo Serra banned all night assemblies after the murder of Ercole Pepoli, Enzo the impresario, Aleotti the designer and for a time Alessandro Guarini the poet collaborated on a spectacular series of dramas-to-music and *intermezzi*, tournaments and quintains, which entertained Ferrara at Carnival and welcomed distinguished visitors. They proved immensely popular and, not least, an incidental benefit to the post of a Papal Legate or President of the Romagna. The Cardinal Rivarola in 1611 and the Cardinal Capponi in 1615 were two who visited Ferrara at the time of a performance on the pretext of business but really, they admitted, for pleasure.[41] Enzo understood perfectly the needs of his audience. A performance of Maffeo Venieri's *Idalba* in 1614, for example, could not begin before sunset but would last some seven hours. Enzo accordingly organised a banquet at which the table was decorated with flowers from Genoa and *amoretti* carried supper baskets to the ladies. He also understood why the audience had come. The *Idalba* had been seen before, but not the *intermezzi* which accompanied it and were performed against the scenery which, according to the printed description, took the audience 'one might say, out of this world and out of themselves'. More popular still was Enzo's *Campo Aperto*, a form of entertainment, part opera, part joust, in which scenes performed by professional singers (usually borrowed from other patrons) within scenic settings onstage alternated with pitched battles in the open space before the stage between a costumed champion or *Mantenitore* (Enzo himself) and his challengers, noblemen who might provide their own costumes and their own machines within Enzo's frame, and contribute their own verses within the poet Alessandro Guarini's text. Dramatic unity was never the aim of these performances. Instead, the audience was offered a succession of spectacular scenes and skilful combats.

The audience of cardinals, nobility and 'people' attending the *Teagene* in the *Sala delle Commedie* on 23 February 1610 saw Enzo, as *Teagene*, and his challengers contest the chivalric question of the nature of the true lover. Their combats were framed by performances onstage, and through the central opening of the Corinthian *scaenae frons* (a vestige of the 'academic' theatres decorated, on this occasion, with fictive reliefs of other jousts organised by Enzo) the audience saw the scene change six times. A town setting, essentially the *Tragic* scene of Renaissance drama, changed to the Temple of Janus, followed by landscapes with palaces, a seascape, delightful gardens and, finally, Mount Parnassus, each setting complementing the deity, such as Cupid, Thetis, the Three Graces and Apollo, who appeared on the stage. The painters responsible for the settings would have included such local artists as Gio. Andrea Ghirardoni and perhaps such newcomers as Tommaso Sandrini, whose perspectives for the Madonna della Ghiara church in Reggio suggest he would have been an excellent scenery painter, Pier Francesco Battistelli, who certainly painted scenery for Enzo in Ferrara in 1617, and Girolamo Curti and Michelangelo Colonna who, wrote Malvasia, went to Ferrara to paint a *muta di scene* for Enzo.[42] But the only artist actually named in the descriptions was he who had helped to compile them, that is, the architect Aleotti.[43]

Enzo's fame as theatrical entrepreneur spread to the courts of Mantua and, most famously, Parma, where in 1618 he supervised the completion of the *Teatro Farnese* (Plate 65), designed by Aleotti and a landmark in the history of the European theatre for the inauguration therein of the picture-frame stage. To Enzo was also entrusted by the Farnese the supervision of scenery and machines, poetry and music, for performances which were eventually given in 1628.[44] In Rome the Cardinal Borghese understood that 'the fine *feste* cannot take place without the

participation and advice of the Signor Enzo', but organising an event in Rome was a complex matter. As another cardinal, Domenico Rivarola, observed, 'to be certain of the joust in Rome, it would be necessary to find those who were enthusiastic, rich and ready' and he implied that they were as scarce as were venues for a joust at night.[45] Enzo's *Campo Aperto* would make its most triumphant appearance in Rome under the patronage of the Cardinal Antonio Barberini on 25 February 1634, when the Piazza Navona was the scene of the famous *Giostra del Saracino* (Plate 66), organised by Enzo's son and heir Cornelio II Bentivoglio to entertain the visiting Prince Alexander Charles of Poland and, according to Fulvio Testi, who contributed verses, amuse a melancholy Pope. As the *Mantenitore*, Cornelio, costumed in green and silver as one Tiamo da Menfi, accepted the challenge of twenty-four Roman knights who disputed, with their lances, his proposition that 'secrecy in love was a superstitious error'.[46]

The name of the Bentivoglio was, however, well known in Rome long before the joust of 1634. In 1623 a slip of an *avvisi* writer's pen, imperfectly corrected, turned 'Ulisse Bolognetti' into 'Ulisse Bentivoglio', which might be seen as a tribute to the family's fame.[47] News in July 1620 of Bentivoglio banquets had probably helped to foster the rumour in August that Enzo 'negotiates to buy for 300,000 *scudi* from the Duke of Altemps the castles of Galtesi and Soriano'.[48] These were, as the writer admitted, 'unsure reports', and Enzo did not buy the castles, but on 22 October 1619, little more than a month before he became, unexpectedly, the head of the family, he had bought from Gio. Angelo Altemps for the price of 55,000 *scudi* payable over twenty years a property on the Quirinal Hill in Rome (Plate 67).[49] This was the property once owned by the Cardinal Borghese (the modern Palazzo Rospigliosi) which included two garden buildings, the *Casino of the Muses* and the *Casino of Aurora*, decorated for Borghese by Guido Reni, Agostino Tassi, Orazio Gentileschi and Paul Bril. In 1620 tapestries from the estate of Ippolito I Bentivoglio in Modena were sent to Rome, and over the next fifteen years Enzo, together with his brother Guido from 1621, continued the decoration of their palace.

As early as 1622 painters had been employed in the palace (but not actually paid, their bills seeming exorbitant to the family agent), and one of them may have been the Florentine Giovanni da San Giovanni.[50] By the mid-1620s an interesting group of painters was at work including, between 1623 and 1627, Filippo Napoletano and Pietro Paolo Bonzi, Andrea Camassei, a young painter from Bevagna perhaps recommended to Enzo by Filippo Napoletano, and now if not before Giovanni da San Giovanni and his compatriot Francesco Furini.[51] Their work attracted attention: Giulio Mancini, for example, papal physician and *dilettante* of art, thought that Giovanni's frescoes were promising (he had probably seen the paintings on the *piano nobile*, including a *Death of Cleopatra* and a *Burning of Troy*).[52] But credit for this patronage is possibly due to Guido Bentivoglio rather than Enzo, and it was Guido who in 1627 specified the seascapes and mythologies he wished Giovanni to paint on the ground floor.[53] For Enzo, new paintings on the walls may have represented a good investment, part of a programme of improvements he had put in hand.

Scipione Borghese had referred to the property as a 'garden', and thus, as a place of resort, he had used it until, in 1616, the Pope had obliged him to sell. There was little of a residence on the steep and awkward site, no stables, kitchens nor pantries, and what had once existed had been allowed to fall into decay under Altemps' ownership.[54] At a cost of 'thousands of

scudi' (the figure of 53,683 *scudi* was mentioned in the late 1630s), Enzo had repaired every-

thing and created more. What had been a wall in 1619 became a double apartment for the Cardinal Guido; a new chapel, new staircases and new storeys were built (in October 1620 Enzo had contracted with the builders Domenico and Giovanni Livizzani for the construction of a new third-floor apartment), and by the late 1630s thirty-one apartments had been created.[55] The paintings which decorated the rooms were valued at 6,000 *scudi*. Further improvements were now proposed to extend the palace and put the garden in order, at a cost of 40,000 *scudi*.[56] Tenders were also being invited from builders for shops on the ground floor, Enzo stipulating strict conditions.[57] The builder must follow exactly the plans provided by Enzo's architect and the instructions for the treatment of façades, rustication, roofs and chimneys. Materials were specified – a well-wetted and smoothed *pozzolana* for example. The builder must pay for the detailing of windows, doors and fireplaces. Enzo retained absolute control over quality, and provided all went satisfactorily, he would pay each Saturday evening a sum commensurate with the work done in each seven-day week.

Enzo had gathered a reliable team in Rome, some of whom had been carried over from the days when Borghese owned the site. The Livizzani, for example, still Enzo's builders in the 1630s, testified then to having 'worked on the said fabric from the beginning to the end'. The craftsman Girolamo Costantino from L'Aquila, a carver of *anticaglie* and spiral staircases alike, had also worked for Borghese. Enzo's architect was the Sienese Sergio Venturi.[58] It was a safe but unadventurous team, and there is no evidence that Enzo ever employed a better-known architect in Rome. But he may not have needed creative architects. Bringing something out of nothing – lengthening a *loggia* by three arches, for example, so that three more apartments could be fitted into the plan – seemed just the kind of challenge to his ingenuity which Enzo enjoyed as much as the extra profit he saw could be made by letting a spare grotto. No professional, perhaps, could have seen the possibilities better than he himself. In 1625 Enzo had told the Cardinal Cennini, then Legate to Ferrara, that he intended to settle in Rome and perhaps this was his intention. But the palace was also an enterprise, an opportunity to transform a garden into a desirable residence and a going concern.

Enzo had created for himself a unique rôle as the supplier of a multitude of services and people relied upon him. In 1612, for example, the Cardinal Capponi asked Enzo's help in finding a new house (Capponi feared his own hearing was defective); in 1617 he answered the Cardinal Alessandro d'Este's taste for the *bizarre* with the swift despatch of the sketches requested of plumes worn in a recent *festa*; in 1627 he promised the Cardinal Borghese to find a place on the Ferrarese *Rota* (or tribunal), for Ottavio Zuccari, recommended by Borghese 'for the affection I have for him and still more as the son of the late, famous painter (Federico) Zuccari'.[59] Letters from cardinals and princes either asking or granting favours accounted for a sizeable part of Enzo's correspondence. No less voluminous was his correspondence with musicians, performers and artists, among them the Bolognese Floriano Ambrosini, architect of S Pietro in Bologna, and the Provenzale family from Cento now established as mosaicists in Rome.[60] It was this network of contacts which made Enzo so useful as an agent, and which he could exploit when he acted as entrepreneur. For his work in Parma in 1618, he had theatre engineers, carpenters and painters from Ferrara to supplement the Farnese artists, and Pier Francesco Battistelli from Cento arrived to supervise as Enzo's deputy.[61] In 1627, when the plans for performances were revived, Enzo summoned a new team. In July he invited Giovanni da San Giovanni, then working in the Bentivoglio palace in Rome, to travel to Parma.

In August he wrote to the Cardinal Capponi in Ravenna requesting the painters Curti and Colonna: 'I had hoped', replied Capponi, 'that the painters would carry out the work for which I had brought them, nevertheless I have released them, so that they come to serve the Lord Duke'.[62] But in truth the artists worked for Enzo as much as for the Farnese. Since Battistelli was now dead, Enzo had brought in the Ferrarese architect Francesco Guitti to supervise work on his behalf and when Guitti could not keep the peace between the assembled artists, only the name of Enzo, he wrote, could restore order.[63]

The name of Enzo seemed indeed to possess magical appeal, promising artists to patrons and patrons to artists. It was Enzo to whom travelling players wrote when they hoped to include Ferrara in their tours, and Enzo to whom hopeful artists were drawn. Some arrived by recommendation, as did, in 1614, a portrait painter named Bernardino sent to Enzo by Luigi d'Este, 'though I know', admitted Luigi, 'that the competent need no more than their *virtù* to win Your Lordship's favour'. In 1627 Marcello Provenzale's painter nephew Ippolito was placed under Enzo's protection. Less lucky, perhaps, was the importunate artist who buttonholed a servant of the Cardinal Magalotti, Bishop of Ferrara, in 1630 to ask if Magalotti might recommend him to Enzo, which he duly did, but drily, as 'one Hieronimo, stone-cutter, whom I do not know at all'.[64] Hieronimo's fate is uncertain, but Enzo could indeed advance an artist's career. The painter–architect Battistelli, for example, obtained a post at the Farnese Court in Parma after working there for Enzo, and in Rome Enzo introduced Andrea Camassei to the patronage of the Barberini.[65] It was also Enzo's patronage of Francesco Guitti in Parma which gave Guitti the opportunity to develop his own ideas on staging methods (including the concealment of the musicians from the view of the audience) and made him one of the most intriguing, if little-known today, theatre artists of the 1630s. In Rome in 1633 Guitti, lodged at the Bentivoglio palace on the Quirinal, collaborated with Bernini on the performance of Rospigliosi's *Erminia sul Giordano* in the theatre within the Palazzo Barberini. It was then Guitti who designed the temporary theatre and machines for the *Giostra del Saracino* of 1634. The Roman diarist Giacinto Gigli was particularly taken by the ship which Guitti had designed to carry musicians representing Bacchus and satyrs into the enclosure at the end of the joust and to glide without visible means of motion – though, added Gigli knowledgeably, it was all done by means of wheels and workmen concealed below. Artists might not profit financially from the Bentivoglio – in 1628 Giovanni da San Giovanni at Gualtieri demanded payment before he would continue 'with fear, love and expedition on whatever you will command' – but they could profit from the consequences of Bentivoglio patronage.[66] Yet it is not easy to say just how sensitive Enzo may have been to the needs of the creative artist, and he was certainly cavalier in the treatment of a poet.

The collaboration between Enzo, Aleotti and Alessandro Guarini had at first been that of equals. In 1608, when Enzo sent Guarini details of Aleotti's proposed stage machinery (a castle was to vanish and be replaced by a temple), Guarini replied that provided the machine could appear in water, he could accommodate the temple within his text. But in 1612, when Guarini sent Enzo a new 'invention', he also returned Aleotti's draft description, which he had found useful for technical jargon but so full-blown in style as to imply, if published, that Enzo was excessively ambitious. In 1613 the poet supplied new *intermezzi*, but he had also 'reduced the number of machines where the multiplication of them seemed inappropriate'. Finally, in 1616, Guarini refused to collaborate again, and in a separate letter he criticised Enzo for expect-

ing him to 'rebuild' another poet's 'invention'. 'In the creation of poetry', wrote Guarini, 'the invention is the form, the particular conceits the material'; form is masculine, the conceits are feminine, so 'Does the Signor Enzo therefore wish that I become the female among poets?'.[67] The answer was probably yes, if it meant that Enzo got what he wanted. Guarini had discovered, as would Ben Jonson in England, that 'invention' in the theatre was now a scenic and not a poetic function, and more immediately, that creativity was subordinate to Enzo's will. In 1628 poets composing for the festivities in Parma would be expected to write in conformity with scenes and machines made ten years before, dusted down and restored. Ascanio Pio, a contributor of *intermezzi*, was frankly baffled by the instructions, and 'almanack in hand', requested a meeting.[68] His confusion strangely echoed that of the Cardinal Capponi's reply when, also in 1627, Enzo tried to enlist his help in obtaining money to pay for repairs to the broken dykes at Trecenta: 'I will write readily to Rome in the manner that Your Lordship wishes, but I confess I do not understand well what it is you wish me to write'.[69] No doubt Enzo's mind moved much faster than those of most people he knew, but he rode roughshod over finer feelings in order to gain his ends, and so he turned everyone, cardinals, poets and artists, into his tools.

It is hard to say what friendship may have meant to Enzo, apart from reciprocal favours, and it is equally hard to define the value he placed upon art. It was perhaps just another commodity in which to trade. In 1608 he had made capital of his own connoisseurship when he identified the pictures in the Palazzo dei Diamanti as originals by Dosso, and tricked the Este agent into letting them go.[70] (He then asked the Este agent if the Duke Cesare was at all angry with the part he, Enzo, had played in the business.) In his search for other paintings Enzo enlisted in 1607 the help of even the Cardinal Aldobrandini (in connection with a picture in Argenta) and in 1611 that of his brother's friend Federico Cornaro, who was to negotiate for him the acquisition of paintings owned by the Jesuits – these may perhaps be associated with the Roman *avvisi* report on 14 May 1611 of the arrival of a *St Peter* and a *Sts Rocco and Joseph*, attributed to Raphael and Girolamo da Carpi respectively and described as 'taken from a church in Lombardy'.[71] With such other gifts as a 'little animal from India' and an embroidered carpet (valued at 3,000 *scudi* but, typically, cheaper to Enzo because it had been sewn at home), the paintings were intended for the Cardinal Borghese.[72] A genuine friendship may indeed have developed between Enzo and the Cardinal Nephew, who in fact called Enzo to be with him when the Pope was taken ill in January 1621 and who, had he outlived Enzo, would have received the bequest of a painting by Dosso.[73] But the signs of affection notwithstanding, this was also a relationship founded upon self-interest. Enzo the agent supplied gifts and services, and Borghese the patron granted leases of land and permissions to raise capital. In the opinion of the Padre d'Este, no innocent in the reading of character, there was in Enzo Bentivoglio a 'sagacity that watches his interest at every turn'.[74] But what, in the end, had he achieved?

He had achieved an unshakable reputation as a theatrical entrepreneur. When the Swedish architect Nicodemus Tessin the Younger visited Parma in the 1670s, he learned not of Aleotti, Francesco Guitti and the other artists concerned in the *Teatro Farnese*, but understood that 'one Marchese Bentivoglio from Ferrara had made the design of the whole work'.[75] And not only the Farnese had benefited from Enzo's entrepreneurial skill. For the Pope in Ferrara, for the Este in Modena (in the 1630s Enzo had supervised work on the Bomporto canal by the

same Antonio Vacchi whom he had borrowed for his own reclamation scheme), and for the family in Ferrara, Gualtieri and Rome, Enzo's talent for constructing, developing and improving represented added value.[76] But the costs had proved too high. The reclamation scheme was not, in fact, over in 1612 but would require some ten new flotations of the *Monte Sisto* and eventually a *Monte Bentivoglio* to finance the continual repairs – in 1630 the assets of Enzo and his partner Nappi were confiscated.[77] The weather could be blamed for the floods, but there was also a suspicion of rushed and defective workmanship on the dyking of the Tartaro river. In 1611 Enzo was serving as the official representative of Ferrara in Rome, but he left his post (while keeping its remuneration) to hurry back to Ferrara to oversee repairs. As a letter from a friend warned him, two sayings were then in circulation in Ferrara: 'quickly and badly', and 'he who spends less, spends more'.[78] The blame for poor foundations and the omission of the vital *restara* (the stretch of level ground between river and dyke), probably falls upon Antonio Vacchi, but ultimately the responsibility fell upon Enzo. By the 1630s, wrote the chronicler Ubaldini, Enzo's reputation and popularity were suffering in Ferrara.[79]

In 1634, agreement was reached with the Este for the exchange of the fief of Gualtieri for that of Scandiano, which bought a little breathing space from debt.[80] In 1636 the fief of Magliano in Tuscany was pawned on a twenty-three year arrangement to the Capponi.[81] In 1637, Enzo entered into litigation with the Altemps over the interest payments charged on the purchase of the palace on the Quirinal Hill in Rome, and though for a time it seemed that he would win the case, it was clear that sooner or later the palace would have to be sold – and hence the proposals for further improvements.[82] No less disturbing for Enzo, perhaps, had been the personal disappointment, in 1633, of failing to be enrolled by Louis XIII of France in the noble Order of Saint-Esprit, despite the pro-French policy which the Bentivoglio had adopted and Enzo's own appeals to such advocates as Duke Carlo I Gonzaga.[83]

Having suffered an apoplectic fit in October, Enzo Bentivoglio died in Rome on 25 November 1639, mourned by all who knew him, wrote the Este agent Mantovani, 'for the sweetness of his nature and because he was a knight of most elevated genius'.[84] But a year later, a letter from Enzo's son Monsignor Annibale to Enzo's eldest son and heir Cornelio II sounded another note.[85] It concerned 'a debt of piety' for 'the body of our father . . . at present lying in a chapel where not even a mass was said'. Annibale would have it sent in a simple pinewood case, and secretly, to Ferrara, 'as if ordinary goods', and then it must be buried immediately, at night, and honoured in the morning with masses for the soul. It seemed a pathetic end for Enzo, who as patron of S Maurelio in Ferrara had so thoughtfully made arrangements there for a tomb for himself and his wife Caterina Martinengo. 'Remember brother', added Annibale, 'the good he wished us, and that wishing it too much has been the cause of our ruin.' Enzo had certainly wished his family well. Ten children had been born to him and Caterina and he had hoped to provide for them all by means of careers in a foreign military service or the Church and marriages within the family. So much of what he did as entrepreneur could be interpreted as an attempt to increase the yield of what he had and create new wealth, and it was unfortunate that conditions in his day were less favourable than in those of Cornelio I. And if his schemes were not always prudent, it had to be remembered that the most ambitious belonged to the time when he had been the intrepid Signor Enzo, not the head of the House. So far, Annibale's reminder was fair to his father's memory. But as much as Enzo had acted for the family, he had also acted for himself, following an almost instinctive desire to alter

and improve what existed, and to achieve personal glory. 'I never say that which I do not intend to perform' he had written in 1617, when first invited to advise on the *Teatro Farnese*, but in the light of the 1630s his confidence looked like hubris. Nobody was harder hit by the nemesis which followed than his brother the Cardinal Guido Bentivoglio.

(iii)

It was sad to meet Guido in 1639, at the time of Enzo's death, sadder still in 1640, when he was seeking a buyer for the palace on the Quirinal which Roman guidebooks described as the home of the Cardinal Bentivoglio (and still in 1645, John Evelyn would write of his stroll in the 'delicious gardens' of the late Cardinal Bentivoglio).[86] Guido had made his name as a papal diplomat and arguably the best of contemporary historians of the wars in Flanders, but in the late 1630s there was little more to add to his reputation, and the Este agent Mantovani wrote of his 'languid' manner and his 'head that suffers from the air and lack of sleep'.[87] The palace was sold in January 1641 for 75,000 *scudi*, the Bentivoglio now the victims of the same fluctuating values of Roman property upon which Enzo's case against Altemps had rested in 1637, that is, that one does not pay for a palace the sum which the vendor may have invested in it.[88] Even so, it was thanks only to the Barberini that the sum paid was so high, for the buyer had proposed only 70,000. As the 'most beautiful in Rome ... more suitable for a great cardinal than for a prelate', the palace was bought by Giulio Mazarin, about to become a cardinal but even as a prelate yielding to 'the mad desire I have always felt to have, before I die, a beautiful palace like that of the Bentivoglio' – a comment which was, perhaps, a tribute to Enzo's ability as a property developer.[89] In 1640 Mazarin had become Guido's landlord when the latter moved from a temporary home to the former residence in the Trevi district of his friend Monsignor, now Cardinal, Federico Cornaro.[90] By November he had decorated his new rooms with tapestries, more telling here than in the larger rooms of the palace and in the opinion of the family agent, Guido had soon created a degree of comfort which 'will compensate in part for the magnificence of Montecavallo'.[91] But it was in a spirit of bitter disillusionment that the Cardinal, at the age of 63, now began to compose his *Memoirs* of the 'scene of trickery, labyrinth of error' which was the Court of Rome. The *Memoirs* were never completed and go no further than 1602. Yet they are an insight into the making of Guido Bentivoglio as diplomat and, perhaps, lover of art, and it seems reasonable to follow his own, retrospective, method in piecing together the mind and the tastes of this most intelligent and sensitive of men.

In the year of devolution, 1598, Guido was a student of law at the University of Padua and enjoying his visits to the Veneto villas of his friend Cornaro to experience 'sweet liberty' and the 'honest and pure pleasures' of study and conversation (he was in the confidence of Galileo, who explained to Guido 'in private the sphere').[92] At the same time, Guido, entitled to call himself a 'Venetian Gentleman', came to love 'the so celebrated, and so majestic Venice', and throughout his life he would always be drawn now to the fresh and simple, now to the rich and grand. The devolution of Ferrara to the Pope made Guido a protégé of the Aldobrandini and directed him (via a visit to Florence, where he witnessed the wedding of Marie de' Medici

to the proxy of the King of France) to Rome and a career in the Church. Rome in 1600 was a revelation.[93] Guido studied the cardinals, among them the great reformers Baronius and Bellarmine, and the patrons, the admirable Federico Borromeo and the unusual Montalto, protector of musicians and the Theatine Order who was also known for what Guido remembered as a nocturnal style of life. He saw the splendour of Odoardo Farnese and the modesty of Paolo Sfondrato: 'the richest furnishings of his house were excellent paintings, in which piety strove with art, art with piety'. Guido also made the acquaintance in Rome of the very rich Genoese banker, patron of artists and art collector, Vincenzo Giustiniani, who in 1606 called on Guido's mother in Ferrara on his route, as a tourist, to northern Europe.[94] Giustiniani visited Flanders in his travels and thus he was perhaps able to provide an informal briefing when, in 1607, Guido, under the patronage now of the Borghese, was appointed papal nuncio to Flanders.

His official instructions included the maintenance of order, censorship of books and protection of the lines of communication with beleaguered Catholics.[95] After the signing of the Twelve Years' Truce in 1609, Guido was able to demonstrate the strength of the Church he represented. In Antwerp, in August 1609, he dispensed the Sacrament for over an hour to Catholics who 'for so many years', he wrote, 'had lived buried under the shadow of the heretics'. Rain then threatened the procession, but he ordered it to continue, 'to show that this and greater discomfort one could endure in honour of the sacred'.[96] In the secular world, there were such diversions as the flight to Brussels (and away from Henri IV) of the Princess of Condé, but more valuable to Guido was the opportunity to frequent a court which seemed to him the most attractive in Europe, presided over by the Archdukes Albert and Isabella, whom he much admired (a portrait of Albert was listed in the Bentivoglio collection in the 1650s) and, given the presence of the army, a meeting-place of many nationalities.[97] He also travelled, inspecting the battlefields (where members of his own family had died), gazing with interest across the channel to heretical England, and everywhere gathering the information he would use first in his report of 1611 to Borghese on the state of Flanders, and later in his book *Della guerra di Fiandra*, which began to be published in 1632.[98] He proposed reforms and stronger measures (new seminaries, for example, in Antwerp and Ghent, 'the two cities most infected by heresy') and he may have assisted in other ways the recovery encouraged by the Archdukes.[99] But though Flanders had been 'the school of negotiation' which made Guido Bentivoglio a politician, the political temperature fell in the first years of the Truce, and at times he may have been restless, and the march that he made with Ambrogio Spinola's army to Augsburg in 1614 was perhaps a welcome opportunity for action.[100]

On his return to Rome, Guido in 1616 awaited his next posting (Germany, he thought, or France) and in July was appointed papal Nuncio to France.[101] In Paris, in the Hôtel de Cluny, residence of the Nuncio since 1561, he encountered heresy again in the form of the Gallican schism ('every schism', he observed, 'degenerates into heresy') and worked to promote peace within France and throughout Europe.[102] He saw Marie de' Medici again, as lovely to his eyes as at her wedding in Florence, and he met for the first time people who would later become guiding influences in French life, among them Richelieu, Pierre de Bérulle and Angélique Arnauld. He learned to respect the ministers of France and they respected Guido, nominating him in 1621 for the protectorate of French affairs in Rome, a responsibility he held until 1633.[103] France was the more stimulating post for a diplomat and politician. But

as he explained to Borghese, there were no painters to speak of in France, for painting 'not being held in great prize here, as a result one does not find any exquisite painters'.[104] For the patron, agent and connoisseur of art in Guido, Flanders had proved more exciting and, perhaps, instructive.

Guido Bentivoglio shared the cultural interests of his peers. He read contemporary poetry (sending to Marino, for example, his comments on the *Sampogna*, which he had preferred to *L'Adone*) and as a writer himself he became a perceptive critic of the style of other prose writers.[105] He was a patron of the musicians Frescobaldi and Girolamo Piccinini, who accompanied him to Flanders, and of Marco Marazzoli, the composer of music for Rospigliosi's *Chi soffre, speri* of 1639 at the Palazzo Barberini (in which, incidentally, Salvator Rosa had taken part) who at Guido's request also worked in Ferrara in 1640.[106] But Guido's interest in the visual arts can sometimes only be assumed and though his letters make many references to painting, few are qualified by an artist's name. In 1610, for instance, he ordered in Brussels, for Borghese's information, a portrait of the newsworthy Princess of Condé, but the artist he commissioned (who was also working for Ambrogio Spinola, equally anxious to send the lady's portrait to Spain) was never named in the correspondence.[107] In the same year, he recommended a series of twelve landscapes to Borghese which were not 'exquisite' but revealed a 'true candour of the brush rather than finesse in little things', but the artist was merely 'a good painter from Antwerp'.[108] (These pictures might be identifiable with the series of twelve Flemish paintings which Guido would offer to the Duke of Modena in 1640, when the artist was named variously as 'Adamo' or 'Abraamo' and could conceivably have been Abraham Govaerts.) When the Cardinal Borghese was the official protector of Catholics in northern Europe, and both he and Vincenzo Giustiniani were patrons of northern artists in Rome, it is tempting to imagine that the flow of these artists to Rome was one of the lines of communication which Guido worked to keep open, but there is no evidence of this. All that is certain is that Guido had made contact with Flemish painters of the day, and his dealings with them were usually not as patron but as agent for Borghese.

He was an excellent agent, informed and conscientious. When he found Borghese a clock which sounded the hour to music, he pointed out that the music was in the Flemish, not the Italian, mode, and provided details too of the means of servicing – this may have been, perhaps, the 'rare clock of German work' seen by Evelyn in the Villa Borghese in 1644.[109] Aware of Borghese's interest in the old masters, he found on his travels a *Deposition* by an artist (unnamed) of the heyday of Bruges. In the matter of tapestries and tapestry cartoons, Guido was acting for both Borghese and the Cardinal Montalto, so when he found a set of cartoons in 1610, he felt obliged to inform both, though it was inevitably Borghese who commissioned the weaving of tapestries from these cartoons in Brussels in 1610.[110] The commission for the *History of Samson* tapestries made Guido a connoisseur of the craft.

From the setting-up of the looms in the Brussels workshop of Jan Raes to the despatch of the finished tapestries to Rome, Guido watched over the commission with care, becoming an almost daily visitor to the workshop in the autumn of 1610, when the most intricate work was in progress. It was all a 'laborious and long' business, 'as much for the innate and irremediable slowness of these people as for the quality of the work'; in short, he decided, here was a craft 'indeed appropriate to the Flemish phlegm'.[111] Yet it fascinated him. He was intrigued by the techniques (he was watching, it seems, the low-warp process), and he discovered now

89

that the most important part of a tapestry, to which only the best craftsmen were assigned, was the weaving of the heads of figures – when the weaving of the largest piece of the series, showing *Samson betrayed by Delilah* and including some ten figures (the tapestry reproduced here (Plate 68) forms part of a replica set, woven by Jan Raes' workshop in *c.*1625), was under way in December 1610, Guido looked on with particular interest.[112] 'They say', he wrote to Borghese, 'that I am the fussiest man who has ever come from Italy to these parts'.[113] If it was true, as the tapestry-master assured the Nuncio, that because of the wars the craft had declined in Flanders, but the *Samson* series was receiving more careful attention (the best silks and wool, and the most experienced workers) than he could recall, it might be argued that the commission from the Cardinal Nephew and Guido's close supervision contributed to the revival of tapestry-weaving in Brussels.[114] The cartoons were not new, having been made, but never woven, for Henri II of France by one 'Gillio of Malines', but an unnamed Antwerp artist supplied additional cartoons to extend the series from twelve to sixteen.[115] If only indirectly, Guido may thus have helped pave the way for the age of Rubens as tapestry designer – and Rubens may just have been the painter friend from Antwerp, who had spent some years in Italy, who advised Guido on the quality of the tapestry cartoons, before taking up the theme of *Samson and Delilah* himself in a painting (now in the National Gallery, London) for the mayor of Antwerp, Nicolas Rockox.[116]

In France Guido found a tapestry industry recently encouraged by the royal patronage of Henri IV but so in need of good designers that one Parisian tapestry-master told Guido that he would readily contribute to the costs of weaving if a design could be sent from Rome.[117] In these circumstances, Guido searched for finished tapestries for Borghese, rejecting a *Diana* series (perhaps one of several woven after designs by Toussaint Dubreuil) but enthusing about a tapestry in the possession of the Count of St Pol which he pursued with such zeal as to embarrass even the Cardinal Borghese, who for once said he was prepared to abandon the hope of a gift and offer to pay.[118] The tapestry was not, however, for sale.

In truth, Guido himself had discovered a taste for tapestries. In the St Pol tapestry he had seen exquisite workmanship, excellent design and the 'freshest of colours'. In the *Samson* series, he had seen such richness of incident, action and expression that the whole, he wrote, 'breathed an extraordinary majesty'. Years later, in the *Memoirs*, Guido analysed the style of a fellow historian, the Jesuit Strada, who tended to wander from the point but neverthe less created a whole 'so well stitched and decorated' that 'one reads all with gusto'.[119] It may be trite but not perhaps mistaken to imagine that Guido derived a comparable pleasure from a set of fine tapestries. In Brussels, Guido possibly had the *Samson* series, or part of it, copied for himself, for 'Sansoni' tapestries were among those brought to his new residence in 1640.[120] But for the most part Guido in Flanders and France had suffered the disadvantages of the agent who negotiated, learned to appreciate but could not himself possess the desired object.

When he returned to Italy after fourteen years in the north, Guido brought tapestries, pictures and his experience of international diplomacy. He also brought a love of northern Europe. French architecture had pleased him, especially Fontainebleau: 'a vast pile, undigested and confused, but the same confusion is full of grandeur and majesty'.[121] When architecture combined with landscape, the effect could be overwhelming, as it was at the country home of the Cardinal de Retz, where Guido saw a scene which 'cannot be more beautiful, because it cannot be more varied', though it was true that water was lacking, and water was an essen-

tial part of Guido's ideal landscape.[122] His pleasure was associated with, and in part perhaps derived from, the pleasure he took in the freshness of the northern climate, in which his health never suffered as it did in the heat of Rome. In 1607, when he saw Brussels for the first time, though it was August it seemed as spring to Guido because the countryside looked so fresh.[123] In France in 1618, he recalled with distaste the craggy Italian landscape with its 'squalid' vegetation of a 'half-dead' green, and in a letter to Cornaro gave his most evocative description of the beauty of the north. He was visiting St-Germain:

> among the verdant hills of France (which) retaining that living colour of spring all the time, ever green, rise gently, separating immense stretches of land with the same undulating softness; thus the views are such that many times the eye cannot follow them, and each seems more lovely, and more desirable, than the other.[124]

Guido was by nature at home in the fresh air, green fields and hazy vistas of northern Europe. But because he also cared for magnificence, and for the life of politics, he returned to become a cardinal, taking up his residence in Rome and his place in the claustrophobic Roman Court.

The Cardinal Bentivoglio was as honest as he was undoubtedly ambitious. According to Gio Nani, Venetian Ambassador to Rome in 1640, Guido won the affection and respect of all, and in 1641 Giulio Mazarin described him as a man of 'angelic morals, a sweet nature, noble thoughts, prudent, wise, experienced, witty, ingenuous and disinterested'.[125] Yet, or maybe as a result, he had been unlucky. From his first nunciature and archbishopric *in partibus* of Rhodes (later exchanged for the see of Palestrina), he might have been a cardinal in 1615, and the Commune of Ferrara at least was disappointed at his omission from that promotion.[126] But the Borghese delayed his cardinalate, perhaps because the Bentivoglio could not pay enough, or because Guido was so valuable as a diplomat. Then in 1623 the long, twenty-one year reign of Urban VIII began. Events of the 1630s bore heavily upon Guido. In 1628 he had become President of the Congregation of the Holy Office, a post suited to his determination to fight heresy until, in 1633, as Inquisitor-General he was obliged to see his old acquaintance Galileo recant 'his new opinions about the motion of the earth'.[127] In the same year Guido stepped down from the French protectorate to make way for the less able but more influential Antonio Barberini. Ill health was compounded by the financial crisis towards which the Bentivoglio were heading throughout the 1630s. In 1644 Guido was a candidate for election as pope, but the chance had come too late. He died, on 7 September 1644, as the conclave was in session.[128]

Guido had made his name as a patron of artists long before the 1630s, and in Rome he would be remembered in particular for his patronage of northern artists. French painters worked for him, among them Claude Mellan, who engraved his portrait, and some decorators, painters of *grotesques*, who when working in the Bentivoglio palace were apparently so jealous of Giovanni da San Giovanni and Furini that they sabotaged their work and nearly succeeded in having the Florentines sacked.[129] Guido was also, in the words of G. P. Bellori, 'enamoured of the Flemish nation', and a patron in Rome of Antony Van Dyck.[130] Van Dyck painted for him a *Crucifixion with the two thieves*, perhaps intended for the new palace chapel. The painting is now lost but if similar to Van Dyck's other paintings of the theme, it would have corresponded to the intensity of Guido's faith, tried in the face of heresy in northern Europe but too easily forgotten when thinking of Guido as the art agent and man of culture. Most famous is Van

91

Dyck's portrait of the Cardinal Bentivoglio of 1623 (Plate 69), which is both a formal portrait and an informal entry into the life and mind of Guido. The eagles carved on the chair and woven into the carpet identify the Bentivoglio; the drape and the red robes convey the magnificence he loved. But the natural, unforced presentation of the sitter, the alertness of his gaze, the letter and the delicate vase of flowers (more usual, perhaps, in Van Dyck's portraits of women) convey a sense of the life, the intelligence and the sensitivity to beauty in Guido Bentivoglio. All that Van Dyck failed to portray, and it may not have been granted to him to see, was the robustness of Guido – it is not easy to imagine that this slender figure, set back from the picture plane, marched alongside Ambrogio Spinola, and played tennis against him for money.[131]

It was possibly Guido who introduced Van Dyck to the patronage of Maffeo Barberini, who also commissioned a portrait, now lost. Years later, he brought to the attention of the same patron, now Pope Urban VIII, the work of Claude Lorrain. Thus Guido became the agent of such paintings for the Barberini as the *Pastoral landscape with a view of Lake Albano and Castelgandolfo* of the later 1630s (Plate 70). According to Baldinucci, Guido himself commissioned paintings from Claude, one of which, it has been suggested, may be the *Coast scene with the Rape of Europa* of 1634 (Plate 71). But according, again, to Baldinucci, Guido was among the first patrons to visit Claude's studio, and so it is tempting (though evidence is lacking) to trace his interest in the painter back to, say, 1629, the date of a landscape by Claude based upon a painting by Agostino Tassi in the Bentivoglio palace.[132] In Claude Lorrain, Guido had found a painter who could create on canvas the verdant freshness of the landscapes which he loved in nature.

Between Van Dyck and Claude are other artists in whom Guido might reasonably be expected to have taken an interest. The association in the mind between Bentivoglio and the Bentveughels, for example, may be no more than a chance similarity of name, but one member at least of the Bentveughels, Herman van Swanevelt from Utrecht, might well have appealed. Swanevelt shared a house with Claude, and if Guido visited one he could hardly have missed the other and, according to Passeri, it was Swanevelt who 'was among the first to introduce into landscape painting that serenity of colour that can seduce so easily at first sight', a novelty to which Guido could have been attracted.[133] In 1640, as has already been discussed, it was Guido who ensured that paintings by Swanevelt and the French artist in Rome François Perrier were sent to the Duke of Modena. But however tempting it is to speculate on the part Guido may have played in promoting the careers of northern painters, for the time being at least, it is only speculation.

If Guido's collection of art could have remained intact, there would be no need to speculate about his taste. But it was passing away as surely as the family fortunes. In July 1631, for example, he gave three gilt-framed pictures (two large, one small but all unnamed in the report) to 'M. Buttiglier', that is, Richelieu's protégé and Mazarin's friend Léon Bouthillier, later Comte de Chavigny.[134] Pictures were given away in 1640 and others were left behind when Guido moved into his new residence.[135] In 1644, the terms of Guido's will made further inroads: paintings were bequeathed to the Cardinals Antonio Barberini, Cornaro, Mazarin and Montalto, to Monsignors Buonvisi and Caetani, to Vincenzo Martinozzi (father-in-law of Mazarin's sister Margarita), and to one Fra Luca, perhaps Guido's confessor, who was to receive the painting kept at the bedside.[136]

By contrast with his brother Enzo, it was at Guido's request that his burial, in the Theatine church of S Silvestro al Quirinale, was simple and that his tomb was 'without inscription'. There was very little of material value left to show for so distinguished a career, yet Guido left behind his work as a historian, his letters testifying to his mind and his interests, his portrait to keep his memory alive, and his name in artists' biographies to commemorate his patronage of art. If an idea of his appreciation of art can truly be gained from his writings, the most telling insight must be that which is found in his analysis of the literary style of Gio. Battista Agucchi. Guido had a high regard for Agucchi's intellect, but considered that:

> he had not, however, the same clarity and facility in style, so that he often appeared laboured and therefore obscure, and wishing also to affect the most recondite Tuscanisms, he made his compositions smack more of the schoolroom than the Court.[137]

It was an interesting light upon Agucchi, the mentor of Domenichino and perhaps Guercino, and it reflected upon Guido himself, whose style was always easy, a balance of metaphor and directness of expression, and whose response to art seemed similar, deriving not from precept but from a sensitivity to beauty and intelligent observation.

(iv)

'I want money, not words', wrote Monsignor Annibale to the family agent in Ferrara in 1641.[138] The case, indeed, seemed desperate. True son of Enzo, Annibale had contrived to transfer a part of his father's debts to the *Monte di Pietà* of Ferrara, promising to pay but not specifying when. In 1647 the Cardinal Legate Donghi doubted that it ever would be paid, for the 'great pile of debts and the chain of *fidecommesso* (entail) are notorious in the House of Bentivoglio'.[139] Only Matilda, Ferrante Bentivoglio's daughter in Modena, had any money to spare and in the 1650s she was finally able to use it (despite opposition from the Duke and the Commune of Modena, but keen encouragement while the Padre d'Este was alive) in the foundation of a Carmelite convent, for which she earned a name for piety.[140] But between Annibale and Cornelio II passed a correspondence not always amicable but recognisable by the sums scribbled on the back. The shortage of money hampered the continuing work of building, drainage and repair at Trecenta: 'I shall not fail to do all that is in my power', wrote the current executant, Niccolo Rosselli, in 1640, 'even though it will be difficult given the lack of money'.[141] Francesco I of Modena, under pressure himself from his Roman banker Sirena, pressed for immediate payment of debts to the *Mont'Estense*, and as Cornelio II began to settle with his creditors, the fief of Scandiano had to be sold back to the Este.[142] But as Annibale observed, 'it is better to be envied than pitied', and the Bentivoglio would survive.[143]

Cornelio II, brought up as a soldier, was as nomadic now as Enzo had been, sometimes in Rome or Venice, in France, in Ferrara or perhaps on the Loreto road, where Geminiano Poggi met him in 1654 as Cornelio was returning from a pilgrimage to the shrine.[144] But the lease of the *Sala delle Commedie* in Ferrara had been granted to Cornelio in 1640, and he was now the patron of professional troupes visiting the city and the entrepreneur of jousts without whose advice a *festa* would 'go cold'.[145] He lived under the shadow of Enzo, and in 1645 seemed truly to raise his father's ghost when he arrived in Rome in the entourage of

93

the Cardinal de' Medici in the liveries Enzo had ordered when he hoped to enter the French Order of Saint-Esprit.[146] A letter of 1654 from the painter Francesco Albani raised memories of Enzo too when it revealed that the artist was still awaiting payment (part in grain) for two pictures painted for Cornelio.[147]

Annibale, meanwhile, had remained in Rome with the Cardinal Bentivoglio, considering himself the most unlucky of Enzo's sons. For the others, Francesco and the stubborn Ermes, for example, there were careers in soldiering, for Giovanni there was the Abbey of St Valery in France, renounced by Guido in favour of his nephew, and for Guido II there was the Theatine Order and later the bishopric of Bertinoro – though as Giovanni observed, neither would make Guido II a rich man.[148] Annibale was probably not cut out for the Church, for he had taken orders following the death in 1627 of his wife Semidea Leni (usefully related to the Cardinal Bishop Leni), and found the life irksome. Yet even he eventually found his niche, Archbishop *in partibus* of Thebes and papal Nuncio to Florence, a congenial post which he combined with that of unpaid major-domo to the free-living Cardinal Gio. Carlo de' Medici, which must have been far from dull.[149]

Annibale's tastes were probably literary rather than artistic. In Florence he lived in a palace rented from the Salviati, and an inventory of its contents taken in 1663, six years before Annibale's death, listed a fascinating miscellany of books: a *Life of Mazarin* and various histories, classical poetry, modern tragi-comedies, Corneille's *Rodogune*, Jewish literature, anthologies of Spanish and French proverbs, the Jesuit Oliva's sermons, the *Annals* of the Capuchins, Alciati's *Emblemata*, a treatise on the river Reno, and many more, some no doubt inherited from the Cardinal but others testifying to Annibale's own range of interests. In 1640 he had pleaded with Cornelio II for money to buy books on the grounds that they would be useful to the younger generation.[150] The 'Abate Bentivoglio' who appeared in the account book of Guercino in 1641 and 1643 was probably Annibale's brother Giovanni.[151] Yet, in 1640, it was Annibale who offered to Francesco I d'Este Bernini's portrait bust of *Costanza Bonarelli*, and it may therefore have been Annibale who had acquired it from the artist.[152] He was, in any case, custodian of the family collection in Rome. In 1656, when temporarily resident again in Rome as Commissioner for Health during the plague, an inventory of his residence (the palace of the monks of Sto Stefano) listed many pictures, among them the paintings by Van Dyck and a *Resurrection* by Garofalo probably preserved from an older family collection.[153] But the 1663 inventory of his Florentine home listed very few pictures, and perhaps the best, including the portrait by Van Dyck, had already followed the bust of *Costanza Bonarelli* into the collection of the Medici.

The Bentivoglio had maintained their alliance with France after the death of Enzo, either by residence there, or by undertaking French missions in Rome, as in 1645 Annibale was authorised to make the first, secret, approach to Rinaldo d'Este concerning the protection of French affairs.[154] It was to sustain this alliance that they also acted as agents for French patronage of Guercino, or ordered pictures from Guercino to send as gifts to France. In 1644, for example, Cornelio II commissioned a painting of *Cephalus and Procris* to give to Anne of Austria, Regent of France, who must then have given it to the Cardinal Mazarin, in whose collection it was listed in 1661. Mazarin himself ordered paintings from Guercino through the agency of the Bentivoglio, including in 1639 a *Madonna and Child* whose subsequent history revealed the difficulties of being the middleman in art. Cornelio II paid for the painting on

Mazarin's behalf in December 1639 and it was then due to be taken to Gio. Filippo Spinola in Genoa, who would presumably arrange its passage to Paris. But somewhere between Cento and Genoa the *Madonna* disappeared, and eight months later Mazarin complained that it had apparently never reached Genoa. Cornelio II prepared a report for Mazarin by November 1640, but if this painting ever was despatched to Paris (two paintings of the *Madonna and Child* by Guercino were listed in the 1661 inventory), it was not perhaps until the following January, when the Bentivoglio family agent Sanguinetti was certainly in Genoa.[155] Where it had been was a mystery (it was not impossible that the collector Spinola had kept it), but its disappearance had made the Bentivoglio seem embarrassingly inefficient. However, when Annibale acted as agent, no transaction could have been better managed. It was Annibale who, as Nuncio to Florence, received in August 1650 Pope Innocent X's request that Pietro da Cortona be released from his commitments in the Palazzo Pitti so that he could paint the gallery of the Palazzo Pamphili in Piazza Navona, and though Ferdinand II de' Medici was tired of the scaffolding which cluttered his antechamber, Annibale was able to report his assent within a matter of days.[156]

On the death of Cornelio II in 1663 his son Ippolito II became head of a rather smaller family, he having only one brother, the Abate Ferrante.[157] Ippolito had grown up at the Court of Modena (he led a squadron of knights in Francesco I's *La Gara delle Stagioni festa* of 1652) and after military experience had settled in the Palazzo Bentivoglio in Ferrara. The title to the marquisate of Magliano had been redeemed in 1660, with financial help from the Medici, and Ippolito was invested with the title. For the next thirty years, he and Ferrante were among the leaders of Ferrarese cultural life, both serving terms as *Principe* of the Academy of the *Intrepidi*, and Ippolito presiding also over the musical academies of the *Morte* and *Spirito Santo*. Ippolito was himself a musician and composer and, under the pseudonym of Michele Colombo, a dramatist. He was also patron of 'civil, military and theatrical architecture'.[158] When the *Sala delle Commedie* theatre burned down in 1660, Ippolito was the principal entrepreneur of the new theatre fashioned within days in a deconsecrated Este chapel in order that performances might continue.[159] He 'dealt' in theatrical affairs, lending, for example, a cornet-player to the Farnese, borrowing a ballerina from the Medici, and writing annually to Parma to book the Farnese players, if possible, for the Ferrarese Carnival.[160] Finally, Ippolito was a useful art agent. When the Cardinal Leopoldo de' Medici, for example, wanted sketches of self-portraits by Ferrarese old masters, he turned to Ippolito for help.[161] As for Ippolito's own patronage of painters, he ordered a new altarpiece for the chapel in S Domenico from Benedetto Gennari, and new frescoes in the family palace from Francesco Ferrari, but the inventory of the Bentivoglio collection made by Ferrari in 1685 does not suggest that he had added pictures of interest to his inheritance.[162] There were costumes for the joust in the wardrobe, a predominance of portraits on the wall, and over the fireplace was a portrait of the Marchese Cornelio which, if it did not portray Ippolito's father, may have been the portrait of Cornelio I brought from Modena to Ferrara in 1620. The Bentivoglio were back where they had started in 1598, only a little less than they had been.

Gualtieri had been too remote to maintain, and it had passed through Bentivoglio hands in some sixty years. The Roman palace had been a luxury, and it had lasted twenty-one years. Scandiano had come and gone in eight years, and possessions in Modena were dispersed among the daughters of Ferrante, the pious Matilda and her half-sisters married into the Rangone

and Boschetti families. The steady contraction of the Bentivoglio had been, perhaps, inevitable. Where there was no access to new wealth there was no space for ambition, and independence of action, like independent patronage, gave way to services rendered to popes, papal families and princes. But there was always Ferrara.[163]

Part III

The Papal State of Ferrara
(1598–1660)

5 *The state of the faith*

In April 1627 Pope Urban VIII conceded to Ferrara the Indulgence of the Seven Churches of Rome.[1] Of the seven churches of Ferrara which the faithful must visit to gain remission of their sins, five were old foundations: the Cathedral, begun in 1135; S Giorgio, the former cathedral just outside the walls which was dedicated to one of Ferrara's patrons and contained the shrine of the other, S Maurelio; Sta Maria in Vado, venerated site of the Miracle of the Precious Blood in 1171; S Giovanni Battista of the Lateran Canons, rebuilt in the sixteenth century; and Sta Maria degli Angeli, one of the churches chosen for the celebration of a pontifical mass by Pope Clement VIII in 1598.[2] But two of the seven churches were new. One was the church of the Confraternity of the Stigmata. The other was the church of the Theatine Order in Ferrara. The quick assimilation of these churches into the hierarchy of Ferrara's religious establishments bore witness both to the popularity of their forms of worship and to the pre-eminence of devotional patronage in the years which followed devolution.

(i)

There were, of course, confraternities in Ferrara before 1598, including one dedicated to St Job and under the protection, not inappropriately, of the long-suffering Cesare d'Este, and the Confraternity of the *Morte*, whose members led the annual Corpus Domini processions. The growth in number of these lay companies in the early seventeenth century cannot be attributed to devolution alone, but to the wider influences upon public piety which brought such new societies into being throughout Italy and elsewhere in Catholic Europe. Yet as a channel for popular feeling and corporate patronage, the confraternities assumed a particularly important place in the life of post-devolution Ferrara.

Some societies found a home within existing churches, as did the Company of the Madonna of Loreto, formed in 1617, in the church of S Pietro. Others, however, transferred quickly from temporary homes into their own new buildings, among them the Suffragi, the Spirito Santo and the society dedicated to the worship of San Carlo Borromeo.[3] The Confraternity of San Carlo was formed in 1611 and as early as 1613 a new church was under way to accommodate the meetings of members, in their white and hooded habits, and the relics of Borromeo's breviary and shoe. The church took ten years to complete (Plate 72). Its architect was Aleotti and he created what must be the finest new church of the century in Ferrara, small but exceptionally lavish, with a rich, sculptural façade contrasting with the customary

Ferrarese brick, and an oval plan which placed it in the forefront of architectural fashion. Mixed-marble columns, marble altars and sculpture in niches decorated the interior. The richness of S Carlo was due in part to Aleotti's use of the commission to experiment, and in part to the patron, for it was not the society itself which had put up the money but the Cardinal Carlo Emanuele Pio, whose name was inscribed above the entrance. Pio was one of the most disliked of prelates both in Ferrara and in Rome, but here his piety and desire for an eponymous monument (twenty years later he was seeking, unsuccessfully, patronage of the Milanese church of S Carlo al Corso in Rome) had enabled Aleotti to create a masterpiece.[4] By comparison, the church of the Confraternity of the Stigmata, begun in 1619, was a plain, even mean, building, but the company it housed had outstripped all others in popularity in Ferrara (Plate 73).[5]

It was probably because it was the most strict that the Stigmata became the most heavily-subscribed of Ferrara's lay societies. Its duties included the burial of the dead and its rules were intended to mortify the flesh: no music in services, expulsion for members who failed to set a good example, and a gown of ash-grey serge tied with a cord from which hung a crown of thorns. If possible, members should go barefoot, *all'apostolica*, in summer.[6] (In processions, the purple capes with a crimson cross of the Suffragi must have looked more splendid, but splendour was not the aim of the Stigmata.) The Confraternity was under the formal patronage of the Bishop of Ferrara and the *Giudice dei Savi*, the leader of the communal council. Yet it needed no outside supervision, being a highly efficient, self-regulating body (its book-keeping was exemplary). Chief among its elected officers were the five Guardians, one for each of the Five Wounds of Christ, and a Governor who, while members were accepted from all sections of society, must always be chosen from the nobility: the Estense-Mosti family in particular identified itself with the interests of the Stigmata.

The company had been formed in 1612 and its church was built between 1619 and 1621, and both the initial delay and the eventual speed of construction suggest what is then evident in the façade: the church reflects thrift and, perhaps, adherence to the Franciscan ideals of poverty, simplicity and humility. The interior is rather less severe, for individual families (the Bentivoglio, Bevilacqua, Pio among them) had spent money on altars, altarpieces and memorials, and pretty marble inlays on altar frontals displayed the patrons' coats-of-arms (Plate 74). But as a corporate patron, the Stigmata did not aim high. It ordered its decorations and furnishings from, for example, a Flemish carver named 'Andriano', and the painters Leonello (not the more famous Carlo), Bononi, Girolamo Grazzalione (or Grassoleoni) and Paolo Varini, names which have not been remembered.[7] It was the pious purpose of the Stigmata and the size and rank of its membership which earned it a place in the Seven Churches of Ferrara, not its material splendour.

New confraternities in Ferrara were complemented by the influx of the Orders. The Catholic Reformation had arrived early in Ferrara (thanks to the controversy attending the wife of Ercole II d'Este, the Calvinist Renée of France) and by 1598 the Jesuits and Capuchins were firmly established. They were about to be joined by a flood of others. When Pope Paul V, in the spring of 1606, placed Venice under interdict for challenging his authority, the religious orders in Venice, whether they were banned by the Republic (as were the Jesuits) or forbidden to leave (as were the Capuchins and Theatines), were placed in an awkward position, and where could they flee but to Ferrara?[8] By the end of May the Modenese chronicler Spaccini

had reports of their arrival: 'all Ferrara is full of Jesuits, Theatines and Capuchins', he wrote, 'and they are expecting more'.[9] Three Capuchin nuns were recommended to the especial protection of the Papal Legate Orazio Spinola by the Cardinal Borghese himself, and with the help of the Bishop of Ferrara and noble families, they were able to settle into their first convent and church of Sta Chiara.[10] The Theatine Order, having first tried unsuccessfully in 1598, finally gained formal permission to establish itself in Ferrara in 1616, and their first church was open by 1618. Next came the Discalced Augustinians, in 1622, and they obtained the existing church of SS Simeone e Giuda, and after them the Tertiaries of St Francis, in 1624, who soon opened their church of Sant'Apollonia.[11] Each application for entry provoked some popular protest at the increased eleemosynary burden the new arrivals represented. But the Orders were embarked upon a process of settlement which, in a Papal State and in the reign, from 1605 to 1621, of a Pope, Paul V, who was known to favour them, would have been impossible to halt.[12] In any case, each found influential support and settled into the life of the city, and there was no clearer proof of the popularity of the Orders, once established, or of the substantial bequests they received, than the new or enlarged churches which began to replace the first makeshift buildings as the congregations grew in size. It was not only the new arrivals who were building. The Capuchin friars had been obliged to rebuild their church, sited too close to the defensive walls of Ferrara, and under the patronage of Enzo Bentivoglio they received their new S Maurelio. But it was perhaps just the sheer desire to improve and expand that encouraged the Eremitani Order to commission Francesco Guitti to remodel their Sta Maria della Rosa in 1624.[13] Devotional patronage was changing the face of Ferrara – it was not, perhaps, inappropriate that materials from demolished Este palaces should be recycled first into the building of churches, as happened to columns and marbles from the Belvedere, donated to the Zoccolanti.[14] But who was in control of this rush to build and rebuild, and what was happening among the secular clergy and to the less fashionable parishes? The temporal authorities, the Legate or the *Giudice dei Savi*, used their influence to introduce or encourage a confraternity or religious order, but the spiritual welfare of Ferrara, and the upkeep of the city and country parishes, was the responsibility of the Bishop.

(ii)

The bishopric of Ferrara was subordinate to the archbishopric of Bologna, and would continue to be so until the early eighteenth century. From 1611, however, the Bishop of Ferrara would always be a Cardinal of the Church. But first the Bishop Giovanni Fontana would have to live out his episcopate, and it is hard to say if his example were good or bad, for reports about Fontana conflicted.[15] His *curriculum vitae* was flawless, because he had been one of the closest followers in Milan of Carlo Borromeo (he had carried the viaticum to him at the end), and gave evidence at the hearing convened in 1601 to consider Borromeo's canonisation. It was probably from Fontana that the Confraternity of San Carlo obtained its relics of Borromeo. As Bishop of Ferrara, Fontana had quarrelled with Alfonso II, presided reluctantly over the accession of Cesare and then turned openly against the Este. As might be expected of a disciple of Borromeo, Fontana in Ferrara preached a rigorous doctrine, keeping his clergy up to the

101

mark, 'because ignorance is inexcusable in a parish priest', condemning scurrility in poetry, plays and art, and urging his congregations to beautify the churches before thinking of their homes. He himself built a chapel in the Cathedral dedicated to Sts Ambrose and Geminiano (the Fontana family had its roots in Milan and Modena), and a private chapel in the episcopal palace where his household was expected to attend for prayers every evening. But he also 'enlarged and almost completely rebuilt the episcopal palace in the city, and those in the country, at great expense', and he infuriated Cesare d'Este's representative in Ferrara in 1608 by demanding, though in the end he was unsuccessful, the Este estate of the Barco.[16] The improvements to the bishop's palace were explained at the time as springing from Fontana's awareness that he would be succeeded by cardinals who would appreciate an attractive residence, and the attempt to obtain Este land might be regarded as a desire to increase the goods of the Church. But personal interest may also have moved Fontana. In 1607, far from protesting, he rather eased the path of the Cardinal Borghese towards the acquisition of a Dosso altarpiece from Ferrara's Hospital of St Anne.[17] When Fontana lay dying in 1611, malicious rumours of past misdemeanours circulated which might have been unfounded, but could not be ignored. The chronicler Cesare Ubaldini, for one, remembered Fontana as a hypocrite.[18]

His successor was the Roman Cardinal Gio. Battista Leni, a relative of the Borghese and thus a witness to the fact that the see of Ferrara was now a gift in papal favour alone.[19] Leni began conscientiously, making his first Pastoral Visit shortly after his arrival in Ferrara and in 1612 issuing general decrees which drew attention to the slipshod state of the parish churches.[20] The Sacrament, he instructed, must be properly kept in a tabernacle with the richest possible baldacchino above, a cross or crucifix beneath, and no relics in the vicinity. Altar tables must conform to approved sizes, as must candelabra, while broken paving and confessional screens must be repaired. In confessional boxes must be displayed, on the penitent's side, an image of the *Crucifixion*, and on the priest's side, the Bull *in Cena Domini* listing the anathematised and excommunicable sins. Cemeteries must be cleared of plants and rubbish and enclosed by a wall above which the Cross should be visible. As far as they went these decrees were reforming, if basic, but their impact was considerably lessened by the Bishop's subsequent absence from his see. From 1614 Leni was only a fleeting visitor to Ferrara, and in the 1620s his influence was felt through his deputies. Admittedly 1614 was also the year in which the Holy Office of the Inquisition arrived in Ferrara, which may not have been coincidental, yet Leni's absenteeism was not a good example.[21] Rome drew Leni as a member of Borghese society, as Dean of St John Lateran and as patron of the church of S Carlo ai Catinari which bears his name across its façade – a legacy to the Cathedral of Ferrara paid for new sacred furnishings, but could not compare with the bequest of 30,000 *scudi* he left to the church of S Carlo in Rome.[22] Leni died in Rome in 1627, having, as the Ferrarese Libanori would later write, 'enjoyed the rich bishopric of Ferrara almost always absent'.[23] In March 1628, he was succeeded by one of the most memorable personalities of post-devolution Ferrara.

Lorenzo Magalotti was a Florentine (his namesake, the polymath Lorenzo Magalotti, was his nephew) and the brother-in-law of Carlo Barberini, and his career until 1628 had been tied very closely to the fortunes of the Barberini (Plate 75).[24] While Maffeo Barberini was Legate to Bologna, Magalotti was Vice-Legate – when the future Pope had supported, successfully, the claims of Leonello Spada to a share in new commissions for S Domenico, Magalotti, acting

almost as a foil, had advanced those of the painter Giovan. Valesio.[25] When Barberini became Pope Urban VIII, Magalotti became his secretary for correspondence with princes and had rooms in the Quirinal Palace, and at this time he was the intermediary between the Pope and the portrait painter Justus Sustermans, and may even have arranged for Sustermans to travel from Florence to Rome.[26] Magalotti was a patron in the new Capuchin church of Sta Maria della Concezione in Rome, founded by the Cardinal Antonio Barberini the Elder, and it was probably for his Chapel of San Lorenzo in this church that Magalotti ordered in 1628 or 1629, when he visited Cento, an altarpiece by Guercino of the *Martyrdom of San Lorenzo* intended, wrote Malvasia later, for a Roman church.[27] Magalotti belonged with the Barberini and owed his preferment to them, and another picture he ordered from Guercino, perhaps in 1637, and then willed to Urban VIII, illustrated the story of *Esther*, synonymous with obedience and loyalty to one's own. But Esther stood also for courage, and Magalotti, whose family motto was 'Liberty', was also his own man, and it was the independent spirit of Magalotti, and the tendency of the Pope to defer to him rather than vice-versa, which most impressed a succession of Venetian Ambassadors to Rome in the 1620s, all of whom were aware of Magalotti's exceptional ability and one of whom, Pietro Contarini, believed that his position at the Barberini Court was constricting for a man of his talent.[28]

In 1628, at the age of 46, Magalotti was appointed to the see of Ferrara and once he had arrived, in June 1628, he would not leave again; no chronicler, however cynical, could sustain for long a critical opinion of this Bishop of Ferrara. Ubaldini, who knew him well, wrote of his 'upright bearing' and a mind 'prudent, cultured and wise', while Theodor Ameyden in Rome, always ready to cut a prelate down to size, recognised in Magalotti the true Tridentine reformer of fallen ways.[29] He set an example in pastoral care. Within a month, he had taken stock of the Ferrarese and sent a report to Rome on the Ferrarese character, fears and abilities, recommending aid and encouragement.[30] To animate not dominate was an injunction to bishops from the Council of Trent, and within his own diocese Magalotti quickly formed new administrative committees within which the most able local men had a place. He was not, however, prepared to please, being, as Ubaldini admitted, 'of rigid nature, difficult to talk to'. When Enzo Bentivoglio had nominated a *maestro di cappella* to the Cardinal Leni, he, in any case absent from Ferrara, had accepted Enzo's word. But when Enzo applied similarly to Magalotti in May 1628 (nominating one 'Piccinini', who might have been Filippo or Alessandro Piccinini), the new Bishop replied that he would reserve all decisions until his arrival.[31] (In fact, Magalotti's tendency to appoint and dismiss musicians as he chose was a matter of concern to the Cathedral Chapter, who until his arrival had presumably taken most of the decisions themselves.) The arts, and performing arts, in the service of public worship were matters of especial importance to Magalotti.

Carnival shows, sports and theatres were, to Magalotti, works of the Devil and a succession of edicts not only forbade the clergy's participation but also kept them from even lingering in the street known as Giovecca on the occasion of horse-races and other popular entertainments. At Magalotti's request, the Cardinal Legate Durazzo banned masquerades on Fridays, and some of the more unruly features of feast-day celebrations (the display of skeletons on St Anne's Day, for example, and the distribution of poems by members of the Confraternity of the *Morte* on Corpus Domini) were suppressed in the interests of decorum.[32] Instructions to the secular clergy revealed Magalotti's deep dislike of spontaneous demonstrations of devo-

tion. They must preach according to the intelligence of their audience, clearly, competently and briefly and without the worldly techniques of rhetoric which were offensive to God. No new devotions might be encouraged, no new confraternities founded nor processions initiated, without permission, and there must certainly be no 'representations' in the pulpit.[33] Yet Magalotti respected the values of performance. Music performed in the Cathedral at the time when plague threatened Ferrara was said to edify the people greatly, and Magalotti himself chose the motets sung at the end of each sermon during the general communion service at which he and the Cardinal Legate Sacchetti dispensed the Sacrament.[34] (It was, perhaps, Magalotti's respect for music which influenced his decree of 1629 threatening unauthorised persons in the Cathedral singing-gallery and organ loft with the unexpectedly harsh punishment of excommunication.)[35] Magalotti wished not to crush but to harness popular devotional feeling, and so he directed the Ferrarese towards a 'seemly' form of public worship, a 'holy contest to prepare the streets for the King of Kings', and decorations in churches which were 'without superfluous curiosities, and very grave and decorous'.[36] He sought also to control cults based on questionable relics and so-called miraculous images, and to prevent the indiscriminate display of images in the streets. 'Holy images must not be painted in sordid places' was an injunction arising from his synod of 1637. Yet again, he respected the need and the value of public images, and 'as it pleased God to be praised in those places in which He has most often been offended', he gave permission for prayers before six approved images in the streets.[37] Permission and approval were the words which governed Magalotti's work to bring the Ferrarese to a form of worship which he, not they, controlled. When it came to considering the state of the parish churches, his control was tighter still.

In October 1628 Magalotti invoked divine aid with a procession and embarked upon his first Pastoral Visit.[38] First, however, he had prepared himself by means of a questionnaire to all curates of the diocese so that he might see what was needed 'for the good progress in the path of the Lord'. Questions searched into the life of communities: who had died without the Sacrament or not communicated since last Easter? Which couples had parted? Who were the blasphemers, debtors, mistresses and paupers? Who engaged in vendettas, heresy or magic? Which were the most frequently committed sins? Did the priest preach the doctrine on feast days and in conformity with Trent? What was his background? Who had appointed him? What were the incomes of his cure? Replies prompted Magalotti to one general observation. Nothing 'weighed so heavily upon our mind than the negligence we hear is committed by parents in the sending of their children to hear the Christian Doctrine', and to ensure that no opportunity for teaching was lost Magalotti dictated the hours when the clergy must be present in their churches. The questionnaire continued:

> You will describe the material state of your church. You will indicate if there are relics of saints and how they are kept. You will say who is the Patron Saint of your church, and you will give a clear inventory of the sacred furnishings.[39]

Thus informed, Magalotti set out to judge for himself.

From 1628 to 1632, the Bishop and his assistants progressed through the diocese, from the Cathedral to the twenty-two parish churches, sixteen confraternities, numerous monasteries, nunneries (these visits were particularly rigorous), schools and 'pious places' of Ferrara and thence out to the ninety-three country parishes and oratories. In 1629 the

pace was intensive, by 1631 more leisurely, but the rigour was unabated. Where Leni had once managed thirteen churches in a day Magalotti's average was two.[40] No general summary of decrees was issued, but the exhaustive nature of the inspection needed no generalisations and, in a sense, Ferrara was under permanent visitation, for the second Pastoral Visit began as soon as the first was over. When he arrived at each church, Magalotti approached first the High Altar and inspected the tabernacle and the keeping of the Sacrament, the relics and the holy oil. Then he turned to the side altars, the baptismal font and the confessionals. He surveyed the state of the interior and exterior fabric, sometimes calling for a report (usually supplied by the local architect Giacomo Rosselli), and finally he visited the archives, the vestry, the bell-tower and domestic buildings.

Public safety was one criterion for Magalotti. The same good sense that urged the confraternities to lay aside their hoods in crowded processions to avoid accidents also required that tombs were properly sealed in the interests of public health.[41] Above all, however, Magalotti wanted cleanliness and good order. Churches, organ lofts and singing-galleries must be swept clean, floors mended, windows reglazed and dilapidation made good. In one of the country parishes, Cesta, not only was the church of St Agatha in deplorable condition but the priest had to be ordered to change his sleeping quarters so that he did not sleep in a room abutting a consecrated place.[42] Instructions for tabernacles, confessionals (and the imagery within them) and the clearing of cemeteries repeated Leni's basic requirements, but Magalotti enforced them in a way Leni never could, by his constant presence, his threat of fines, and his habit of leaving nothing to chance – no dilatory priest could say, for example, that he had been uncertain how to proceed with the repair of confessionals when the Bishop had indicated those of S Romano as a model.[43] Cleanliness and good repair in the churches must be accompanied by clarity as to their function. Magalotti ordered crosses for towers and cemeteries to announce from afar the holy nature of the building, and one of his most frequent commands was that the image of the patron saint should be painted on the façade to announce holy protection. Baptismal fonts must be decorated with paintings of the *Baptism of Christ* or *St John the Baptist* and not, as was found in one country parish, with the insignia of the Olivetan Order or any other unsuitable ornament.[44]

Once in a while Magalotti's visit reports made note of the beautiful or tasteful: the altars of the late sixteenth-century church of S Paolo of the Carmelites, for example, or 'a most beautiful original by Garofalo' at Bondeno.[45] But Magalotti, who through his visits was becoming indirectly the commissioner of much work from local painters, carvers and artisans, did not demand the beautiful, and specifically forbade the pretty, the '*imagines mulierum*'. Instead, he expected the '*decens*', the proper and seemly, in place of the '*sordes*', the squalid, he deplored. Thus the programme of repair and repainting he ordered would not aspire to the quality of his own *Martyrdom of San Lorenzo* by Guercino. Yet it was interesting, and perhaps not completely fortuitous, that during the tenure of Magalotti, Ferrara became the possessor of three new altarpieces by Guercino. The first was painted for the Confraternity of the Stigmata, whose building had been commended by Magalotti on his visit in June 1629 but for which the Confraternity had not yet ordered any decoration of distinction. But in 1631, under the governorship of Cesare Estense-Mosti, the Stigmata commissioned its *Stigmatisation of St Francis* from Guercino, which arrived in August 1632 to be blessed by Magalotti and installed in the church, where it was soon framed by a new altar (Plate 77).[46] In 1634 the Commune

of Ferrara, led by the current *Giudice dei Savi* Giovanni Rondinelli, finally honoured the vow made in the plague year of 1629 with a new marble altar in the church of S Rocco and above it the *Intercession of the Virgin for Ferrara* by Guercino.[47] And in the same year, the Olivetan Don Angelo Missoli, Abbot of S Giorgio outside the walls, ordered from Guercino a *Martyrdom of San Maurelio* to decorate the shrine of the saint.[48]

In the churches as in all public worship, Magalotti's passion for cleanliness and order seemed at times to cut across popular tradition. Images of saints were removed from High Altars (the place for crucifixes only), flowers were banned from all altars, plants were uprooted in cemeteries and away with all the debris within church buildings went 'the insignia of the dead'.[49] Twice at least Magalotti also ruled against assumptions of the proprietorial rights of *giuspatronato*.[50] Elsewhere, however, he insisted that patrons repair or replace their chapels, altars and altar paintings.[51] No one and no institution was immune. Superstitions and false doctrine being anathema to Magalotti, he suspended pending proper investigation the cult which had grown up about relics of a saint at the church of Sto Stefano.[52] At S Carlo, a church he commended as warmly as that of the Stigmata, he accepted as genuine the relics of Borromeo, but ruled that the Confraternity's 'spine' from the Crown of Thorns must be removed from view because it was not documented.[53] At the country parish of Cona, he ordered that relics donated by no less than the Ferrarese Cardinal Bonifazio Bevilacqua must also be removed, for they too lacked the necessary proofs.[54] Magalotti could upset popular and noble feelings alike, but he was clearing out the lumber from the churches of Ferrara in the interests of the 'healthy and orthodox' doctrine laid down by the Council of Trent.

In 1628 he had ordered in his own Cathedral improvements of the kind he was about to demand in the parishes, paying perhaps still more meticulous attention to every detail. Repairs, replacements and renewals were ordered; John 3 or Mark 16 were given as prescribed texts for inscriptions in the Baptistery; the 'old, ignoble, uncomfortable and pitiful' house of the canons was condemned; and from Aleotti and Rosselli opinion was obtained on the state of the fabric. For the time being, however, Magalotti contented himself with the clearing of the shops, squalid and offensive to God, which abutted the south and west walls of the Cathedral (Plate 2).[55] He turned his attention then to the chapel in the bishop's palace, and had brought there relics formerly kept at his abbey just outside Naples. His altarpiece by Guercino was also transferred to the palace.[56] It was after the first and second parish inspections, and just before a synod, that Magalotti in 1636 took his Cathedral in hand. In June the silver reliquaries housing the relics of Ferrara's protectors St George and San Maurelio were sent away, to Rome, for restoration.[57] On 2 August the first stone was laid of what Magalotti intended should be the complete rebuilding of the interior of the Cathedral, to include new brick vaults, to the design of Luca Danese of Ravenna, Architect to the Apostolic Chamber in Ferrara.[58] A year later, work on the east end and the transept chapels, one of which had been designated by Magalotti as his place of burial, was well advanced. But on 18 September 1637 Magalotti died, and the impetus to rebuild died with him. Work went on for some years, the transept chapels progressing very slowly as the Chapter waited for Magalotti's heirs to honour his legacy to the Cathedral and supply the designs for the altars.[59] The bequest to Magalotti's own chapel, the Chapel of S Lorenzo, was agreed in 1641, thanks to the intervention of the Barberini, and it included the altarpiece by Guercino, now brought out of the episcopal palace to hang over the door of the New Sacristy until the chapel should be ready.[60]

A chapel seemed a very small memorial to Magalotti, and it may not even have taken precisely the form he intended. Even so, it was still in its way exemplary. It was self-commemorative, as was Guercino's much-travelled altarpiece, but in this case there was perhaps more than the ordinary connection between the patron of a chapel and his name saint – Lorenzo Magalotti, no less than San Lorenzo himself, would be remembered for having protected the goods of the Church. And the simple commemorative inscription, *Ossa Laurentii Cardinalis Magalotti Episcopi*, left no superfluous clutter.

Occasional reports of banquets at the bishop's palace and the restoration of the palace itself (Fontana's improvements must have seemed, after all, inadequate to a cardinal) reveal that Magalotti in Ferrara had not entirely neglected the secular world.[61] It was perhaps for the palace, or for the Bishop of Ferrara's country seat at Contrapò, that Magalotti ordered genre pictures from Guercino's brother, Paolo Antonio Barbieri, in 1630 and 1636.[62] He may also have collected pictures in Ferrara unless he had, in fact, commissioned years before the *Massacre of the Innocents* by Scarsellino which he owned and then bequeathed to the Cardinal Cesare Monti, Archbishop of Milan and one of a number of prelates whom Magalotti had reportedly 'carried' to the cardinalate.[63] Among others were Giulio Sacchetti and Bernardino Spada, one the Legate to Ferrara and the other Legate to Bologna during Magalotti's years as Bishop, and in these circumstances it was inevitable that Magalotti's authority would extend into the temporal world – though he never let temporal authority invade the spiritual. The banquets at the bishop's palace were laid on for official guests, and it was as natural that Magalotti should entertain them as that he should be consulted, as he was, on the building of the *Fortezza Urbana* at Castelfranco on the Bolognese border.[64] No one would accuse Magalotti of excessive worldliness, nor of hypocrisy. He might, perhaps, have been accused of excessive severity, and there was apparently an outbreak of crime in Ferrara in 1638 which it is tempting to explain as a city breathing out after nine years of vigilance.[65] But, as Ubaldini had observed with reference to the Bishop's stern nature, such severity was 'so much the better for his Church and his people given the pernicious and bad example of his predecessor'. Ferrara was certainly the cleaner for the presence of Magalotti – and had it not been for Ferrara, Magalotti might have missed his chance to make a reputation.

(iii)

After Magalotti, for four years Ferrara lacked a resident Bishop, for the successor, who was Magalotti's nephew Francesco Maria Macchiavelli, was delayed at the European peace conference in Cologne until 1641 when, having been created a cardinal, he arrived in Ferrara.[66] Macchiavelli published the decrees of his uncle's synod, suspended in 1647 all public worship before a supposedly miraculous, but unauthenticated, painting of the Virgin in a portico near the church of Sto Stefano, and was buried, in 1653, in the Chapel of the Guardian Angel opposite the Chapel of S Lorenzo in the Cathedral. Thus he showed himself ready to follow the example of Magalotti. But Macchiavelli was also 'a Signor of great sincerity and the best of natures' and 'Charity' was said to be the word most often on his lips, and thus he softened that example.[67] So did his successors, first the Cardinal Carlo Francesco Pio (nephew of the Cardinal Pio who

had paid for the church of S Carlo) and then Cardinal Stefano Donghi, both of whom were described as diligent defenders of the faith who kept their clergy up to the mark and encouraged church repairs, but neither of whom earned a name for rigour – it was perhaps no longer needed in a Bishop of Ferrara. Pio, indeed, allowed his clergy to stage plays about the lives of saints with scenery, costumes and lighting, while Donghi allowed himself the luxury of restoring a popular cult suspended by Magalotti.[68] Not until the early eighteenth century would a Bishop of Ferrara, in the person of Tommaso Ruffo, leave so deep an impression upon his diocese as Magalotti. Ruffo would carry out Magalotti's intention of remodelling the interior of the Cathedral, would rebuild completely the bishop's palace, and would have the status of the see raised at last to that of an archbishopric.[69] In the interim the initiative in devotional patronage had passed back to the religious orders.

Only the Oratorians, who arrived in the 1650s, seemed content with the church they had been given, which was perhaps just as well, for theirs was the lovely fifteenth-century church of Sto Stefano, which might otherwise have been rebuilt.[70] But every other order in Ferrara appeared anxious to rebuild. In the 1630s the Servites as the Capuchins before them were obliged to move because their church had been too close to the new fortress of Ferrara. A new Sta Maria dei Servi was founded to the design of the papal architect Luca Danese, but the 7,000 *scudi* provided by the Apostolic Chamber as compensation proved insufficient and Danese had to modify the plan.[71] An unwholesome site obliged the Capuchin nuns to move to a new Sta Chiara, designed again by Danese, in the 1640s.[72] S Giuseppe of the Discalced Augustinians was begun in 1639 and from 1651, when devotions vowed in 1624 on the occasion of an earthquake on St Joseph's Day were formally transferred to the new church, it entered into the programme of public worship in Ferrara.[73] In the 1660s, the Ferrarese architect Carlo Pasetti designed for the Tertiaries of St Francis the new Sant'Apollonia, devising a novel oval-octagonal form almost as striking as Aleotti's S Carlo of fifty years before.[74] But nowhere were the aspirations of the orders and their patrons more evident than in the new church of Sta Maria della Pietà of the Theatines.

In October 1641 the Cardinal Legate Marzio Ginnetti reported to Rome his concern about the new Theatine church, which he could see from the windows of the Castello. For some months, he wrote, they have been building the choir, already 70 Ferrarese *piedi* and due to rise to 80. Ginnetti was alarmed, partly because the papal fortress would be 'discovered, and dominated by the greater height of this building', partly because he had been advised that the foundations were inadequate for the height, but principally because the Castello, he believed, would be deprived of air from the east and of 'a beautiful view, in which one can see at present not only the city but the great *Montagna*, and the countryside beyond'. (The open *loggie* of the staircase tower at Ginnetti's own palace at Velletri would later reveal the pleasure he derived from a landscape vista.) He had therefore ordered a suspension of work and offered money of his own to pay for the adjustments necessary to bring the walls down to a 'just height'.[75]

Sta Maria della Pietà was the grandest of the new city churches of Ferrara. Materials from the demolished Este palace of Certosa had been allocated to the Theatines and the first stone of the building had been laid by the Cardinal Legate Sacchetti in 1629. Luca Danese had provided the design, and since the architect to the Apostolic Chamber in Ferrara was presumably aware of building regulations imposed to protect the security of the fortress, it was perhaps

the aspirations of the Theatines themselves which were pushing the walls of their church to such disturbing heights, higher even, wrote Ginnetti, than the Cathedral. (A number of architects had been consulted in addition to Danese, including at some stage the Roman Paolo Maruscelli, whom Borromini replaced in 1637 as architect to the Roman Congregation of the Oratory.)[76] Even as adjusted, Sta Maria della Pietà is a large building, broad, suggesting large congregations, as well as tall. Yet it is also disappointing, not altogether unlike a barn, which is largely due to the fact that the façade, for which Enzo Bentivoglio had once intended to pay, was never begun. The interior is more interesting.

Private patrons brought two notable altarpieces to Sta Maria della Pietà. One was the *St John in the Wilderness* by Andrea Sacchi, an unlikely sight in Ferrara, which was due to the patronage of the Dottore Alessandro Scannaroli. The Scannaroli from Verona were one of the very few new families to settle in Ferrara, a move perhaps encouraged by their connections with the Barberini. The Dottore Alessandro was a deeply religious man who, having donated several relics to the Theatines in Ferrara, chose their church for the commemoration of his family in the Chapel of St John the Baptist. In 1641 he had acted as agent in an Imperial commission to Guercino (he may have been assisted by Antonio Scannaroli, who in the 1630s was a papal governor of Cento), and Guercino, still accessible in Bologna, might have seemed the obvious choice when, in the early 1650s, Scannaroli decorated his chapel with an altarpiece.[77] The choice of the Roman Sacchi may simply reveal a personal preference, a wish to oblige Sacchi's protector, Antonio Barberini, or perhaps a desire to be different. Guercino, in fact, had already been commissioned to paint an altarpiece for the Theatine church, that is, the *Purification of the Virgin*, ordered in 1653 by the Dottore Claudio Bertazzoli, who was also a member of the Stigmata (Plate 78).[78] By the time the church was finished, a curious variety of painting had gathered about these altarpieces, including frescoes by Clemente Magoli, a pupil of Pietro da Cortona, and at the altar of St Joseph a painting by a 'Scotsman', who might conceivably be identified with the Scottish pupil of Cortona, a 'Monsù Abmon', whom the Cardinal Legate Girolamo Buonvisi brought from Rome to Ferrara in the 1660s primarily to copy paintings.[79] All in all, from the fabric to the interior decoration, Sta Maria della Pietà was, and is, a remarkable church.

By 1653, the year of Alberto Penna's *Compendiosa Descrittione* of Ferrara, there were ninety-six churches and some fifty monasteries, friaries, convents and pious institutions in a city whose population, according to contemporary estimates, now amounted to just 23,000.[80] These included a number of new buildings, some notable, the majority plain but each testifying to the vitality of faith. Of the older churches of the city there was probably not one which had not been in some way improved, either decorated with new paintings or sculpture, rebuilt, repaired or just swept clean. Devotional patronage, aspiring, reforming or simply God-fearing, had given work – more humdrum than exciting but at least work – to local artists and architects and occasionally a more challenging opportunity. And in the church of Sta Maria della Pietà of the Theatines was reflected the history of post-devolution Ferrara to date – faith, ambition, financial insecurity, foreign influence (especially from Rome) and, perhaps, an underlying lack of cohesion.

6 *The Papal Legation*

In the sixteenth century, the 'Cardinal of Ferrara' was the Cardinal d'Este. In the seventeenth, it meant the *Legate à Latere*, supreme representative of the Pope in Ferrara, in whom were invested certain pontifical powers. A Ferrarese scholar once claimed that Ferrara, having been a duchy, took precedence over the other legations, but in practice it ranked below Bologna.[1] Ferrara was often the first posting for a new cardinal who had worked his way up through the diplomatic service or the management of the papal treasury, and as the latter might suggest, many postholders were Tuscans (reflecting also the nationality of several popes) or Genoese.

If the Legate were not Genoese, the Vice-Legate probably was, and from the time of devolution such names as Centurione, Imperiale, Lomellini and Spinola would appear often in the chronicles of Ferrara. Genoese prelates brought with them Genoese investment in land and in Ferrara's public debt by means of holdings in the *Monte di Pietà* and later the *Monte Sanità*, 'erected' by the Legates in an attempt to relieve Ferrara's perennial financial crises. At least one Genoese family, the Costaguti, settled in Ferrara, and at a time when the ability of the Genoese abroad to make money usually earned them enemies too, when Gio. Giorgio Costaguti, farmer of the Ferrarese *gabelle*, died in 1630, he was mourned not only by the Legate Giulio Sacchetti but also by the customarily acid chronicler Ubaldini, for he had been a public benefactor.[2] (The Vice-Legate Fabio Chigi, the future Pope Alexander VII, composed the inscription for Costaguti's memorial portrait bust in the church of Sto Spirito as if it were a public work.)

The post of Legate was a gift but not a sinecure. His powers overlapped, sometimes awkwardly, with those of the Bishop of Ferrara and, in the city which was now the northern bastion of the Papal States, with those of the military staffs. In 1646, for example, the Cardinal Legate Donghi was refused entry to the papal fortress – 'I, a Cardinal, in the States of the Church, and a Legate!' – and because the insult had been received in public, Donghi spent some days at the fortress to assert his authority.[3] Certain responsibilities of government had, in theory, been delegated to the Council of One Hundred noblemen, merchants and artisans, and to its executive committee led by the *Giudice dei Savi*, and separate bodies had been formed for specific purposes. The management of the university, for example, was now the responsibility of the *Riformatori* of the Studio, and when the Academy of the *Intrepidi* was formed in 1601, there was, in effect, a committee for official entertainments of a literary kind, while the Commune itself looked after the more humble horse-races and other feast-day events. The victualling of the city and the state, the regulation of the waterways and the cleaning of the streets, roads and, most important, the drains beneath the streets, had also devolved upon the Commune, which had a resident architect–surveyor to undertake any structural or engineering work required. But if only because its funds were so unstable, and because not all elected

members were reliable, the communal council and its committees rarely seemed able to manage its affairs efficiently. In practice, the Legate assumed control.

He was expected to implement in Ferrara the policies (social, economic, military and political) determined in Rome, which appeared straightforward enough. But for those who could not govern without a little imagination, and without taking a personal interest in the state under their control, the case was more difficult. Not always, but often, the Legates were responsible and responsive men. In 1636, for instance, the Cardinal Stefano Durazzo of Ferrara, the Cardinal Baldeschi of Bologna and the President of the Romagna met to discuss a request from the city of Ravenna for extraordinary aid to repair city walls and divert rivers (a sad appeal from the once great Byzantine city), and they agreed to recommend that 'the case is truly worthy of the full compassion of His Holiness'.[4] Now and then, the letters of the Legates to Rome bring to mind those of Pliny to the Emperor Trajan, which is a reminder of the ancient Roman origin of their post.

To assist him in the day-to-day administration of the state, the Legate had the services of Monsignor Vice-Legate and of secretaries, accountants and a police lieutenant and officers. There was also an architect attached to the Apostolic Chamber in Ferrara, the post from the late 1620s of Luca Danese of Ravenna, and other engineers and surveyors were summoned or found when needed. These were the executants of whatever works, maps or surveys the Legate might put in hand. On the face of it, however, there was little scope for extensive use of these men. A Legate was not appointed for life, so there was no incentive for church or palace building and, in any case, most Legates already had palaces, family chapels and titular churches to attend to in Rome and their native cities. The official residence was ready-made – the Legate lived in the Castello and the Vice-Legate had apartments in the Corte Vecchia, which he shared with local government committees, the Academy of the *Intrepidi*, artisans and private individuals, all, as he was, tenants of the Este. There was no call at all for a legation painter. Bolognese artists, draughtsmen and engravers created the cartouches which publicised a Legate's virtues as a frame for his coat-of-arms.[5] The illuminated documents, cased in silver, which endorsed the gift of Ferrarese citizenship to a Legate and sometimes members of his family were commissioned from local artists by the Commune, which also, presumably, paid for the series of portraits of Legates by the Ferrarese Maurelio Scannavini in one of the Commune's committee chambers.[6] Yet in a private capacity, the Legates were patrons of painters, or more accurately of Guercino, for it was almost exclusively from Guercino that Legates, Vice-Legates and a few police officers ordered pictures during their tour of duty in Ferrara. Patronage of this kind, of an artist of Guercino's calibre, was to be expected of a cardinal of the Church. But the Legates were also patrons of architects and engineers in Ferrara, which was in a way more interesting, for it made them patrons of the city and its state in the interests of the Pope and of the public. It was sometimes hinted that a legation was an opportunity to make (or at least to save) money.[7] But in the end perhaps the most valuable possession that a Legate took with him when he left was his experience in the public service and his name as a patron of public works.

(i)

If the Legates of Ferrara rarely received unqualified praise from the Ferrarese, it was partly due to a reputation which they had to live down and which was the fault of the Cardinal

Pietro Aldobrandini, an absentee Legate who took himself and his Ferrarese pictures back to Rome and delegated his duties to a Co-Legate, the Cardinal Francesco Blandrata, who was himself absent in 1603 and died in 1605. Matters improved with the election of the Borghese Pope, Paul V, and the appointment, from 1606 to 1615, of the Cardinal Orazio Spinola, Archbishop of Genoa. Spinola's work to revive, by means of reform, the declining silk industry in Ferrara was a step towards economic recovery to be expected from a Genoese, and a cartouche by the Bolognese artist Francesco Brizio indicated a time of 'Moderate' and 'Bountiful' government (Plate 79).[8] But it was Spinola who issued a string of edicts which progressively banned popular games and entertainments, and if he was, perhaps, less stern than his compatriot Benedetto Giustiniani, the Legate to Bologna, he kept Ferrara on a tight rein, which was probably why he was reappointed to the legation.[9] It was Spinola's responsibility to supervise the building of new defences in Ferrara and inevitably they overshadowed his term of office, none more than the papal fortress.

The Fortress of the Annunciation was to be the most up-to-date citadel in Europe, and its five great bastions quickly became a tourist sight: in 1612, for example, the Genoese nobleman Gian. Vincenzo Imperiale visiting Ferrara heard beautiful music and strolled in delightful gardens, but when he returned in 1622 he made a point of seeing the Fortress.[10] The site had been cleared in 1599 when the Belvedere palace was pulled down, and building finally began in 1609. For Pope Paul V, the *Fortezza* of Ferrara was a glorious undertaking, inaugurated with coins struck by Paolo Sanquirico, master of the papal mint and later commemorated on the Pope's tomb in Sta Maria Maggiore.[11] But for the resident soldiers, numbering some 300, it was a death-trap, built on the unhealthiest of sites. As early as 1633, the Cardinal Legate Pallotta had to propose more frequent changes of the guard, 'because the soldiers are dead or dying, unable to endure so long (i.e. two months) the suffering and bad air'.[12] New defences added in the 1630s only made matters worse, enclosing the space and breeding sickness. It was not so much the site, in fact, which was at fault but the decision to alter the course of the river Reno and flood the fertile San Martino lands, for as a result of this the ground on which the fortress stood was rendered damp and unhealthy. As the Ferrarese Alberto Penna later explained, with heavy sarcasm: 'The fabric was perfect, the moat exquisite and everything a marvel. The site alone did not correspond to the idea'.[13] The architect had not been Ferrarese.

The defences of Ferrara, like the management of its waterways, formed part of policies made in Rome for the Papal States as a whole, and it was at this time a part of Roman policy to exclude the Ferrarese completely from any matter affecting security. Thus, while the Ferrarese G. B. Aleotti enjoyed the patronage of the Legate Spinola, gave his opinion on the fortress and later designed both its gateways (and other forbidding gateways to Ferrara) and the church of the Annunciation within its walls, in 1608 it was doubted that he should be consulted at all. Aleotti's advice against the diversion of the Reno was therefore ignored.[14] In 1608 and 1609, the Pope, acting on the recommendation perhaps of the general Mario Farnese, sent to Ferrara the goldsmith-cum-Reviewer-General of papal fortifications Pompeo Targone and, as an *avvisi* writer of 1607 had foreseen, Targone was not the man for such responsibility. The Fortress of Ferrara would join the growing list of mistakes in the career of the unlucky Targone.[15] Meanwhile the Reno works were entrusted to one Agostino Spernazzati SJ, a man, recalled Ubaldini, of 'much theory and no practice' and no comprehension at all of the Ferrarese

art of 'dykes, conduits and drains'.[16] Everything for which papal policy was responsible in Ferrara was proving to be destructive, and after eighteen years of ruin, repression and plain stupidity it was time for a more imaginative approach to government. Spinola's departure in 1615 made way for it, in the person of the Genoese Cardinal Giacomo Serra, who arrived in Ferrara in December (Plate 80).

In a cartouche designed by Giovan. Valesio, 'Strength' and 'Fame' were attributed to Serra, and they illustrated fairly accurately his career to date.[17] In 1606 he had been Commissioner–General for the proposed offensive against Venice and in 1607, after a nunciature to Hungary, he had taken charge of troops levied for war against the Turk. In 1608 he was appointed Treasurer–General, spending a reported 60,000 *scudi* on the post and resigning his clerkship of the Apostolic Chamber (which he had bought for 38,000 *scudi*) in anticipation of a cardinalate, which duly followed in 1611. It was proof of Serra's efficiency in the Treasury post (finding, for example, the enabling means for Borghese patronage and building in Rome) that he retained his financial responsibilities for some years after his promotion. It had, in fact, been rumoured in 1611 that he would be appointed to the legation of Ferrara, but for the time being Serra's place was at the papal court and in Roman society – he had a palace leased for life near the Capitol. His first titular church was S Giorgio in Velabro and in 1611 he responded quickly to a request for help towards its restoration. He also shared in the artistic life of the city, collecting antiquities, for example, and in 1607 he had contrived to obtain for a protégé, that is, Rubens, who may have been recommended to him by the Genoese Pallavicini, the important commission for a new altarpiece for the High Altar of the Chiesa Nuova of the Oratorians.[18] But Serra was not destined to remain in Rome.

Where the name of the Cardinal Serra is known at all today, it is partly because of his patronage of Rubens but principally because in Ferrara he was a patron of Guercino, whom he may have visited in company with other cardinals (unexpectedly, of course, as all such visits to Guercino seem to have been made) in, perhaps, 1616.[19] In 1619, the Commune of Cento made the Cardinal Legate a gift of a Guercino painting, and in September that year he called the artist to Ferrara. In December 1620, with the powers vested in him, Serra created Guercino a Knight of the Papal Order of the Golden Spur. According to the biographer Malvasia, Guercino painted five pictures for Serra: the *Samson captured by the Philistines* (Plate 81), the *St Sebastian succoured by Irene*, and the *Parable of the Prodigal Son* (Plate 82), all, it seems, of 1619, and the *Elijah fed by ravens* and the *Jacob blessing the sons of Joseph* of 1620. How these subjects (and there may have been others which Guercino painted for Serra) were chosen is not known, but they are notable for the absence of myth and poetry (and of the New Testament, for that matter) and for the comparative rarity of both the *Jacob* and the *Elijah* (identified by the appropriate chapter reference in Kings). If Malvasia may be believed, Serra admired especially the 'roundness and relief' of Guercino's style of these years, and paid him handsomely for his work, which was surprising, perhaps, if Serra is to be identified with the Treasurer–General who once scoffed at Guido Reni's high prices and pretensions.[20] But in Ferrara, the patronage of Legate's would have been rather a pleasure than a responsibility, one of the more civilised aspects of the Legate's life and on a par with the acquaintanceship of the Ferrarese antiquarian and art collector Roberto Canonici, to whom Serra gave pieces of Roman pottery from his own collection.[21] Yet it may be that some of the more serious issues facing

the Legate of Ferrara were represented among his Guercino paintings, if only because they happened to be running through his mind; such issues as the segregation of the Jewish community demanded by the Ferrarese, the victualling of the city, and the housing of the poor and homeless.

Serra was a vigilant governor who seemed, recalled Ciriaco Rocci, a Vice-Legate at the time, to have had eyes in the back of his head.[22] In the city it was rumoured, probably rightly, that he intercepted the mail, and the tone of his own letters to the Commune was sometimes reminiscent of a parent to a child. In the opinion of Cesare Ubaldini, Serra, like Spinola, had issued 'bans too many to be heeded', and when he banned in 1617 all assemblies of people at night (in the aftermath of the murder of Ercole Pepoli), he effectively closed the city's theatres.[23] But perhaps his introduction of a new horse-race, paid for by money confiscated from the Jewish community, enabled Serra to win back a little popularity.[24] In another cartouche designed, in 1616, by Giovan. Valesio, the figures supporting the Cardinal's *stemma* promised 'Liberality' and 'Mildness' (*Dolcezza*) from Serra, and if the Ferrarese did not see this face, they did at least see a governor committed to the public good (Plate 83).

In 1599 the Co-Legate Cardinal Blandrata had put in hand the construction of a new canal, the *Cavo Barco*, to link Ferrara with the river Po at Pontelagoscuro. Serra followed the example, and had a canal built to connect the Po and the Panaro rivers and though it proved to be a failure which cost the Commune some 150,000 *scudi*, the idea had been sound and failed only because policy changed in Rome.[25] Serra also followed Spinola's example in introducing further reforms in the *Arte della Seta* in the hope of encouraging the production and sale of silk. But he was more successful when introducing his own ideas, such as the *Abbondanza*, which he established in 1619, financed and thereby ensured Ferrara supplies of good bread.[26] In the same year, he reopened the city's Mint.[27] For the young noblemen of Ferrara who now lacked a Court to train them (unless, that is, they deserted to Modena), Serra founded a college, and for the less fortunate he founded a hostel, 'of large capacity and much beauty' (now destroyed), to accommodate two hundred of Ferrara's mendicant poor.[28] When he turned his attention to the cleaning of the streets, his approach was imaginative.[29] For two reasons, he explained in a promulgation of 1620, 'this city more than any other in Italy has need of such provision'. One reason was the low-lying situation of Ferrara, which weather and winds rendered prone to dust in the summer and mud in the winter. The second was the result of Ferrara's past, for the ample breadth and length of the streets laid out by Ercole I d'Este had rendered Ferrara so much more noble than other cities that their upkeep was essential, so as 'not to lose the glory and prerogative of such beauty and magnificence'. Serra therefore set up a committee for the streets, 'resembling the ancient and noble Presidency of the Streets in Rome', divided Ferrara into six zones, appointed deputies in each and arranged that all future rents would include the costs of paving. This marriage of Ferrarese civic pride and ancient Roman precedent was perhaps one of the most thoughtful and sensitive solutions which could be applied in the new papal city, and it revealed that Serra's intelligence was rather greater than Ubaldini, who thought him proficient in bookkeeping alone, would allow.

One by one, Serra was addressing the basic needs of Ferrara (food, education, welfare, public health and amenity, commerce, and pride) and of course his concern was not totally disinterested. He and the papal general Paolo Savello had also commissioned a bronze statue of Pope Paul V for the courtyard of the Fortress of the Annunciation which was presumably

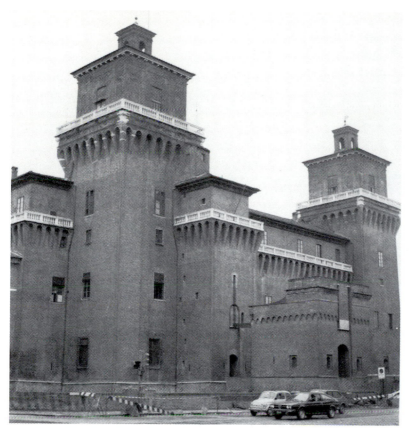

Plate 1. *Ferrara: Castello Estense*

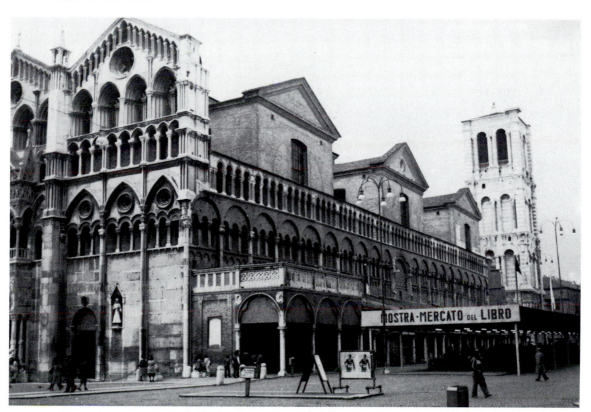

Plate 2. *Ferrara: Cathedral*

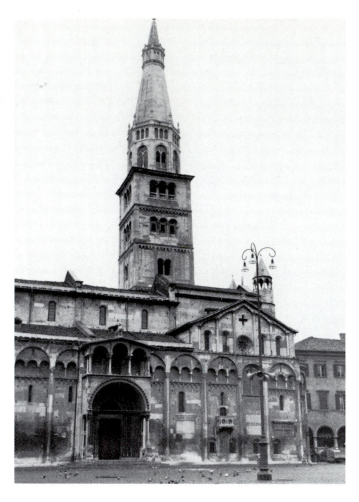

Plate 3. *Modena: Cathedral and Torre Ghirlandina*

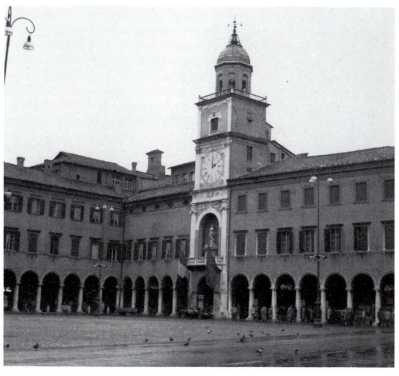

Plate 4. *Modena: Palazzo Communale*

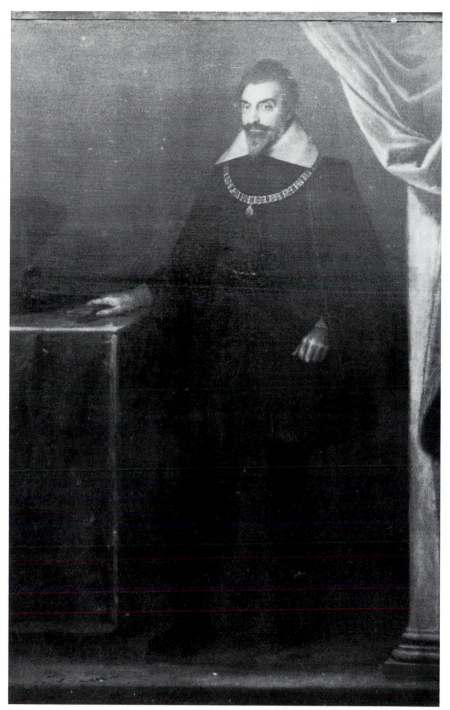

Plate 6. *Cardinal Alessandro d'Este*

Plate 5. Sante Peranda: *Duke Cesare d'Este*

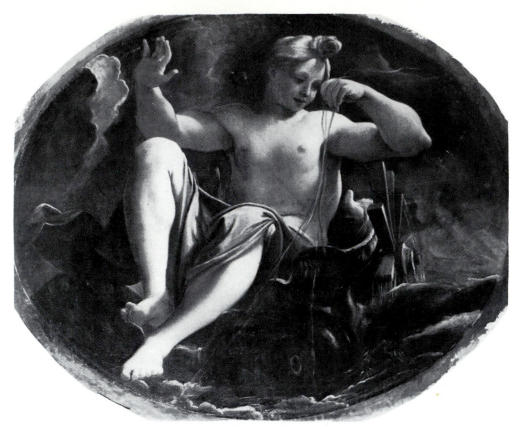

Plate 7. Lodovico Carracci: *Galatea*

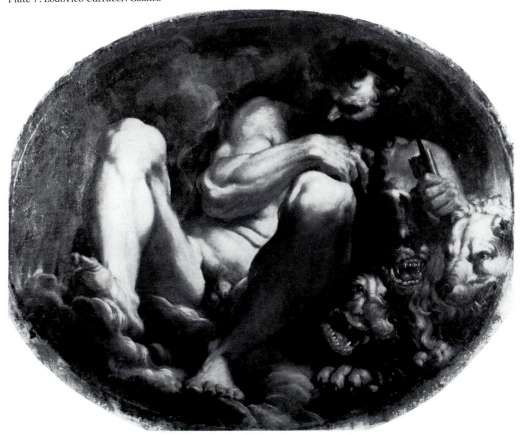

Plate 8. Agostino Carracci: *Pluto*

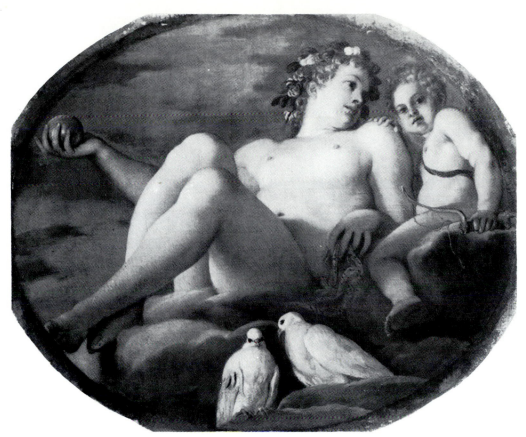

Plate 9. Annibale Carracci: *Venus and Cupid*

Plate 10. Annibale Carracci: Flora

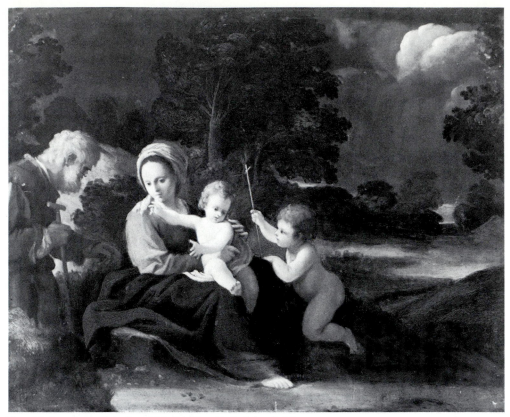

Plate 11. Bartolomeo Schedoni: *Holy Family with the Infant St John*

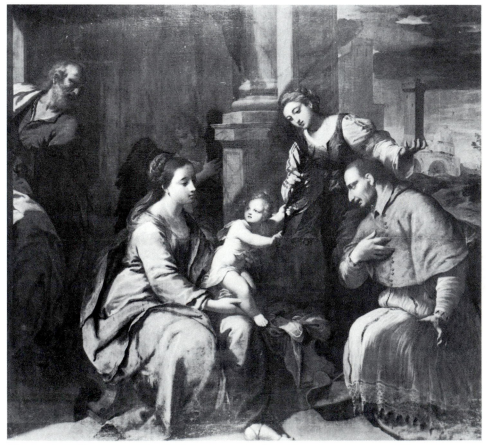

Plate 12. Scarsellino: *Holy Family with St Barbara and Carlo Borromeo*

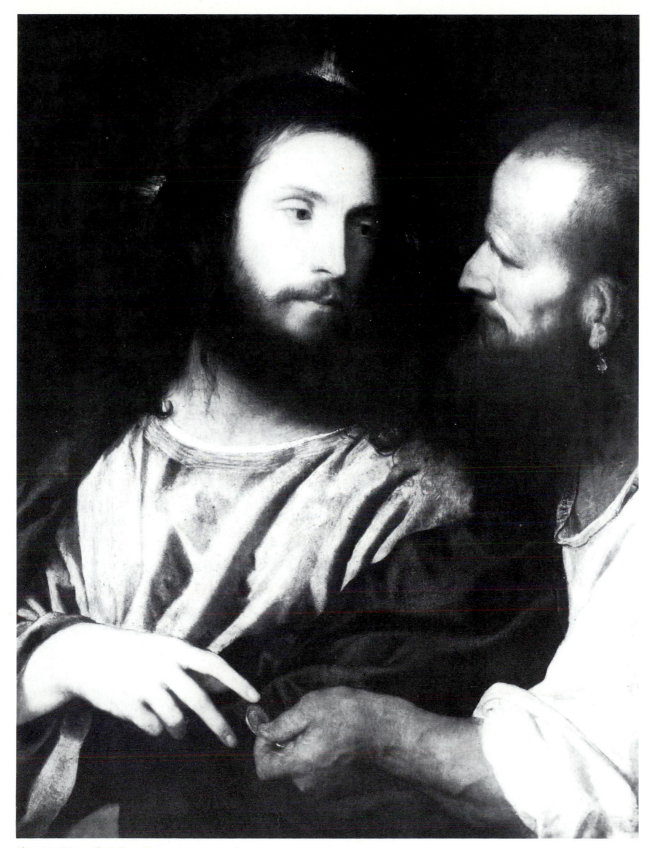

Plate 13. Titian: *The Tribute Money*

Plate 14. Francesco Brizio after Parmigianino: *San Rocco*

Plate 15. Annibale Carracci: *The Genius of Fame*

Plate 16. Guercino: *St Matthew*

Plate 17. Guercino: *St Mark*

Plate 18. Guercino: *St Luke*

Plate 19. Guercino: *St John*

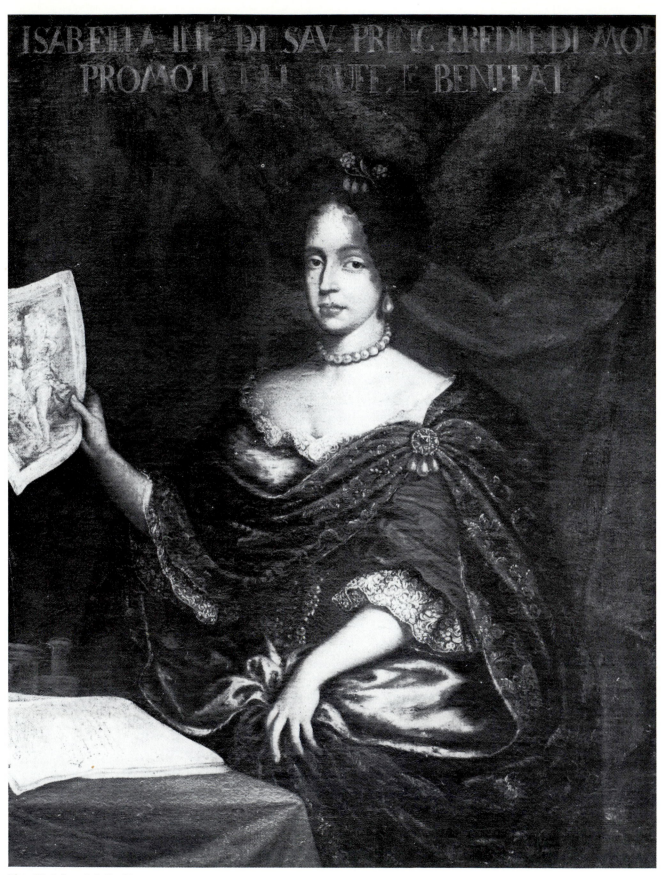

Plate 20. *Infanta Isabella of Savoy*

Plate 21. Castelnuovo de Garfagnana:
Capuchin monastery

Plate 22. Guercino: *Madonna and Child with
the Blessed Felice*

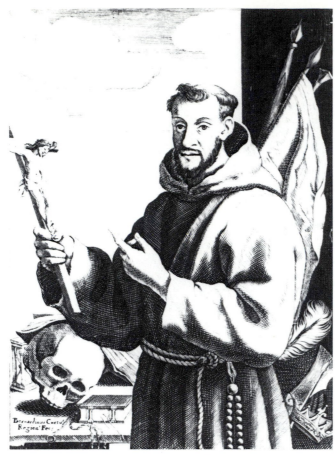

Plate 23. Bernardino Curti: *Padre Giobatta d'Este*

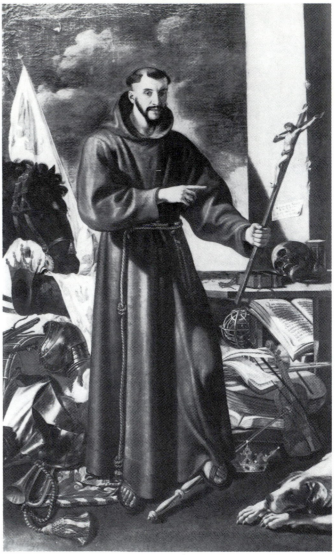

Plate 24. Matthew Lowes: *Padre Giobatta d' Este*

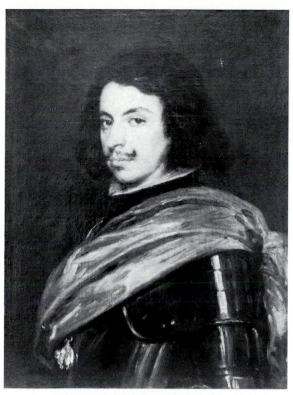

Plate 25. Velazquez: *Duke Francesco I d'Este*

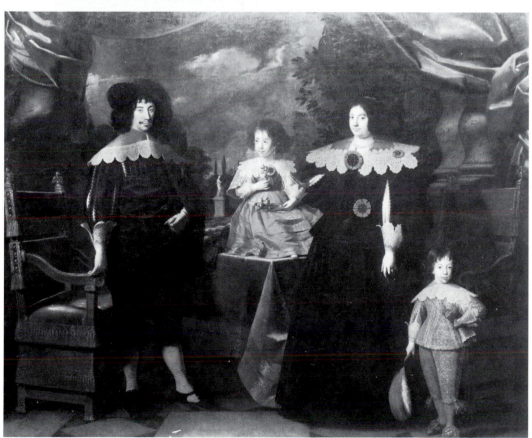

Plate 26. Justus Sustermans:
*Francesco I d'Este with Maria
Farnese and their children*

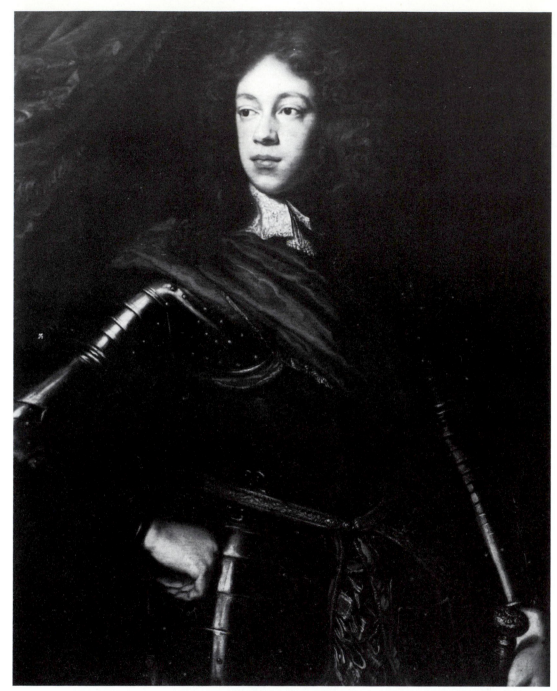

Plate 27. Justus Sustermans: *Prince Alfonso d'Este (later Duke Alfonso IV)*

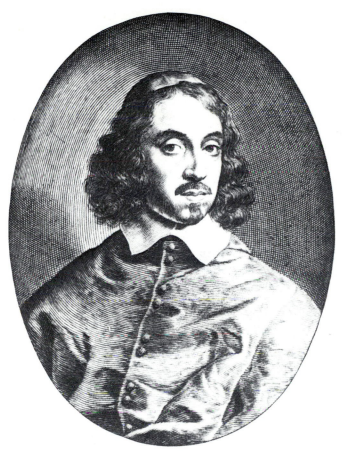

Plate 28. *Cardinal Rinaldo d'Este*

Plate 29. Bernini: *Duke Francesco I d'Este*

Plate 30. Guercino: *Madonna with Sts John the Evangelist and Gregory Thaumaturge*

Plate 31. *The Palazzo Ducale, Modena in the 1650s*

Plate 32. *The Palazzo Ducale, Sassuolo in the 1650s*

Plate 33. Stefano della Bella: *Theatre constructed in Modena for the performance of 'La Gara delle Stagioni'*

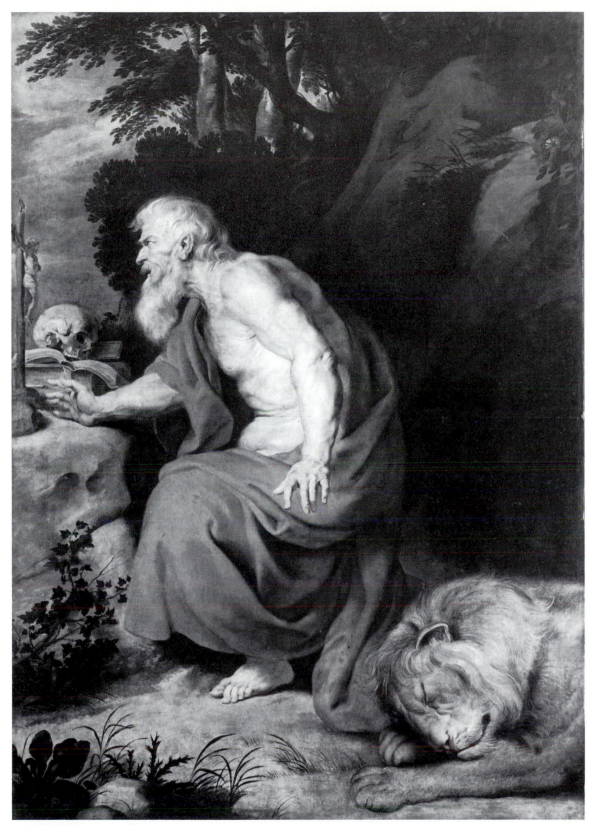

Plate 34. Rubens: *St Jerome*

Plate 35. Veronese: *The Good Samaritan*

Plate 36. Francesco Albani: *Diana and Actaeon*

Plate 37. Guercino:
Venus, Mars and Cupid

Plate 38. *The Prince at Study*

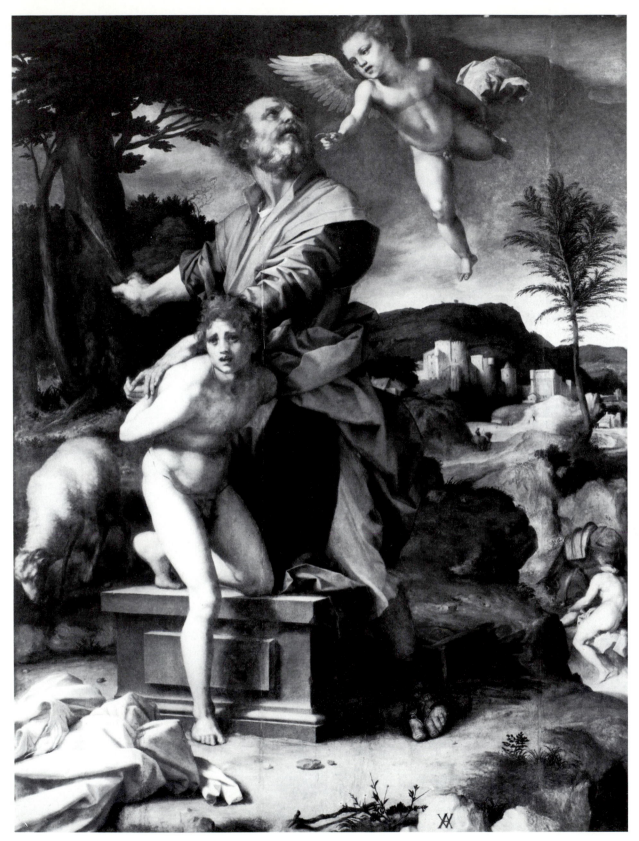

Plate 39. Andrea del Sarto: *The Sacrifice of Abraham*

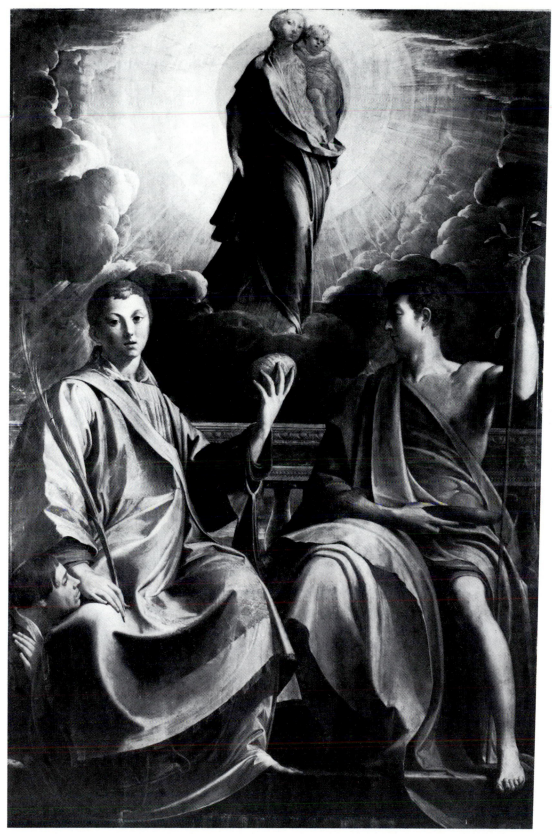

Plate 40. Parmigianino: *The Madonna of Casalmaggiore (Madonna and Child with Sts Stephen and John the Baptist and a donor)*

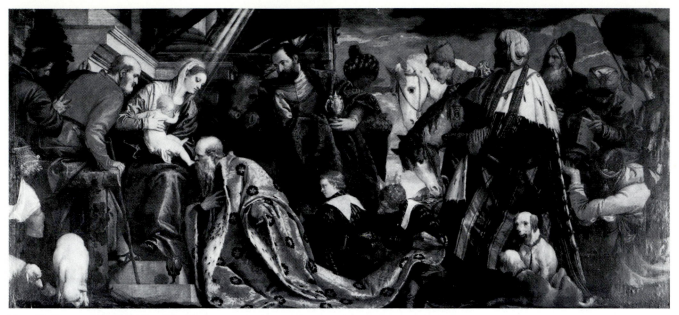

Plate 41. Veronese: *The Adoration of the Magi*

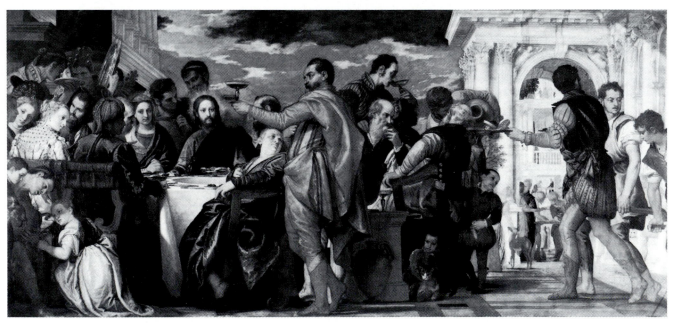

Plate 42. Veronese: *The Marriage at Cana*

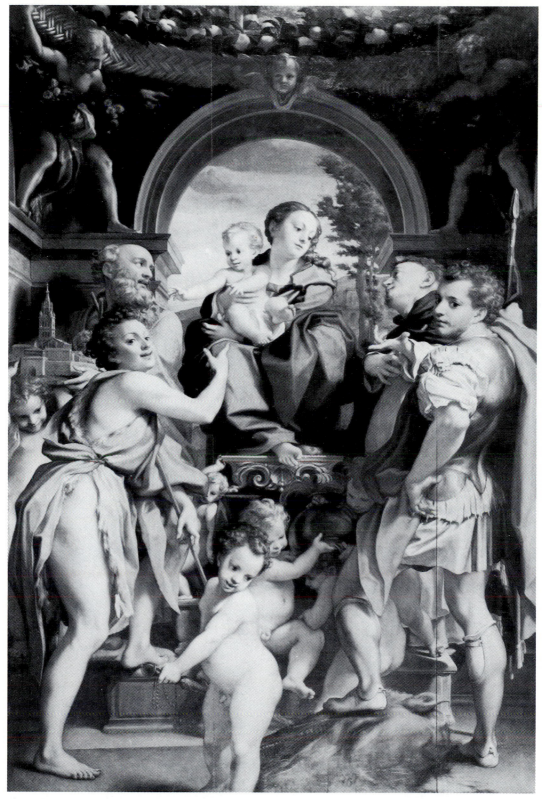

Plate 43. Correggio: *The Madonna of San Giorgio (Madonna and Child with Sts George, John the Baptist, Peter Martyr and Geminiano)*

Plate 44. Correggio: *The Madonna of San Sebastiano (Madonna and Child with Sts Sebastian, Rocco and Geminiano)*

Plate 45. Correggio: *The Adoration of the Shepherds (La Notte)*

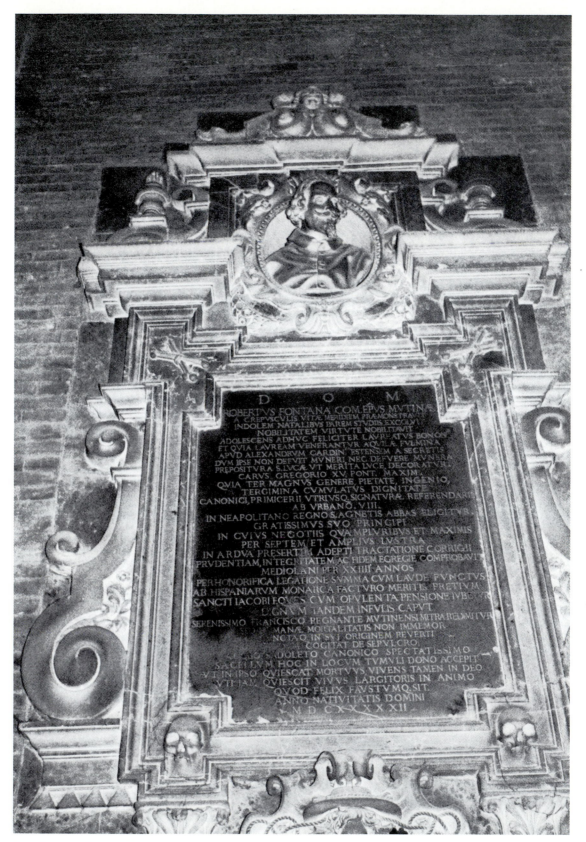

Plate 46. Ercole Ferrata: *Monument to Roberto Fontana*

Plate 47. Guercino: *Caricature of Fra Bonaventura Bisi*

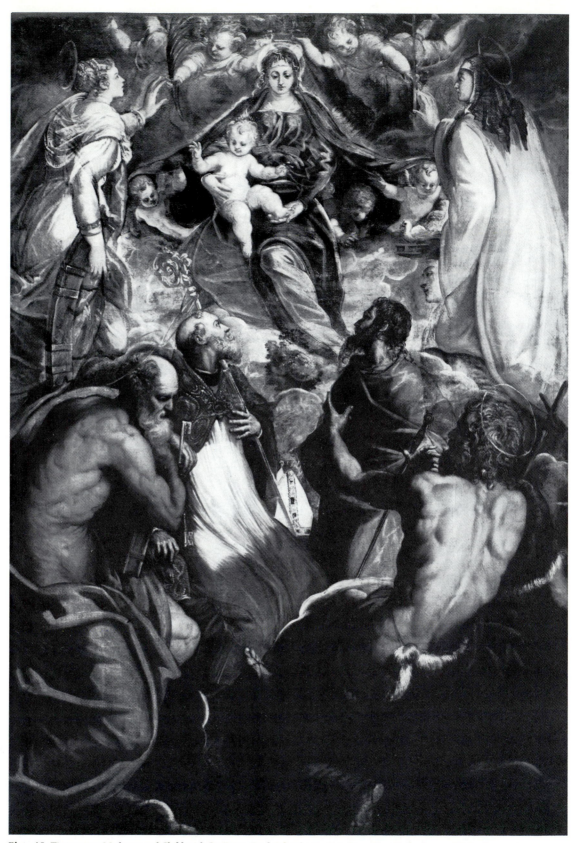

Plate 48. Tintoretto: *Madonna and Child with Sts Peter, Paul, John the Baptist, Augustine, Catherine, and Columba*

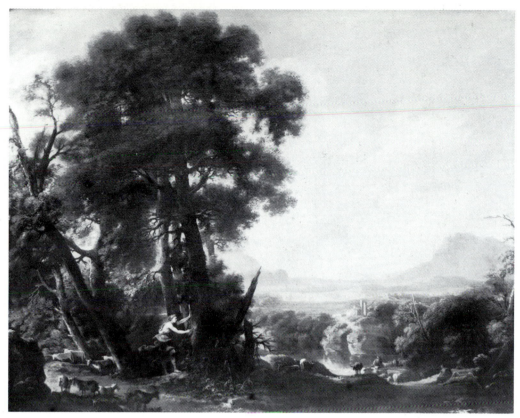

Plate 49. Salvator Rosa: *Landscape with Erminia*

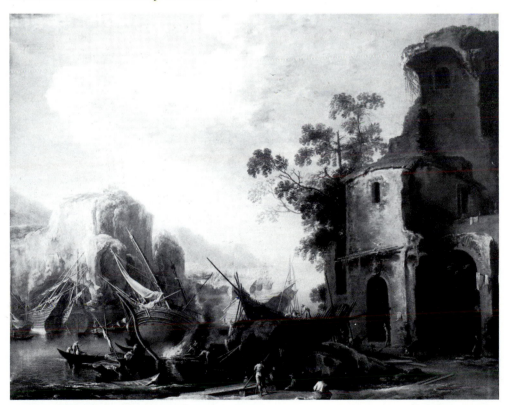

Plate 50. Salvator Rosa: *Harbour Scene*

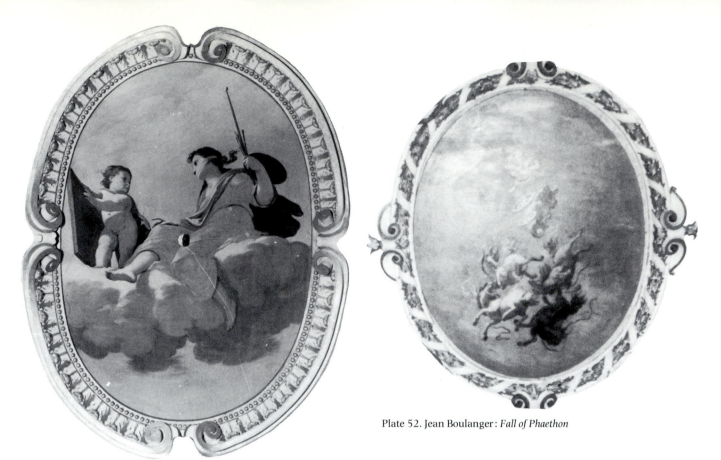

Plate 52. Jean Boulanger: *Fall of Phaethon*

Plate 51. Jean Boulanger: *Allegory of Painting*

Plate 53. Jean Boulanger and assistants: *Bacchus and Ariadne on Naxos*

Plate 54. M. Colonna and A. Mitelli and assistants: *Frescoes in the Salone della Guardie*

Plate 55. *Modena: Pallazzo Ducale* (detail)

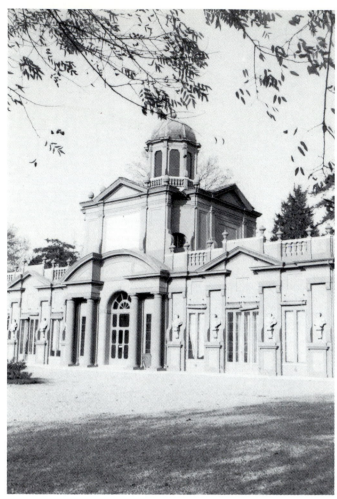

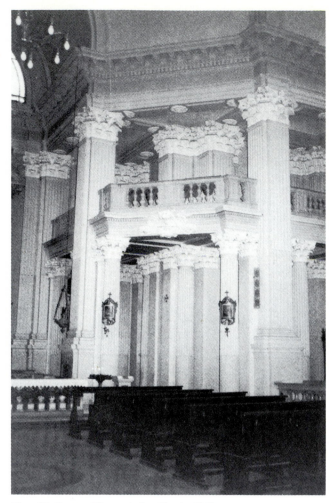

Plate 56. Gaspare Vigarani: *Palazzetto, Modena*

Plate 57. Gaspare Vigarani: *San Giorgio, Modena*

Plate 58. *The Prince and his Virtuosi*

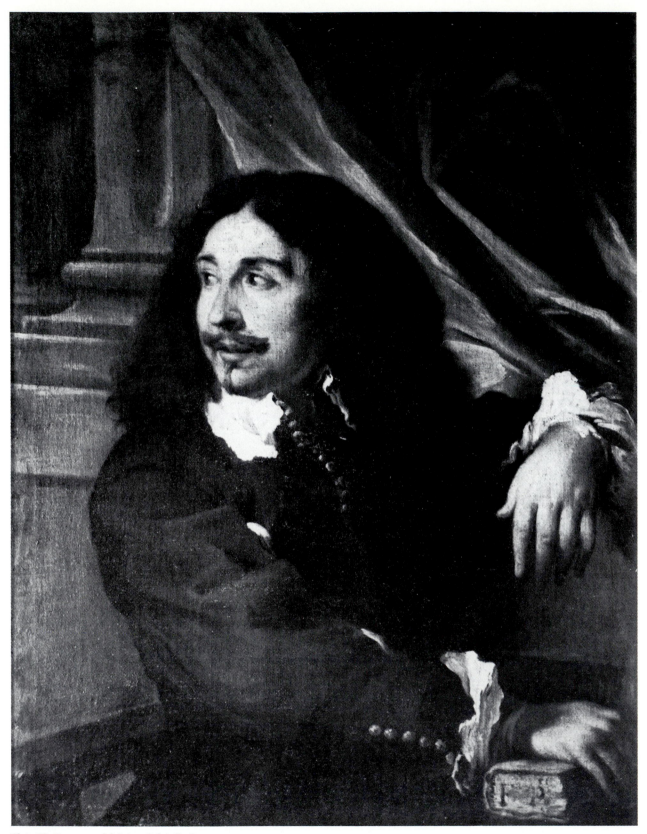

Plate 59. Francesco del Cairo: *Fulvio Testi*

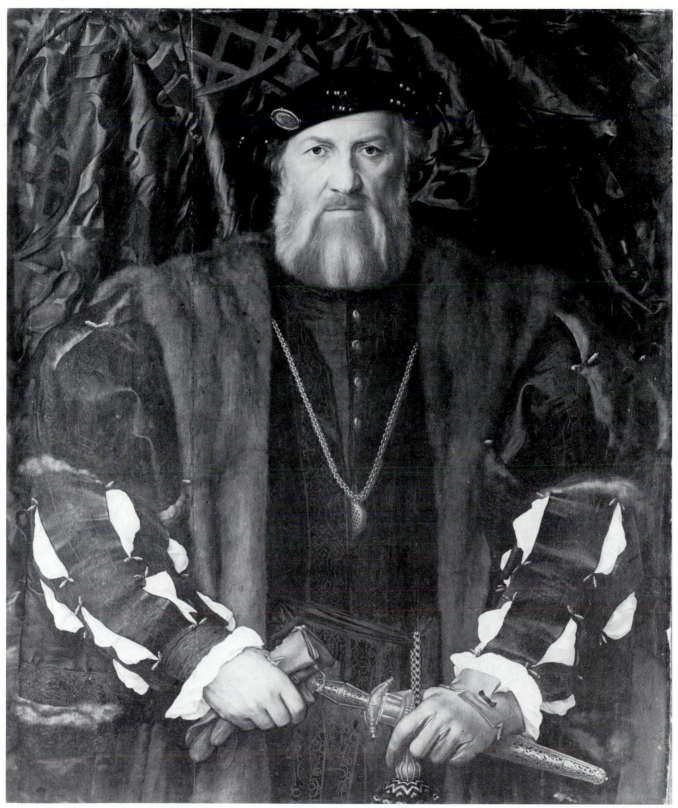

Plate 60. Hans Holbein the Younger: *Charles de Solier, Sieur de Morette*

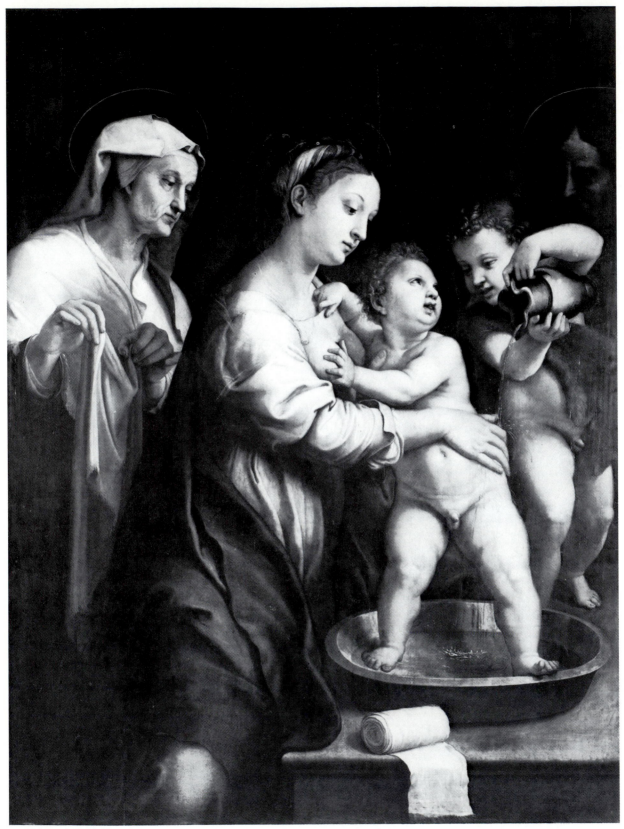

Plate 61. Giulio Romano: *Madonna of the Washbasin*

Plate 62. G. B. Aleotti: *Palazzo Bentivoglio, Gualtieri*

Plate 63. *Land drainage culvert, Gualtieri*

Plate 64. *Ferrara: S Maurelio*

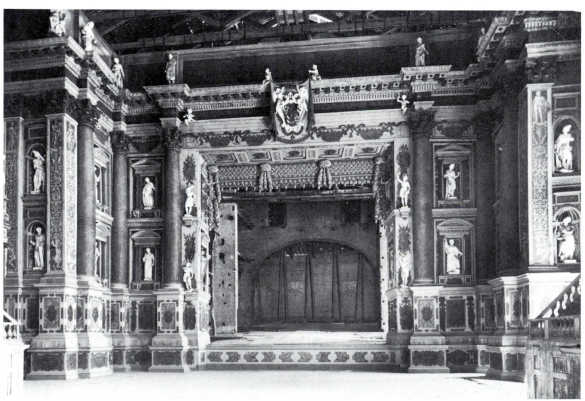

Plate 65. G.B. Aleotti and Enzo Bentivoglio: *Teatro Farnese, Parma*

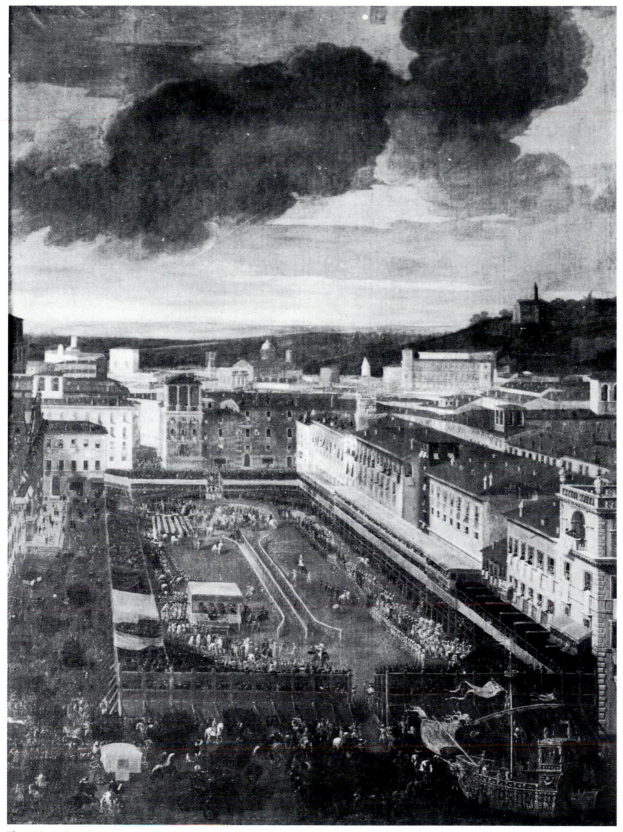

Plate 66. Andrea Sacchi: *Giostra del Saracino in Piazza Navona, 1634*

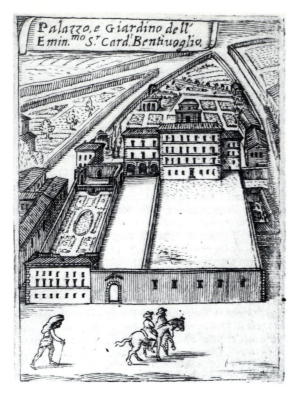

Plate 67. *Palazzo Bentivoglio, Rome in 1638*

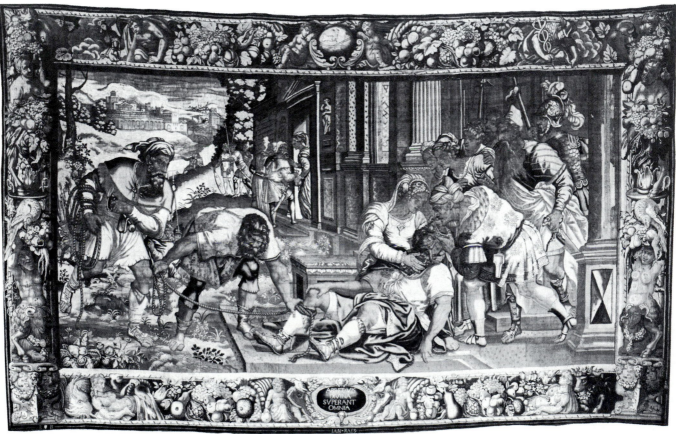

Plate 68. Jan Raes: *Tapestry: Samson betrayed by Delilah*

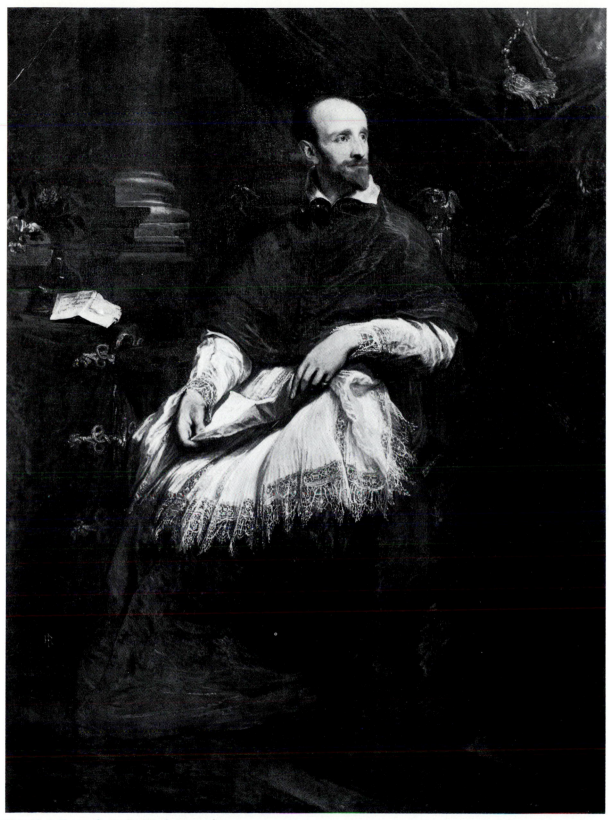

Plate 69. A. Van Dyck: *Cardinal Guido Bentivoglio*

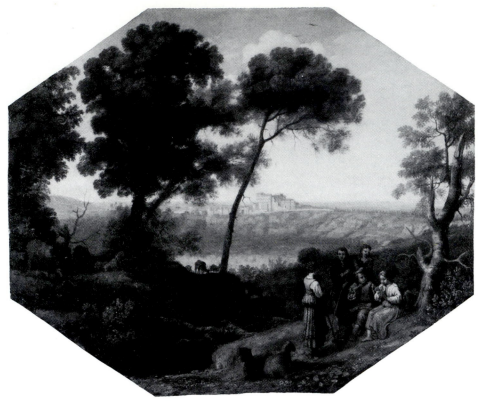

Plate 70. Claude Lorrain: *Pastoral landscape with a view of Lake Albano and Castelgandolfo*

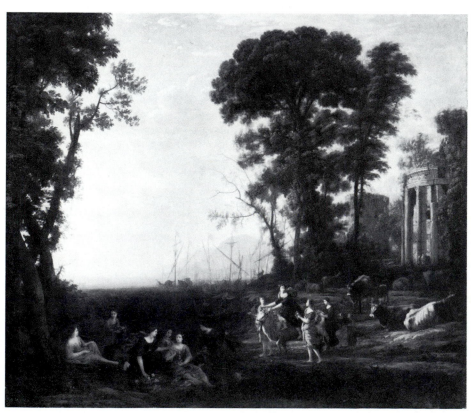

Plate 71. Claude Lorrain: *Coast scene with the Rape of Europa*

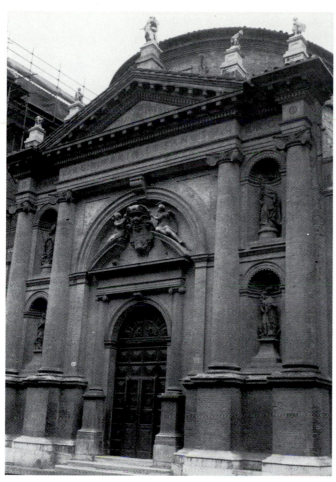

Plate 72. G. B. Aleotti: *S Carlo, Ferrara*

Plate 73. *Ferrara: Church of the Confraternity of the Stigmata*

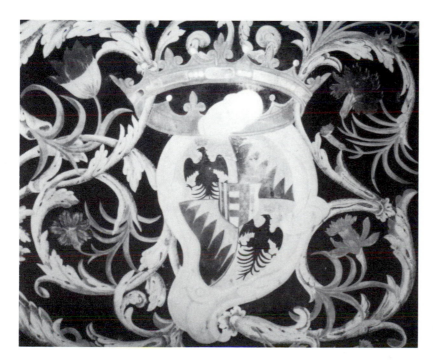

Plate 74. *Altar frontal incorporating the Bentivoglio coat-of-arms*

Plate 75. *Cardinal Bishop Lorenzo Magalotti*

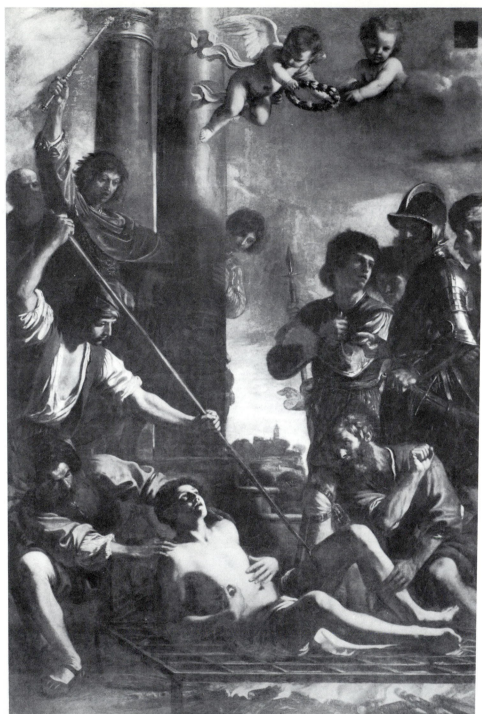

Plate 76. Guercino: *Martyrdom of San Lorenzo*

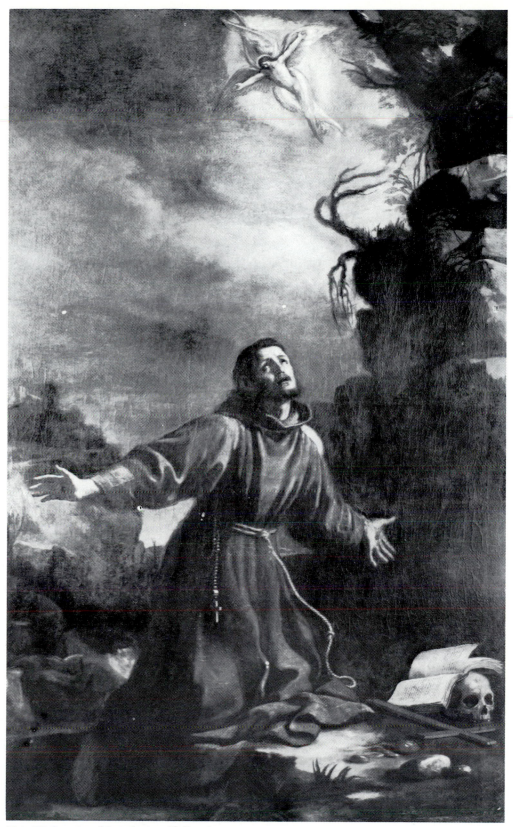

Plate 77. Guercino: *Stigmatisation of St Francis*

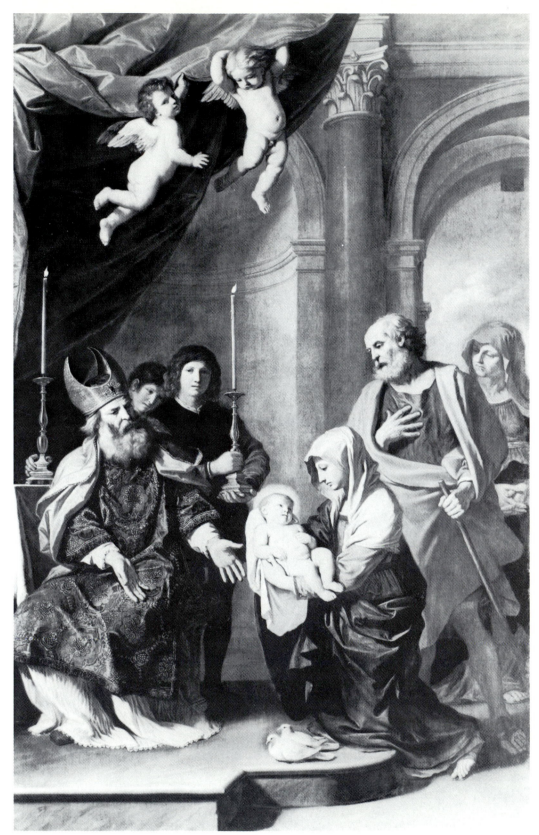

Plate 78. Guercino: *Purification of the Virgin*

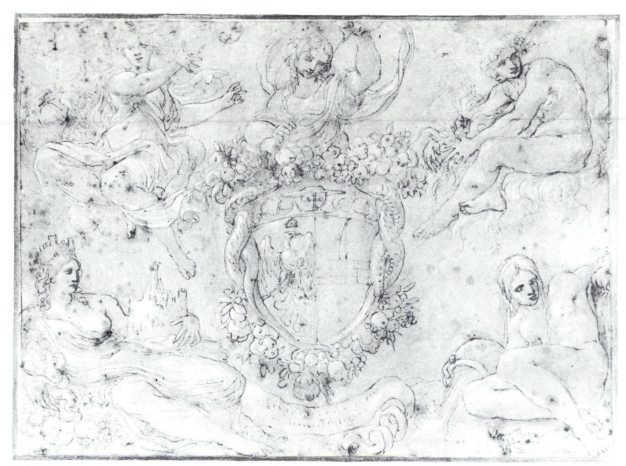

Plate 79. Lodovico Carracci: *Escutcheon with the 'stemma' of the Cardinal Spinola*

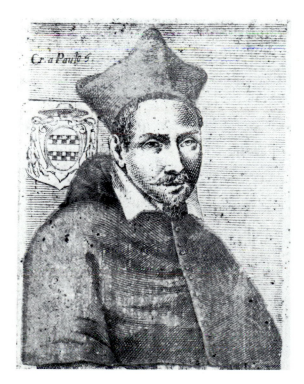

Plate 80. *Cardinal Giacomo Serra*

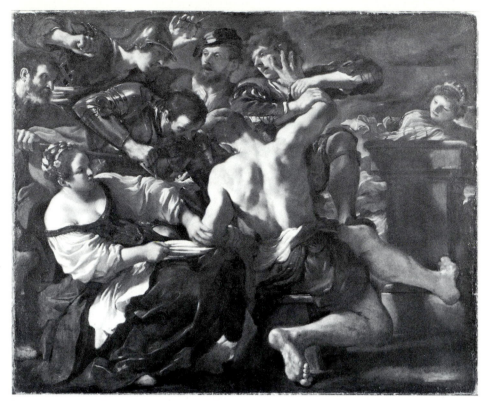

Plate 81. Guercino: *Samson captured by the Philistines*

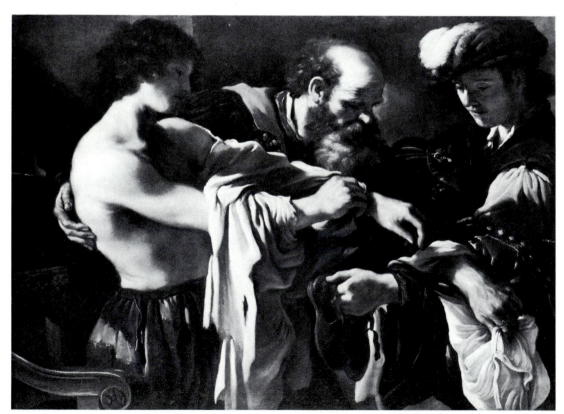

Plate 82. Guercino: *The Parable of the Prodigal Son*

Plate 83. Giovan Valesio: *Escutcheon with the 'stemma' of the Cardinal Serra*

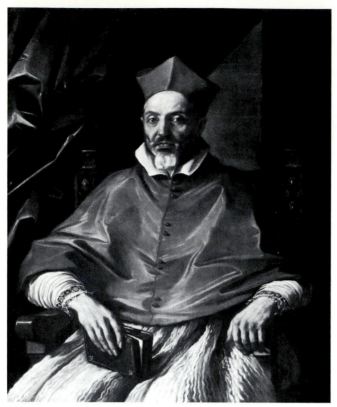

Plate 84. Guercino: *Cardinal Francesco Cennini*

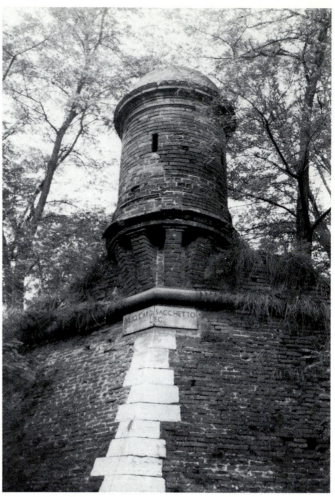

Plate 85. *Ferrara: Bartizan with inscription commemorating the Cardinal Sachetti*

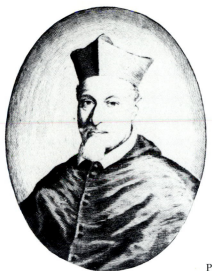

Plate 86. *Cardinal G. B. Pallotta*

Plate 87. Guercino: *Damon and Pythias*

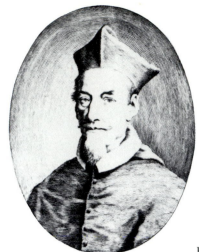

Plate 88. *Cardinal Stefano Durazzo*

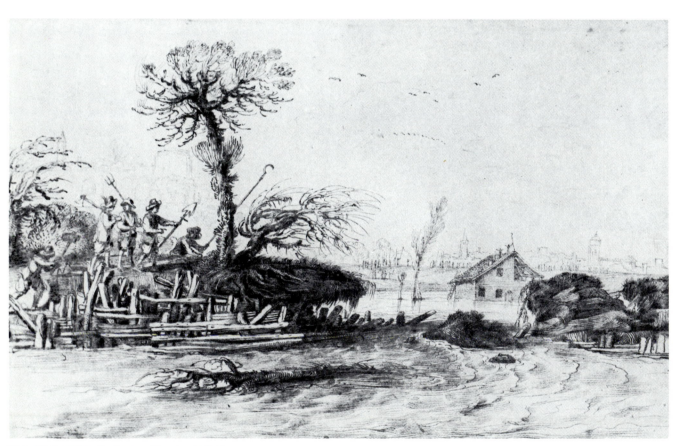

Plate 89. Guercino: *Landscape with a river in flood*

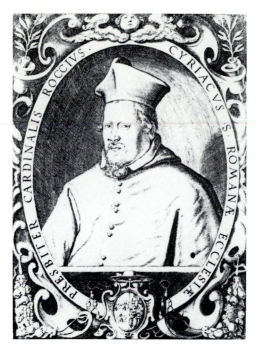

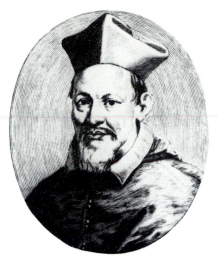

Plate 91. *Cardinal Marzio Ginnetti*

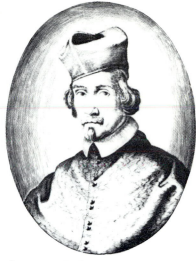

Plate 92. *Cardinal Stefano Donghi*

Plate 90. *Cardinal Ciriaco Rocci*

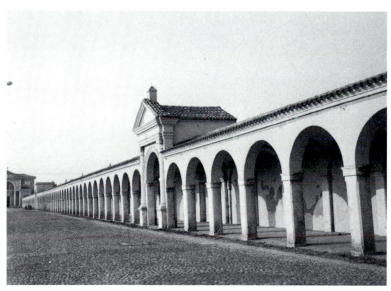

Plate 93. Comacchio: *Portico, façade*

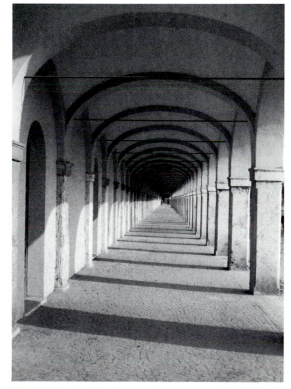

Plate 94. Comacchio: *Portico, interior view*

Plate 95. G.B. Aleotti: *Façade of the Studio (now the Biblioteca Comunale Ariostea), Ferrara*

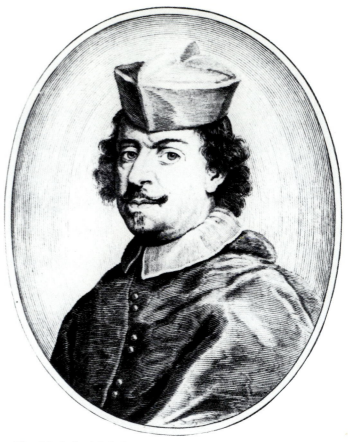

Plate 96. *Cardinal Carlo Francesco Pio*

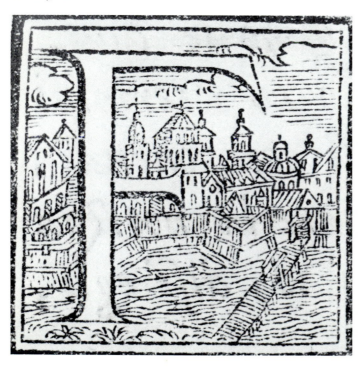

Plate 97. *Capital 'F' with a view of Ferrara*

Plate 98. Luca Danese: *Sta Chiara, Ferrara*

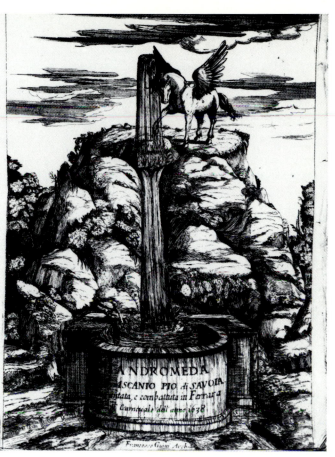

Plate 99. Francesco Guitti: *Title-page to 'L'Andromeda', 1638*

Plate 100. *L'Andromeda: Seascape with Time*

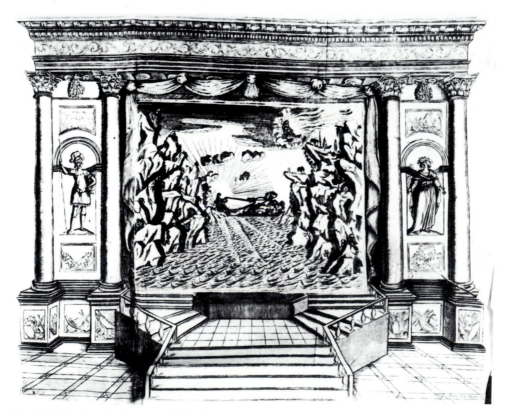

Plate 101. *L'Andromeda: Seascape with Sunrise*

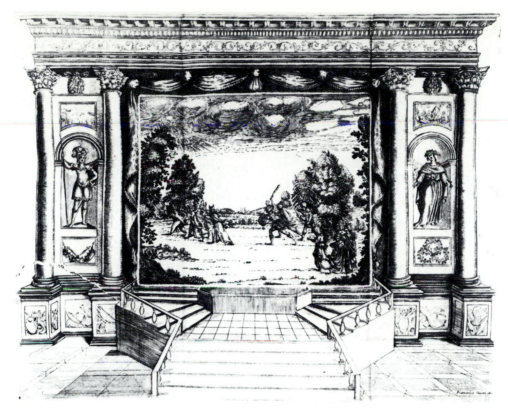

Plate 102. *L'Andromeda: Pastoral landscape with the priests of Neptune and Amphitrite insulted by the servants of Queen Cassiopeia*

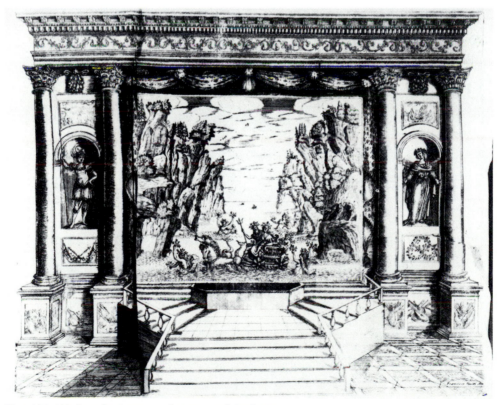

Plate 103. *L'Andromeda: Seascape with Neptune and Amphitrite*

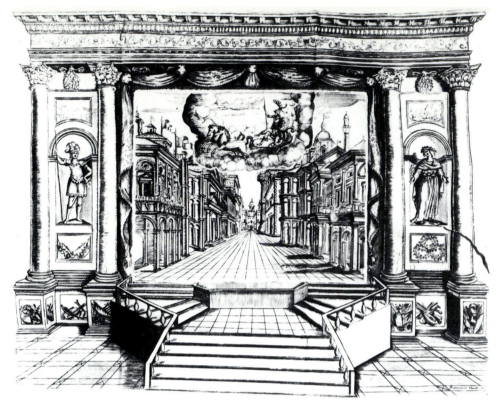

Plate 104. *L'Andromeda: City of King Cepheus with the Chariot of Mars*

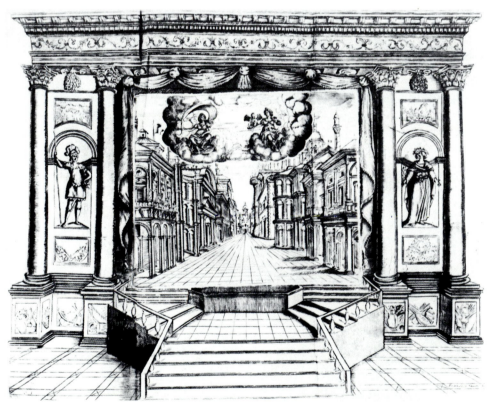

Plate 105. *L'Andromeda: City with Fortune and Goodness*

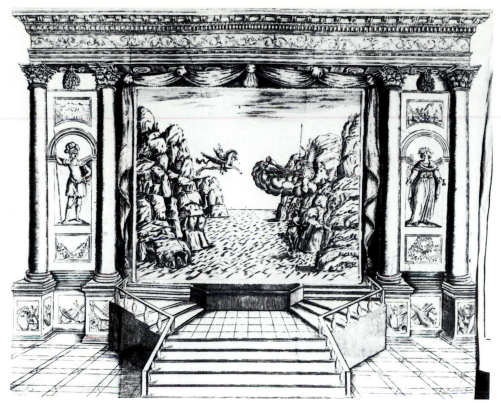

Plate 106. *L'Andromeda: Seascape with the Chariot of Pallas, Andromeda, Perseus and Pegasus*

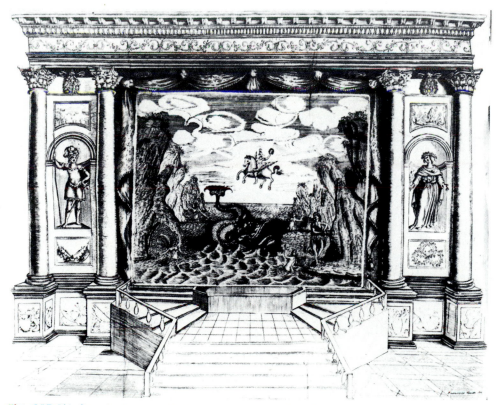

Plate 107. *L'Andromeda: Seascape with the sea monster emerging from the waves*

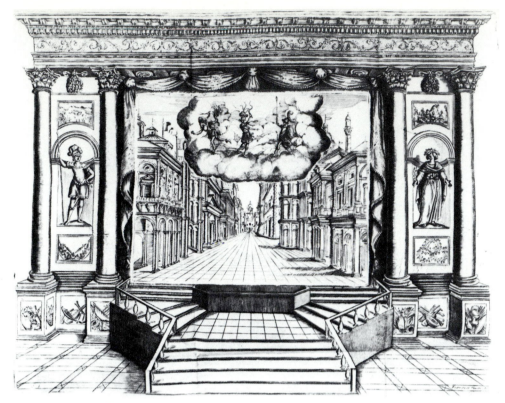

Plate 108. *L'Andromeda: City with the fiery cloud of Mars. Bellona and the Fury*

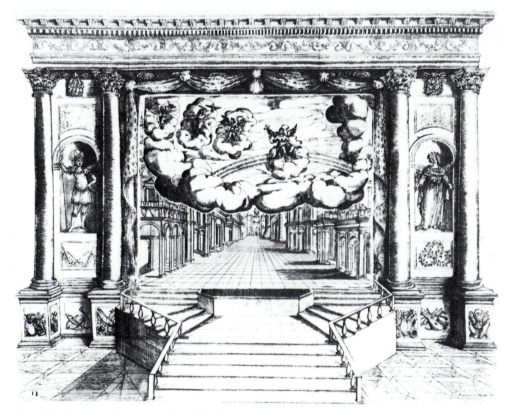

Plate 109. *L'Andromeda: City with Isis and the Evening Hours*

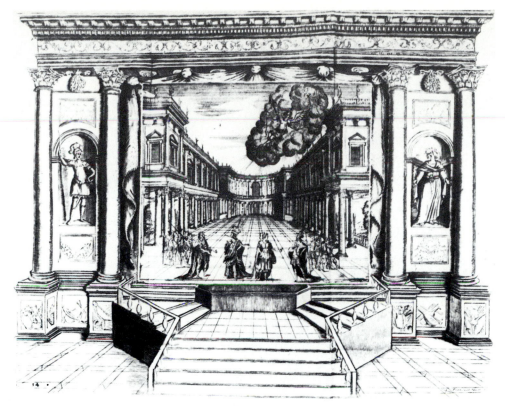

Plate 110. *L'Andromeda: Royal Court with Evening Twilight*

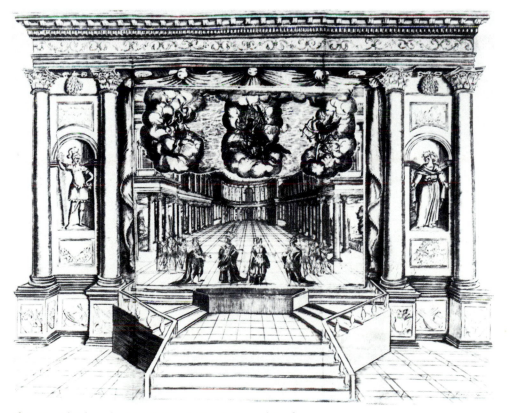

Plate 111. *L'Andromeda: Royal Court with Jove, Hymen and Cupid*

intended to endear Serra to the Pope rather than Ferrara.[30] (The statue, now destroyed, was attributed to a Genoese named Gio. Luca, and if the attribution is correct it may be that Serra had himself summoned the sculptor to Ferrara. The statue inscription was composed by Serra's *mastro da casa* Ghino da Ghini of Forlì, who also drafted the inscriptions inside the church of the Annunciation within the Fortress.) The Legate's interest in Ferrara was becoming proprietorial: his Po-Panaro canal, for example, was known locally as the *Cavo Serra*. On the election of Pope Gregory XV Ludovisi in 1621, Serra paid for reappointment to Ferrara, and when the Holy See fell vacant again in 1623 it was Serra's name and coat-of-arms which appeared with the *Sede Vacante* on the coinage of Ferrara's Mint – an assumption of permanence, perhaps, which was not repeated in a subsequent interregnum.[31] In 1623 Serra left Ferrara for the conclave in Rome which elected Urban VIII and not only did he reassure the Commune that the new Pope would be a friend to Ferrara but he also expected to return.[32] But at the end of an unbearably hot August in Rome, Serra died.[33] From the church of the Gesù his body was taken to his last titular church of Sta Maria della Pace to await transport to Genoa and burial in the family tomb. His third city, Ferrara, was excluded from the funeral rites. His collection of Guercino paintings was dispersed, some perhaps taken by the nephew Gio. Paolo Serra who had accompanied him to Ferrara (and who, on the testimony of Malvasia, had shared his interest in art), others perhaps left in the Castello to be acquired by his succccessors.[34] More enduring, for the time being, were the buildings and commemorative inscriptions which Serra left behind, and more influential were the precedents he bequeathed to subsequent Legates in both conduct and the patronage of public works.

(ii)

It may have been to prevent the building of private empires in Ferrara that the Barberini introduced a strict three-year term of office, without reappointments, for the Legates of their choice. Thus they reduced the possibility of identification with Ferrara's interests to almost nil. The Barberini age was, moreover, a great age for Rome and St Peter's but an age of war or the threat of war for the Papal States, and Ferrara suffered as troops poured in, finances collapsed and new defences entailed new demolition. Yet it was the Barberini who by their appointments to the legation gave Ferrara some twenty years of government in which strong-minded reformers alternated with the more lenient and encouraging (that is, the Genoese alternated with the rest), and to measure the effect of this sequence of governors it is worth taking each three-year term as it came.

After Serra came the Tuscans. First, following a brief interregnum when Enzo Bentivoglio's friend Luigi Capponi served as stopgap, was the Cardinal Francesco Cennini from Siena, who presided over the building of forbidding gateways (now demolished) to enclose the Ghetto, ordered the signposting of rubbish dumps and left in 1627, taking with him the portrait which Guercino had painted in, perhaps, 1625 (Plate 84). Ubaldini remembered Cennini as a weak man, ruled by his police officers, and perhaps there is weakness, or at least mildness, in the features Guercino portrayed.[35] He was followed by the Cardinal Giulio Sacchetti, a member of the very wealthy Florentine banking family. Sacchetti in Ferrara welcomed the visiting

115

Velázquez in 1629 (he would have met the painter during the nunciature to Madrid which had preceded his appointment to the cardinalate and Ferrara), commissioned paintings from Guercino and made the acquaintance, like Serra before him, of the Ferrarese collector Roberto Canonici, to whom Sacchetti also made gifts of antiquities and such curiosities as a rhinoceros horn.[36] But it was just one of the consequences of sad times that Sacchetti, who would become famous as a patron of artists, was so preoccupied with the practical needs of Ferrara that there seemed little time for art. When Sacchetti became Legate to Bologna in 1637, he brought Pietro da Cortona to that city to advise on the education of artists, but when he had arrived in Ferrara ten years before he had plunged straightaway into a succession of crises caused by flood, war and the fear of plague.[37] Even so, he managed to leave a fine reputation behind him. Sacchetti was very popular in Ferrara for his gentleness of manner and his kindness. New bakeries were built during his term and he offered his own money to help relieve the city's famine – after his departure the Commune pursued a debt of 200 *scudi* for bread he had dispensed to the hungry and Sacchetti quickly apologised and made arrangements to pay.[38] As he was preparing to leave in 1631 (he had stayed an extra year as Co-Legate to Antonio Barberini, head of a triple legation in expectation of war), Sacchetti was forwarding to Rome wordings drafted by the Vice-Legate Chigi for inscriptions on the city walls and the Fortress to commemorate Urban VIII's new defences.[39] His own memorial in Ferrara is of a similar kind, carved on a bartizan tower at the south-east corner of the walls; the effect is strangely pretty, but this is also a sad reminder of what Sacchetti might have done in peace-time (Plate 85).

The Cardinal Gio. Battista Pallotta, from Calderola in the Marche, had been Vice-Legate in 1623 and when he returned as Legate in July 1631, aged 37, the chronicler Ubaldini noticed a distinct change in manner (Plate 86). Where the Vice-Legate had been courteous and charming, the Legate was rigid and cold, and as Pallotta made rather similar remarks about changes he saw in Ferrara, it was clear that the city and the Legate were not destined to agree.[40] When the *Giudice dei Savi* of 1632, Gio. Rondinelli, made the mistake of co-operating with Pallotta, he was criticised by his peers, and in 1633 a minor rebellion among the Ferrarese nobility resulted in the unprecedented arrest and imprisonment in the Castello (as opposed to the more customary and genteel house-arrest) of the ringleader, Nicolo Estense-Tassoni. The Legate explained that he had had no personal animosity towards the man and had tried not to use the special powers granted him by the Barberini, but he feared Estense-Tassoni's influence in Ferrara, and particularly in the local elections.[41] Circumstances, it seemed, always forced Pallotta's hand.

'Candid and free' was Pallotta's own assessment of his style, and in this spirit he set about a range of civil and military engineering works in Ferrara.[42] He was responsible for progress on the new *mezze-lune* reinforcements for the Fortress, and his discussions with the papal engineers Giulio Buratti (architect of the *Fortezza Urbana* and brother-in-law of the luckless Pompeo Targone) and Pietro Paolo Floriani (like Pallotta, from the Marche) must have served Pallotta in good stead when, in the 1640s, he was responsible for new fortifications designed to protect the Loreto coast against Turkish raids.[43] But more immediately, Pallotta looked to the border with Venice. 'Being the Cardinal Pallotta Legate to Ferrara', remembered a Venetian historian thirty years later, 'many changes and much damage was done on the Venetian border, building prisons, laying roads, diverting the course of the Po.' Acting on

his own initiative, or at least in such a way that he alone took responsibility, and presumably credit, Pallotta had within six months of his arrival rendered the Po from Ariano to the sea at Porto di Goro impassable to armed ships, and when the Venetians retaliated, he had a fort built at Bocchette to meet their threat.[44] On the civil engineering front, Pallotta reminded the Barberini in February 1632 of a plan to dig a canal from the Castello to the city walls so as to provide both earth for the construction of defences and, 'for the benefit of the (Apostolic) Chamber and for the public and private benefit of the city', access to the *Cavo Barco* and thus to the Po. It was perhaps to this project which the elder Cardinal Pio took exception, loudly, in Rome: 'send him to me', wrote Pallotta to the Cardinal Barberini, 'the best servant and gainsayer Your Eminence possesses'.[45]

Very soon after his arrival in Ferrara, Pallotta had also assessed the risks of flooding in the state and seen the need for a provision, similar to that for the streets, for the regular repair of embankments and, most urgent, for new dykes to safeguard the land around Bondeno on the river Panaro. But for this he was required to collaborate with his neighbours Modena, Mantua and Mirandola, and when Pallotta left Ferrara in 1634 repairs had been carried out on the Ferrarese side at Bondeno, but not yet the Modenese, and the new dykes were still awaited.[46] Faring rather better, however, was the scheme designed to improve navigation on the secondary branches of the Po which flowed through the Ferrarese state, the Po di Primaro and Po di Volano, which constituted a major hydraulic undertaking in the interests of commerce upon which both Buratti and Floriani were consulted while the local architect and engineer Giacomo Rosselli supervised. Pallotta, writing to Rome, looked forward to a time when there would be 'no more Po di Primaro but . . . Po Barberino to the perpetual glory of the name and House of His Holiness and memory of his incomparable beneficence to this state'.[47]

Once described as 'desirous of glory and of undertaking works of great public benefit', Pallotta was also highly conscientious and anxious to complete all works within his brief term of office.[48] On the strength of his relations with executants, it might have been done. Buratti, Floriani and the official architect Danese apart, Pallotta made great use of two Capuchin friars who were also surveyors, one Fra Francesco of Lugano, whose presence he had requested in June 1632, and the other Fra Giunipero, whose grandfather appears to have been a mason in the employ of the Duke of Modena. For some ten years, Fra Giunipero was one of the most useful members of the legation staff, overseer of building projects in the city and the Fortress and of various civil works. When fellow Capuchins jealously spread rumours in 1633 of a style of living (travel by carriage, for example) and duties incompatible with the Capuchin Rule, Pallotta defended Fra Giunipero: 'he works from morning to evening, helping, checking and going everywhere'. Ubaldini had little time for him, for it was apparently Fra Giunipero who had been responsible for the decision to reduce the number of Ferrara's city gateways to four (easier to patrol, but meaning further destruction). But the Legate saw his work from another point of view. Fra Giunipero had built a new granary for only some 500 *scudi*, and under his supervision, said Pallotta, nobody could 'gorge' at the expense of the Apostolic Chamber. It was very probably Fra Giunipero who set the compensation payment to the Servites at the conservative 7,000 *scudi*, with unhappy results for the plan of their new church.[49] Pallotta had also, however, a high regard for Ferrarese architects and engineers, including Francesco Guitti. It was Guitti who, acting as Floriani's assistant, took charge for Pallotta of the fortifications on the Po, and when Guitti was allowed to leave for Rome in December

1632, Pallotta recommended him warmly to the Barberini for his 'faithful and diligent service, his capacity and ability', qualities which Guitti had indeed shown in February of that year by running up in just seven hours a new redoubt with ditch and parapet capable of taking a garrison of fifty.[50] Pallotta had in addition requested the presence, by courtesy of the Jesuit Superior, of the Padre Nicolo Cabeo, an 'excellent mathematician, much skilled and knowledgeable about this country' explained the Legate. Cabeo advised Pallotta on waterways and land drainage schemes and thus the errors of earlier years and foreign advisers were avoided. But on one occasion even Cabeo's opinion was called into question, that is, when he proposed an excavation (at Punta di Stellata) which Pallotta's personal judgement told him would be wrong.[51] But it was hardly Cabeo's fault, for he, as adviser, was seeking a compromise forced by the land-owning nobility of Ferrara, and the nobility, not the executants, were Pallotta's stumbling-block.

The Venetians blocked his defences (they also refused to sell him rubble to use in defence building), local landowners blocked his flood precautions, papal soldiers blocked his policemen, and Bishop Magalotti blocked his attempt to extend civil law and order into the ecclesiastical world. When local priests objected to the arrest of a fugitive in a Carmelite convent, Pallotta wrote to Rome of their desire 'to make new tragedies and bring new discredit to me and my courts'. Magalotti even blocked Pallotta's scheme for cleaning the streets (the only occasion on which Ubaldini found fault with the Bishop), because he construed the call to the clergy to contribute as an invasion of ecclesiastical immunity.[52] In the end, Pallotta's health broke down. As he explained to Rome, he had 'tolerated, dissimulated, fooling even myself', but the strain told in the chronic headaches from which he suffered, and the works he had promoted fell behind.[53] When his successor arrived in May 1634, he found an accumulation of work to be done.

Yet Pallotta had tried to be a benefactor. Years later, as a member of the building committee for St Peter's in Rome, he would oppose Bernini's scheme for a new and grand Piazza because 'it would reduce the Borgo to nothing', and in Ferrara he had never been a wanton destroyer.[54] He had protected the city's palaces from conversion to religious use, for it would be 'most inconvenient in such a city as this to take one of the most impressive and spacious residences and damage it for the use of friars'.[55] New trees had been planted along the city walls and the Strada dei Pioppони, laid by order of Ercole I d'Este, had been extended beyond the Palazzo dei Diamanti to Sta Maria degli Angeli.[56] The Castello Estense itself had been renovated, its prisons removed and the marble staircase continued up to new apartments on the top floor. Admittedly, these latter improvements may not have been unconnected with the 'diligence' Pallotta used in accommodating the rebellious Nicolo Estense-Tassoni in the Castello in 1633, but that imprisonment was apparently not so uncomfortable, for he was given two rooms 'more healthy, more noble, more cheerful, more pleasant and larger than any in his own home' wrote Pallotta to the Barberini.[57] There had been demolition about the Castello, but partly in order to open a new road 'for convenience and ornament to the city', and partly to make way for a new educational initiative.[58]

During Pallotta's last months in Ferrara in 1634 he was spending his own money on the purchase (through the agency of Enzo Bentivoglio) of sites for a new school which would, he proposed, be run in a manner different from other colleges, by which he may have meant his suggested system of local community grants to students. The Jesuits would administer

the institution, and Pallotta hoped that the Barberini themselves would take his '*Collegio Urbano*' under their protection. Pallotta was a confirmed educationalist – as senior prelate of the Marches of Ancona, in the 1640s he would take charge of schools founded there some fifty years before by Pope Sixtus V.[59] But in Ferrara, he seemed a hopeless idealist. As Serra before him, Pallotta was anxious to keep the noble youth of the city usefully occupied – he once tried to lure back a riding master, Tarabino, who had transferred to Modena by promising him an arranged marriage, notwithstanding the man's advanced age.[60] Combining his own interest in the cavalry arts with supervision of the nobility, Pallotta had a space cleared near the Castello where they might practise their skills under his observation, ordered a brick bridge to be built across the moat, had old trees felled for the convenience of riders and audience and new trees planted for amenity. But the nobility turned down the invitation and continued to practise in their preferred venue by the Piazza Nuova.[61]

Art must have been a relief for Pallotta, for he made use of his time in Ferrara to visit the studio of Alessandro Tiarini in Bologna, and it was perhaps on these visits to Bologna that he acquired the paintings by Francesco Albani which were later mentioned, with pictures by Mattia Preti, as being in his possession.[62] He was also a patron of Guercino. Yet even in his patronage there were, perhaps, signs of strain. If there is any truth, for example, in Malvasia's story that Pallotta first ordered as a parting gift to Francesco I d'Este and then retained a *Christ and the Moneychangers* painted by Guercino in 1634, it might be explained by the state of hostility which often obtained between Modena and Ferrara during Pallotta's term. The demonstration of good faith and self-sacrificing loyalty between friends in the *Damon and Pythias* which Pallotta commissioned from Guercino in 1632 almost asks to be interpreted in the light of Pallotta's character (Plate 87).[63] As it happened, it was this painting which, according to Malvasia, later became the property of Fabio Chigi, which was not unfitting, for Chigi had been Pallotta's steady and invaluable support as Vice-Legate. It would, indeed, be the 'sufficiency and excellent quality' of Chigi which, when Pallotta had already left Ferrara for his native Calderola, would brief his successor in May 1634. Then Chigi too departed to become Apostolic Delegate to Malta, and the legation changed hands.

The Cardinal Legate Stefano Durazzo was Genoese and so was his Vice-Legate Girolamo Moneglia, and soon a tougher spirit showed in despatches to Rome (Plate 88). 'I must say that even if it is guided by zeal, I doubt that it will last, and I will not encourage it, for this is not a time when the communes can afford the expense'; and thus Durazzo laid Pallotta's *Collegio Urbano* to rest.[64] Durazzo had been the Papal Treasurer and he was now specifically charged with improving the 'pecuniary interests' of Ferrara. Six months after his arrival the city was well on its way to settling its debts, for 'without taking from any official his authority, I have gently drawn to myself the control of the matter'.[65] Once asked to comment on proposals to improve the local administration, Durazzo agreed that official welcomes must be curbed, for the 'cost exceeds the capacity of the public, often passing 1,000 *scudi* and . . . as the community has debts, one can fix a limit of 200 *scudi* and then only for the Legate or other prince'.[66] It was said against Durazzo, as against his compatriot Serra, that he was 'good only at keeping accounts'.[67] This was unjust, but he was without doubt a realist.

To Durazzo it was clear that the upkeep of the state thoroughfares mattered more than education. 'Because I wish as far as possible that my letters attest the truth', he wrote in June 1634, 'I plan to travel in person all the waterways of this legation'.[68] The need for

119

first-hand experience informed all Durazzo's undertakings as Legate. He made himself familiar with alternative methods of building a fort (for example, earth, time-consuming and expensive, or wattle), and he learned the local language of water management: when reporting on flood repairs in 1635 he used the term *restara*, then added, in a helpful marginal note, that the *restara* 'in these parts they call the ground between the dyke and the river'.[69]

No less than his predecessor, Durazzo respected the individual merits of the architects and engineers at his disposal. The Padre Cabeo was a hydrostatician and therefore not the man to send to repair a fort. Instead, Durazzo sent the Commune architect–surveyor Bartolomeo Gnoli, to assist Francesco Guitti.[70] The efficient Fra Giunipero could safely be left to superintend all works, and plans drawn by the architect Luca Danese were despatched to Rome (as was Danese himself on occasion) with a note of their 'exquisite diligence'.[71] Again, however, it was Francesco Guitti who enjoyed the Legate's special favour. In 1635 he repaired, and in the process strengthened by the addition of a sluice-gate, the papal fort at Bocchette on the Po. Shortly afterwards, in July 1635, Durazzo nominated Guitti for the reversion, when the aged Aleotti should die, of the post in perpetuity of architect to the Fortress.[72] The executants were the same, and so was the work they did, yet everything seemed to progress more quietly under Durazzo than it had in Pallotta's day.

Durazzo was a peacemaker, the mediator in 1637 of a dispute between Modena and Mantua, but he was not mild.[73] In January 1635 the river Reno overflowed its banks and particularly serious was the flooding at Sant'Agostino on the border with Bologna. (Guercino's drawing, *Landscape with a river in flood*, may record this disaster (Plate 89).) Durazzo sent his Vice-Legate to supervise the repair work by Luca Danese and Gnoli, and then arrived himself to inspect the damage and the repairs. But, he reported to Rome, while 'our part' had been completed, the 'Signori Bolognese not only do not wish to condescend to this task, but have required that our men stop', and for once his temper and patience were tried as he urgently appealed to his colleagues in Bologna, the Cardinal Baldeschi, for a meeting to resolve differences.[74] There was, of course, reputation at stake in this exchange of letters. As Fulvio Testi had reported in 1634, it had then been rumoured that Baldeschi would be posted to Ferrara, but in the end he had obtained the higher-ranking appointment.[75] Yet there was also genuine concern in Durazzo's response.

Stefano Durazzo was, in fact, capable of a greater sensitivity towards the needs of Ferrara than might have been expected when he arrived to audit its books, After only six months in office, he had requested extraordinary aid to clean the city's streets and drains ('which here are called *dozze*', he explained), since in their present condition they were a hazard to public health and the 'decorum' of the city.[76] In 1636 he saw that 'the city's houses . . . while they serve as billets for soldiers, quickly become uninhabitable', (the estimated number of infantry and cavalry in Ferrara in the 1630s was 2,400), and thinking of ways of 'housing the poor people' he forwarded to Rome with his letter of recommendation the city's case for a new barrack building, proposing a new *monte* to pay for it and an income in peacetime from civilian rentals.[77] In May 1637 Durazzo, nearing the end of his term, could report good progress on the new defences for the Fortress, from which, he added, 'would result such security and decorum to the city as to render it surely one of the most impressive in Italy', and income from the sale of fishing rights, he suggested, would cover the maintenance costs.[78] In Stefano Durazzo, as in Giacomo Serra, financial good sense mixed

happily with a sense of responsibility for, and pride in, the legation under his control.

Durazzo was respected in Rome for his excellent management of Ferrara, and in Ferrara itself his legation was regarded as a time of 'good and holy government'.[79] During his term he had acquired at least three paintings by Guercino, no portraits or mythologies but devotional pictures. In 1635 the Commune of Cento had presented him with a picture of *St Joseph* in which Joseph was teaching carpentry to the Infant Jesus, an apt choice for a Legate so drawn to the practical. In 1636, while his relative Giacomo Saluzzo ordered a *Rinaldo and Armida* from Guercino, Durazzo paid more for a *Madonna and Child*, and in 1637 commissioned a *St John in the Desert*. It may be that the *San Lorenzo* ordered from Guercino in the same year by the Vice-Legate was also intended for Durazzo, who certainly later possessed a *San Lorenzo distributing the goods of the Church* which was attributed to Guercino.[80] There was, perhaps, no more popular saint than San Lorenzo in Ferrara of the mid-1630s, for not only was he a patron saint of Genoa (and Durazzo's titular church in Rome was S Lorenzo in Panisperna) but he was also the name saint of the Cardinal Bishop Magalotti. It was notable that Durazzo at least was able to work well with the powerful Bishop, and the influence of Magalotti may have been the most important gift which Durazzo took when he left Ferrara in 1637. In 1634 Durazzo had been appointed Archbishop of Genoa but the legation to Ferrara, followed by his appointment to Bologna (where he was a kind patron to the ageing Guido Reni) in 1640, obliged him to be absent from his see. But when he returned to Genoa he would become famous for his active encouragement of the building and repair of churches and for his long dispute with the Republic over the subsidy to poor churches.[81] Since Magalotti would appear to have been the immediate example before him, it must have been satisfying for Durazzo to receive in 1650, by means of a thoughtful bequest from his friend the Cardinal Monti, the same *Massacre of the Innocents* by Scarsellino that Monti had himself received from Magalotti.[82] Ferrara, meanwhile, had come under rather different management.

In 1637 the Cardinal Ciriaco Rocci, a former Vice-Legate, returned as the Legate to Ferrara (Plate 90). The Ferrarese were reported to be delighted, for Rocci was known to be a 'mild and gentle' man.[83] Under the rule of Rocci, control was quickly relaxed, as the outbreak of crime in 1638 and the sudden and unexpected arrival, direct from Rome, of the new police lieutenant Argoli, might suggest.[84] The genial Rocci belonged to a Cremonese family which had settled in Rome, where he had become rather a figure of fun for his apparent dullness, his greed (a taste for the grapes which formed part of the Rocci *stemma* would finally, in 1651, kill him by choking) and his conceit: 'if they had chosen me', he once said of the exiled Barberini, 'they would not now be in the labyrinth'.[85] But if Rocci was foolish to imagine that he might have been Pope, he was at least one of the few to keep faith with the Barberini, which was a mark of some distinction in a turncoat world, if not politically wise.[86] From his taste in art, Rocci was certainly devout. The first painting he ordered from Guercino was a *Lucrezia Romana* in 1638, but in 1639 he commissioned a *Penitent St Peter* and a *Magdalen*, while the Commune of Cento, which seemed to be quite sensitive in its choice of gifts to the Legates (preferences may have been canvassed in advance), had in 1638 ordered a painting of the *Dead Christ* for Rocci.[87] Rocci also kept as sharp a look-out as his predecessors for spies in Ferrara, and in June 1638 sent the architect Guitti and a captain from the Fortress to reconnoitre and report on Venetian defences on the Po under cover of a fishing trip – one result of which was a map drawn and signed by Guitti with a flourish to be expected of a

121

man who also designed for the theatre (Colour plate 5).[88] But Rocci was not a disciplinarian and he was disposed to be generous in Ferrara, which affected his style of government.

'I believe', he wrote to the Barberini in March 1638,

> that one could give permission to these Ferrarese of being able to place on its feet again the Academy of the *Intrepidi*, for thus the youth in particular, who are for the most part idle, may advance in the literary and cavalry arts that once thrived in this city . . . and I would also give assistance to encourage them in such a way that there would be no need to fear sinister repercussions.[89]

Rocci had clearly been so impressed by the 'Barriers with various machines' (that is, the *Andromeda*) which had welcomed him formally to the city during the Carnival of 1638 that he had willingly listened to the arguments of the Ferrarese nobility. In June that year he gave further proof of his encouragement of the performing arts in Ferrara by appearing, in full pontifical robes, on a stage structure built in the Piazza Nuova. The performance was, admittedly, devotional in intent, for this was *Ferrara Trionfante*, celebrating the Coronation of the Rosary, and an inscription in the rosary Chapel of S Domenico, where the venerated image of the Virgin of the Rosary was kept, still records the occasion. Durazzo's dignity would not have countenanced his participation (Pallotta would not have been invited) and had Magalotti been alive the performance might well have been forbidden as indecorous. But Rocci enjoyed the theatrical and when in May 1640 a group of young Ferrarese wished to show their respect for the Legate and the ladies by performing a pastoral play, and hoped that the Commune would contribute, a note on their letter of application revealed that Rocci himself would pay 10 *scudi* for lighting.[90]

Rocci was happy in Ferrara, so much so that in 1640 it was said that he would cheerfully end his days in the legation.[91] It therefore seemed unjust that in October 1640, at the very end of Rocci's term, the river Po should burst its embankments at La Zocca, causing a flood which some believed must be the worst in centuries in Ferrara. Rocci duly sent his Vice-Legate, the Genoese Girolamo Lomellini, to the scene and then came himself to survey the repairs, which he described in his report to Rome. The new retaining palisade amazed him: 'believe me, this structure deserves to be seen as a great work achieved in very little time'. (Illustrated in Colour plate 6 is Luca Danese's sketch of 17 March 1652 illustrating repairs undertaken for another flooding of the Po and showing in particular the *coronella* (so called, suggested Aleotti in the *Idrologia*, because it forms a proud crown to the embanked area) and the row of *gucchie* (needles, or piles) driven into the earth to fill the gap in the bank.[92] Rocci's report was comforting, but somehow suggested a theatrical show rather than a disaster. Equally reassuring was his estimate of the cost as 20,000 *scudi* and not the 40,000 first feared, and at the most 25,000 *scudi*.[93] But the *Rotta alla Zocca* would eventually cost Ferrara at least 80,000 *scudi*, and according to Alberto Penna it was nearer 90,000.[94] It would be a grave burden upon Ferrara, as Rocci's successor lost no time in pointing out to Rome.

The successor was Marzio Ginnetti from Velletri, who would come to share with Sacchetti the reputation of being Ferrara's most popular Legate (Plate 91). With the experience gained from administrative duties as Vicar of Rome and diplomatic duties at the peace negotiations in Cologne, Ginnetti took charge of the emergency, explaining to Rome the need for extraordinary aid and working closely with both local noblemen and Luca Danese to ensure that the

damage was made good.[95] A year later, in October 1641, it was raining heavily again and another disaster was feared. The Vice-Legate Lomellini was sent to inspect the places most at risk and Danese undertook preventive maintenance of the dykes (using the opportunity to review also Venetian defences along the Po).[96] Ginnetti himself remained in Ferrara to keep the people calm and 'try to encourage them not only with words but with deeds, watching everywhere, giving orders, regardless of time and discomfort' – it made an impressive despatch, but Ginnetti knew well that another flood 'would be the entire extermination of the city and these poor citizens'.[97] By 6 November, however, the waters had subsided and 'The city breathes', wrote Ginnetti.[98] He was now able to devote time to other affairs and interests which showed him to be in sympathy with the Cardinal Rocci, if considerably more efficient.

Ginnetti was an art collector who perhaps used his time in Ferrara to acquire the many examples of Bolognese painting (from Francia and Amico Aspertini to the Fleming in Bologna, Denijs Calvaert and Reni and Albani) to which Malvasia would refer in his mention of the Cardinal's 'famous gallery'.[99] He also owned Guercino paintings, though seemed to commission none himself during his term of office. From the Commune of Cento, however, Ginnetti received a painting commissioned from Guercino in 1642 of *Angelica and Medoro*, a poetical subject which reflected Ginnetti's tastes.[100] Literary societies flourished in Ferrara in his day and he himself formed an academy for discourse and the composition and recital of poetry. When the Cardinal Franciotto of Ravenna, responsible for the management of the Papal State waterways, visited Ferrara in June 1642 he was welcomed by the Legate and a committee of Ferrarese noblemen with a literary gathering in the Castello.[101] Patronage of the theatre complemented Ginnetti's literary interests, and in January 1642 the legation (or it may have been Ginnetti himself), agreed to reimburse the Commune, whose entertainments budget was still restricted, for money spent 'staging the *festa* and paying the musicians' for a performance in the *Sala delle Commedie*.[102] The performances of early 1642 were given in honour of the Prince Prefect Taddeo Barberini, and since November 1641 local carpenters and painters (Leonello Bononi and Antonio Casoli were among the names of artists paid) had been working to plans provided by the architect Giovanni Burnacini for settings to a joust in the courtyard of the Corte Vecchia which, with the indoor *festa*, would welcome Barberini.[103] But if the joust and the *festa* brought a sense of gaiety to Ferrara after the floods, corresponding well with the kind and charitable government for which both Ginnetti and his former assistant at Cologne, the Cardinal Bishop Macchiavelli, were remembered in Ferrara, it was unfortunately the case that within a year the Pope would be at war with the League of Italian princes and Venice, and Ferrara would suffer the usual consequences.

When the first war of Castro was over in 1644, Ferrara needed strong rather than benevolent government, and the new Legate to Ferrara, who took up his appointment in July, was the Genoese Cardinal Stefano Donghi (Plate 92). Donghi would be the last of the Barberini Legates, for in the same July Urban VIII died, and the dove which Donghi had had added in May to his portrait commissioned from Guercino in February (when Donghi, the papal plenipotentiary for peace, had come to Ferrara to sign the treaty) therefore seemed a wise and prophetic precaution, though it may simply have personified the peace. On the election of Pope Innocent X Pamphili, upon whose *stemma* the dove featured prominently, Donghi was duly reappointed to Ferrara.[104] As the Cardinal Rinaldo d'Este observed, Donghi was 'truly a person of spirit . . . much experienced in the ways of the world and . . . a fine judge of all things'.[105]

Donghi being Genoese, practical good sense informed his term of office in Ferrara. The legation archives were reorganised and the city's *Monte di Pietà*, bankrupt once again under the combined pressure of war, floods and the Bentivoglio, and in debt to the tune of 450,000 *scudi*, was 'rebuilt'.[106] But Donghi was also proud, which led him to make a number of silly mistakes, such as the sacking in 1647 of an architect who had made a thoughtless remark and who, when dismissed, simply crossed the border to Modena with information of use to the Este.[107] Donghi's soul, wrote one chronicler, 'could find neither rest nor quiet without great and magnanimous undertakings'.[108] Inevitably, therefore, he resurrected an old, but unrealisable, dream of popes and legates in which, by means of an excavation known as the *Cavo Contarino*, the main force of the river Po would be directed back into the Ferrarese channel and away from the Venetian border. New excavations were begun but floods destroyed them and at considerable cost to the state the scheme was again laid to rest.[109] The only mark Donghi left on the Venetian frontier was the *Torre Pamfilia*, a tower he had built to the design of Luca Danese.

Within Ferrara, Donghi was more successful. In March 1646 Francesco I d'Este was outraged at the high-handed way in which the Legate had virtually expropriated Este properties (only a derisory 600 *scudi* had so far been paid in compensation) in order to make way for a new canal from the Castello to S Benedetto by the city walls. But the *Canal Pamfilio* was of service to Ferrara and the Pope, for the Castello was now connected to the Fortress (which improved not only communications but also the quality of the water in the latter's moat) and, at last, it was possible to transport goods from the heart of the city direct to the Po at Pontelagoscuro.[110] At Pontelagoscuro itself, Donghi invested his own money in one of his most ambitious schemes, that is, the building of a new and capacious granary supported on *loggie* at the point where the canal entered the river – and dues from Po traffic could, advised Donghi, be channelled back to the *Monte di Pietà*.[111] In 1647 Donghi took up once more the perennial problem of Ferrara's streets, the dirtiness of which had in 1645 horrified John Evelyn (whom Donghi had in fact met at San Quirico in 1644). Having in Macchiavelli a rather milder Bishop than Pallotta had had to deal with, Donghi applied to Rome for a papal brief obliging the clergy to contribute and it was his opinion that they should also assist with the costs of repairing dykes and aqueducts and paying off Ferrara's public debt.[112] Having served a little longer than the usual term, Donghi departed in 1648, but he returned in 1663 as the Bishop of Ferrara, the 'Angel of Peace' according to one contemporary writer. What stance he now took on ecclesiastical immunity is not clear, but he had not forgotten Pontelagoscuro, and in the year of his appointment to the see he was seeking to acquire, from the Bentivoglio, a house in that district 'for my use and for the pleasure and the quality of the air'.[113]

From Giacomo Serra to Stefano Donghi, Ferrara had meant many things to its Cardinal Legates, from opportunities for self-advancement or public benefaction to a source of pleasure or mental fatigue and finally a place to retire. But what had they meant to Ferrara?

(iii)

The government of Legates has no other aim than to leave this city as they found it, or a little less, when they depart, and so deteriorating in the hands of each it inevitably follows that it loses its beauty, and lies miserable, as all the other cities of the Ecclesiastical State'.[114]

Cesare Ubaldini's judgement on the Legates from devolution to the early 1630s was perhaps both right and wrong: wrong, because their aim had always been improvement; right, because they failed. Partly they failed because among the problems they were facing were some which were present, or latent, in the latter years of the Este in Ferrara, while others were common to Italy, even Europe, at large and could not be solved by an edict. Partly they failed because their more reforming policies went against the grain of Ferrara, a city with traditions which could not be changed overnight. And partly they failed because of the very conditions under which they worked. Natural disasters, local indifference, or opposition, and changing policies in Rome killed worthwhile schemes from bakeries to schools, canals and flood repair funds, and no Legate stayed long enough to see his policy carried through. There was useful flexibility in the alternation of styles of government, but like all stop–go policies it achieved nothing in the long term. Repeated attempts to clean the streets, promote trade and industry, educate and protect from flood simply pointed to the need to repeat, for every initiative faltered when the Legate who took it had gone. Urban renewal in Ferrara proved too difficult for legation patronage. But east of Ferrara, at the Adriatic fishing port of Comacchio, was evidence that the same patronage could be creative when directed towards urban development.

The importance of Comacchio lay, as it always had, in the salt and fishing industries. The 50,000 *scudi* a year they yielded had been the most reliable of all Alfonso II d'Este's incomes, and from January 1598 this money was due to the Apostolic Chamber. Pope Clement VIII had visited Comacchio in 1598 and so had the Cardinal Aldobrandini, and among his company had been Guido Bentivoglio, to whom the little fishing village with its brackish, stagnant canals and humble buildings had seemed 'a dim and crude reflection' of the magnificent Venice he adored.[115] A century later the local historian Gio. Francesco Ferri of Comacchio would quote Guido's remarks and then confute them with a 'Comacchio reborn' under the patronage of the Papal Legates.[116]

It was Cardinal Serra who acted first to put both the trade and the *Monte di Pietà* of Comacchio on a firmer footing (helping the poor, it was said, by taking from the rich), and to install a freshwater fountain in the salt town. Then, in 1621, Serra had had built at the market centre a marble *loggia* where people could meet, trade and shelter from the weather, and above the *loggia* was a granary (Colour plate 7). The name of Serra's architect was not recorded, but the appearance of his building brings to mind the Loggia dei Mercanti at the Banchi, the commercial heart of Genoa which had been rebuilt in the 1590s, and the similarity was probably not accidental. Then Serra looked to the religious orders as a means of introducing new life into the community. The Capuchins were already established in Comacchio at the church of the Virgin in *Aula Regia*, and Serra, resorting as usual to financial incentives, hoped to persuade the Theatines to settle with an offer of 500 *scudi* a year. But the Theatines had to refuse him and Serra turned instead to the Discalced Augustinians, who accepted, and seemed thereby to maintain the old reputation of the Augustinians as agents of new life in depressed urban conditions.[117]

It may have been at Serra's instigation or encouragement that the Genoese Gio. Giorgio Costaguti now made his contribution to Comacchio. When the former Este hunting lodge of Le Casette was demolished, Costaguti used the bricks to build cottages for local fishermen. 'We lost a great splendour', admitted Ferri, 'but acquired a great benefit and one could say the life of those who had starved in shacks'.[118]

But no one cared as much for Comacchio as the Cardinal Pallotta.[119] According to Ferri, Pallotta found the air of Comacchio healthier than that of Ferrara and the statement might be read figuratively, for there Pallotta could escape the incessant wrangling in Ferrara and supervise improvements with which nobody wished to quarrel. Laying the first stone of the new church of the Discalced Augustinians at Comacchio in 1634 was one of Pallotta's last acts as Legate, and at the same time he personally selected Comacchiese students for enrolment in his doomed *Collegio Urbano*.[120] More memorably, however, he presided over a programme of building which, though planned or at least mooted in the days of Cennini and Sacchetti, would be associated with Pallotta.

As the port of Magnavacca itself was improved and fortified, a canal was cut from Comacchio to the sea so that the tidal flow would refresh the waters and the air of the town. New pavements were laid and new bridges were built across the canals. One of these was the *Trepponti* or *Ponte Pallotta*, a bridge designed by Luca Danese to span the intersection of five canals which was in its way a masterpiece of art and engineering and which ennobled both the town and the seaward approach (Colour plate 8).[121] Comacchio was now apparently beginning to feel the pressure of speculators seeking profits rather than a permanent residence, and in the interests of the 'conservation and increase of the city', Pallotta forwarded to Rome in 1634 an appeal for protection against exploitation. The terms proposed that foreigners must own at least 1,000 *scudi* worth of land in the Valleys of Comacchio, must build at their own expense (or plan to do so within a year) a new house for the enrichment of the city (and spend at least 1,000 *scudi* on it), must contribute some 500 *scudi* to public services and must settle in Comacchio.[122]

Pallotta left before the works he had promoted were complete, and Stefano Durazzo succeeded him. But this time Durazzo did not let Pallotta's enthusiasm die. He watched over the work of Fra Francesco of Lugano, the Capuchin called to Ferrara by Pallotta and employed almost exclusively at Comacchio, and being the man he was, Durazzo could not help but straighten the course of the canal to the sea to ease the flow of the tide in the manner he imagined Pallotta had intended. In 1636 Durazzo and the Commune of Comacchio put work in hand for the construction of a second canal, this to encircle the town and improve still further the air and amenity – Durazzo described this project in a letter to Rome, regretting only that with Danese absent, he had no one 'good at drawing' who could sketch it for the information of the Barberini.[123]

As Durazzo had once observed, better defences were needed at Comacchio, and these would be built in the term of the Cardinal Ginnetti immediately before the war of Castro. Luca Danese was engaged on this work, but a report was prepared by a newcomer to the legation works, that is, Francesco Vacchi, the former executant of building works for the Este who had transferred his allegiance to Rome.[124]

This part of the history of Comacchio closes with Stefano Donghi, the last Legate to take so close an interest in the development of the town.[125] In April 1647, just as he was paying, in fact, for the painting of *St John in the Desert* he had commissioned from Guercino, Donghi wrote to the papal secretary Cardinal Panziroli a letter worth quoting at length for the balance it strikes between public, papal and private interest, all managed by Genoese intelligence.[126]

If His Holiness will deign to honour with a glance the attached drawing, he will see the sketch of a portico that from the city of Comacchio . . . runs in a straight line to the church of the

Capuchins, and in his benignity he will perhaps conceive, that one could not built any thing of greater value and ornament to that city, in which my aim is to honour his most fortunate name. I am pleased to send you both notice of the idea and advice of its completion. None could estimate a cost of less than 12,000 *scudi*. In fact, it cost 6,000. I lack 2,000, to be drawn from old debtors of the city and set aside for its embellishment. The rest I have myself supplied with the desire and ardour to see the recent irreparable destruction of the flood (of 1645) balanced by this perpetual and unique amenity for the city (Plates 93 and 94).[127]

A month later, Donghi reported again, having just visited the site, and added that 'the magnificence and usefulness it will bring to the city exceeds imagination'.[128] The architect was never named – perhaps Luca Danese simply supplied a drawing and Donghi put the project out to tender. In fact, the *portico* is a little less majestic than his letters would imply, and the detailing of its 142 arches (restored in 1686 under the Legate Nicolo Acciauoli) is far less professional than that of Serra's *loggia*. But in a photograph the building looks impressive, and so it probably did in the sketch which Donghi sent to Rome. In any case, a view from a distance was part of Donghi's idea, and in August 1647 he applied for a papal brief to prohibit building by or near the *portico*, lest it spoiled the view from the Valleys of Comacchio.[129]

Had Donghi had the time, other communities in the state might have enjoyed the same care as Comacchio. He did consider, for example, the needs of Lugo and as part of schemes to improve that town's economy he had built there another 'long *loggia*' (clearly the legation's preferred, because most useful, building type), this one incorporating shops and constituting a development 'worth more than all Lugo before'.[130] But Comacchio remained the legation's cumulative achievement, the sum of continued patronage over some thirty years.

Serra had pointed the way, but from 1623 the Barberini, so often criticised for destructiveness (*Quod non fecerunt barbari / Fecerunt Barberini* as the saying went in Rome), had been behind the development of Comacchio. If, wrote Pallotta, the navigation of the Po could be so improved that goods could be shipped from Comacchio to Ferrara, Bologna and Lombardy, then 'His Holiness would see in his own lifetime his prophecy of the great development of Comacchio fulfilled'.[131] When Pallotta had gone, it was the Barberini who sent Durazzo to inspect the works left unfinished at Comacchio, and who sent him back in 1636 specifically to discuss with the Commune proposals for 'improving the plan, increasing . . . the housing and enhancing the decorum of this city'.[132] Donghi's *portico* was built in the reign of Innocent X Pamphili, but it belonged in spirit to a programme of urban development promoted by Urban VIII Barberini. In the opinion of Alberto Penna, by the 1660s contact with civilised people had improved the rough, seafaring folk of Comacchio.[133] The same might be said of their town. Legation patronage, at its best and with continuing encouragement behind it, was a civilising influence, giving architectural form and therefore civic pride to communites which had perhaps hardly known them before.

Donghi's successor was the Cardinal Benedetto Odescalchi from Como (the future Pope Innocent XI), who appeared to leave no greater impression upon Ferrara than a reputation for modest piety and a reluctance to take part in the festive life of the city.[134] In retrospect, his quiet legation seemed a watershed. It was not that his successors were uninteresting, but that what they did seemed no longer to matter.

On the face of it, nothing had changed. The Legates continued to acquire paintings by

Guercino, some as gifts, some by commission, and every so often arrived a Legate who took particular interest in the theatre, most notably Sigismondo Chigi, whose youth, it was said, had 'multiplied the *feste*, the spectacular shows and the happiness of our city', while 'his position as the rich nephew of a Pope allowed him to show . . . a pomp and magnificence above that of the other Legates'.[135] Fear of flood continued to disrupt the pattern of life. In 1651 the Cardinal Alderano Cibò arrived to find a new state of emergency – drains overflowing, embankments broken and disaster imminent – and he sent the nobleman Girolamo Rossetti, Luca Danese and the younger Ferrarese architect Carlo Pasetti to cope with this 'scourge of God on the city and duchy'.[136] (When working in the vicinity of Cento, Pasetti was in fact imprisoned by the Bolognese, no more disposed to co-operate now than they had been in the time of Durazzo in 1635.) During the pontificate of Alexander VII Chigi, from 1655 to 1667, a degree of papal patronage was to be expected from a former Vice-Legate to Ferrara, and it was indeed on behalf of the Pope that the Genoese Cardinal Legate Giacomo Franzone ordered a new altar in the church of the Certosa to house a painting which Chigi had once given to the Carthusians.[137] The Pope also reduced taxes in Ferrara, for which he was duly thanked by the Commune by means of a bronze statue, paid for by the public, cast in Venice and set up in Ferrara under the supervision of Danese.[138] But as far as major public works were concerned, the attention of the Pope was concentrated upon Rome and the new Piazza of St Peter's designed by Bernini.

Papal interest in Ferrara had faded after the Barberini years. Despatches turned less and less upon Ferrarese affairs and the vigilance of the Legates was relaxed. In 1660 the *Sala delle Commedie* burned for four hours before the Legate Imperiale was informed; it would never have happened in the time of Serra, Durazzo or Donghi.[139] In 1673 the Count Nicolo Pepoli was imprisoned for trafficking in contraband goods and the Legate Chigi, disposed to be kind, thought that he might be given, not rooms in the Castello, but 'the whole Fortress as his prison'; it would once have been unthinkable to let anyone, let alone a Ferrarese nobleman, loose in the Fortress, for reasons of security.[140] Now, indeed, Ferrara was in decline.

7 *The Ferrarese nobility*

Keeping the peace among the nobility of Ferrara had ranked higher even than repairing the river banks in a report on the priorities of government submitted to the Pope in 1598.[1] The Ferrarese were unpredictable, some openly restless, others quiet and home-loving, but even the latter could be troublesome, as happened in 1606 when they refused to leave their homes at the Vice-Legate's request that they defend the border with Venice.[2] After thirty years of papal government they were not necessarily more manageable, and the Cardinal Magalotti at least recognised their legitimate cause for concern. In 1628 he informed Rome of the fear among the Ferrarese of exclusion from papal preferment and, more seriously, of the decline in their own numbers. Many families, or branches of families, died out in the seventeenth century, an accident of fate for which the Pope could hardly be blamed but the effects of which he could alleviate by the speedier renewal of privileges and by increasing the number of names enrolled in Ferrara's 'Golden Book'. The Barberini duly increased the number of eligible families from twenty-seven to fifty, and when a Legate recommended a Ferrarese applicant they were often prepared to act quickly: the appointment of the Ferrarese Filippo Forni to the post of *Mastro di Campo* at Urbino, for example, followed just two months after Rocci's recommendation.[3] The extent to which peace in the community depended upon relations between the nobility and the Legate was revealed in 1633, in the time of Pallotta, when a minor rebellion had had to be quelled by imprisonment of the ringleader. At the same time, however, the Barberini themselves found a more subtle way of controlling the Ferrarese.

When the Duke of Modena in 1633 had invited his Ferrarese feudatories to accompany him to Milan ('for we would not wish to leave Your Lordship behind') the majority had accepted, but when they considered the costs involved their enthusiasm began to fade. It was at this point that the Barberini, who had been informed of the invitation and were prepared at first to let the matter pass, decided that any nobleman already attached to the Court of Modena should go and 'endure the discomfort', but those who were not yet regular courtiers of Francesco I should be forbidden and so provided with a legitimate excuse to withdraw.[4] There was no better way of persuading the Ferrarese nobleman than by such an appeal to his private interest.

There would always be rowdy elements among the nobility (in 1637 it was reported that one reason why the *Contestabile* Colonna wanted the see of Bologna, and not that of Ferrara, for his son was that he believed the Bolognese to be more manageable) and there would always be some whose loyalties were not entirely clear.[5] But by and large the Legates were increasingly able to report a reasonable degree of loyalty, and occasionally 'heartfelt devotion and incomparable fidelity towards the Apostolic See'.[6] The reason was probably to be found in their

perception of the advantages of Ferrara. The Duke of Modena was looking to the nobility to provide him with an illustrious setting but not a rival splendour. Ferrara, by contrast, offered space and opportunity.

(i)

One immediately noticeable change which devolution had effected was that more members of the nobility were now attracted to the Church. It had been noted in the later sixteenth century that, the Este apart, Ferrara had produced few prelates, but now that it was a papal city many Ferrarese chose the Church as a career and several achieved the cardinalate, including, in 1599, Bonifazio Bevilacqua. The Cardinal Bevilacqua was one of the most splendid figures of the early seventeenth century in Ferrara, a patron of churches, including S Francesco where his family was commemorated, and a collector of art. In 1602 he acquired the villa of Tuscolana near Bologna where he assembled his lapidary collection. It was also the Cardinal Bevilacqua who gave the family palace in Ferrara its sculptured façade. It was in the hope of acquiring more property that Bevilacqua in 1609 made application to the Este to buy or rent their palace of Isola on the Po.[7] He was not successful on this occasion, but his attempt was not without significance. Some thirty years later, when the Este were more prepared to part with their Ferrarese properties, the Ferrarese Marchese Guido Villa was able to obtain the lease of the Palazzo dei Diamanti. Este palaces left standing in Ferrara were now no more than a source of income to their owners, but they were ideal, ready-made residences for noblemen seeking a more spacious style of living, in which connection it was interesting that new palace building in Ferrara was virtually at a standstill.

The Palazzo dei Diamanti made a suitable setting for the aspirations of the Villa, whose ancestors included Agostino Villa, a *Pater Patriae* of the fifteenth century. In the seventeenth century, the Marchese Guido Villa earned himself the title 'Mars of the *Patria*'. Villa had followed the time-honoured career of mercenary soldiering, in the service most frequently of the House of Savoy. He died in Turin in 1648 but his body was brought back by river to Ferrara for a full-dress military ceremony 'in the antique manner not only of funerals but also of triumphs'. Five months later, the architect Carlo Pasetti and some thirty other artists were at work on decorations for a grand memorial service for Villa in the church of S Francesco, where this family, like the Bevilacqua, were commemorated. The cost of the service, said to be some 5,000 *scudi*, were met by Guido's son Ghirone Villa, who would become the hero of the next generation. Having also taken service with Savoy, Ghirone Villa died in Turin in 1670 but was commemorated in Ferrara by a highly elaborate monument, the creation of the Torinese Don Emanuele Tesauro, in the church of S Francesco.[8] In Modena, commemoration of this kind was reserved for the Este. In Ferrara, there was room for glorification of the nobleman.

Commemoration by means of public works was also open to the nobility. Galeazzo Gualengo, for example, was thought by Ubaldini to have been a weak man, and by a fellow chronicler, Rondoni, to have been ambitious, but he was indisputably a man of culture who used his term as *Guidice dei Savi* to revive the city's public archive and had his name inscribed, as a *Riformatore* of the Studio, with that of the Legate Spinola and the current *Guidice*, on the

new façade designed by Aleotti for the Studio in 1610 (Plate 95).[9] Giovanni Rondinelli, *Guidice dei Savi* in 1633, used his term not only to make himself unpopular by co-operating with Pallotta but also to build a new marble gateway bearing his coat-of-arms and that of his executive committee. Since Pallotta spoke well of Rondinelli, it may be that his portal added dignity and decorum to Ferrara, but if the cost was truly the 14,000 *scudi* mentioned by Ubaldini, it is difficult not to feel with him that this was a useless piece of public expenditure.[10] Ubaldini regarded Rondinelli's self-commemoration as just another example of the 'customary, natural vanity of the Ferrarese'. Yet it was not impossible to find, here and there, nobler motives at work.

Education was a matter of concern to Ferrarese as well as to the Legates. Alberto Penna, for example, recognised a 'great necessity' for a college to bring 'decorum, and utility and assistance to my fellow-citizens in need'.[11] As far as the young nobility was concerned, where Pallotta's project had failed, the Marchese Lodovico Bevilaqua succeeded in running a very well-attended academy for cavalry skills in the courtyard of his palace, which earned him the honorary title *Pater Patriae*.[12] Exemplary in a different way was the Count Girolamo Rossetti, whose family was ennobled by the Emperor but whose real worth lay in his ability as an architect and hydraulic engineer. Rossetti represented the interests of Ferrara on the regular inspections of rivers and canals, and when the Po flooded in 1640 it had been Rossetti upon whom the Legate Ginnetti had relied. He possessed, said Ginnetti, 'singular qualities', such that in 1642 Rossetti was elected *Guidice dei Savi* 'against his expectation and against his will'. An unwilling politician, Rossetti nevertheless served his term and accepted his election for a second year, and though he stood down upon a third election in 1652, he continued to serve both the Legate and the Commune as a consultant on water management.[13] A third and final example of the public-spirited nobleman was set by Carlo Francesco Pio (Plate 96). His intense dislike of his uncle, the Cardinal Carlo Emanuele Pio, made Pio postpone his intention to enter the Church and made him a traveller and a soldier. His uncle having died in 1649, Pio returned to the Church in 1650, became Treasurer–General in 1652, a cardinal in 1654 and Bishop of Ferrara in 1655, the first Ferrarese (for by now the Pio were considered Ferrarese) to hold an office of high responsibility in Ferrara. He did not, in fact, stay for long, returning to Rome and resigning his bishopric for reasons of health in 1662. But while Pio was in Ferrara he stood out from his peers by the interest he took in Ferrarese art.[14]

Art collecting in Ferrara may have been a casualty of devolution, or at least it had come to a standstill, no new collection rivalling that formed by Roberto Canonici but partly destroyed soon after his death in 1638. With collecting seemed to go also the kind of sophisticated cabinet painting for which Scarsellino and Carlo Bononi had been known, but which had now all but disappeared from the work of Ferrarese painters. (It is interesting to note how few Ferrarese individuals, as distinct from church and confraternity patrons, appear in the account book of Guercino.) The Cardinal Bishop Pio, however, was the patron of Costanzo Catanio, perhaps the most interesting Ferrarese painter of the mid-century. According to Baruffaldi, biographer of Ferrarese artists, Pio called Catanio to Rome in 1654, drawn to him, it appears, as much by Catanio's experience as a soldier and huntsman as by his art, and Catanio accompanied Pio to Ferrara in 1655. It was at Catanio's suggestion that Pio in Ferrara took an interest in the career of the young and apparently diffident Ferrarese painter Giovanni Bonati, whom he sent to study with Guercino. When the Cardinal returned to Rome and his refurbished 131

palace in Campo dei Fiori where the Pio family collection was kept, he brought Bonati with him, enabling the painter to continue his studies and find patrons in Rome. Any name that Bonati, or *Giovannino del Pio*, made in Rome, as the painter, for example, of the Spada Chapel in the Chiesa Nuova, he owed to the patronage of Pio. It is, of course, possible that when Baruffaldi was writing his biographies, he was inclined to exaggerate Pio's motives in protecting these artists, but it was nevertheless the opinion of Baruffaldi that Pio's intentions had been to breathe life into art in Ferrara.

It was in the early years of the seventeenth century that signs of a new kind of patriotism first appeared in Ferrara. The city which had for so long formed the backdrop to the Este Court was now becoming the *Patria*, with traditions which must be protected and interests which must be served. The emergence of an independent Ferrara might be sensed in small things: in the riverside city, for example, which decorated the local printer Suzzi's capital 'F' (Plate 97), or in the revived poetical concept of Ferrara the *Città di Ferro* (Ferat), the descendant of Noah who, according to legend, had founded Ferrara after the Flood.[15] Thus at a literary gathering in the Castello after the floods of 1645, the Marchese Giovanni Villa, brother of the *condottiere* Guido, on behalf of the *Città di Ferro* gave thanks to the Legate Donghi of Rome, the *Città di Marte*, for his tireless efforts to have embankments reinforced to hold back the waters.[16] Given Ferrara's outstanding literary tradition (the result of Este patronage), it was not surprisingly the writers of Ferrara, mostly clerics, who expressed first the new patriotism, explaining that it was love of the *Patria* which had prompted them to write the chronicles, eulogies and descriptions of the city which now began to appear in increasing numbers. Among the nobility, the concept of patriotism took rather longer to appear, and when it did it was closer, perhaps, to class-consciousness than civic altruism. Yet in Rossetti, Lodovico Bevilacqua and others a sense of responsibility towards city and state had been added to the ideas which could move a nobleman to action and to patronage.

Don Ascanio Pio, brother of the elder Cardinal, father of the younger, and a particularly attractive personality, was perhaps the perfect Ferrarese nobleman of the first half of the seventeenth century. Ubaldini thought him cold, irresolute and self-interested, but Pallotta trusted Pio, as did Magalotti.[17] He had grown up at the Court of Turin, travelled in Spain and married first into the Roman Mattei family. Then he had settled in Ferrara and married, on the death of his first wife, Enzo Bentivoglio's daughter Beatrice. In the plague years 1629 and 1630 he was elected *Guidice dei Savi*. In 1646 he refused the appointment of Ferrara's ambassador to Rome, preferring, it seems, to concentrate on his investments in Ferrarese land, still 'laying down the foundations of his House', noted the Legate Donghi, 'as if forgetful of any other place'.[18]

All the interests most dear to the Ferrarese nobleman met in Ascanio Pio. He was member, sometime Governor, of the Confraternity of the Stigmata, in whose church he would be buried at the Pio Chapel of the Pietà in 1649, after a funeral procession in which the doctors of the university had walked, for Pio had also been a *Riformatore* of the Studio.[19] In the 1640s he had been the principal patron of the new church of Sta Chiara for the Capuchin nuns (Plate 98), and the report that he not only provided money but assisted personally with the building might mean that it was he as much as the architect Luca Danese who was responsible for the form of this church, and for the harmony which exists between it and the brother church of S Maurelio of the Capuchin friars.[20] A painting of the *Last Supper* by Costanzo Catanio,

with the legend *Orate pro Pijs*, hung in the refectory of the Cappuccine, but Pio may not himself have been the patron of this work by his son's protégé. In fact, only an engraving dedicated to Pio in 1626 by the Centese artist Pasqualini, after a *Virgin and Child with San Lorenzo* by Guercino, suggests any interest in art patronage.[21] Instead, according to the contemporary writer Agostino Superbi, Pio's pastime was study and his talent lay in literary composition.[22] In poetry, Pio's genius could sparkle. A collection of moral precepts and maxims composed for the benefit of his son Carlo Francesco was notable both for its pithy wisdom, as of Polonius to Laertes, and for the rich variety of verse forms which Pio adapted to his use, the better, he explained, to instruct and be remembered.[23] Pio was one of the Ferrarese personalities chosen for inclusion in *Del Convito*, a book published in 1639 by the poet and secretary of the Ferrarese Commune Ottavio Magnanini and composed, on the model of Plato's *Symposium*, to enshrine the academic traditions of Ferrara.[24] Magnanini presented here what may well have been the true liveliness of Ascanio Pio, both in the discourse and in the impulsive interruption of others to propose his own palace, in the Strada dei Piopponi, as the venue for the conversation.

In 1617 Pio had been one of a number of noblemen to whom artists associated with Enzo Bentivoglio were reporting as they prepared scenery for a performance to which Pio was to contribute. In 1627 Pio was composing *intermezzi* for Enzo's productions in Parma, daring to propose at least one change in stage effects, a darkening then clearing of the heavens, for the sake of perfection and a challenge to Enzo's ingenuity.[25] This experience stood Pio in good stead when in 1630 he became principal poet and impresario of the festive theatre in Ferrara, which completed the picture of him as the pattern of the Ferrarese nobleman.

(ii)

In the 1630s the festive theatre of Ferrara, over which Enzo Bentivoglio had presided for so long, began to change under the influence of Ascanio Pio and, not least, the architect Francesco Guitti. Change was already indicated at the Carnival of 1631, when an audience including the Cardinals Sacchetti and Bernardino Spada, Legate to Bologna, and members of the House of Gonzaga of Mantua, watched performances which celebrated the wedding of Sacchetti's brother Gio. Francesco Sacchetti to the Ferrarese Beatrice Estense-Tassoni, and which, after the threat of war, famine and plague, marked the end of a state of emergency in Ferrara. One *festa* was presented in the *Sala de' Giganti* of the Castello by the nobleman Borso Bonacossi, who organised a tournament and a performance of *L'Alcina Maga, favola pescatoria* and employed as his designer the Ferrarese Alfonso Chenda (Il Rivarola). The second *festa, La Contesa* , was performed in a room of the palace of Camillo Bevilacqua and managed on behalf of the Estense-Tassoni by the same Girolamo Rossetti who, ten years later, would also manage the flood repair works on the river Po. Rossetti's designer was Francesco Guitti.

The influence of Enzo Bentivoglio, under whose direction Chenda as well as Guitti had worked in Parma, was obvious enough in these productions. Bonacossi's joust had been announced in advance, in the usual way, by a herald in the city streets, and in the *feste* both Bonacossi and Rossetti, as the principals or *mantenitori*, fought as the champions, having

provided and lit the stage, and offered space within it to other noble participants, the *venturieri*. Bonacossi's venue, however, had been too small to accommodate their machines without sacrificing the space for combat, and his tournament therefore relied upon Chenda's 'Lies of Painting'. Like Enzo before him, Bonacossi exalted himself in his *festa*. His name and *stemma* were emblazoned across the temporary proscenium arch (and in a separate recitation that evening, dedicated to Carlo Gonzaga, reference was in fact made to the Bonacossi (or Bonacolsi) lordship of Mantua in earlier centuries). In his published description of the *festa*, the poet Francesco Berni speculated upon the significance of Borso's appearance upon an island in a river, and wondered if it referred to the great-hearted man's steadiness amid the waves of fortune. By comparison, Rossetti was extremely modest, for the proscenium arch designed by Francesco Guitti complimented instead the Legate Sacchetti, whose *stemma* was seen here to hold firm in a world falling into ruin. The changing settings, or perspectives, of both *feste* repeated the established favourites: rocky coasts and islands, charming landscapes with woods, rivers and distant views of the sea, and hellish night. Yet Bonacossi's settings were interesting in that now these scenes were identified as the landscape of the Po and the Tiber, of the *Città di Marte* and the *Città di Ferro*. Rossetti's production was consciously novel. According to Guitti's published description of *La Contesa*, that *festa* had reflected a desire for a 'new form' of tournament. This was perhaps fulfilled in part by means of Guitti's stage engineering, for the *venturieri* in *La Contesa* appeared first onstage, marched forward to the edge of the stage, and were then lowered to the ground floor for the combat on a section of the stage floor which Guitti had designed to 'fall with a pleasing motion'. It was perhaps the cramped space which had inspired Guitti's genius, but in effect he had established continuity between stage and battleground, which was a step towards a more integrated performance.[26]

By the mid-1630s, fashion in Ferrara had clearly changed in favour of coherence and integration in place of the episodic productions of Enzo Bentivoglio's day. In 1635 Guitti was the designer of the *Discordia Superata* presented before the Legate Durazzo in a former tennis-court on the street called Giovecca, another makeshift venue and another opportunity for Guitti to use his ingenious device for lowering the stage floor. On this occasion, wrote Guitti in the description, the group of Ferrarese noblemen who were his patrons had expressed a wish to avoid the 'customary practice of champions and the issuing of amorous arguments because they had become, by reason of satiety, contemptible'. Nor had they desired superfluous 'poetical ornament'. Therefore, they had given Guitti charge of the theatre, Antonio Goretti charge of the music, and Ascanio Pio had taken charge of inventing the fable of the Four Elements at war in the world.

Pio took active part in Ferrara's jousts, being *Mastro di Campo*, for example, of *Le Pretensioni del Tebro e del Po* performed before Taddeo Barberini in 1642. But his gift lay in his poetry. Pio's genius was revealed less in his invention of themes (for these were drawn usually from the stock of mythology, the poetry of Tasso or the time-honoured forms of combat) than in his imaginative interpretation of character and in the dramatic effects of his poetry for performance. The sustained echo, for example, and the repeated cry, had formed part of his technique since the *intermezzi* he had composed for Enzo in Parma, and he developed them in order to heighten dramatic tension. The range of verse forms at his command enabled Pio to create character and to imitate the quality of human emotions. In his *L'Amore trionfante dello sdegno* of 1642, for example, the deserted Armida sobbed broken verses which reflected a dislocated

mind, while *Sdegno* (Scorn) personified jabbed with sharp, bitter couplets. Pio, wrote his contemporary Francesco Berni, could 'wound with the pen and write with the sword'.[27] Under his aegis, the separate, disjointed recitations of the past cohered into a consistently developing plot, and the balance once lost between poetry and spectacle was thus redressed. Pio was helped, not hindered, by Francesco Guitti as designer. Guitti's period in Rome in 1633 and 1634, when he had worked on productions for the Barberini, would have been influential, not so much for his part in the *Giostra del Saracino* in Piazza Navona (which would appear to have repeated, complete with a herald's announcement, the form of joust now *passé* in Ferrara) but for his collaboration with Bernini on the *Erminia sul Giordano*. It need not, however, be assumed that the influence was necessarily all one way. Guitti was already in 1633 an experienced theatre designer and engineer and though the visit to Rome would have brought him up to date with Roman fashion, the direction in which his design for the stage was leading was clear in Parma, where in 1628 he had concealed the source of music from the audience, and Ferrara, where in 1631 he had linked stage and floor to assist the flow of events. Guitti wished not only to amaze an audience but also to sustain dramatic illusion, which made him a perfect partner for the poet Ascanio Pio.

The *Andromeda* of the Carnival of 1638, the performance which had so impressed the Legate Rocci, was the joint masterpiece of Pio and Guitti (Plate 99). The occasion was the wedding of Cornelio II Bentivoglio and Constanza Sforza, and the guests included, besides Rocci, the Cardinal Sacchetti, now Legate to Bologna, and the Archbishop Colonna of Bologna. The venue was the *Sala della Commedie*, protected (for this was a year of crime in Ferrara) by guards on the doors and a squadron in the courtyard. The *Andromeda* was 'fought and sung' with the help of the violinist Michelangelo de' Rossi, borrowed from the Duke of Modena and composer of the music. Guitti's description neglected, however, to name the painters engaged upon his scenery, but very probably they included Leonello Bononi, Antonio Casoli and other local artists employed on festive decorations for the Commune in these years.[28] Guitti reserved his praise for his own work and especially the changes of scene, so smooth that 'from one beauty without interval the eye passed to another'. The music for the *Andromeda* is lost, but the text and the illustrations to Guitti's description suggest that it was a classic performance.

The story of Andromeda, as told by Ovid in the *Metamorphoses*, was a popular subject for festive occasions. It was performed at the S Cassiano theatre in Venice in 1637 and seen in France in the 1640s with text by Corneille and machinery by Giacomo Torelli of Fano, who had, incidentally, learned much from Aleotti and worked for Enzo on the Teatro Farnese. Pio's audience in 1638, familiar with the story, was therefore promised variety. Pio's *libretto* comprised, as Guitti's description explained, a diversity of verse forms (among them, odes and *canzoni*), philosophical *concetti*, moral observations, *scherzi* and, of course, combats, but 'without that now old-fashioned form of challenges and proclamations'. For his part, Guitti devised scenes of a city and a royal court, seascapes, pastoral landscapes and some possibly stunning effects, including the 'bizarre motion' of the winged horse Pegasus. But as Guitti assured the reader, neither scenes nor machines had been intended to 'break the thread of the plot'. True settings for action replaced a progression of separate marvels as scenes appeared, vanished but reappeared if the plot required.

Here, as in the Teatro Farnese, Guitti had concealed the musicians. When they had played and the curtain had disappeared, the passage of Time across the stage (Plate 100) was followed

by that of *Aurora* in a blue chariot and by the Sun, whose 'sententious' song concerning infinity and the life to come gave a moral setting to *Andromeda* (Plate 101). A resplendent cloud encircled the chariot of the Sun, giving off rays of light which, according to Guitti, the audience found convincingly real. It is tempting to wonder whether this machine bore any resemblance to the sun-machine which, according to Baldinucci, Bernini was the first to devise to represent the rising sun.[29]

The opening seascape changed to a landscape for the first episode of the narrative, that is, the insult received by the priests of the sea-gods from Queen Cassiopeia's retinue (Plate 102), but returned for the appearance, in a chariot of shells, of Neptune and Amphitrite (Plate 103). Then the scene changed to the city of King Cepheus (in fact, the well-established Tragic Scene) for the news of the Oracle's pronouncement that Andromeda must die to placate the gods. Into the same setting flew the chariot of Mars, disturbed to know that Andromeda's lover, Coralto, is soon to die (Plate 104). The battle in which Coralto was then killed was an interesting piece of stagecraft, for it took place not on the floor of the *Sala delle Commedie* but within the settings. It was followed by the meeting of Fortune, whose costume appeared to be ever-changing in colour, and *Bontà* (Kindness), whose white cloud contrasted with that of her companion, which moved in an irregular pattern imitating the vagaries of fortune (Plate 105). The seascape reappeared to reveal Andromeda chained to the rocks and sea-nymphs, of Pio's invention, rising from the waves to cry '*Mora, Andromeda, Mora*' (Die, Andromeda, Die) before the arrival of Pegasus, bearing the warrior Perseus (Plate 106), who vanquished the monster which arose from the sea (Plate 107). The city setting returned for the arrival of Phineus, enraged to learn that Andromeda is to marry Perseus, and the subsequent, and spectacular, appearance of the flaming-red cloud, smoking and 'shaking from side to side', of the war-gods Mars, Bellona and the Fury, dressed in a torn and blood-stained costume (Plate 108). Their cry promised the land of Cepheus no peace nor truce but war: '*Lunghi da questa Terra / E la Pace, e la Tregua. Guerra. Guerra.*' The discussion between Cepheus and Phineus then led to a resolution to fight, seven knights on each side. Guitti, on this occasion, did not need to engineer the knights' descent for steps led them down to the *campo*, Instead he had concentrated his ingenuity on the seating box which until now had occupied the place of combat, and upon which the most distinguished guests were seated. Lights blazed from the ceiling, music sounded and the box divided into two, each part gliding back to make way for the knights.

The knights fought with picks and swords and even fisticuffs, though the latter was forbidden by the *Mastro di Campo*, who restored order. The combats ceased with the silencing of the drums and the appearance across the stage of a rainbow and of Iris herself, who made peace and then sang with her companions, the three Evening Hours (Plate 109). The lights dimmed and, according at least to Guitti, some members of the audience suspected a mistake had been made, 'not considering that it was artifice'. The scene changed to a royal court in which, after discussion, the cloud of Evening Twilight appeared and the figure discovered within it brought Perseus and Andromeda together (Plate 110). The assembled company then invoked Hymen, who appeared above with Love and, in the centre, Jove, and the joining of their three separate clouds into one apparently amazed the audience (Plate 111). Jove sang the praises of the Cardinals and ordered the battle to be changed to a dance. The performance ended with a noble *balletto*, in which the knights, having bowed to the Cardinals and the ladies,

performed figures of the galliard. It is not difficult to see why the Cardinal Rocci had so enjoyed this 'noble entertainment', its plot so clearly unravelled and vividly (to judge from the text) sung and fought, its machines so dazzling yet, in their own terms, so convincing, its unexpected effects so exciting, and its variety so rich. Ascanio Pio had composed and managed the *Andromeda*; Cornelio II Bentivoglio had advised; Roberto degli Obizzi had acted as *Mastro di Campo*. They formed, wrote Guitti, who was something of a poet as well as an architect and designer, 'the perfect trinity of the Platonic concept of God', which was a measure of how exalted a tone the theatre in Ferrara could excite.

It was presumably because Guitti was spying on Venetian defences for the Legate Rocci that in June, some few months after the *Andromeda*, Pio collaborated with Alfonso Chenda on the Coronation of the Rosary celebrations in the Piazza Nuova. In his description of this *festa* (published some twenty years later), the Dottore Giovanni Bascarini explained that it represented another change of fashion, for dissatisfied now not with the tournaments so much as with their own splendour, the Ferrarese had chosen to celebrate their faith, and since no indoor theatre could be a fit setting for the Mother of God, the Piazza Nuova had been selected as the site, with the additional benefit, presumably, of permitting more people to attend. For this new example of the old liturgical drama, Pio and Chenda had chosen the form used in previous centuries of fixed, simultaneous settings. A network of staircases connected the three storeys of the structure upon which the Coronation of the Virgin of the Rosary was enacted, the Legate Rocci accepting the crown from a flying angel and progressing from the second to the third level to perform the ritual coronation. For the scenery, Chenda had converted favourite settings to new devotional use: a rocky scene with a flaming mountain was, for example, Mount Sinai of the Old Law, and a mountain with slopes covered in plants and flowers was Mount Tabor of the New.

Ferrara Trionfante was, however, unique. More in character was the wish expressed by Pio and twelve other noblemen in the autumn of 1640 for a *festa*, the *Armida*, to 'give a little gaiety' to the forthcoming Carnival.[30] But this was not such an easy matter now. A musician, Marco Marazzoli, had to be borrowed from Rome with the help of the Cardinal Bentivoglio, but more serious had been the loss, in 1640, of both Chenda and Francesco Guitti, deaths which left Ferrara without a theatre designer. Cornelio II Bentivoglio was asked to find a replacement, and it may have been through his agency that Giovanni Burnacini arrived in Ferrara to design for the performances of early 1642 which greeted Taddeo Barberini.[31] Burnacini, however, was only a stopgap and the need for a regular designer was shown in the performance, in honour of the visit of Anna de' Medici in 1646, of Pio's *Discordia Confusa*, which was little more than a repeat, in abbreviated form and with certain changes of plot, of the *Discordia Superata* of 1635. But in Pio's last appearance as Ferrara's unofficial master of ceremonies, that is, in his management of the memorial service for Guido Villa in 1649, he was able to bring together for the 'invention' the poet Francesco Berni, and for the design the architect Carlo Pasetti. With the musician Andrea Mattioli, Berni and Pasetti now became the creative artists of the Ferrarese theatre, working with another impresario, Pio Enea II degli Obizzi.

Pio Enea, and his father Roberto degli Obizzi, deserve an introduction. Their family home was Cataio on the Brenta, which made them Venetian subjects, but they also owned land in the Modenese, estates in Tuscany and a palace in Ferrara; it would have been while in

137

residence there, perhaps, that Roberto degli Obizzi ordered in 1631 and 1632 paintings of *San Domenico* and *Sant'Andrea Corsini* from Guercino and a still life of fruit from Paolo Antonio Barbieri.[32] Roberto, however, did not consider that he was obliged to reside permanently in Ferrara, and when he accepted Francesco I d'Este's invitation to accompany him to Milan in 1633, he told the Cardinal Pallotta that he, Obizzi, was a free agent and expected to be treated as such in Ferrara. Very well, decided the Barberini, if he wishes to be considered a foreigner, it shall be so, but he must thereby forfeit his place on the city council and, as a consequence, the chance of being elected *Giudice dei Savi*, for which election, as the Barberini knew, Obizzi was in line.[33] That he was duly elected *Giudice* in 1635 suggests that Obizzi came round to their point of view. Yet it was not the constraints of the papal government which alone induced Obizzi to stay in Ferrara. He had long been a promoter of the interests of the Academy of the *Intrepidi* (expressing indignation when, in 1616, the Ferrarese Cardinal Bevilacqua contributed nothing towards the costs of the Academy's new theatre, while even the usually absentee Leni had given 100 *scudi*) and he acted often as the *Mastro di Campo* for tournaments.[34] Finally, in 1640, he became a theatre owner in Ferrara, acquiring from the Este the now disued *Intrepidi* theatre designed by Aleotti, and making it the *Teatro degli Obizzi*.[35] Theatre ownership and management was the next step in the development of the theatre in Ferrara.

Pio Enea II degli Obizzi inherited the theatre and opened it to the public. His own theatrical experience was considerable, for he had organised *feste* for the Duke of Modena in 1635 and the Commune of Padua in 1636, and in 1639, in collaboration with Alfonso Chenda, he had created the *Teatro della Sala* in Bologna.[36] His career as a theatrical entrepreneur continued into the 1650s, at the service, in particular, of the Duke of Mantua. By now, however, Pio Enea had also had his own private theatre constructed at Cataio within a recreation block separate from the palace and designed also to house his collection of armour.[37] The walls of five rooms within the palace were painted with scenes of the jousts Obizzi had staged for other patrons, and in another room were frescoes of settings designed for his theatre in Ferrara. From 1640, and regularly from 1650, the *Teatro degli Obizzi* was the home of the lyric drama in Ferrara and among the plays performed were several, including the *Dafne* of 1660, composed by Obizzi himself, under the pseudonym, 'D. Azzio Epibenio'. According to Francesco Berni, Obizzi had been his own architect at Cataio, but in Ferrara it was Carlo Pasetti who remodelled his theatre and designed new scenery for it in 1660.[38] To decorate Cataio, Obizzi had employed the Bolognese painter Gabrielle de' Rossi, and to assist him the Ferrarese Francesco Ferrari. Thus Obizzi was instrumental in the artistic development of Ferrari, who by the 1660s was recognised not only as a fresco painter, but also as a scenographer, an essential, and named, member of the team of creative artists (poet, architect, composer and painter) working for the theatre in Ferrara.[39]

Obizzi was soon joined by other enterprising theatre owners. In 1660 Ippolito II Bentivoglio became the principal patron of the *Teatro di Cortile*, built at speed by Pasetti and Alberto Gnoli after the fire that destroyed the *Sala delle Commedie*. By an agreement of 1660, Bentivoglio bought the theatre building, a former chapel, from the Este.[40] It was at this stage that the architect Pasetti made the mistake of aspiring to theatre ownership himself, and his brother was obliged to write humbly to Bentivoglio asking pardon for Pasetti's attempt to acquire the lease of the *Teatro di Cortile* in 1660.[41] Theatre ownership remained the preserve of the

nobleman, and in 1662 a third member of the Ferrarese nobility opened his theatre in the city. This was the *Teatro Bonacossi* (or *Teatro Santo Stefano*), and it was the property of the Count Pinamonte Bonacossi, son of Borso and master of the knightly arts, patron of musical academies and the *Intrepidi*, director of performances for Mantua, composer of festive entertainments for Ferrara; in short, the new model of the perfect Ferrarese nobleman.[42] Bonacossi was a patron of Pasetti and Francesco Ferrari and he was also responsible for bringing forward a second Ferrarese scenographer, that is, Francesco Scala, son of a factor on the Bonacossi estates. Pinamonte offered sympathetic protection to Scala, ministering to both his melancholic temperament (he once arranged for Scala to be admitted to the Hospital of St Anne, where the poet Tasso had once been interned) and his artistic talent. Scala's temperament and talent may have coincided in the prison settings for which, and for scenes of flower gardens, he was particularly noted.[43] The 'most versatile, spirited, handsome and capable cavalier of the *Patria*', Bonacossi was also the last of the entrepreneurs, but he carried the festive theatre of Ferrara, with its jousts and its entertainments on the river, up to the turn of the eighteenth century.[44]

(iii)

The history of Ferrara's theatres is well-known, and there is no mystery surrounding the source of the tradition from which they developed. In a letter of 1627, Alfonso d'Este expressed his pleasure at learning that the youth of Ferrara still practised the knightly arts 'which under the shade of this House once flowered in that city more than any other', and he was writing to Enzo Bentivoglio, to whom was due the credit for ensuring that both the joust and the dramatic performance had continued to flourish when the Este Court had gone.[45]

What is less easy to explain is why Ferrara in the 1660s should have been capable of developing and sustaining so rich a range of entertainments: lyric drama in the *Teatro degli Obizzi*, narrative drama (a historical play, perhaps, by Ippolito II Bentivoglio) in the *Teatro Bonacossi*, a borrowed troupe of players in the *Teatro in Cortile*, and the popular events sponsored by the Commune. Aristocratic patrons of the theatre were appearing in Venice, Bologna, Rome, Genoa and other cities, but in Ferrara the population had fallen sharply, there was no tourism as in Venice and Rome, no commerce as in Bologna, no court as in Rome, Modena, Mantua and Parma, and only intermittent support from the papal authorities. Thus the *feste* of Ferrara might seem as incongruous as a nobleman's titles. In 1660 the Legate Imperiale had noticed that while many Ferrarese had titles, few had the land which gave titles substance, and perhaps the splendour of their theatre was no less of a sham, a form of retreat into the past.[46] Yet, however ephemeral the form, there was surely real substance to an art which neither died nor stood still but responded to changing tastes and created its own succession of poets, architects and artists.

It may be that the theatre should instead be regarded as Ferrara's most successful business, capable of sustaining creative artists and support services, of finding its own market (news of a *festa* in Ferrara could attract visitors from other cities, including Venice), and of exporting entrepreneurs and artists to work for princely courts. The performing arts were deeply rooted in Ferrara; they satisfied a need and were, moreover, capable of adaptation to new aims and new conditions.

139

The encouragement which an individual Legate, a Rocci, say, or Ginnetti, might give to the theatre was probably less important for its continuation than the regular arrivals and departures of all Legates and distinguished visitors which had become a feature of social life in papal Ferrara and provided a focus for the art. Weddings within the Ferrarese nobility itself provided other occasions.[47] But the nobility did not need prompting. If Guitti's description can be believed, the *Discordia Superata* of 1635, for example, evolved from no more than the wish of a group of noblemen that Carnival should not pass without some 'public, knightly, event' and, apparently, no expense was spared. Equally spontaneous was Ferrara's welcome to the travelling Archdukes of Austria in 1652. Had it been left to the Legate Cibò, there would have been no splendid welcome at all. But the Marchese Federico Mirogli, 'having made a killing of 2,700 *ungari* gambling in Modena, and not knowing how it might more worthily be spent than upon this occasion', commissioned from Francesco Berni, Andrea Mattioli and Carlo Pasetti a '*ricreazione dramatica musicale*' to be organised at speed and presented in a room in the Mirogli palace, and thus *Gli Sforzi del desiderio* was created for the entertainment of the Habsburg guests.[48]

The festive theatre was the finest expression of the skills of the Ferrarese nobleman: his horsemanship, in which, in the case of Pinamonte Bonacossi, he had been schooled by Lodovico Bevilacqua; his poetry, refined in the literary academies; his musicianship, or at least his love of music, publicly expressed in his patronage of the Academies of the *Morte* and Sto Spirito which brought such composers as Mattioli and Giovanni Legrenzi to Ferrara; and his interest, and sometimes proficiency, in architectural design. Thus the Four Virtues of Military Training, Poetry, Music and Architecture which defeated the Four Elements bent on destruction in Ascanio Pio's *Discordia Confusa* of 1646 were none other than the four virtues of the Ferrarese nobleman.

Patronage of the theatre was not entirely an act of charity. The Bentivoglio would not have held the lease of the *Sala delle Commedie*, nor moved so swiftly to construct an alternative venue when the *Sala* burned, if there had not been some return. Ticket sales were a source of income for both Ippolito II Bentivoglio and Pinamonte Bonacossi; that the Este agents in Ferrara should have free seats was a condition written into the contract for the *Teatro di Cortile*, but the Commune of Ferrara paid for its annual block booking of seats for its executive committee in the *Teatro Bonacossi*.[49] Such income could not, however, compare with the outlay on the building, the settings and artistes. If not profit then perhaps personal glory was the motive, as it had been in the case of Enzo Bentivoglio and Borso Bonacossi. Yet it was also possible to see the entrepreneur and theatre owner in a patriotic light, as a public-spirited noble citizen to whom it was an honour to uphold the reputation of Ferrara as, in Francesco Guitti's words, the 'ancient and accredited school' of the theatrical art.[50] This was certainly the interpretation which the writer Antonio Libanori gave to Pinamonte Bonacossi's patronage of the theatre. At his own expense, wrote Libanori, Bonacossi had founded the theatre and presented plays 'for the glory of the *Patria* and the entertainment of the People'.[51] Patriotism entered also into the festive performances, in so far as the defence of Ferrara against another city, usually Rome, or against supernatural forces had become the poetical justification for the joust, and settings representing the countryside of Ferrara and sometimes the city itself had become a regular feature of the *feste*.[52] There is no evidence, however, to suggest that the joust could ever have been a vehicle for dissidents in Ferrara. Attendance at the joust, however, might

have been another matter. In his preface to the description of Ascanio Pio's *Le Pretensioni del Tebro e del Po*, Francesco Berni conjured up a 'Genius of the *Patria*' who had summoned him from his villa retreat to see 'a theatre to celebrate with sounds, now poetic, now warlike, the virtue and the devotion of the knights of Ferrara'. His presence was therefore a patriotic duty.

By the 1660s, patronage of the theatre in Ferrara had become a matter of professional management and future programmes; Ippolito II Bentivoglio wrote letters to book troupes of players in advance, and Pio Enea degli Obizzi in his study at Cataio made plans for the next year's Carnival. Where Francesco Guitti never seemed to have more than a month between the commission and the performance, there were now standing sets and expert scenographers to provide whatever special settings were required. Organisation replaced spontaneity and perhaps something of the uniqueness of the Ferrarese theatre, and of its relevance to Ferrara, was lost. In the book of Ippolito Bentivoglio's *Achille in Sciro*, the Printer and Reader explained that the aim of the performance was not to be useful but to delight, but in days of the *Andromeda* it had been assumed that one could do both. The Ferrarese theatre was in step with the theatre in Europe at large (in itself remarkable for a town which was now little more than a backwater), but the connection between the theatre and contemporary events was breaking, which seemed only to emphasise the growing sense of emptiness in Ferrara.

Conclusion

(i)

This book has hitherto been mainly concerned with the needs of art users and patrons, but what, it might be asked, was the effect of their patronage upon the artists and architects who served them, that is, upon local artists who looked to local patrons for a living?

In 1598 neither the architect Aleotti nor the painter Scarsellino chose to leave Ferrara and follow the Court to Modena. Neither, admittedly, was a young man at the time of devolution, but both appeared to conclude, as did their lesser contemporaries, that the political upheaval would not affect their careers. Indeed, while the Pope was in Ferrara, and even later, while Enzo Bentivoglio directed the festive theatre and connoisseurs in Rome continued to find Ferrarese art of interest, it was possible for artists to work more or less as they had before and, in the case of Scarsellino and Carlo Bononi at least, to find new patrons.[1] (One painter who did leave Ferrara for Modena, Domenico Mona, apparently did so only because of a fight with an abbot of the Aldobrandini party, and having immediately fled the consequences, he felt able to return to Ferrara by 1601.[2]) For Domenico Mona's younger contemporary, and perhaps pupil, Jacopo Bambini, there was work available both for the churches of Ferrara and for the connoisseurs (Roberto Canonici owned pictures by Bambini) and the academy *del nudo* which Bambini had opened by 1615 seemed a sign of confidence in the future.[3] But the copies which Bambini made of Ferrarese paintings carried off to Rome, and the growing number of local painters who, according to Baruffaldi, made copying a regular part of their work, was a less encouraging sign.[4] Thirty years after devolution, conditions had changed for the painters of Ferrara.

In 1604 Scarsellino had obtained permission from the Este to take a room in the Corte Vecchia for his studio and when he died in 1621 the painter Camillo Ricci had applied for the tenancy. But in the early 1620s Cesare Ubaldini described the *artisti* then lodged in the Corte Vecchia as 'poor and unhappy people' and, significantly perhaps, he placed them together with *mecanici*.[5] Perhaps the status of painters in Ferrara had never been on a par with their peers in, say, Florence or Venice, but now they seemed to be almost disregarded. It was still possible for such a painter as Giuseppe Caletti (Il Cremonese) to make a respectable career for himself (especially as a painter of altarpieces and other works for Ferrara's confraternities), and for Costanzo Catanio to make a local name for himself before enjoying the patronage of the Cardinal Bishop Pio. In perhaps the mid-1630s Catanio painted a *Crowning with Thorns* and a *Flagellation* for the Olivetan church of S Giorgio (whose Abbot Angelo Missoli was also

142

a patron of Guercino) and showed an individuality of style to contrast with the paintings in the same church by this compatriot Francesco Naselli, from whom had been commissioned copies of paintings by Lodovico Carracci and Guido Reni at the Olivetan monastery of S Michele in Bosco near Bologna. It would have been because they recognised Catanio's ability that the Commune and the Discalced Augustinians jointly commissioned him, in the early 1650s, to paint the important commemorative altarpiece in San Giuseppe of the *Trinity with the Virgin and Sts Joseph, Augustine and Monica*.[6] But Catanio was the exception. The very difficulty of discovering the names, let alone the careers, of other local painters, of a Casoli, Grassoleone or Paolo Varini, suggests their relatively lowly status. Only those artists who could adapt their skills to the theatre stood any real chance of fame. Alfonso Chenda, for example, may well have been the 'Alfonso Riverolla' who worked for the church of the Stigmata in 1624 and he certainly painted altarpieces. But the career of Chenda, a pupil of Carlo Bononi, took off when he worked for Enzo Bentivoglio in Parma, designed a *festa* for Borso Bonacossi in 1631 and, having given Bonacossi faithful service ('*servitù strettissima*' in the words of Baruffaldi), passed on to the patronage of Pio Enea degli Obizzi.[7] As for Chenda, so for Francesco Ferrari a generation later. Ferrari painted fresco decorations in Ferrarese churches and palaces but it was his work for the theatre, under the patronage of Obizzi, Ippolito Bentivoglio and Pinamonte Bonacossi which brought him fame, attracting as it did the attention of Lodovico Burnacini, scenic designer to the Imperial Court, on whose recommendation Ferrari was summoned to Vienna to work with other artists on the famous extravaganza of 1667, *Il Pomo d'Oro*, an honour which was later recorded on his tomb in Sta Maria in Vado.[8]

Since papal Ferrara had become, like Rome itself, a city of commemorative art, of inscriptions on façades and portrait busts in churches, and particularly the churches of S Paolo and Sto Spirito, it might be assumed that sculptors had fared better than painters. But much of this sculpture was the work of foreigners (a Genoese named Tommaso Gandolfi is credited with portrait statuary in Sto Spirito), and the only local sculptor whose name stands out is Filippo Porri, whose sculpture in wood decorated many churches.[9] Lack of raw materials seemed to combine with lack of interest in sculpture in Ferrara: when the Legate Imperiale was asked, in 1659, to look for stone carvers in Ferrara who could work on the new Piazza of St Peter's, he found one who refused to move and another, a Milanese, in the Fortress, but he had doubted the possibility of finding any at all, 'for the little use of this art here'.[10] One carver of inscriptions was, however, lucky enough to have his name recorded, that is, one Cesare Mezzogori of Comacchio who was actually working in the 1670s but who may stand representative of the many who had carved since 1598 the inscriptions which commemorated the beneficence of a pope, a cardinal or a public-spirited nobleman.[11]

It was the architects who had gained most from the devolution of Ferrara, for in a city which must at times have resembled a building site, and in which both Legates and nobility took particular interest in building, there was plenty of work for the architects (and for the Gnoli, Rosselli and Vacchi families of architect–engineer–surveyors) to do. Aleotti had been wise to stay in Ferrara in 1598. With new churches, new theatres and new public buildings to design, the quality of patronage had been high and stimulating, better than Cesare d'Este could have offered. From Aleotti the line descended to Francesco Guitti and thence to Carlo Pasetti, in whose education the architectural self-sufficiency of Ferrara was reflected. Pasetti was apparently the pupil of four masters: the Jesuit Padre Nicolo Cabeo taught him geometry

and perspective, Girolamo Rossetti instructed him in hydrostatics, Francesco Vacchi introduced him to fortifications design, and Francesco Guitti schooled him in architecture and, presumably, the art of theatre design.[12] The architect to the Apostolic Chamber, Luca Danese of Ravenna, stood outside the local tradition (he did not, for example, design for the theatre), but the patronage of the religious orders and of Magalotti allowed him to work on projects other than flood repairs, and he was unique in obtaining the two honours which it was in the power of the Legates to bestow: from Sacchetti he received the Order of the Golden Spur and from Cibò appointment as an apostolic protonotary.[13] The high status which Ferrara's own architects enjoyed was revealed by their inclusion, together with the city's poets, prelates and other heroes, in Antonio Libanori's *Ferrara d'oro imbrunito*. Libanori took pride in recording that Carlo Pasetti not only served his *Patria*, 'without payment', in designing for *feste* and jousts, but that Pasetti too had been summoned to Vienna to work for the Emperor Leopold I.[14] Yet the career of Francesco Guitti at least may have revealed a flaw in the character of patronage in Ferrara. Guitti worked for the religious orders and the Bentivoglio in the 1620s, and for the legation (and the Barberini) and Ferrara's theatrical entrepreneurs in the 1630s. If the separate parts of his work are pieced together an artistic character may appear. But as far as his patrons were concerned, the Guitti who drew and signed a survey map and the Guitti who drew and signed the frontispiece to the text of the *Andromeda* might have been two separate people (and as far as Fulvio Testi was concerned, Guitti in Rome was a spy).[15] It was, perhaps, this fragmentation of Guitti's work which helped to account for his subsequent obscurity.

The position of Francesco Guitti in Ferrara was not unlike that of Gaspare Vigarani in Modena, who was equally if not more talented, but of whom, as it happened, posterity was scarcely better aware. Even so, Vigarani was more fortunate than any other artist from the duchies of Modena and Reggio. By the 1660s, the group of local painters who trained as decorators under Jean Boulanger was available to fresco new churches in Modena, including Sant'Agostino, rebuilt by the Regent Laura Martinozzi, and S Vincenzo. One of these painters was Sigismondo Caula, who may well have been a talented artist. So, perhaps, was the Modenese Francesco Stringa, Court Painter to Alfonso IV, of whom Tiraboschi would write in the eighteenth century that had 'he been as excellent in design as he was in colour, and less capricious in invention, he could have had a place among the most worthy of painters'.[16] But neither Caula nor Stringa nor any other local artist achieved fame through the patronage of the Este Court. Francesco I had preferred to import the art and the artists needed to create quickly the environment he desired, and as a result the arrival of the Este in Modena had not, after all, led to any flowering of Modenese art, and Lodovico Vedriani's slender *Raccolta de' pittori, scultori et architetti Modonesi più celebre* was inspired more by the mere presence of the Este than by their encouragement of local art. Published in 1662, the *Raccolta* seems as precociously early as Baruffaldi's *Vite de' pittori e scultori Ferraresi*, written in the early eighteenth century, was remarkably late.

Painting in Ferrara was losing its distinctive character and painting in Modena was losing the chance to develop a character at all. Local patronage was responsible, but only in part. For the painters of Modena and Ferrara alike, the presence of Guercino in Cento had proved both influential and inhibiting, for an artist had to be very confident indeed to develop a style which owed nothing to him. Local patrons too had been drawn to Guercino.

144

(ii)

Guercino was not a scenery painter but he attracted the attention of Enzo Bentivoglio, whose visit, unannounced, to the painter's studio on Cento apparently made Guercino wish he were able to recite plays extempore.[17] This visit was perhaps made in 1617, and by December of that year Enzo was certainly hoping to employ Guercino, and his compatriot Pier Francesco Battistelli, on decorations in a Bentivoglio palace. Enzo was not unaware of the unusual talent of Guercino, for the draft contract for this work stipulated that 'Gianfrancesco Barbieri' must undertake to devote to it one-and-a-half months a year, but though Guercino toyed with the idea of one month, the commission seemed not to appeal and the contract was not signed.[18] Guercino then came to the notice of another patron anxious to tie him down, that is, the Cardinal Giacomo Serra, whose demand for paintings obliged Guercino to defer work for the Gonzaga of Mantua. In Rome from 1621 to 1623, Guercino worked for many patrons, including the Ludovisi, the family of the reigning Pope Gregory XV, and Scipione Borghese, and came under the influence, it seems, of the aesthetic tastes and theories of Gio. Battista Agucchi. Yet it was, according to G. B. Passeri, Enzo Bentivoglio who obtained for Guercino the most memorable commission of his period in Rome. Having been asked by the Cardinal Lodovico Ludovisi to advise on the decoration of the Ludovisi villa at Porta Pinciana, Enzo considered the merits of Reni, Albani and Domenichino and then remembered the 'squint-eyed' (*guercino*) artist from Cento 'who is also very good and would benefit from the opportunity', and thus he gave Guercino both his nickname and the commission to paint, in collaboration with Agostino Tassi, the ceiling fresco of the *Aurora* in the Casino Ludovisi.[19] The story may not be true since it was the Ludovisi who had, in fact, brought Guercino to Rome, but it is very tempting to see Enzo, the director of *feste*, as the agent also of the *Aurora*, the most spectacular fresco of the day in Rome.

When Guercino returned to Cento in 1623 he was thirty-two years old and an experienced, sophisticated artist who could only profit from the effects of devolution, which by dividing one state into two had increased the number of patrons. His studio developed to supply the need for portraits, histories, allegories, mythologies, public altarpieces and private devotional images. Everything in short, could be ordered from Guercino, excluding, from the early 1630s, the mural decoration but including, thanks to his brother Paolo Antonio Barbieri, the still life. It was now that Guercino began to experience the kind of demand which, according to Passeri, kept him so busy that he had to scribble patrons' names on the back of canvases in order to control the work in hand, and which kept his account book in the black until he chose to spend the money, as he did in 1645 on his house in Bologna and his chapel in Cento.[20]

Guercino had no competition in Cento and when Guido Reni died in 1642, Guercino, who now moved to Bologna, was uncontested. He worked, through agents, for patrons he never met, and he worked for an admiring public at home, for whom he was both a local painter and an artist of international stature. When the patron of a church or a chapel, or a group of patrons in a confraternity, wanted an altarpiece of distinction, they commissioned Guercino, so that by the 1660s there were five altarpieces by him in Ferrara, four in Modena and seven in Reggio. Some of these may have represented a challenge. For the *Stigmatisation of St Francis* commissioned in 1631 by the Ferrarese Confraternity of the Stigmata, Guercino, 'since there

was no other work by his hand on public display in the city, had made every effort to ensure that it was exquisite'.[21] Fourteen years later, however, his response to a commission from the Modenese Confraternity of the Stigmata was somewhat less enthusiastic. The commission was supported by the Duke of Modena, and Guercino did not refuse, but he did explain that he was very busy, and in fact took two years to deliver the painting. This was the *Glory of All Saints* completed in 1647 (now in the Musée des Augustins, Toulouse), and it is perhaps not difficult to see why Guercino did not find it a particularly attractive commission. The Trinity, with angels, and the Madonna with Sts Joseph, Peter, Paul, John, Sebastian, Francis and, as the protector of Modena, Geminiano, had all to be accommodated in the altarpiece. No fault could be found with the patron, for this was the painting they needed, but there was an archaic quality in the commission which brings to mind observations made by Francesco Scannelli before the two confraternity altarpieces by Correggio in the ducal gallery in Modena, altarpieces similarly packed with figures deemed essential but difficult to organise into an aesthetically satisfying whole. Scannelli had to admit that there were defects in these paintings, but he blamed the demands of the patrons.[22] For Guercino, it might be expected that the patronage of the local princes, the Este and the Cardinal Legates, would be more stimulating. Once at least, however, it almost caused a political incident.

Guercino was a papal subject but when he worked for the Este, when, for example, he sent a proposal for a painting to the Cardinal Alessandro d'Este, it is unlikely that he needed the Legate's prior consent. When he visited Modena in the autumn of 1632 to work for Francesco I, he would have needed permission and a passport, but the Legate Pallotta was probably not asked to approve his subsequent dealings with Francesco, or he would not have written as follows to the Cardinal Barberini in March 1633:

> I know that they [the Este] have tried and still try to lead Guercino of Cento astray, and I would think it timely with him, and with others who might take that path, to say that His Holiness and Your Eminence will not be pleased, and thus they will understand what they let themselves in for.[23]

It may be that Guercino was warned, for it seems to have been some years before he again crossed the border. Nor did Francesco appear to have visited his studio in Cento, but he did continue to commission paintings from Guercino (and from Paolo Antonio Barbieri), as did the Padre d'Este and Francisco's brother Obizzo, which made Guercino the House of Este's most favoured painter.[24]

A special relationship between Francesco and the artist was recognised as early as 1633 not only by Pallotta but by the House of Savoy, for in that year Girolamo Graziani, sent as an envoy to Turin, was asked if Francesco would recommend to Guercino a protégé whom they hoped he would agree to train.[25] In 1649 the kindness that the Duke of Modena could show to his faithful courtiers was shown also to Guercino, who on the death of his brother Paolo Antonio was escorted, by Poggi, to Sassuolo to recover from his grief. In return, he restored for Francesco an altarpiece by Dosso which the Duke had just acquired.[26] How many paintings by Guercino entered the Este collection (by gift as well as commission) in Francesco's day is difficult to say. Nor is it known how or where they were then displayed. By the 1670s, however, a room at Sassuolo, the Room of Dreams, had become a little gallery of Guercino's

paintings, and among the six pictures displayed there were two, the *Venus, Mars and Cupid* of 1634 and the *Decollation of the Baptist* of 1638, which were certainly ordered in Francesco's time.[27] The Duke of Modena, wrote Malvasia, respected Guercino's *virtù*. With the access he had to the papers held by Guercino's heirs, the Gennari, Malvasia had perhaps seen the letter which, in draft, indeed expressed Francesco's admiration for the 'goodness and merit of your eminent *virtù*'.[28]

Forty miles east, Guercino enjoyed a rather similar relationship with the Cardinal Legates of Ferrara, painting their portraits, devotional images or histories, providing them with pictures for use as gifts (as Rocci ordered a painting for Gio. Carlo de' Medici and Imperiale ordered a *Flagellation of Christ* for Pope Alexander VII), and occasionally restoring a picture for those who brought their art with them, such as the Cardinal Cibò, for whom Guercino restored a painting by Titian.[29] Their patronage, and that of the Cardinal Magalotti, was imitated at a lower level by officials, by the police lieutenants Benaduccio, Valentino Pellegrini and Argoli for example, whose customary preference for devotional paintings was upset by Argoli's ordering of a *Hercules* and an *Artemisia*, but perhaps something different was only to be expected of an officer sent suddenly and urgently from Rome.[30] The gifts of paintings to Legates from the Commune of Cento made the legation taste for Guercino seem almost an institution. There was, moreover, scarcely a distinguished visitor or temporary resident who did not acquire his work. Passeri recalled a conversation in Rome with someone who had collected drawings and paintings by Guercino during a term as governor of Cento. The Cardinal Antonio Barberini commissioned work and so did the papal troop commanders of the 1640s, Taddeo Barberini and the Baron Mattei. There was also the intriguing Raffaello Gabrieli, Castellan of the *Fortezza Urbana*, who commissioned between 1659 and 1663, from a now elderly Guercino, a series of *Diana*, *Apollo*, *Aurora* and *Night* whose poetical character seemed at odds with the patron's vocation.[31]

If they were not themselves commissioning paintings, local patrons might act as agents, as did the Bentivoglio, for example, one of a number of means whereby Guercino's pictures entered French collections, and in particular that of the Cardinal Mazarin.[32] Even the Duke of Modena or, more accurately, his brother the Cardinal Rinaldo, became an agent when in July 1648 he chased progress as requested on an *Angelica and Medoro* ordered in November 1647 for Francesco's companion-at-arms, the French marshal Plessis-Preslin.[33] Worth mentioning here among the agents is the interesting if somewhat obscure figure of Gio. Battista Tartaglione of Modena, a patron of Guercino (and of Lodovico Lana) in his own right but also the agent of commissions to the artist from the Count Alfonso Gonzaga of Novellara. (The precise nature of Tartaglione's connection with either Gonzaga or Guercino is not clear, but he also appeared to buy a Titian for Gonzaga and he may have dealt as an amateur in art.[34]) Guercino was surrounded by admiring patrons and useful agents. How comforting and lucrative it must have been, and yet, maybe, how impersonal.

In conversation with Francesco Scannelli, Guercino once said that he had begun to abandon the deep chiaroscuro of his early maturity and to paint in lighter colours because his patrons, wishing to see more clearly the figures he painted, had asked him to do.[35] Of all the explanations which critics from Scannelli to the present day have offered for the change, as perceived in the artist's lifetime, from a first to a second manner, this is perhaps the most interesting, not only because of the insight it gives into the somewhat prosaic minds of patrons, but because

it reveals how responsive Guercino was to his patrons, and how ready to adapt to their wishes. It seems, therefore, unfair that contemporary critics should find fault with the 'second manner'. Scannelli and Passeri, for example, believed it to be inferior to the first, a regrettable departure from Guercino's personal, innate style. Their opinion is at first hard to credit before such an exceptionally beautiful example of Guercino's later paintings as the *Purification of the Virgin* of 1654 in Ferrara, but an observer who looks through the eyes of a Scannelli, say, and seeks a truth, divine or otherwise, beyond the flawless surface, may be disappointed even here. It is difficult to feel before this painting, as is unavoidable before any of the paintings for Serra, that the artist had committed himself to his subject and worked until he arrived at what was for him its essential meaning. Scannelli the physician wondered if age was to blame for the weaknesses he saw in the later paintings, and the practical demands of a busy career might also be considered. No less significant, however, may have been the quality of local patronage, both as a part of Guercino's patronage as a whole and, more important, as the environment in which he lived and worked and to which he belonged.

The Legates and their officials represented an interestingly varied source of work, but they were also passing presences who came and went, and if they continued to order paintings (as did the Cardinal Cibò), they did so by post or agent. So much of Guercino's work was now undertaken in this way, though in earlier days he had seemed not only dependent upon advisers and mentors, such as the Bolognese Canon Antonio Mirandola and, in Rome, perhaps Gio. Battista Agucchi, but also to benefit from personal contact with patrons. The Cardinal Serra may well have been an uncomfortably overbearing patron to work for, but his patronage gave Guercino the chance to work not with the soft, poetical themes he already knew but with stories of violent action, dramatic tension and complex psychology. Thus Serra helped to steel Guercino's highly sensitive style in readiness for Rome and such a testing, probably exhausting, commission as the *Aurora*, when it was perhaps the turn of another domineering personality, Enzo Bentivoglio, to urge the artist on. This was the kind of creative patronage which Guercino later lacked. When Francesco d'Este asked, by letter, for a painting of St Jerome, he asked that it should be 'as beautiful as it is spiritual', but left all decisions to Guercino.[36] There was a world of difference between Serra's patronage, as, according to Malvasia, he paced robustly about the painter demonstrating the illusion of all-round reality he liked in Guercino's figures, and the Duke of Modena's much better mannered but somewhat bland regard for Guercino's *virtù*. In any case, as Guercino presumably realised, the taste of the Este Court was moving away from contemporary art towards sixteenth-century painting, more satisfying to study and collect. In 1651 Francesco may well have been, as Malvasia claimed, delighted with the gift of a *Lot and his daughters* by Guercino, but in the same year an agent sending him news of pictures available for purchase deliberately omitted the price of a Guercino, assuming that the Duke would not wish to acquire another 'modern'.[37] It would have been, perhaps, dispiriting for Guercino to know, and surely he did know, that his old acquaintance at the Este Court, Geminiano Poggi, had by now come to believe that his painting was inferior to that of Federico Barocci, and not to be mentioned in the same breath as that of Correggio. Honourable treatment and polite respect had replaced passion and commitment in the patronage of Guercino, and it was reflected in his art. It was in one sense Guercino's luck, in another his misfortune, to live and work in a world which had need of art for many purposes,

had great admiration for artists and knew how to analyse and classify style, but seemed no longer capable of inspiring its finest painter.

(iii)

In 1671 the Marquis of Seignelay, Colbert's son, travelled in Italy. He spent a day in Modena, where he visited the ducal gallery and saw Correggio's *La Notte*; 'one of the most beautiful pictures in the world' he observed. He spent just two hours in Ferrara, where of course he inspected the Fortress.[38] Modena's stock was rising while that of Ferrara fell, and so it would continue.

In the year of Seignelay's travels, a *Descrizione* of Ferrara set down in terms which were bitterly sad the growing desolation of the city:

> One no longer sees gardens or labyrinths, no aviaries, grottoes nor fountains, for all have been ruined, destroyed and razed . . . no more vines, pergolas or fruit-trees, for all have been cut and uprooted; there remains only, as if for remembrance, the bare *Montagna* . . . and the Palazzino . . . so unkempt that it resembles a pig-sty rather than a human habitation, ruined by the soldiers who have been quartered there.[39]

Soon the theatres too began to vanish, that of the Obizzi destroyed by fire, that of the Bentivoglio closed down, leaving only the *Teatro Bonacossi*. When the Comte de Caylus visited Ferrara in 1714, he saw a fair city with fine roads but a small population, an observation repeated by an English traveller of the 1720s: ''Tis pity the beauties of so fine a place as Ferrara should be enjoyed by so few', he wrote, adding that 'the rigour and extortion of the papal government is assigned as a reason for it.'[40] So much, then, for the efforts of the Cardinal Legates who had once worked to preserve Ferrara and safeguard its interests. The Church fared a little better. In the person of the Legate, then Bishop and finally Archbishop of Ferrara Tommaso Ruffo, the Church produced one of Ferrara's most lively patrons of the eighteenth century until, in 1738, he left Ferrara for good. There remained the Bentivoglio, patrons of literary academies, and of Vivaldi, in residence at their palace near S Domenico and possessing what the Englishman Arthur Young dismissed in 1798 as a 'garden full of bad statues'.[41] Ferrara, it seemed, had little more than its past to recommend it. A sense of nostalgia for the past had been growing in Ferrara since the early seventeenth century (it had been reflected in the collection of the Ferrarese Alfonso Gioia who, wrote Baruffaldi, had collected remembrances of Ferrara, including portraits by Dosso, and left them to the Duke of Modena in 1687[42]). In the late eighteenth century, Ferrarese nostalgia would join the mainstream of European Romanticism. Goethe visited the city and Byron, who composed there in 1817 his *Lament of Tasso*: 'When ducal chiefs no longer dwell / Ferrara shall fall down.' In 1859 it was the turn of the Fortress of the Annunciation to fall, demolished with as little ceremony as the Belvedere palace it had replaced, and represented now by the overgrown ditches and surviving brick walls which are a relic of the papal era in this undeveloped (and still unwholesome) corner of the city.

The Este, meanwhile, had flourished in Modena, and as if invigorated by devolution they remained when other Italian dynasties failed. When Francesco II, the son of Alfonso IV and Laura Martinozzi, died without issue in 1694, he was succeeded by Rinaldo I, the son of

Francesco I and Lucrezia Barberini, who renounced the cardinalate to become Duke of Modena. He continued the process of Este expansion in Lombardy, absorbing Mirandola in 1707 and Novellara in 1737, and with the help of the Emperor Joseph I, he also regained, though only briefly, possession of Comacchio. 'The Duke of Modena is more highly regarded today than any other of those known as the minor princes of Italy', wrote a visitor of the 1720s.[43] After Rinaldo, the Este would continue in Modena until 1803, when Duke Ercole III abdicated in favour of his son-in-law Ferdinand of Habsburg-Lorraine-Este, a new dynasty which ruled (in theory only after 1860, when Modena was annexed to the House of Savoy) until 1875, when the title passed back to the House of Austria.

With the exception of the Palazzo Ducale in Modena and the Palace of Sassuolo, much that Francesco I had built or assembled would be destroyed or dispersed. The citadel or fortress of Modena was demolished in the 1780s by order of the enlightened Ercole III and made space for public recreation.[44] The gallery of pictures survived the Regent Laura Martinozzi's wish to restore altarpieces to churches and the desire of cadet line princes, especially Cesare Ignazio d'Este, to enrich their own collections. Francesco II was not himself a notable collector, preferring music and considerably increasing the riches of the Este library through his collecting of books and manuscripts.[45] Nor was Rinaldo I a keen collector of art, but he did protect the collection and in his time it seemed substantially unchanged since the days of Francesco I and his son. As late as 1743 the three famous altarpieces by Correggio were displayed together as they had been when Francesco Scannelli had studied them, the then curator Gherardi possibly wishing to recreate the *Microcosmo della Pittura* as Scannelli had described it. But in 1746 one hundred of the finest pictures, among them those by Correggio, Parmigianino, Titian, Veronese, Giulio Romano and Andrea del Sarto, were sold to Augustus III, Elector of Saxony and King of Poland, and were sent to the Electoral Gallery in Dresden and to new generations of admirers, not the least of whom was Hegel. Henceforth the Este collections would be subject to repeated raiding by invaders or heirs, and each time would have to be replenished from the reserves of art at Sassuolo or in the local churches.[46]

The presence of the Este had undeniably given a new dignity to the city of Modena. As far as the Comte de Caylus was concerned, they alone were responsible for the few sights worth seeing there. 'This town is not well built', he began, and having seen the unfinished ducal palace ('built with much good taste in architecture') and praised the ducal gallery, he left remarking that 'there is nothing more to see in Modena'.[47] Yet Modena had flourished before the arrival of the Este and it would continue to flourish when they had gone. The Modenese had retained their traditional talent for commerce: Arthur Young was pleased to see children charging travellers for ready-saddled mounts between Modena and Reggio: 'this shows attention and industry, and is therefore commendable'.[48] It may therefore be the same talent which has made Modena today one of the most prosperous cities of Italy. The Este never took so firm a hold upon the life of this city as it had upon the other, perhaps because Modena always lived in the present, never the past. Say Modena today and it may bring Lambrusco wine, or Ferrari cars from Maranello, to mind, but Ferrara still means the Este.

Notes

Full details of books and manuscripts cited here can be found in the Select Bibliography.

Introduction

1 Penna, 1663, p. 10.
2 Frizzi and Laderchi, V, chapter 1; Prinzivalli; Pastor, 1933, p. 328 and 1958, p. 597.
3 Coffin, 1960, *passim*.
4 Agnelli, pp. 290–1. The papal *Gonfalone* occupying the central field of the Este *stemma* or coat-of-arms was granted in 1368, and not surrendered in 1598. The papal Keys were conceded in 1474 but the assumption of the papal crown or *Triregno* is of uncertain date. The original Este *stemma* was the silver Eagle on a blue field. In 1431 Charles III of France granted the Este use of the three Golden Lilies on a blue ground, and in 1452 they were granted by the Emperor the Imperial Eagle on a gold ground (representing the duchies of Modena and Reggio) and the divided Eagle, part black on gold, part silver on blue, representing the County of Rovigo. (See Litta, *Celebri famiglie italiane*, vol. II.).
5 Agnelli, pp. 299–300.
6 Prinzivalli; Agnelli, pp. 302–3.
7 Spaccini, I, p. 36.
8 PRO, SP85, 2, 62–3.
9 Prinzivalli.
10 Prinzivalli. The Emperor confirmed the investiture of Modena, Reggio and Carpi on 8 August 1594, at a price, according to Prinzivalli, of 400,000 *scudi*.
11 Spaccini, I, p. 134.
12 Bellini, pp. 230–6.
13 Moryson, p. 120.
14 Frizzi, p. 22; Chiappini *et al.*, pp. 9–12 and 49–50, with extensive bibliography.
15 Bentivoglio, 1648, p. 16; Frizzi, p. 22; Ferri, p. 465.
16 Frizzi, pp. 48–9; Bonasera, p. 55 and p. 62; Herz.
17 Bentivoglio, 1934, p. 39; Frizzi, pp. 31–2.
18 BCA *ms.*, Ubaldini, pp. 8, 21, 27; Frizzi, pp. 19–20; Trotti, p. 23, n. 1; d'Onofrio, pp. 15–20, 158–62, 202–11. Lucrezia's marriage of 1570 to Francesco Maria della Rovere of Urbino had not been a success and she returned to Ferrara, residing in the Corte Vecchia (Agnelli, p. 317). According to Ubaldini, Aldobrandini persuaded Lucrezia by promising her Bertinoro as a duchy.
19 Venturi, p. 16; d'Onofrio, Mezzetti, *Il Dosso*, 1965, p. 135; Wethey, III, p. 29; Goodgal; Hope.
20 Moryson, p. 148. It is not quite true to say that no European power intervened, for Queen Elizabeth of England's favourite, the Earl of Essex, sent a small force of 25 men to assist Cesare d'Este, though the party had only reached Augsburg when news came of Cesare's surrender. (See E. Denison Ross: *Anthony Sherley and his Persian adventure*, London, 1933, p. 12.) It was in fact the English ambassador in Constantinople who had reported there the news of Cesare's succession and the Pope's response and who was of the opinion that the Sultan might take advantage of this report in the negotiations for peace. (See *Calendar of State Papers, Venetian, vol. IX, 1592–1603*, Public Record Office, London, 1897, p. 304.) There is no evidence, however, that the Sultan was indeed able to do so.

21 Penna, 1663, p. 3.
22 Libanori, p. 119.
23 Agnelli, pp. 316–17.
24 ASV, *Ferrara*, 2, 41–7, *Copia della scrittura del Rondinelli.*
25 Agnelli, pp. 302–9; Montaigne, *Oeuvres Completes*, M. Rat (ed.), 1962, pp. 1189–90.
26 Agnelli, pp. 268–72.
27 BCA *ms.*, Ubaldini, p. 22; Penna, p. 11; Guarini, p. 135; Frizzi, p. 19; Frizzi and Laderchi, pp. 35–6. Penna estimated a fall in the population by 1601 from 50,000 to 32,680, while the source cited in n. 24 above estimated a reduction from 34,000 to between 20,000 and 22,000; neither is likely to be precise but that there was a sharp fall in population is agreed. According to Frizzi, the *Podestà* Fabio Fabri was responsible for the excessively severe punishments, and after appeals the post was abolished and replaced by that of lieutenant.
28 ASM, *Cam. Duc.*, *Ferrara*, 13, 31.10.1608; Frizzi and Laderchi, pp. 37–8; Trotti.
29 Ubaldini, p. 23.
30 Scoto, p. 160.
31 Vedriani, 1662, p. 10
32 Vedriani, 1662, p. 86 (the Buonomi family of craftsmen). According to R. Lassels (*The Voyage of Italy*, Paris, 1670, p. 140), the Modenese still made the best 'vizards' in his day.
33 Agnelli, p. 218.
34 Tassoni, p. 488. Tassoni's *La Secchia Rapita Poema Eroicomico*, composed *c.* 1614 in Rome, takes its story from a skirmish between Modena and Bologna in the 1320s over possession of a bucket (said to be that preserved in the Ghirlandina tower), a story which Tassoni uses to satirise contemporary society and certain Modenese individuals in particular. This 'Satire of the Varronian kind', much admired by Dryden, was in part translated into English by M. Ozell as *The Trophy-Bucket* and published in London in 1713. With it, Tassoni virtually invented the mock-heroic epic.
35 Vedriani, 1668, p. 606; Mor and Pietro, p. 37.
36 Agnelli, p. 280; Artioli and Monducci, *passim*. The image of the Madonna, derived from a *bozzetto* for a fresco by Lelio Orsi, was said to have cured a deaf-mute in 1596. Alessandro Balbi won the competition for the design of the new church (defeating Aleotti among others), and among painters represented by frescoes or altarpieces in the church are Alessandro Tiarini, Leonello Spada, Carlo Bononi and Guercino.
37 'Nicolo of Modena' (mentioned in E. K. Waterhouse, *Painting in Britain*, Penguin, first pub. 1953, p. 4) must be 'Nicholas Bellin of Modena' (J. Summerson, *Architecture in Britain*, ed. 1977, p. 34), an artist–decorator who worked at Fontainebleau before entering Henry VIII's service.
38 Vedriani, 1662, pp. 103–4. Giovanni Guerra, a painter–architect who also worked in Ferrara and Modena, spent most of his career in Rome with his brothers Gio. Battista (an Oratorian) and Gaspare (*Giovanni Guerra*, ex. cat.; Modena, 1978). Another Modenese in Rome was the shady 'Gironomo' named as the violator of Artemisia Gentileschi at the trial of Agostoni Tassi (R. and M. Wittkower, *Born under Saturn*, London, 1963, p. 163). A 'Tassoni of Modena' was working in Bologna in 1598 (Malvasia, II, p. 11). Schedoni was in Parma.
39 Tiraboschi, V, pp. 136–7.
40 Agnelli, p. 280 and pp. 300–1.
41 BCA *ms.*, Ubaldini, pp. 36–8; Pastor, 1933, p. 382.

1. Reactions

1 ASV, *Ferrara*, 2, 191, 3.7.1607.
2 ASM, *Canc. Duc.*, CSCPE, 82a/182, 23.1.1602.
3 ASV, *Ferrara*, 2, 192, 7.7.1607 (report on Ranuccio I Farnese); Bentivoglio, 1648, pp. 20–1.
4 BCA *ms.*, Ubaldini, p. 136; ASV, *Ferrara*, 1, 13.11.1597.

5 ASM, *Canc. Duc.*, CSCPE, 23, 14.9.1602; Schenetti, p. 148.

6 BCA *ms.*, Ubaldini, p. 19; M. Bellonci, *Segreti dei Gonzaga*, Mondadori, 1947, p. 177.

7 Novelli, p. 23, n. 28.

8 ASV, *Ferrara*, 1, 13.11.1597; PRO, SP85, 2, 63, 17.11.1597.

9 Agnelli, pp. 316–17; Prinzivalli, p. 241; BCA *ms.*, Ubaldini, p. 21.

10 Spaccini, I, p. 206 and p. 327; Tiraboschi, III, p. 58.

11 Spaccini, I, p. 268 and II, p. 287; BCA *ms.*, Ubaldini, p. 21. (For a discussion of the papal *monti*, introduced into the papal economy, perhaps on Florentine precedent, by Clement VII and increasingly used by popes during the sixteenth century to raise money for specific purposes by means of loans secured against revenues, see J. Delumeau, *Vie économique et sociale de Rome dans la seconde moitié du XVIe siècle*, II, Paris, 1957.)

12 S. Petrasancta, *De Symbolis Heroicis*, IX, Antwerp, p. 272. Cesare shared the *impresa*, with a device of the sun dispersing the clouds, with the seventeenth-century Imperial General Collalto.

13 Orbaan, p. 129.

14 Vedriani, 1668, II, pp. 603–4; Prinzivalli.

15 Venturi, p. 18; della Pergola, I, p. 154; Mezzetti, *Il Dosso*, 1965, p. 74 and p. 135; Mezzetti, *Paragone*, 1965; Hope; Cavicchi *et al.*, pp. 93–106.

16 Fava, pp. 164–7.

17 Venturi, p. 113.

18 Venturi, p. 113.

19 ASM, *Canc. Duc.*, Pittori, 15/3, Tisi, Benvenuto, 9. 8. 1605; *Cam. Duc.*, Ferrara, 12, 10.1.1608. According to Spaccini (Spaccini, I, p. 223), in November 1598 Cesare had explained to the Cardinal Aldobrandini that his only reason for wishing to keep certain paintings left in Ferrara was for the sake of his ancestors (*per memoria delli suoi antecessori*). It is not clear if this applied to all paintings. If it did, it would shine an interesting light on Cesare's attitude towards the art in his inheritance.

20 Campori, 1855, pp. 243–4; ASM, *Canc. Duc.*, CSCPE, 23, 1.8.1602; Muratori, I, Part II, pp. 516–17.

21 Campori, 1855, pp. 239–40; Wethey, II, pp. 93–4; Malvasia, I, p. 351.

22 Campori, 1855, pp. 243–4; ASM, *Canc. Duc.*, Pittori, 13/1, Giovanni di Ark, 5.1.1604 and 27.6.1604. For von Aachen, see T. Dacosta Kaufmann, *L'Ecole de Prague. La Peinture à la cour de Rodolphe II*, Paris, 1985.

23 Spaccini, III, p. 93; Armandi *et al.*, p. 106.

24 Spaccini, 14.2.1605; Basini, p. 19.

25 ASM, *Cam. Duc.*, Amministrazione, Card. Alessandro, 348, *Eredità del Cardinale Alessandro d'Este*; Canc. Duc., Documenti, 413, *Scritture diverse riguardanti Luigi del Duca Cesare*.

26 ASM, *Cam. Duc.*, Fabbriche, 14, Carteggi 1697–1727, *Discorso per abelimento et accomodamento del Parco del Ser.mo Duca Cesare con puoca spesa e molta vaghezza*.

27 Vedriani, 1668, II, p. 635; Campori, 1855, pp. 391–2, and p. 414; Armandi *et al.*, p. 106 and p. 154.

28 Vedriani, 1662, pp. 143–4; Tiraboschi, V, pp. 136–7.

29 Venturi, pp. 138–9.

30 Lodi, *passim.*; D. Miller, 'Bartolomeo Schedoni a Modena: la fase iniziale della sua opera (1602–7)', *Atti e Memorie della Deputazione di Storia Patria per le antiche Provincie Modenesi*, 1982, serie XI, IV, pp. 175–203, discusses Schedoni's commission of 1604 from the Commune of Modena.

31 Vedriani, 1668, II, pp. 615–16. Precedents for a commune standing godfather include, in the sixteenth century, the Republic of Venice acting in this capacity to Charles Emmanuel I of Savoy.

32 ASM, *Canc Duc.*, Estero, Roma, 168, 11.6.1605, 6.8.1605 and 13.8.1605; Posner, II, n. 110; Zapperi; Friedlaender, pp. 310–14.

33 ASM, *Canc. Duc.*, Estero, Roma, 168, 30.8.1605; Spaccini, 8.9.1605.

34 Mazza Monti, p. 39.

35 Lodi, *passim.* (Schedoni signed a contract with the Farnese on 1.12.1607. It is possible that he was forced to leave Modena, having been imprisoned that year for a brawl, and petitioned the

Duke, by means of a poem, for clemency, but since it had once been hoped that the outlaw Caravaggio might flee to Modena and so complete his commission, it is unlikely that Cesare at least would have obliged Schedoni to leave the city; Vedriani, 1662, pp. 131–2; Tiraboschi, VI, p. 536.)

36 Lodi, p. 62. See also Vedriani, 1662, p. 116 and Venturi, pp. 182–3. On Schedoni's death in 1615 Cervi completed his training with Guido Reni. He worked as the Court's painter in the 1620s (painting altarpieces, festive decorations, etc.) and died in the plague of 1630.

37 ASM, *Canc. Duc., Pittori*, 13/1, *Belloni, Giulio*, 29.3.1608; Malvasia, II, p. 73; Campori, 1855, p. 447; F. Frisoni, 'Leonello Spada', *Paragone*, 1975, 299, pp. 53–79.

38 Gamberti, *Idea*, p. 264 (with reference also to the funeral oration for Cesare by Lodovico Scapinelli).

39 Tassoni, Preface to the *Pensieri Diversi*.

40 Ridolfi, ed. 1924, II, p. 269; Campori, 1855, pp. 352–6; Venturi, p. 146; ASM, *Canc. Duc., Pittori*, 15/3, *Peranda, Sante*, 28.9.1620. See also Marchioni Ascione.

41 Spaccini, I, p. 145.

42 Marino, I, p. 111. Marino had visited Modena some time between 1604 and 1607.

43 Soli, I, p. 349; Campori, 1855, p. 352; Baruffaldi, II, p. 158; ASM, *Canc. Duc., Documenti*, 412, *Testamento e codicillo di Luigi del duca Cesare*, 18.3.1662. Neither the corridor nor S Domenico as it was then exists today. The church was rebuilt between 1708 and 1731 on a oval plan designed by Giuseppe Antonio Torri.

44 Novelli, pp. 20–1 and ASM, *Canc. Duc., Pittori*, 16/4, *Scarsellino, Ippolito*, 2.6.1615, 9.6.1615 and 19.6.1615. (The chapel of Alfonso was in the church S Benedetto in Ferrara.)

45 ASM, *Canc. Duc., Pittori*, 15/3, *Peranda, Sante*, 19.2.1611 and 30.10.1619; Silingardi, p. 100. (For the features of Borromeo, Scarsellino perhaps worked from portraits of him in Ferrara; see Peverada, pp. 326–7.)

46 Soli, III, p. 398; Wethey, I, pp. 161–3; Ridolfi, ed. 1914, I, pp. 161–2.

47 Tassoni, p. 507.

48 See n. 26 above.

49 ASV, *Ferrara*, 18, 60, *Capitoli trovati . . .*, found and sent to the Barberini by Legate Rocci on 16.2.1639.

50 ASM, *Cam. Duc., Ferrara*, 8, 20.3.1603.

51 Superbi, p. 17; Libanori, pp. 10–11; ASM, *Canc. Duc., CSCPE*, 82b/183, 4.7.1612. (Spaccini, 13.8.1606, recorded that when the Pope called Alessandro to Rome, he would plead an excuse, such as need of a purge.)

52 ASM, *Canc. Duc., CSCPE*, 84a/186, 8.12.1621 and 2.2.1622.

53 ASM, *Canc. Duc., CSCPE*, 82a/182, 16.1.1602.

54 ASM, *Canc. Duc., CSCPE*, 82b/183, 23.8.1604.

55 ASM, *Canc. Duc., CSCPE*, 82b/183, 14.10.1608.

56 ASM, *Cam. Duc., Amministrazione, Card. Alessandro*, 348, *Eredità . . .*; Campori, 1870, p. 61. Alessandro bequeathed several paintings to the Princess Giulia, that is, Cesare's daughter, with whom the Cardinal's name had been linked by gossip, rather than his own natural daughter Giulia Felice.

57 ASM, *Cam. Duc., Amministrazione, Card. Alessandro*, 371, *. . . nota delli argenti che si ritrovino in due cassette entrovi cose appartenenti al dissegno dell'Ill.mo Card.le d'Este*.

58 ASM, *Cam. Duc., Amministrazione, Card. Alessandro*, 371, *Circa la vendita di Mobili di Roma* and *Inventario delli Mobili trovatosi nel Vescovato di Reggio*; Campori, 1855, p. 453.

59 ASM, *Cam. Duc., Amministrazione, Card. Alessandro*, 348, *Libri manuscritti dell'eredità del Sig. Card. d'Este*.

60 ASM, *Cam. Duc., Amministrazione, Card. Alessandro*, 371, *Rolo della famiglia a dì 5 gennaio* (?) 1611; Marino, p. 33; Campori, 1870, pp. 57–73; Campori, 1866, pp. 82–3.

61 ASM, *Canc. Duc., CSCPE*, 82b/183, 16.5.1609; Ridolfi, ed. 1924, II, p. 168.

62 Mancini, I, pp. 233–4. Another female painter of whom Alessandro was a patron was apparently Artemisia Gentileschi, to judge from her letter from Naples of 22.5.1635 to Francesco I making reference to Alessandro's generosity (ASM, *Canc. Duc., Pittori*, 14/2, *Gentileschi, Artemisia*).

63 Campori, 1870, pp. 57–73; Malvasia, I, p. 379; Campori, 1855 (the donor of the Carracci painting was Asdrubale Bombasi of Reggio).

64 ASM, *Canc. Duc.*, *Pittori*, 14/2, *Carracci, Agostino*, 2.5.1619, Francesco Paselli in Bologna to Alessandro.

65 ASM, *Canc. Duc.*, *Pittori*, 16/4, *Spada, Leonello*, 2.6.1620; Malvasia, II, pp. 77–8.

66 ASM, *Canc. Duc.*, *Pittori*, 13/1, *Barbieri, Giovan. Francesco detto Guercino*, 20.5.1624, written in the month of the Cardinal's death; Marino, p. 122. For Guercino's lodging in the Strada Paolina, Rome, see Bagni, pp. 225–6.

67 Vedriani, 1662, p. 102. (Only a drawing represented Schedoni in Alessandro's collection and there were no other Modenese paintings. He was, however, a patron of Scarsellino in Ferrara; see Novelli, p. 25.)

68 Campori, 1855, p. 339. The church of the Paradiso, one of the dullest, perhaps, in Modena, was begun in 1596 to the design of Giovanni Guerra. It had no regular incumbent, becoming the home of the Discalced Carmelites once the Theatines had moved to their own church; see Soli, II, p. 253.

69 Campori, 1866, pp. 87–95.

70 ASM, *Canc. Duc.*, *Pittori*, 15/3, *Reni, Guido*, 31.8.1621; Dondi, p. 230 (and p. 68, p. 104 and pp. 165–7).

71 G. Galvani, 'B.V. Assunta in Cielo dipinta da Guido Reni per la venerabile Confraternità di Sta Maria degli Angioli in Spilamberto', *ASPM*, 1864, pp. 217–50.

72 Orbaan, p. 158 and pp. 249–50.

73 ASM, *Canc. Duc.*, *CSCPE*, 83a/184, 9.5.1620 and 27.6.1620.

74 Coffin, 1960, pp. 103–9; ASM, *Cam. Duc.*, *Amministrazione, Card. Alessandro*, 371, 23.11.1615, *Nota di quanto dovera fare . . . da me Franc.co Peperelli*. Despite what developed into a busy career in the 1630s, when Peperelli worked for the Barberini and other patrons on projects including the hospice of S Gerolamo della Carità, the façade of Sta Brigida and the choir of Sta Maria in Traspontina, he retained his title as Este architect in Rome and was still tending Tivoli in 1641 (ASM, *Canc. Duc.*, *Estero, Roma*, 197, 19.10.1641).

75 Orbaan, p. 204; ASM, *Canc. Duc.*, *CSCPE*, 82b/183, 5.7.1612. Fountain engineers employed by Alessandro at Tivoli include Orazio Olivieri, Curzio Donati and, in 1619, Vincenzo Vincenzi; see Coffin, 1960, pp. 103–109.

76 ASM, *Canc. Duc.*, *CSCPE*, 83a/184, letters April to August; ASV, *Avvisi*, 9, 16.9.1620 and 7.10.1620; Orbaan, pp. 262–8. For the changes at Tivoli, see Coffin, 1960, pp. 106–7.

77 Testi, *Lettere*, I, p. 21, 17.10.1620. With regard to expenses, an undated *Soma della spesa per un anno da farsi a Roma* (ASM, *Cam. Duc.*, *Amministrazione, Card. Alessandro*, 371) shows a total bill of 21,918 *scudi* assuming 123 mouths to feed (in 1611 the number was 115). Hence Cesare's interest in the hospitality at Tivoli, lavish or otherwise.

78 A. Belloni, *Storia Letteraria d'Italia, Il Seicento*, Milan, 1930, p. 203 (Arlotti) and p. 389 (Testi); *Poesi*, p. 577 (the surviving fragment of *Arsinda*); Orbaan, p. 271 (with reference to a literary academy of 1621 of which Alessandro and Agostino Mascardi were members).

79 ASM, *Canc. Duc.*, *CSCPE*, 23, 25.4.1620.

80 ASM, *Canc. Duc.*, *CSCPE*, 23, 8.7.1620.

81 ASM, *Canc. Duc.*, *CSCPE*, 92, 19.6.1619 (with reference to a subsidy from the Gonzaga of Novellara, through the agency of Ferrante Bentivoglio, to enable Alfonso to go to war); Bravi, p. 20 and p. 22.

82 ASV, *Avvisi*, 9, 8.7.1623; Frizzi and Laderchi, p. 69.

83 Bravi, p. 23.

84 Testi, *Lettere*, I, p. 45, letter of December 1623 or 1624.

85 Venturi, pp. 137–8.

86 Campori, 1870, pp. 56–7.

87 Malvasia, II, p. 130; ASM, *Canc. Duc.*, *Pittori*, 14/2, *Garbieri, Lorenzo*, 13.9.1620 and 20.5.1627 (the latter refers to Spaccini and the court painter Cervi assessing drawings and a painting by

Garbieri in Bologna on Alfonso's behalf). See also Artioli and Monducci, p. 180 and pp. 193–4 for the Este attempt to obtain a commission at the Madonna della Ghiara in 1622 for Garbieri and resistance of the commissioning committee on the ground that he was a mediocre artist.

88 ASF, *Bentivoglio*, 130, 9.12.1620; Vedriani, 1668, II, pp. 651–2.

89 ASM, *Canc. Duc., Storie, Alfonso III*, 64, *Ordini et modo di vivere*

90 ASM, *Canc. Duc., Storie, Alfonso III*, 64; Bravi, p. 21.

91 Bravi, p. 25, note.

92 ASM, *Canc. Duc., Pittori*, 15/3, *Peranda, Sante*, 21.10.1612; Campori, 1855, p. 400.

93 ASM, *Canc. Duc., Storie*, 64, *Memoria*.

94 Soli, I, p. 14.

95 Soli, III, p. 275; Mazza Monti, p. 45. The Court artist Cervi was paid in 1625 for painting the Confraternity's altarpiece (ASM, *Canc. Duc., Pittori*, 14/2, *Cervi, Bernardino*).

96 Soli, III, p. 341; Sossaj, pp. 67–9; Mazza Monti, pp. 55–6. Isabella's confessor was the Theatine Superior in Modena and her funeral ceremony took place in S Vincenzo.

97 Bravi, p. 25.

98 ASF, *Bentivoglio*, 130, 26.1.1627.

99 Soli, I, p. 223.

100 ASM, *Canc. Duc., CSCPE*, 91, 28.9.1628.

101 Vedriani, 1668, II, pp. 651–2; Coffin, 1960, p. 111.

102 ASM, *Canc. Duc., CSCPE*, 93, 8.9.1629.

103 Bravi, p. 32.

104 Testi, *Lettere*, I, p. 424 and p. 538, 18.1.1633 and 31.12.1633; ASM, *Canc. Duc., Estero, Torino*, 8, *Ragguaglio del il Co. Girolamo Graziani del suo viaggio fino a Torino*, 1633; Bravi, p. 68.

105 ASM, *Canc. Duc., CSCPE*, 93, 19.1.1634 and 4.6.1634.

106 ASM, *Canc. Duc., CSCPE*, 93, 9.12.1631, *Lettere assai religiosa, morale, politica, economica, ecc*

107 ASM, *Canc. Duc., CSCPE*, 93, 19.6.1632.

108 ASM, *Canc. Duc., CSCPE*, 93, 19.11.1629.

109 ASM, *Canc. Duc., CSCPE*, 93, 14.8.1632.

110 ASM, *Canc. Duc., CSCPE*, 93, 16.9.1639 and 19.4.1640.

111 ASM, *Canc. Duc., CSCPE*, 94, 30.9.1642 and 24.5.1641.

112 ASM, *Canc. Duc., CSCPE*, 93, 18.10.1634.

113 Muratori, II, p. 533 and Bravi, p. 21 (for the Padre's power as a preacher); Campori, 1870, pp. 56–7 (for the drawings collection).

114 ASM, *Canc. Duc., Storie*, Alfonso III, 64, *Del transito felicissimo . . .*, pp. 9–10. (Giuseppe of Leonessa (1556–1612), later canonised, had devoted his life as a Capuchin to obtaining the release of Christian slaves. Felice of Cantalice (1513/15–1587) beatified in 1625 and canonised in 1712, worked as Capuchin in Rome, numbering Carlo Borromeo and Filippo Neri among his friends.) On the Padre's death, the Garfagnana monastery passed by prior agreement with Rome from the control of the Bolognese province of the Capuchins to the Tuscan.

115 Bravi, p. 65.

116 Malvasia, II, pp. 320–3.

117 Erri, pp. 254–5; Vedriani, 1665, p. 234.

118 Bravi, p. 34.

119 Bravi, p. 54 (the Padre received the Capuchin habit on 8.9.1629, the Feast of the Virgin).

120 Malvasia, II, p. 263; Mahon, 1950.

2. Restoring the ancient splendour

1 Testi, *Lettere*, II, p. 510, 11.8.1635.

2 ASM, *Canc. Duc., Estero, Venezia*, 104, 7.1.1646.

3 ASM, *Canc. Duc., Storie, Francesco I*, 345, 26.6.1628; Testi, *Lettere*, I, pp. 137–8.

4 ASV, *Ferrara*, 12, 23.1.1633.

5 ASM, *Canc. Duc., Estero, Venezia*, 104, 18.2.1645 and 7.3.1645. (No ship could be found, this being the year in which Venice needed all ships for war against the Turk. Gamberti's reference (*Idea*, p. 335) to a levy of 1,000 men to fight for Venice since Francesco could not go himself is probably connected with the enquiries of 1645.)

6 Testi, *Lettere*, I, p. 159, 4.7.1628, 5.7.1628 and 7.7.1628; ASM, *Canc. Duc., Estero, Milano*, 100, 18.1.1634; Grandi, p. 52.

7 ASM, *Canc. Duc., Storie, Francesco I, Relazione*; ASFirenze, *Spagna, Cart. Med.*, 4964, letters from 4.9.1638 to 30.10.1638; PRO, SP94, letters from 1.9.1638 to 27.10.1638; Testi, *Lettere*, III, p. 8 and p. 58, 6.6.1638 and 15.9.1638. See also Justi, pp. 534–41.

8 ASFirenze, *Spagna, Cart. Med.*, 4964, 25.9.1638; Justi, p. 537.

9 Malvasia, II, p. 263; Mahon, 1950.

10 Justi, pp. 534–41, quoting Testi, *Lettere*, III, p. 134, 12.3.1639.

11 ASV, *Ferrara*, 5, 17.10.1629.

12 PRO, SP94, 40, 25.9.1638.

13 Q. Bigi, 'Camillo e Siro da Correggio', *ASPM*, V, 1870, *passim*. Francesco obtained the investiture in 1636 but Siro's heir did not fully surrender his claim until 1649.

14 ASM, *Canc. Duc., Documenti, Luigi del Duca Cesare*, 412, 15.8.1629.

15 Ippolito d'Este settled in Reggio, where Paolo Parisetti, a patron of Guercino, was his *maggiordomo*. Ippolito left his collection of pictures to Luigi (ASM, *Canc. Duc., Storie*, 414, *Inventario dell'Heredità del Ser.mo S. Pren.pe Ippolito d'Este*).

16 ASM, *Canc. Duc., Estero, Milano*, 105, 15.2.1645, for example, reports Borso's expenditure of 400 *scudi* on jewellery for 'that person Your Highness knows'.

17 ASM, *Canc. Duc., Documenti, Luigi del Duca Cesare*, 412–14 and *CSCPE*, 195, letters from Luigi to Francesco I. Having travelled in Europe, including a visit to the English Court of James I, Luigi was in the Venetian service by 1613. His properties included Confortino near Reggio (the Reggio architect Francesco Pacchioni remodelled the house for him *c.* 1630) and a house, purchased in 1640, on the Canalgrande in Modena. On 1.5.1658 Francesco appointed Luigi his General of the Infantry and Cavalry of the State.

18 ASM, *Canc. Duc., CSCPE*, 93, 17.3.1632; *Estero, Milano*, 106, 26.7.1639.

19 G. Saccani, *Cronotassi dei Vescovi di Reggio-Emilia*, Reggio, 1898, p. 118, with reference to Rinaldo's piety, sobriety and zeal for his Church, and his decision of 23.4.1660 to renounce the bishopric while maintaining an income and a residence in the bishop's palace.

20 BCA *ms.*, Ubaldini, p. 143; Bravi, p. 118. The dowry was 325,000 *ducatoni*.

21 ASM, *Canc. Duc., CSCPE*, 93, March 1634.

22 L. Chiappini, *Gli Estensi*, Varese, 1967, p. 418.

23 Mazza Monti, p. 63 and p. 77.

24 Testi, *Lettere*, III, p. 529; Gamberti, *Idea*, p. 245.

25 Serra, pp. 166–7 and for Reggio, O. Rombaldi, *Gli Estensi al governo di Reggio*, Reggio, 1959.

26 ASM, *Canc. Duc., CSCPE*, 105, 11.9.1648; *Estero, Milano*, 100, 25.1.1634; Testi, *Lettere*, II, p. 3, 4.1.1634.

27 Testi, *Lettere*, III, p. 78, 1.11.1638.

28 ASM, *Canc. Duc., Estero, Parma*, 6, 4.8.1642.

29 Testi, *Lettere*, III, p. 413, 24.9.1643.

30 See Massano, Appendix, pp. 13–28, for Testi's arguments for and against the Spanish alliance, his belief that 'it is a fine thing to be the free and independent Duke of Modena, who commands and is not commanded, who teaches and does not learn to obey', and his letter of 25.11.1633 counselling acceptance, after all, of the alliance.

31 Muratori, II, p. 510.

32 Grandi, *passim*.

33 Testi, *Lettere*, III, p. 95, 6.11.1638; PRO, SP94, 40, 27.10.1638.

34 De Cosnac, pp. 310–11 and p. 349.

35 Grandi, *passim*.

36 Testi, *Lettere*, III, p. 198, 1.12.1640; Testi, *Opere*, II, pp. 83–7, 20.12.1640 and 14.6.1641; Testi, *Poesie*, pp. 383ff., for the first and only canto written.

37 G. Graziani, *Il Conquisto di Granata*, Modena, 1650.

38 Fraschetti, pp. 221–9.

39 ASM, *Canc. Duc.*, *CSCPE*, 102, 21.1.1645.

40 ASM, *Canc. Duc.*, *CSCPE*, 93, 17.3.1632.

41 ASM, *Canc. Duc.*, *CSCPE*, 102, 3.6.1645; Testi, *Lettere*, III, p. 568, 31.5.1645; Malvasia, II, p. 307; Campori, 1855, p. 37. St Gregory Thaumaturge was a saint in whom the Padre d'Este placed great trust. Francesco also petitioned (Testi, *Opere*, II, pp. 208–9, 24.5.1645) for the canonisation of Felice of Cantalice, showing again a sense of filial duty.

42 Soli, II, p. 311; Sossaj, p. 99; Serra, p. 228. The church was begun in 1634 to the design of the local architect Cristoforo Malagola (Il Galaverna). Lodovico Lana painted the altarpiece of the *Madonna with Sts Omobono, Geminiano, Rocco and Sebastian* for the votive altar of the Tailors' Guild, whose patron St Omobono's feast day, 30 November, had in 1630 been the first day upon which no plague deaths were recorded.

43 See Mahon, 1969, pp. 75–7 and Mahon and Ekserdjian, p. 31, for ducal support for a patron wishing to commission Guercino, in this case the Modenese Gio. Torri ordering a *Deposition* for the Chiesa Nuova.

44 Campori, 1855, p. 6, pp. 143–5 and pp. 397–8; Zanugg, *passim*.

45 Armandi *et al.*, pp. 121–8.

46 ASM, *Canc. Duc.*, *CSCPE*, 109, 24.6.1654.

47 ASM, *Canc. Duc.*, *CSCPE*, 109, 3.6.1654 and 15.7.1654.

48 ASM, *Canc. Duc.*, *CSCPE*, 109, 14.3.1654, 16.5.1654 and 17.6.1654; *CSCPE*, 239, 27.5.1654, 6.6.1654 and undated letter, perhaps of June.

49 Fraschetti, pp. 221–9; ASM, *Canc. Duc.*, *CSCPE*, 237, 2.4.1654; Gamberti, *Idea*, p. 451. For the cost of an Algardi portrait bust, ASM, *Canc. Duc.*, *Scultori*, 17/1, *Algardi, Alessandro*, undated letter, perhaps June 1650.

50 Vedriani, 1668, II, pp. 660–2; Senesi, pp. 78–80; Testi, *Lettere*, II, p. 454, 7.7.1635; ASM, *Canc. Duc.*, *Estero*, *Spagna*, 58, 13.7.1652. A description of *La Gara* was sent to the Cardinal Legate Cibò in Ferrara by an agent, or spy, in Modena, who wrote of Gaspare Vigarani's 'great machine, representing a Rock, on which is the throne of Aeolus, King of the Winds, and when he commands his ministers . . . the Rock will be seen to grow by 8 *braccia*, and . . . four corners will spread out and in the cavern will be seen the Four Seasons . . . who . . . will beg Aeolus for judgement, but he . . . will call the four principal winds who will fly to the Mount from the four corners of the theatre . . . they will call the Cavaliers to battle, guided by four animals . . . Camel, Lion, Rhinoceros and Bear'. At the height of the battle (with lance, javelin, mace, pick, rapier and pistol) a Temple of Janus would open, a chariot would appear and an equestrian ballet would close the performance (ASV, *Ferrara*, 28, 6.4.1652).

51 ASM, *Canc. Duc.*, *CSCPE*, 114, 9.1.1648 and *CSCPE*, 105, letters of January 1648.

52 ASM, *Canc. Duc.*, *Segretari*, *Graziani*, 50a, 17.6.1656.

53 ASM, *Canc. Duc.*, *CSCPE*, 114, 2.8.1654; Amorth *et al.*, pp. 59–67.

54 ASM, *Canc. Duc.*, *CSCPE*, 105, 5.5.1648.

55 ASM, *Canc. Duc.*, *CSCPE*, 106, 7.3.1650; *CSCPE*, 108, 7.1.1652.

56 ASM, *Canc. Duc.*, *Estero*, *Venezia*, 197, 5.3.1650 (and 16.10.1649 for the copy of Ridolfi); *CSCPE*, 106, 26.2.1650 and 2.3.1650; Ridolfi, ed. 1837, II, pp. 235–6; *Corpus Rubenianum L. Burchard*, VIII, 'Saints', II, ed. H. Vlieghe, Phaidon, 1973, pp. 91–101.

57 ASM, *Canc. Duc.*, *Storie*, *Francesco I*, *Ordini de gli esercitij cosi dell'animo, come del corpo del Ser.mo Francesco ed Ecc.mi Principi fratelli*.

58 Silingardi, pp. 118–19 (landscapes and portraits were apparently Alfonso's strengths).

59 S. Maddocks, 'Trop de beautés découvertes – a new light on Guido Reni's late *Bacchus and Ariadne*', *The Burlington Magazine*, September 1984, p. 544.

60 ASM, *Canc. Duc., Pittori, 13/1, Albani, Francesco*, 23.11.1639, from Gherardo Martinengo. See Malvasia, II, p. 176, p. 183 and p. 198 for references to paintings by Albani of *Salmacis and Hermaphrodite*. Of his various treatments of this subject, the version in Turin is perhaps the most explicit, but it is not clear to which type the picture mentioned in 1639 belonged.

61 Malvasia, II, p. 263 and p. 312 (the Wardrobe assistant Cesare Cavazza's name appeared in the account book).

62 ASM, *Canc. Duc., CSCPE*, 106, 18.6.1650 and 10.6.1650.

63 ASM, *Canc. Duc., Estero, Roma*, 218, 17.1.1652 (letter from Monsignore degli Oddi with reference to this painting, now in the Vatican Pinacoteca); Campori, 1863.

64 Venturi, pp. 256–7, citing letter of 26.10.1649.

65 Campori, 1855, p. 45, citing letter of 4.8.1647; ASM, *Canc. Duc., Pittori, 14/2, Cagliari, Paolo detto Veronese*, 25.10.1647.

66 Bonsanti, pp. 18–19, citing Gherardi's *Descrizione* of 1743.

67 Bartolomeo Fenis, an artist who in the 1660s engraved for the Ducal Printer in Modena, Soliani, was responsible for these illustrations. (See Campori, 1855, pp. 199–200, for Fenis.) The initials 'L.T.' for the engraver Lorenzo Tinti (?1634–?1672) appear on a number of the engravings.

68 Scannelli, p. xxii, letter of 23.5.1654 to, perhaps, Geminiano Poggi, refers to 'Don Marco'. With the exception of the letters of 1654 reproduced in the introduction to the 1966 edition, which suggest a fairly long-standing association with the Court, no other trace of Scannelli has yet been found in the Este archives.

69 Scannelli, Introduction (*Al Lettore*) and p. 225.

70 Venturi, p. 256, citing letter of 3.10.1658.

71 Scannelli, *Al Lettore*. The concept of the 'microcosm' of art had already been used by Pietro Francavilla. J. Schlosser-Magnino, *La Letteratura Artistica*, ed. Florence, 1964, pp. 614–15, is, however, perhaps too dismissive of Scannelli's admittedly rambling book. Scannelli's reliance upon the evidence of his eyes, as opposed to precept, is refreshing, and his genuine response to a concentrated grouping of paintings is evident, e.g. the Borghese gallery in Rome (pp. 166–7), Venetian churches (pp. 215–16) and the Este *sala* (pp. 287–98).

72 Scannelli, pp. 287–98.

73 Gamberti, *Corona Funerale*, is a usefully abbreviated version of the description of the elaborate decorations.

3. Ways and means

1 Venturi, p. 214; Grandi, p. 10, p. 24 and pp. 39–41.

2 Venturi, p. 186; Campori, 1870, pp. 140–2; ASM, *Canc. Duc., Estero, Milano*, 105, 15.8.1637 (Airolo); *Estero, Milano*, 106, 7.10.1641 (Balbi); *CSCPE*, 108, 13.12.1653 (Francesco is 'resolved to use Genoa').

3 Venturi, p. 234. After the Sack of Mantua, Francesco presented the Gonzaga with a gift of 200 cattle; Gamberti, *Idea*, p. 457.

4 ASM, *Canc. Duc., Ingegneri, 2, Carlo, C.te*, 5.11.1629; ASM, *Canc. Duc., Estero, Torino*, 9, 11.4.1635 and 12.7.1635.

5 Campori, 1855, pp. 397–8; Zanugg, pp. 216–17; Fasolo, p. 339; Armandi *et al.*, p. 103; ASM, *Canc. Duc., Architetti, 9/1, Rainaldi, Girolamo*, 11.9.1641 and 5.10.1641.

6 ASV, *Avvisi*, 97, 18.2.1645 and 14.3.1645.

7 ASM, *Canc. Duc., Estero, Firenze*, 69, 9.10.1651 and 5.1.1653.

8 ASM, *Canc. Duc., Ingegneri, 2, Cantagallina, Remigio*, 24.8.1633.

9 M. Campbell, *Pietro da Cortona at the Pitti Palace*, Princeton, 1977, p. 247.

10 ASM, *Canc. Duc., Estero, Firenze*, 69, 8.8.1651 and 3.10.1651.

11 ASM, *Canc. Duc., Estero, Firenze*, 69, 1.9.1654 (letter enclosing note giving these details); Baldinucci, IV, p. 660; de Vesme and Massar, p. 61.

12 ASM, *Canc. Duc., Estero, Firenze*, 69, 10.9.1652 and 24.9.1652.

13 ASM, *Canc. Duc., Estero, Firenze*, 69, 17.6.1653 and 10.7.1653, 15.7.1653, 22.7.1653 and 29.7.1653. The sum of 500 *piastres* (or *scudi*) Francesco wished to spend was low for *pietre dure*, so Guidoni suggested a work in the softer, less durable, *pietre tenere*, which he had been assured could be ready in a year for 600 *piastres*.

14 ASM, *Canc. Duc., Estero, Roma*, 219, 30.6.1655.

15 See, for example, ASM, *Canc. Duc., Estero, Firenze*, 69, 6.5.1653. Baldinucci (IV, p. 499) mentioned a visit to Modena in 1645 (which may have been a mirror-printing of 1654 when the Cardinal Cibò, whose patronage of Sustermans was also mentioned, was the Legate to Ferrara) and 1649. An earlier visit, *c.* 1640, may be assumed on the basis of the portrait in the Galleria Estense attributed to Sustermans.

16 *Dessins Baroques florentins du Musée du Louvre*, Louvre, 1981–2, pp. 162–5. The Este albums of drawings were taken to France in 1796.

17 ASM, *Canc. Duc., Estero, Firenze*, 69, 18.6.1652, 25.6.1652, 20.5.1653, 10.7.1653, 3.9.1653 and 21.10.1653; de Vesme and Massar, I, p. 58; ASM, *Canc. Duc., Galleria, Inventario della roba de Camerini 1662*.

18 Tiraboschi, III, pp. 45–6 for Guidi's career.

19 ASM, *Canc. Duc., Estero, Spagna*, 51, 10.4.1641.

20 ASM, *Canc. Duc., Estero, Spagna*, 51, 14.5.1641.

21 ASM, *Canc. Duc., Estero, Spagna*, 51, 4.5.1641, 23.7.1641 and 18.9.1641. The fate of these tapestries is uncertain. (See Göbel, *Wandteppiche, Niederlande*, Leipzig, 1922–3, 2, ill. 319 for a set of *Theseus* tapestries woven by Jan Raes the Younger and then in the possession of the Spanish state.)

22 ASM, *Canc. Duc., Estero, Spagna*, 51, 20.11.1641.

23 ASM, *Canc. Duc., Estero, Spagna*, 51, 23.7.1641 and 13.11.1641

24 ASM, *Canc. Duc., Estero, Spagna*, 51, 20.11.1641 and 11.12.1641 (see also Venturi, p. 205); Tassoni, p. 510.

25 ASM, *Canc. Duc., Estero, Spagna*, 51, 26.11.1641

26 ASM, *Canc. Duc., Estero, Milano*, 105, 2.11.1644.

27 ASM, *Canc. Duc., Estero, Milano*, 20.10.1644 (and 17.8.1644).

28 Testi, *Lettere*, II, p. 729, 15.8.1637.

29 See G. Melzi d'Eril, 'Federico Borromeo e Cesare Monti collezionisti milanesi', in *Storia dell'Arte*, 15/16, 1972, 13–16, p. 293–306 for collecting in Milan.

30 Vedriani, 1662, pp. 47–8; Tiraboschi, II, pp. 322–3.

31 L. Pascoli, *Vite de' pittori, scultori ed architetti moderni*, ed. 1933, p. 237, Ercole Ferrata. See also Dondi, pp. 90–1 and p. 258 for Fontana's chapel in the Cathedral.

32 ASM, *Canc. Duc., Estero, Milano*, 106, 30.9.1639; *Pittori*, 16/4, *Varese, Pittore*, 5.10.1639.

33 ASM, *Canc. Duc., Estero, Milano*, 100, 5.2.1634.

34 ASM, *Canc. Duc., Estero, Milano*, 105, 24.8.1644.

35 ASM, *Canc. Duc., Estero, Milano*, 106, 17.8.1638.

36 Campori, 1870, pp. 138–40, citing letter of 15.4.1635. The Procaccini painting was sold to Dresden in 1746.

37 ASM, *Canc. Duc., Estero, Milano*, 100, 13.9.1634; *Milano*, 105, 18.10.1634.

38 ASM, *Canc. Duc., Pittori*, 13/1, *Balestrieri, Gabriele*, 31.1.1644. (See also Campori, 1855, p. 468 for Balestrieri's poor opinion of Schedoni as a restorer of a Garofalo in the Coccapani collection.)

39 ASM, *Canc. Duc., Estero, Milano*, 105, 2.11.1644; Testi, *Lettere*, III, p. 520, 17.11.1644; ASM, *Canc. Duc., Estero, Milano*, 105, 17.11.1644 and 7.12.1644; *Pittori*, 13/1, *Balestrieri, Gabriele*, 31.11.1644.

40 Venturi, pp. 251–2.

41 ASM, *Canc. Duc., Segretari, Poggi, Geminiano*, 47a, 22.11.1647.

42 ASM, *Canc. Duc., Particolari*, 82, 14.1.1648.

43 ASM, *Canc. Duc., Segretari, Poggi, Geminiano, 47a*, 5,8.1651; *Pittori*, 13/1, *Bisi, Bonaventura*, letters of 1651, 1653 and 1658; R. Galleni, 'Bonaventura Bisi e il Guercino', *Paragone*, September 1975, XXVI, pp. 80–2. n. 307, and 'il bolognese Bonaventura Bisi frate e pittore fra i Medici e gli Este', *Il Carrobbio*, 1979, V, pp. 176–88.

44 ASM, *Canc. Duc., Estero, Spagna*, 58, letters of August 1651, 13.1.1652 (also in Justi, p. 636), 6.7.1652 and 13.7.1652. From the other Spanish possession in Italy, Naples, Francesco ordered flower bulbs, furnishings and fabrics, but only correspondence with Artemisia Gentileschi, who sent him paintings in 1635, suggests an interest in Neapolitan art (Venturi, p. 218). In 1635, however, Fontana had sent him a *St Bartholomew* attributed to Ribera, one of the paintings sold to Dresden in 1746.

45 A. Baudi de Vesme, *L'Arte negli Stati Sabaudi*, Turin, 1932, p. 161, cites a letter of 3.5.1652 referring to 'Chignolo (the Milanese painter Girolamo Chignolo) here (in Milan) resident for the Duke of Modena', but what Chignolo's precise connection with Modena may have been is not clear.

46 ASM, *Canc. Duc., Segretari, Graziani, Girolamo*, 50a, 21.12.1660 (statement by Venetian republic); M. Boschini, *Venetia aflita per la morte del Prencipe Almerigo d'Este*, Venice, 1661.

47 ASM, *Canc. Duc., Estero, Roma*, 197, 13.10.1641.

48 ASM, *Canc. Duc., CSCPE*, 237, 6.12.1653.

49 ASM, *Canc. Duc., CSCPE*, 103, 22.10.1645 and 8.11.1645.

50 ASM, *Canc. Duc., CSCPE*, 229, 8.10.1645. In 1645 Rinaldo was in fact planning various repairs to Tivoli but the recall of the architect Vigarani to Modena would have prevented their execution. An inscription of 1632 on the Tivoli fishponds still commemorates repairs ordered by Francesco *in absentia*.

51 Testi, *Lettere*, II, p. 10, 7.1.1634; ASM, *Canc. Duc., Estero, Venezia*, 97, 24.10.1637.

52 ASM, *Canc. Duc., Estero, Venezia, buste* 97 and 98 (Scalabrini), 104 (various), 107, 108, 109, (Codebò), many despatches; Testi, *Lettere*, I, p. 339; ASM, *Canc. Duc., Particolari*, 852, 29.4.1634 (spectacles for Poggi); *CSCPE*, 225, 31.8.1643 (the first print-run of 150 copies of the *Ragioni* (for kings, princes, cardinals, etc.) had been quickly exhausted).

53 ASM, *Canc. Duc., Estero, Venezia*, 97, 9.8.1636, 23.8.1636 and 16.6.1640; 107, 13.2.1649, 26.3.1649, 5.2.1650 and 30.4.1650.

54 ASM, *Canc. Duc., Estero, Venezia*, 107, 30.4.1650 and 7.5.1650; *CSCPE*, 106, 9.4.1650. For the theatre in Modena, see L. Gandini, *Cronistoria dei Teatri di Modena dal 1539 al 1871*, Modena, 1873.

55 ASM, *Canc. Duc., CSCPE*, 239, 27.6.1654.

56 ASM, *Canc. Duc., CSCPE*, 233, 22.3.1647; 236, 31.8.1650; 237, 24.9.1650.

57 Fantelli (drawing upon ASM sources in which material concerning Regnier is grouped under 'Raineri' and 'Vanieri'); ASM, *Canc. Duc., Pittori*, 14/2, *Desubleo, Michele*, 18.7.1654 and 29.8.1654. Desubleo painted the altarpiece for the rebuilt church of S Francesco which formed one side of the new piazza before the palace of Sassuolo.

58 For Paolo del Sera, see articles by G. Chiarini de Anna and S. Meloni Trkulja in *Paragone*, XXVI, pp. 15–38 and 87–99, 1975, and J. Fletcher, 'Marco Boschini and Paolo del Sera, collectors and connoisseurs of Venice', *Apollo*, November 1979, pp. 416–24; Goldberg, pp. 54–78.

59 ASM, *Canc. Duc., Estero, Venezia*, 104, *Memoria per il Poggi nella sua andata a Venezia*.

60 Venturi, pp. 252–5; ASM, *Canc. Duc., Estero, Venezia*, 104, 27.5.1645 and 1.6.1645.

61 Venturi, p. 237; ASM, *Canc. Duc., Estero, Venezia*, 107, 6.4.1650. Shortly after buying them, Francesco corresponded with Guidoni in Florence about the possibility of having the cartoons woven there.

62 Venturi, p. 236 and p. 255.

63 M. Boschini, *Funeral fato de la pittura Venetiana per el passazo de la terena a la celeste vita del Serenissimo de Modena*, Venice, 1662.

64 Venturi, p. 256.

65 ASM, *Canc. Duc.*, CSCPE, 102, 14.6.1645; CSCPE, 233, 22.3.1647 and 24.4.1647; *Estero, Roma*, 197, 19.11.1639.

66 Testi, *Lettere*, I, p. 407, 14.1.1633.

67 See Fraschetti, pp. 167–8, citing Theodor Ameyden on the 'cervello torbido' of Mantovani, his imprisonment in 1643, police searches of his house in 1646, etc.

68 ASM, *Canc. Duc.*, CSCPE, 235, 19.9.1648.

69 ASM, *Canc. Duc.*, CSCPE, 102, 5.2.1645 and 11.2.1645.

70 ASM, *Canc. Duc.*, *Estero, Roma*, 199, 7.2.1646 (Algardi) and 23.3.1645 (exhibition at the Sapienza); ASV, *Avvisi*, 99, 16.4.1646 (Bracciano). (All *avvisi* in folder 99, ASV, are by Mantovani.)

71 ASM, *Canc. Duc.*, *Estero, Roma*, 197, 21.1.1640.

72 Testi, *Lettere*, III, p. 180, 22.9.1640.

73 Venturi, pp. 249–51; Salerno, pp. 91–7; A. Buzzoni *et al.*, *Torquato Tasso*, exhibition catalogue, Bologna, 1985, p. 296 (illustrating an *Erminia among the shepherds* in the Galleria Estense, Modena attributed to Swanevelt (and a figure painter) and proposing this as the first Swanevelt picture sent to Modena). Perrier's *Acis and Galatea* in the Louvre, from the collection of Andre Le Nôtre, may give some idea of his painting of the same subject for Francesco.

74 Venturi, pp. 249–50, citing letters of 18.7.1640 and 21.7.1640.

75 Venturi, p. 251, citing letter of 1.9.1640.

76 Passeri, 1772, p. 421.

77 ASM, *Canc. Duc.*, *Estero, Roma*, 197, 3.11.1640.

78 ASM, *Canc. Duc.*, *Estero, Roma*, 197, 27.4.1641, 11.5.1641 and 6.7.1641.

79 ASM, *Canc. Duc.*, *Pittori*, 14/2, *Manzoli, Francesco*, 16.10.1658.

80 ASM, *Canc. Duc.*, *Estero, Roma*, 219, 18.8.1655.

81 See Fraschetti, pp. 242–3; Salerno, p. 97; G. Briganti, *Pietro da Cortona*, Florence, 1962, p. 149.

82 Campori, 1855, pp. 160–5, citing Spaccini of 2.8.1631; Vedriani, 1662, p. 113; Baruffaldi, II, p. 198; Tiraboschi, VI, p. 446; Guarini-Borsetti, p. 231 and p. 257 (Lana painted a *Sant'Agnese* for the Ferrarese church of that name for the Marchese Massimiliano Montecuccoli).

83 ASM, *Canc. Duc.*, *Segretari, Poggi, Geminiano*, 47b, 15.12.1646; *Pittori*, 14/2, *Manzoli, Francesco*, 16.10.1658; Venturi, p. 266.

84 Venturi, p. 268.

85 Malvasia, II, pp. 23–4, Pirondini, *passim*. See also A. Colombi Ferretti, 'La decorazione pittorica del Palazzo Ducale di Sassuolo' in *L'Arte degli Estensi: la pittura del Seicento e del Settecento a Modena e Reggio*, exhibition catalogue, Modena, 1986.

86 Campori, 1855, p. 92; Pirondini, p. 10.

87 See Pirondini, *passim*.; Amorth *et al.*, pp. 59–67; J. Schulz, 'A forgotten chapter in the early history of *quadratura* painting: the *fratelli* Rosa', *The Burlington Magazine*, 103, 1961, pp. 90–102. The suggested sequence of the work at Sassuolo (from Pirondini) is: Rooms of Enchantments, Music, Painting, Fountains and Dreams, 1643–8; Rooms of Phaethon, Fame, Dawn, Aurora and Night, 1648–50; Rooms of Jove, Winds, Genius, Este Virtue, Love, Fortune and, perhaps, Marital Fidelity, 1651–5. Boulanger was an oil, not fresco, painter and his pictures, many of which are now lost, were set into gilded stucco frames at Sassuolo.

88 Pirondini, p. 15, citing letter of 13.11.1643.

89 Pirondini, p. 15, citing letters of 31.10.1643, 9.10.1644 and 17.6.1644.

90 Pirondini, p. 16, citing letters of 6.1.1647 and 29.9.1647.

91 Pirondini, p. 16; ASM, *Canc. Duc.*, CSCPE, 225, 23.11.1644; CSCPE, 230, 26.5.1646.

92 ASM, *Cam. Duc.*, *Fabbriche, Sassuolo*, 14, inventory of *c.* 1679–80; Venturi, p. 356.

93 Pirondini, p. 40, n. 34.

94 Malvasia, II, p. 110 and pp. 349–50; Baldinucci, IV, p. 660; Campori, 1855, p. 160 and p. 176.

95 Malvasia, II, p. 349 and p. 351; ASM, *Cam. Duc.*, *Pittori*, 13/1, *Agostino*, 14.1.1638.

96 Malvasia, II, p. 354.

97 ASM, *Canc. Duc.*, *Pittori*, 14/2, *Colonna, Michelangelo*, 11.11.1647 (Pepoli); *Pittori*, 14/2, *Monti, Giovan. Giacomo*, 20.5.1647 (Cornelio Malvasia).

 98 Malvasia, II, p. 349; *Cam. Duc., Pittori*, 14/2, *Colonna, Michelangelo*, 9.8.1647.

 99 Passeri, ed. 1934, p. 281; Campori, 1855, p. 164, n. 2.

100 Campori, 1855, p. 77; Feinblatt, pp. 17–22.

101 ASM, *Canc. Duc., Scultori*, 17/1, *Pacchioni, Prospero*, 8.2.1630 and 15.1.1631.

102 ASM, *Canc. Duc., CSCPE*, 106, 29.4.1650 (letter from Francesco recommending Luraghi's brother, Cesare, to the Cardinal Rinaldo's protection).

103 ASM, *Cam. Duc., Fabbriche, Sassuolo*, 14, undated letter from Provost Marinelli (who died in 1649).

104 ASM, *Canc. Duc., Scultori*, 17/1, *Baratta, Francesco*, 1.11.1651.

105 Fraschetti, p. 229; Donati, pp. 11–13; Acidini Luchat *et al.*, p. 20; ASM, *Cam. Duc., Estero, Roma*, 218, 30.11.1652, 18.12.1652, 4.1.1653 and 8.12.1652 and 25.12.1653; *Segretari, Poggi, Geminiano*, 47a, undated letter (after Carnival, 1653) and 12.3.1653. A sketch attributed to Bernini for Sassuolo was sold by Christies in Monaco on 15.6.1986 for £115,188.

106 Campori, 1855, p. 307 and Riccomini, 1972, pp. 56–7.

107 ASM, *Canc. Duc., Architetti*, 9/1, *Avanzini, Bartolomeo*; Campori, 1855, p. 16; Armandi *et al.*, pp. 103–81. (Avanzini appears to have arrived in Modena after work on Capitoline building schemes in Rome, Girolamo Rainaldi being Capitoline architect; Fasolo, p. 269.)

108 ASM, *Canc. Duc., Architetti*, 9/1, *Avanzini, Bartolomeo*, 23.6.1651; Campori, 1855, p. 21.

109 ASM, *Canc. Duc., Architetti*, 9/1, *Avanzini, Bartolomeo*, 19.7.1651.

110 ASM, *Cam. Duc., Fabbriche, Palazzo Ducale*, 8, August 1634.

111 ASM, *Cam. Duc., Fabbriche, Sassuolo*, 14, 1.3.1635.

112 ASM, *Canc. Duc., Architetti*, 9/1, *Avanzini, Bartolomeo*, 14.2.1636.

113 ASM, *Canc. Duc., Architetti*, 9/1, *Avanzini, Bartolomeo*, 11.7.1642, 16.4.1643 and 27.5.1644; ASM, *Cam. Duc., Fabbriche, Sassuolo*, 14, 10.8.1644 and 5.9.1644; *CSCPE*, 106, 15.10.1649; and see n. 109 above.

114 ASM, *Canc. Duc., CSCPE*, 106, 12.3.1650 and 26.3.1650; *Architetti*, 9/1, *Avanzini, Bartolomeo*, 9.3.1650.

115 ASM, *Canc. Duc., CSCPE*, 106, 22.7.1650.

116 Zanugg; ASM, *Canc. Duc., Architetti*, 9/1, *Avanzini, Bartolomeo*, 23.3.1651.

117 Fraschetti, p. 353, citing letter of 22.7.1665.

118 Zanugg, p. 231; citing letter of 13.5.1651.

119 Zanugg, pp. 231–2, citing letter of 20.5.1651.

120 Zanugg, p. 231–2, citing letter of 20.5.1651.

121 ASM, *Canc. Duc., Architetti*, 9/1, *Avanzini, Bartolomeo*, 19.3.1650 and 7.12.1652, among others.

122 ASM, *Canc. Duc., CSCPE*, 108, 2.9.1652

123 ASM, *Canc. Duc., Architetti*, 9/1, *Avanzini, Bartolomeo*, 5.1.1652.

124 Campori, 1855, p. 16, citing letters of 3.10.1644 and 1653. In the 1650s Francesco made Avanzini a gift of land (ASM, *Canc. Duc., Architetti*, 9/1, *Avanzini, Bartolomeo*, 23.12.1654(?); draft letter to Abbot of Nonantola concerning investiture in 'mio Ingegniere' of a piece of land).

125 ASM, *Canc. Duc., Segretari, Poggi, Geminiano*, 47a, 4.7.1658.

126 Sandonnini, p. 503. The election of Guarini and not the nominee of Prince Alfonso as praepostor in 1655 was perhaps the cause of hostility. In 1652 Guarini had made a model of a dome of wood covered with lead for S Vincenzo but lack of money caused a postponement of work on the church.

127 ASM, *Canc. Duc., CSCPE*, 102, 14.6.1645.

128 See Rouchès, *passim.*, for Vigarani's life and work.

129 See Armandi *et al.*, p. 122 and p. 156, n. 12.

130 ASM, *Canc. Duc., CSCPE*, 102, 26.4.1645.

131 ASM, *Canc. Duc., CSCPE*, 227, 19.4.1645.

132 ASM, *Canc. Duc., CSCPE*, 114, 5.10.1650.

133 See Armandi *et al.*, pp. 185–215.

134 Soli, II, p. 115. The balconies are sometimes said to be an early experiment in the diagonal perspective settings, or *scena per angolo*, later widely adopted in Italian theatre, and there are sufficient

correspondences with, say, Christopher Wren's St Stephen Walbrook in London as to suggest that these two gentlemen architects shared an empirical, mathematician's, approach to planning.

135 ASM, *Canc. Duc.*, CSCPE, 102, 31.5.1645.

136 ASM, *Canc. Duc.*, CSCPE, 105, 3.11. 1648 and 26.6.1648.

137 ASM, *Canc. Duc.*, CSCPE, 105, 3.10.1648. (The Scotsman was not named.)

138 See Rouchès, *passim*. The *Teatro della Speltà* (dest.) opened in 1656 with Manelli's *Andromeda* in celebration of the wedding of Alfonso and Laura Martinozzi, and Francesco's sister Anna Beatrice to Alessandro II Pico della Mirandola. It was a public theatre, built within the Palazzo Comunale. A separate *teatrino* existed within the ducal residence for Court performances, such as the *Alexander and Roxana* of 1654. For the *Darsena* of Modena, see Sossaj, p. 15. For the Carnival *festa* in Rome, see ASM, *Canc. Duc.*, CSCPE, 227, 1.3.1645, and ASV, *Avvisi*, 97, 4.3.1645.

139 Rouchès, p. 21 ; Fraschetti, p. 266.

140 See F. M. Valenti, *Notizie di artisti Reggiani*, Reggio, 1892, p. 87 for Beltrami.

141 Tiraboschi, VI, p. 562.

142 ASM, *Canc. Duc.*, CSCPE, 93, 6.1.1630.

143 ASM, *Canc. Duc.*, *Storie, Francesco I.*, *Relazione* by Don Pietro Valenti, Abbot of Bobbio; Agnelli, pp. 320–1.

144 ASV, *Ferrara*, 8, 8.10.1631; *Ferrara*, 22, 16.3.1646.

145 See Gamberti, *Idea*, p. 317, p. 45 and (for the autopsy report on Francesco) p. 48.

146 ASM, *Canc. Duc.*, *Galleria, Inventario*, 1662; Tiraboschi, IV, p. 357.

147 Testi, *Lettere*, III, p. 531.

148 Testi, *Lettere*, II, p. 373, 23.8.1634.

149 Tassoni, p. 250, 255 and p. 259, for example.

150 Testi, *Lettere*, I, p. 192, May 1629, letter to Cesare Molza.

151 Testi, *Lettere*, III, p. 212, 3.5.1641 (which may be compared with Tassoni's essay; Tassoni, p. 277).

152 ASM, *Canc. Duc.*, CSCPE, 102, 28.3.1645; Armandi *et al.*, p. 185; ASM, *Cam. Duc.*, *Fabbriche, Sassuolo*, 14, 15.9.1646 and Tiraboschi, III, p. 163 (on Marinelli).

153 See, for example, ASM, *Canc. Duc.*, CSCPE, 114, 18.11.1647 and *Canc. Duc.*, *Architetti*, 9/1, *Avanzini, Bartolomeo*, 27.10.1647.

154 ASM, *Canc. Duc.*, *Storie, Francesco I, Relazione* by Don Pietro Valenti, Abbot of Bobbio; Sandonnini.

155 Testi, III, p. 52, 6.9.1638; Malvasia, II, p. 312 and p. 330; ASM, *Canc. Duc.*, *Pittori*, 13/1, *Barbieri, Giovan. Francesco detto Guercino*, documents of 1637, and Mahon and Ekserdjian, p. 31. (For Giulio Cavazza, see n. 83 above. Cavazza must have arrived in Rome at about the same time as Manzuoli, being mentioned in Francesco's letter to the Cardinal of 2.4.1646 listing those ready to join Rinaldo's service; ASM, *Canc. Duc.*, CSCPE, 103.)

156 PRO, SP94, 40, 7.10.1638. Tiraboschi, V, p. 245; Massano, *passim*.

157 Testi, *Lettere*, I, p. 538, 31.12.1633.

158 ASM, *Canc. Duc.*, *Estero, Torino*, 8, *Istruzione* of 1633 to Graziani; Testi, *Lettere*, III, 21.6.1640, quoted in J. Brown and J. H. Elliott, *A Palace for a King*, London and New Haven, 1980, p. 225.

159 Testi, *Lettere*, III, p. 100, 7.11.1638 (to the Cardinal Bentivoglio).

160 Testi, *Lettere*, I, p. 407, 14.1.1633.

161 Testi, *Lettere*, I, p. 535, 30.12.1633.

162 Testi, *Lettere*, I, p. 432, 29.1.1633.

163 Lodi, p. 46.

164 See Brunori for a discussion of the two portraits, one in the Brera, Milan and the other in the Galleria Corsini, Rome. Lodovico Lana and Bernardino Curti were credited with the portraits of Testi reproduced in contemporary editions of his poetry printed by Soliani in Modena. For the comment on the Borghese bust, as in n. 162 above.

165 Testi, *Lettere*, I, p. 472, 19.11.1633 and p. 474, 19.11.1633 (separate letters).

166 Testi, *Lettere*, I, p. 494, 3.12.1633.

167 Lodi, p. 46.

168 Campori, 1855, pp. 411–12, citing the *canzone* 'Rosa il tempo sen vola . . .'.

169 Testi, *Lettere*, II, p. 742, 17.8.1637 and III, p. 212, 3.5.1641.

170 Of these paintings (now lost), *Disegno* was represented by the 'line of the Apelles', decorum by Apelles' choice of King Antigonus's undisfigured profile for his portrait, proportion by Timanthes' painting of the Cyclops as two satyrs measured the giant's body, ideal beauty by Zeuxis's famous combination in one figure of the individual beauties of five women of Croton, and the *affetti* by Timanthes' painting of the sacrifice of Iphigenia at Aulis.

171 Tiraboschi, V, p. 260.

172 Testi, *Lettere*, III, p. 178, 21.8.1640 and p. 254, 10.1.1642; ASM, *Canc. Duc.*, CSCPE, 94, spring 1641.

173 Testi, *Lettere*, III, p. 373 and p. 404.

174 Testi, *Opere*, I, p. lxix; Tiraboschi, V, p. 245.

175 Tiraboschi, III, p. 12. There is a portrait of Graziani by Benedetto Gennari in the Galleria Estense, Modena.

176 ASM, *Cam. Duc.*, *Amministrazione, Francesco I, Nota de Ser.ri del Ser.mo S. Principe Francesco*, 1624; *Canc. Duc.*, *Particolari*, 852, 18.1.1631 from Girolamo della Torre and *Particolari*, 1040, 1.4.1654 from Superchi (secretary of the postal service).

177 Testi, *Lettere*, II, pp. 572–3, 15.1.1636; *Opere*, II, pp. 336–8, letter of 1644.

178 Muratori, II, p. 541; ASM, *Canc. Duc.*, *Segretari, Poggi, Geminiano*, 47a, 6.10.1658.

179 Malvasia, II, p. 384. Poggi had been no less solicitous in the case of Lodovico Lana's bout of catarrh in 1636 (ASM, *Canc. Duc.*, *Segretari, Poggi, Geminiano*, 47a, 23.3.1636).

180 ASM, *Canc. Duc.*, *Particolari*, 852, *Testamento originale*, 1.4.1662 and *Narrativa del fatto intorno al Testamento del Signor Giminiano Poggi*.

181 Scannelli, pp. 301–2; ASM, *Canc. Duc.*, CSCPE, 108, 25.12.1653; *Canc. Duc.*, *Particolari*, 1040, 9.2.1652 from Superchi; *Canc. Duc.*, *Segretari, Poggi*, 47a, 17.5.1653 (in which Poggi promised to research also the other names given him, but did not reveal the reason for this research); *Segretari, Poggi*, 47b, 9.5.1657 (one 'Michele Orologgiero' was to make the device).

182 ASM, *Canc. Duc.*, *Segretari, Poggi*, 47a, 26.1.1639; Malvasia, II, p. 318.

183 ASM, *Canc. Duc.*, *Estero, Roma*, 218, 25.12.1652.

184 ASM, *Canc. Duc.*, *Estero, Roma*, 196, 23.4.1636.

185 See n. 179 above and Tiraboschi, V, p. 446, citing Poggi's letter to Francesco of 19.8.1646 on the death of Lana.

186 ASM, *Canc. Duc.*, *Estero, Roma*, 218, 27.11.1652; Campori, 1855, pp. 382–4 (who follows the eighteenth-century biographer of Neapolitan artists B. De Dominici in assuming that these frescoes are of the 1640s); Soli, I, p. 182, for the history of S Biagio including the rebuilding to the design of the Commune architect Cristoforo Malagola. In 1652 Preti would have just completed his work at Sant'Andrea della Valle and if he was, as was reported, dissatisfied with that work, a journey to Modena and a new commission might have seemed an ideal opportunity. See R. Causa, 'Per Mattia Preti: il tempo di Modena e il soggiorno a Napoli', *Emporium*, 1952, pp. 201–12.

187 ASM, *Canc. Duc.*, *Estero, Roma*, 218, 14.12.1652 (Poggi thought Mattei one of the best art experts in Rome); *Canc. Duc.*, *Estero, Parma*, 6, 29.4.1639 and *Canc. Duc.*, *Segretari, Poggi*, 47a, undated letter, for two among many references to meetings with and friendship for Balestrieri.

188 ASM, *Canc. Duc.*, *Estero, Roma*, 218, 30.11.1652 (also quoted by Fraschetti).

189 ASM, *Canc. Duc.*, *Estero, Roma*, 218, 21.12.1652 (and see drawing 62v in Van Dyck's *taccuino italiano*).

190 ASM, *Canc. Duc.*, *Segretari, Poggi*, 47a, 20.6.1645 (Dosso's *St Michael* and *St George* (now in Dresden) and *Fortune* and *Peace*) and 8.7.1646 and *Poggi*, 47b, 4.7.1646 (a *Calumny of Apelles* by Garofalo); *Poggi*, 47a, 27.11.1655.

191 ASM, *Canc. Duc.*, *Estero, Roma*, 218, 27.11.1652; Campori, 1863.

192 ASM, *Canc. Duc.*, *Estero, Roma*, 218, 4.12.1652. See J. Fletcher, 'Francesco Angeloni and Annibale Caracci's "Silenus gathering grapes"', *The Burlington Magazine*, CXVI, November 1974, no. 860, pp. 665–6.

193 ASM, *Canc. Duc.*, *Segretari*, *Poggi*, 47a, 11.11.1651 and 5.8.1651.

194 ASM, *Canc. Duc.*, *Segretari*, *Poggi*, 47a, 20.6.1645.

195 Justi, pp. 633–4, citing letter of 12.12.1650. It was also Poggi who in 1649 received a description of the ducal gallery in Turin (ASM, *Canc. Duc.*, *Galleria*, 29.9.1649 from G. M. Bottero) and was asked by Marco Boschini in 1661 for a list of paintings in the Este collection (ASM, *Canc. Duc.*, *Pittori*, 14/2, *Cagliari, Paolo detto Veronese*, 27.8.1661).

196 ASM, *Canc. Duc.*, *Estero*, *Roma*, 218, 7.12.1652.

197 ASM, *Canc. Duc.*, *Pittori*, 16/4, *Sanzio, Raffaele*, 12.11.1652.

198 ASM, *Canc. Duc.*, *Pittori*, 16/4, *Sanzio, Raffaele*, 17.11.1652 and 18.11.1652.

199 ASM, *Canc. Duc.*, *Pittori*, 16/4, *Sanzio, Raffaele*, 10.11.1652 (Poggi saw Mastelletta paintings in Rimini); Scannelli, p. 367.

200 ASM, *Canc. Duc.*, *Estero*, *Roma*, 218, 14.12.1652.

201 ASM, *Canc. Duc.*, *Estero*, *Roma*, 218, 7.12.1652.

202 Scannelli, p. xx, 4.4.1654.

203 Scannelli, p. 391.

204 ASM, *Canc. Duc.*, *Storie*, *Francesco I*, *Relazione* by Don Pietro Valenti, Abbot of Bobbio. In the 1580s, Este revenue from Modena was 40,000 *scudi* (Agnelli, pp. 316–17) and by the 1670s it had risen to 300,000 crowns (R. Lassels, *The Voyage of Italy*, Paris, 1670, p. 140). These are not necessarily accurate figures, but they suggest, inflation apart, the great increase in the demand made upon the duchy.

205 Muratori, II, p. 541; Namias, p. 391. For an example of a coin minted in Francesco's reign, a *doppia d'oro* of 1639 purchased in 1957 for the Instituto Numismatico Italiano, see *Bollettino d'Arte*, XLII, 1957, p. 373.

206 ASM, *Cam. Duc.*, *Amministrazione*, *Francesco I*, *Spese che furono stabilite dalla gl. mem. del Ser.mo S.re Duca Francesco nel 1650 come dalla nota di sua propria mano.*

207 ASM, *Cam. Duc.*, *Amministrazione*, *Francesco I*, *Memoria di Spese considerabile che si dicono fatte dal Ser.mo Sig.e Duca Francesco . . .*; *Canc. Duc.*, *Storie*, *Francesco I*, *Robbe portate dal Sig. Duca di Modena in Spag.a.*

208 Basini, pp. 149–53. Special grain purchases were made, for example, in 1636 and 1642.

209 ASM, *Canc. Duc.*, CSCPE, 227, 11.2.1645.

210 ASM, *Canc. Duc.*, CSCPE, 104, 16.2.1647.

211 ASM, *Canc. Duc.*, CSCPE, 237, 6.9.1650 and 7.9.1650; *Canc. Duc.*, *Segretari*, *Poggi*, *Geminiano*, 47a, 19.6.1646, 20.6.1646 and 22.6.1646.

212 Testi, *Lettere*, II, p. 282, 12.7.1634; ASM, *Canc. Duc.*, *Scultori*, 17/1, *Algardi, Alessandro*, note, undated but *c.* 1650.

213 ASM, *Canc. Duc.*, *Estero*, *Roma*, 198, 11.1.1642; Testi, *Lettere*, III, p. 134, 12.3.1639.

214 Malvasia, II, p. 311 and p. 313.

215 Fantelli; ASM, *Canc. Duc.*, *Pittori*, 15/3, *Raineri, Nicolo*, 24.9.1639.

216 ASM, *Canc. Duc.*, *Estero*, *Roma*, 218, 6.4.1652. Both Monsignor degli Oddi and the Cardinal Sacchetti chased progress with Cortona but there is no further word of the *Coriolanus*.

217 ASM, *Canc. Duc.*, *Estero*, *Firenze*, 69, 6.5.1653 and 16.5.1653.

218 Testi, *Lettere*, I, p. 494, 3.12.1633; ASM, *Canc. Duc.*, *Estero*, *Firenze*, 69, 17.6.1653.

219 ASM, *Canc. Duc.*, *Estero*, *Firenze*, 69, 18.6.1652 and 25.6.1652.

220 Campori, 1870, pp. 138–40; ASM, *Canc. Duc.*, *Estero*, *Milano*, 106, 8.5.1643 and *Milano*, 100, 21.2.1635. For Tassoni: Tiraboschi, V, p. 180.

221 Campori, 1870, pp. 420–2 and pp. 175–202.

222 ASM, *Cam. Duc.*, *Fabbriche*, *Sassuolo*, 14, contract of 1653 with Girolamo Beltrami and note of 17.5.1646.

223 ASM, *Cam. Duc.*, *Amministrazione*, *Francesco I*, *Memoria di Spese considerabile*

224 ASM, *Canc. Duc.*, *Segretari*, *Poggi*, *Geminiano*, 47a, 11.9.1649.

225 Venturi, pp. 256–7; Poggi.

226 See Venturi, e.g. p. 224 and p. 228, for these and other gifts; Scannelli, p. 266.

227 Scanelli, pp. 175–6 (the painting may have been one of the gifts from Ferrante Gonzaga to which Rinaldo referred in a letter 13.3.1647 (ASM, *Canc. Duc.*, *CSCPE*, 233); Venturi, p. 259 and Scanelli, p. 142. (Este agents in Venice had made contact with 'Lesles' in the 1640s. There is now no trace of this painting.)

228 ASM, *Cam. Duc.*, *Fabbriche*, *Sassuolo*, 14, 17.12.1651. The sculptor of these statues was Prospero Spani and they had decorated the portal of the Palazzo Scaruffi in Reggio.

229 ASM, *Canc. Duc.*, *Segretari*, *Poggi*, *Geminiano*, 47a, 30.6.1646; Venturi, pp. 257–8, citing letter of 12.4.1651.

230 Venturi, pp. 252–5 and p. 270. In 1604 Vincenzo I Gonzaga had given a fief in Monferrato for a painting which may be Raphael's *Holy Family* (*La Perla*) now in the Prado, Madrid.

231 Campori, 1866, p. 101.

232 Venturi, p. 309.

233 ASM, *Canc. Duc.*, *Estero*, *Roma*, 197, 15.5.1638. For all acquisitions of Correggio paintings by Francesco, see Pungileoni, II, pp. 108–10, 194, 211–12, 236–8; Venturi, pp. 225–6; Gould, pp. 176, 201–7; and Pirondini, pp. 8, 63.

234 ASM, *Canc. Duc.*, *CSCPE*, 106, 15.10.1649 and *Canc. Duc.*, *Segretari*, *Poggi*, *Geminiano*, 47a, 18.10.1649 are letters from, respectively, Francesco, asking that the 'matter of S Sebastiano' be expedited quickly, and Poggi, confirming that the 'matter of S Pietro Martire' had been completed. This may have been a slip of the pen on Francesco's part, or it may mean that the *Madonna of San Sebastiano* was being negotiated for at the same time as the *Madonna of San Giorgio*. See Soli, III, p. 275 for the church of S Sebastiano.

235 Tassoni, p. 507.

236 Venturi, pp. 270–1; G. Galvani, '*B.V. Assunta in Cielo* dipinta da Guido Reni per la venerabile Confraternità di Sta Maria degli Angioli in Spilamberto', *ASPM*, 1863, pp. 217–50.

237 ASM, *Cam. Duc.*, *Fabbriche*, *Palazzo Ducale*, 8.

238 ASM, *Cam. Duc.*, *Fabbriche*, *Sassuolo*, 14, *Assegni per la fabrica di Sassuolo*, e.g. 1652.

239 ASM, *Cam. Duc.*, *Fabbriche*, *Sassuolo*, 14, for example, *Comparti et altre scritture per la fabrica di Sassuolo, 1652–53*, *Comparto fatto sopra a Pietre n.33335* and *Comparto per modo di provigione* (for works on Secchia river banks). Such *comparti* were also made with communities for the transport of munitions in wartime.

240 ASM, *Cam. Duc.*, *Fabbriche*, *Sassuolo*, 14, petition of 1649.

241 ASM, *Cam. Duc.*, *Fabbriche*, *Sassuolo*, 14, *Comparto* **for** *gesso*, 1651; 17.3.1654 (letter from Gandolfo della Torre); *Fabbriche*, *Palazzo Ducale*, 8, *Materiali*, 21.3.1651.

242 ASM, *Cam. Duc.*, *Fabbriche*, *Sassuolo*, 14, 2.8.1656.

243 ASM, *Cam. Duc.*, *Fabbriche*, *Palazzo Ducale*, 8, *Materiali*, 27.11.1653.

244 ASM, *Cam. Duc.*, *Fabbriche*, *Sassuolo*, 14, *Comparti et altre scritture*, 13.3.1653; 10.8.1644 (with reference to *capomaestri*); 8.8.1653.

245 ASM, *Canc. Duc.*, *CSCPE*, 108, 15.9.1652 and *Canc. Duc.*, *Estero*, *Roma*, 218, 30.11.1652; *Cam Duc.*, *Fabbriche*, *Sassuolo*, 14, *Comparti et altre scritture*, memorandum, 1652–3.

4. Patrons, agents and entrepreneurs

1 ASF, *Bentivoglio*, *Lib. 70*, *Inventario tutelare et ereditario . . .*, 30.6.1685; Evelyn, p. 195.

2 *Dizionario biografico degli italiani*, 8; Barnes.

3 Campori, 1855, p. 8; Coffin, 1962.

4 Bentivoglio, 1648, pp. 11–12.

5 ASF, *Bentivoglio*, *Repertorio Generale*, p. 26; ASV, *Ferrara*, 1, 12.12.1597.

6 ASF, *Bentivoglio*, 56, 6.1.1616 and 7.11.1616 (the executant was perhaps the Bolognese G. B. Censori, called to Modena by Cesare and responsible also for casting new bells, such as that of

S Bartolomeo (Campori, 1855, pp. 148–9). ASM, *Canc. Duc.*, *CSCPE*, 92, 4.4.1621 for Cesare's wish to reorganise his staff's responsibilities.

7 Campori, 1855, p. 8, citing Aleotti's *Idrologia*.

8 Campori, 1866, pp. 83–4.

9 ASF, *Bentivoglio*, *Lib.* 98, n. 33 and *Lib.* 96, n. 8.

10 Lodi, p. 51.

11 Campori, 1866, pp. 83–4; Cavicchi *et al.*, p. 168, n. 27.

12 Armandi *et al.*, p. 114.

13 ASF, *Bentivoglio*, *Lib.* 96, 13, *Depositione de benj . . .*, 15.12.1619.

14 Spaccini, 18.2.1605 and 5.2.1606.

15 Soli, II, p. 253; ASF, *Bentivoglio*, *Repertorio Generale*, II, p. 23.

16 Cavicchi *et al.*, p. 100.

17 Soli, I, p. 123; Campori, 1855, pp. 227–8 and p. 291; Malvasia, II, p. 212, refers to paintings by Garbieri at Gualtieri.

18 ASF, *Bentivoglio*, *Lib.* 97, n. 52. A Francesco Vacchi was a witness in Graz to Ferrante's death certificate. He is described as the son of Antonio of Modena, and in all probability would be the son of the Este architect. He then served the Este, and in 1642 the Papal Legate, in the same capacity.

19 Bentivoglio, 1934, pp. 418–19 and pp. 425–7; ASF, *Bentivoglio*, 130, 28.10.1622.

20 ASF, *Bentivoglio*, 130, 20.7.1627 and 30.7.1627.

21 Testi. *Lettere*, I, p. 231, 2.1.1630.

22 ASF, *Bentivoglio*, *Lib.* 151, n. 6, 20.5.1647.

23 Guarini and Borsetti, p. 175.

24 Testi, *Lettere*, II, p. 93, 4.3.1634.

25 Magalotti's letter of 1.7.1628 is reproduced in Cesare Ubaldini's manuscript; see bibliography.

26 ASF, *Bentivoglio*, *Lib.* 98, n. 32; Cavicchi *et al.*, pp. 161–72; Bagni, pp. 239–50.

27 ASF, *Bentivoglio*, *Lib.* 97, n. 77, *Calcolo dello stato . . .*, gives a value of L.24,699 for the palace in 1595 and L.83,347 *c.* 1619; Ridolfi, ed. 1924, II, pp. 252–3.

28 ASF, *Bentivoglio*, *Lib.* 89, n. 20, concession of burial rights in S Maurelio for Enzo and his wife Caterina Martinengo, 21.11.1620; Guarini, p. 146 and Guarini and Borsetti, p. 175; Chiappini *et al.*, pp. 70–89.

29 AAF, *Curia*, *Memoria*, 38, doc. 13.

30 ASF, *Bentivoglio*, 57, 28.8.1612, cited in Cavicchi *et al.*, p. 104.

31 ASF, *Bentivoglio*, *Lib.* 80, n. 20, heads of agreement of 1608 with Apostolic Chamber; *Repertorio Generale*, II, p. 36, 9.3.1609, permission from Treasurer–General, Giacomo Serra, to begin; p. 37, 4.7.1609, survey of site by Aleotti; p. 39, 8.10.1609, Legate Spinola's permission to begin; *Lib.* 89, n. 41 and n. 37, Aleotti reports and judges scheme complete, 6.11.1612 and 22.12.1612.

32 ASF, *Bentivoglio*, *Lib.* 115, n. 16 and n. 18, *c.* 1626.

33 ASF, *Bentivoglio*, *Lib.* 115, n. 16; Penna, 1663, p. 59.

34 For example, ASM, *Cam. Duc.*, *Ferrara*, 13, 31.12.1609.

35 Penna, 1663, p. 59.

36 ASF, *Bentivoglio*, *Lib.* 80, n. 65, total as at 15.3.1611.

37 Povoledo V, p. 173. The Academy *degli Intrepidi*, whose theatre this was to be, would raise the other half.

38 Testi, *Poesie Liriche*, p. 49.

39 Bentivoglio, 1934, pp. 428–30, 24.12.1611.

40 Povoledo, V, p. 173.

41 ASF, *Bentivoglio*, 57, 29.10.1611; 78, 31.10.1615.

42 Cavicchi *et al.*, pp. 167–8; Malvasia, II, p. 349. See Artioli and Monducci, pp. 25–6, for Sandrini in Reggio.

43 ASF, *Bentivoglio*, 378, 28.2.1612 (letter to Enzo from Alessandro Guarini returning Aleotti's draft description).

44 Reiner; Lavin.

45 ASF, *Bentivoglio*, 78, 15.4.1618 (Borghese); 57, 29.10.1611 (Rivarola).

46 Testi, *Lettere*, II, p. 15, 11.1.1634. For a description of the tournament see, in addition to the published text (see the Bibliography), G. Gigli, *Diario Romano*, G. Ricciotti (ed.), Rome, 1958, pp. 142–3.

47 ASV, *Avvisi*, 9, 7.1.1623.

48 Orbaan, p. 266, 1.7.1620; ASV, *Avvisi*, 132, 26.8.1620.

49 ASF, *Bentivoglio*, Lib. 97, n. 45, 22.10.1619.

50 ASF, *Bentivoglio*, 164, 20.7.1622.

51 Baglione, p. 335 and p. 343; Pugliatti, p. 77; Passeri, ed. 1934, p. 169; Baldinucci, IV, p. 579 and pp. 230–3.

52 Mancini, I, pp. 248–9.

53 Campori, 1866, pp. 103–6; Haskell, p. 49.

54 ASF, *Bentivoglio*, Lib. 133, n. 14, *Fede qualmente quando il S.re March.e Bentivoli compro dal Sig.r Duca Altemps il Palazzo di Monte Cavallo era imperfetto, c. 1637.*

55 As n. 54 above and n. 2, *Appartamenti che sono al presente nel Palazzo di Sig.ri Bentivogli in Roma*; Lib. 9, n. 1, 18.10.1620 and *Lib.* 115, n. 62, *Misura e stima delle opere di scarpello fatti da M.co Giuseppe Codanini et M.co Bernardino Masone nel Palazzo dell'Ill.mo et Rev.mo Card.le Bentivoglio,* 15.7.1626.

56 ASF, *Bentivoglio*, Lib. 133, n. 2, *Nota di quel che resta da farsi.*

57 ASF, *Bentivoglio*, Lib. 133, n. 10, *Capitoli, e Propositioni del Sig.re March.e Enzo Bentivoglio sopra le fabriche del Palazzo di Roma da osservarsi da quelli che avessero voluto pigliare a fabricare in d.to Pallazzo.*

58 All named in ASF, *Bentivoglio*, Lib. 133, n. 14, *Fede . . .*

59 ASF, *Bentivoglio*, 57, 7.11.1612; 78, 10.3.1617 and 30.3.1617; 132, 13.2.1627.

60 ASF, *Bentivoglio*, 58, 25.1.1611; Campori, 1866, pp. 81–2.

61 See Reiner; Lavin; and Bagni, pp. 242–5.

62 Reiner; Lavin; Campori, 1866, pp. 103–6; ASF, *Bentivoglio*, 132, 25.8.1627.

63 Campori, 1866, pp. 106–7, citing letter of 22.9.1627.

64 ASF, *Bentivoglio*, 56, 16.10.1614 (Bernardino) and 240, 10.3.1630 (Hieronimo); Campori, 1866, p. 107 (Provenzale).

65 Passeri, ed. 1934, pp. 168–9; Haskell, p. 50.

66 A. Banti, *Giovanni da San Giovanni, pittore della contraddizione*, Florence, 1977, p. 91, citing letter of 15.5.1628. See Cavicchi *et al.*, p. 181, for the Bolognese Francesco Bigari's similar appeal for payment.

67 ASF, *Bentivoglio*, 378, 11.4.1608, 28.2.1612, 20.11.1613 and 4.3.1616; A. Guarini, *Prose*, Ferrara, 1611 (incorporating *Delle lettere di Alessandro Guarini*), undated letter.

68 Reiner, citing letter of 17.8.1627.

69 ASF, *Bentivoglio*, 132, 30.6.1627.

70 See Chapter 1, p. 12 and ASM, *Canc. Duc., Pittori*, 14/2, Dossi, Dosso, 10.3.1608.

71 Cavicchi *et al.*, p. 99; ASF, *Bentivoglio*, 58, 16.1.1611, and 29.1.1611; Orbaan, p. 190, 14.5.1611.

72 ASF, *Bentivoglio*, 57, 4.6.1614; Orbaan, p. 190.

73 Bentivoglio, *Nunziatura*, IV, pp. 551–2, 26.1.1621; Cavicchi *et al.*, p. 123, n. 10.

74 ASM, *Canc. Duc., CSCPE*, 93, 18.9.1632.

75 Tessin, p. 213.

76 The DNB entry discusses the Bomporto canal project.

77 ASF, *Bentivoglio*, Lib. 124, n. 3, notice of sequestration, 24.8.1630. New capital had to be raised by recourse to the Monte Sisto in 1609, 1610, 1611, 1613, 1615, 1619, 1621, 1625, 1630 and 1633.

78 ASF, *Bentivoglio*, 378, 3.3.1611 from Ottavio Magnanini.

79 BCA *ms.*, Ubaldini, pp. 75–6.

80 ASF, *Bentivoglio*, Lib. 128, n. 7.

81 ASF, *Bentivoglio, Lib.* 124, n. 27.

82 ASF, *Bentivoglio, Lib.* 133, n. 1., *Processus*, 28.3.1637; n. 3, *Informatione pertinente alla Compra del Palazzo a Monte Cavallo di Roma.*

83 ASF, *Bentivoglio*, 240, 7.6.1633 (copy of a letter from Bouthillier to Guido Bentivoglio enclosing Louis XIII's letter of regret of 4.6.1633); R. Quazza, *Mantova e Monferrato nella politica europea alla vigilia della guerra per la successione, 1624–7*, Mantua, 1922, p. 319.

84 ASM, *Canc. Duc., Estero, Roma*, 197, 26.11.1639.

85 ASF, *Bentivoglio*, 253, 8.12.1640.

86 Evelyn, ed. 1908, p. 104, 26.2.1645.

87 ASM, *Canc. Duc., Estero, Roma*, 196, 29.11.1636.

88 ASF, *Bentivoglio*, 254, 9.1.1641.

89 Dethan, p. 18. Mazarin admitted that his purchase was extravagant.

90 ASF, *Bentivoglio, Lib.* 142, n. 21, 1.7.1640.

91 ASF, *Bentivoglio, mazza* 253, 28.11.1640.

92 Bentivoglio, 1648, p. 31 and p. 123.

93 Bentivoglio, 1648, p. 124, pp. 64–5, p. 73 and pp. 67–8.

94 See A. Banti, *Europa milleseicentosei, Diario d'un viaggio*, Milan, 1942. Giustiniani's companion keeping the diary, Bernardo Bizoni, was also intrumental in Enzo's dealing in pictures for Borghese in 1608; see Cavicchi *et al.*, p. 103, n. 56.

95 ASF, *Bentivoglio, Lib.* 97, n. 65, instructions, 5.6.1607.

96 ASV, *Nuncio*, 12A, 22.8.1609.

97 Bentivoglio, 1646, p. 141, p. 144 and p. 157.

98 Bentivoglio wrote reports also upon England and Denmark; see *Relazioni del Cardinal Bentivoglio*, Milan, 1806.

99 Bentivoglio, 1646, p. 194.

100 Bentivoglio, 1646, p. 185; Bentivoglio, 1934, pp. 49–50, 15.6.1616.

101 Bentivoglio, *Raccolta di lettere scritte del Cardinal Bentivoglio in tempo delle sue Nuntiature di Fiandra e di Francia* including *Relationi del Cardinal Bentivoglio*, Cologne, 1646, pp. 45–7, 10.4.1616 and 15.7.1616.

102 Bentivoglio, *Nunziatura*, IV, pp. 539–47, 31.1.1621; Bentivoglio, 1648, pp. 184–5 (Marie de' Medici).

103 Bentivoglio, *Nunziatura*, IV, pp. 539–47, 31.1.1621.

104 Bentivoglio, *Nunziatura*, I, pp. 168–9, 23.3.1617.

105 Bentivoglio, 1631, pp. 99–102, 7.4.1620.

106 Cavicchi *et al.*, p. 28; ASF, *Bentivoglio*, 252, 25.9.1640.

107 ASV, *Pio, Registro di Lettere*, pp. 87–8, 12.6.1610.

108 Baschet, I, 9.1.1610.

109 Baschet, I, 9.1.1610; Evelyn, ed. 1908, p. 73, 17.11.1644.

110 Baschet, I, 9.1.1610.

111 ASV, *Nuncio*, 12A, 23.10.1610 and 11.12.1610.

112 ASV, *Nuncio*, 12A, 11.12.1610 and 31.7.1610.

113 ASV, *Nuncio*, 12A, 4.12.1610.

114 ASV, *Nuncio*, 12A, 31.7.1610.

115 Baschet, I.

116 Baschet, I, 9.1.1610.

117 Baschet, II; Bentivoglio, *Nunziatura*, I, p. 256, 23.5.1617.

118 Bentivoglio, *Nunziatura*, I, pp. 138–9 and pp. 168–9; III, p. 143, 12.12.1618.

119 Bentivoglio, 1648, pp. 138–42.

120 ASF, *Bentivoglio*, 253, 12.12.1640.

121 Bentivoglio, 1631, p. 101.

122 Bentivoglio, 1631, pp. 74–9, 22.9.1618.

123 ASV, *Pio*, pp. 7–8, 11.8.1607.

124 Bentivoglio, 1631, pp. 74–9, 22.9.1618.

125 Barozzi and Berchet, *Roma*, II, p. 28; Dethan, p. 68–9, September 1641.

126 ASF, *Storico, Corrispondenza, Cardinali*, 11, *Serra*, December, 1615.

127 Bentivoglio, 1648, p. 123.

128 Frizzi and Laderchi, p. 111; ASV, *Avvisi*, 96, 10.9.1644.

129 J. von Sandrart, *Academie der Bau-Bild-und-Mahlerey Kunst von 1675*, ed. Munich, 1925, p. 260; Baldinucci, IV, pp. 230–3.

130 Bellori, pp. 273–4.

131 Bentivoglio, 1934, pp. 427–8, 1.11.1610.

132 Baldinucci, V, pp. 91–3; H. Diane Russell, p. 452 (the pendant to the Castelgandolfo view is the *Port of Santa Marinella*, Musée du Petit Palais, Paris); Kitson.

133 Passeri, ed. 1934, pp. 174–6; G. Hoogewerff, *De Bentveughels*, s-Gravenhage, 1952, p. 144 and p. 164; and see Chapter 3, pp. 48–9 above.

134 ASF, *Bentivoglio*, 236, 21.7.1631.

135 Dethan, p. 18.

136 ASF, *Bentivoglio, Lib.* 145, 11, 7.7.1644.

137 Bentivoglio, 1648, p. 147.

138 ASF, *Bentivoglio*, 254, 26.1.1641.

139 ASV, *Ferrara*, 23, 9.2.1647.

140 Soli, III, p. 313.

141 ASF, *Bentivoglio*, 252, 11.5.1640.

142 ASF, *Bentivoglio*, 254, 19.3.1640 and 253, 12.11.1640; *Lib.* 144, 43, 2.4.1643 (repurchase of Scandiano by the Este by cancellation of debt of 74,617 *scudi* to the *Mont'Estense*).

143 ASF, *Bentivoglio*, 253, 27.10.1640.

144 ASF, *Canc. Duc., Segretari, Poggi, Geminiano*, 47a, 11.4.1654.

145 ASF, *Bentivoglio, Lib.* 142, 36, 9.9.1640; 253, 9.12.1640.

146 ASM, *Canc. Duc., Estero, Roma*, 199, 22.2.1645.

147 Malvasia, II, p. 182.

148 ASF, *Bentivoglio*, 253, 14.11.1640; 331, 15.2.1660.

149 Guarini and Borsetti, p. 175.

150 ASF, *Bentivoglio, Lib.* 164, 52, 21.4.1663; 253, 6.11.1640.

151 Malvasia, II, p. 265 and pp. 320–1 (a *Woman of Samaria* of 1641), and p. 323 (a *Magdalen* of 1643).

152 Fraschetti, pp. 49–50; ASM, *Canc. Duc., Estero, Roma*, 196, 18.7.1640, quoted in Venturi, pp. 249–50. By 1644 the portrait was in Florence, where it was seen by John Evelyn, and it is possible that it was not in fact presented to Francesco.

153 ASF, *Bentivoglio, Lib.* 158, 26, 25.2.1656, and see n. 150 above for the 1663 inventory.

154 ASM, *Canc. Duc., CSCPE*, 227, 15.2.1645.

155 Malvasia, II, p. 264, p. 266, pp. 317–18 and p. 324; ASF, *Bentivoglio*, 250, 19.10.1639 and 20.12.1639; 252, 16.8.1640; 253, 24.11.1640; De Cosnac, p. 293 and p. 326.

156 ASF, *Bentivoglio*, 300, 20.8.1650 and 10.9.1650; ASV, *Nuncio, Firenze*, 31, 30.8.1650.

157 Cornelio had married twice, to Anna Strozzi and then Costanza Sforza, whom he made his universal heir. ASF, *Bentivoglio, Lib.* 164, n. 46, 24.3.1663 gives details of his will.

158 Libanori, p. 184.

159 Frizzi and Laderchi, p. 126.

160 ASF, *Bentivoglio*, 333, June 1668 (cornet-player Giuseppe Foschetto); 24.9.1664 (Leonora ballerina); 8.3.1661 and 3.4.1662 (Farnese players).

161 Baldinucci, VI (Appendix), p. 148; Goldberg, p. 25.

162 Guarini and Borsetti, p. 51; Baruffaldi, II, p. 279; ASF, *Bentivoglio, Lib.* 170, n. 1, 30.6.1685.

163 Ippolito was unique in the family in that he served in 1669 and 1670 as *Giudice dei Savi*, leader of the communal council. Enzo had been elected Ferrara's ambassador to Rome in 1608 but never Giudice.

5. *The state of the faith*

1 AAF, *Curia, Editti*, 24.7.1627.

2 See Guarini for these churches. As a result partly of an earthquake in 1570, and partly of the early introduction into Ferrara of new religious orders, the last decades of the sixteenth century had been a time of new church building, the Gesù and S Paolo of the Carmelites (both attributed to Alberto Schiatti and S Paolo later decorated by Scarsellino with scenes from the life of Elijah in landscape settings) being perhaps the most interesting and attractive buildings.

3 Guarini, p. 279; Guarini and Borsetti, p. 171, p. 202 and p. 36; Coffin, 1962; Chiappini *et al.*, p. 70.

4 ASM, *Canc. Duc., Estero, Roma*, 197, 5.11.1639. The Ferrarese Superbi, p. 18, and Libanori, p. 13, extolled Pio's virtues, but the Este agent in Rome Mantovani reported his less likeable characteristics, his unpopularity (Testi called Pio a 'devil incarnate') and gossip about his private life and dealing in gold prices (*Canc. Duc., Estero, Roma*, 197, 8.6.1641 and 15.6.1641, both following Pio's death).

5 Guarini, p. 219 and Guarini and Borsetti, p. 218.

6 ASF, *Bentivoglio, Lib.* 151, 37, copy of 1649 of the rules of Confraternity, formed on 30.6.1612.

7 ASF, *Bentivoglio, Lib.* 96, 2, *Conto delle spese che andarà a fare la Chiese delle Sacre Stimmate*; AAF, *Stimmate, Filza delli Ordini dei S. Governatori . . .*, November 1620–October 1632. No architect's name is recorded, but the building was to 'conform to a design'. It is possible that Aleotti, who made drawings for the church of the Spirito Santo confraternity, also provided the noble patrons of the Stigmata with sketches.

8 Pastor, XXV, 1952, pp. 138–41.

9 Spaccini, 20.5.1606 and 23.5.1606.

10 Frizzi and Laderchi, p. 54.

11 Guarini, p. 37; Guarini and Borsetti, p. 105 and p. 30.

12 Pastor, XXV, 1952, p. 269.

13 Guarini and Borsetti, p. 137 (the church has been demolished).

14 Trotti.

15 Bertoldi, 181, p. 32; Peverada, *passim*. Fontana belonged to the same family as Roberto Fontana, the Este Resident in Milan and then Bishop of Modena.

16 ASM, *Cam. Duc., Ferrara*, 12, 19.7.1608.

17 Della Pergola, I, p. 151.

18 Peverada (*Borromeo*), pp. 323–5; BCA *ms.*, Ubaldini, pp. 79–80.

19 Bertoldi, 1818, p. 33.

20 AAF, *Curia, Editti*, 4.5.1612.

21 Guarini and Borsetti, p. 48.

22 BCA *ms.*, Ubaldini, p. 80; Testi, *Lettere*, I, p. 124, 3.11.1627.

23 Libanori, p. 118.

24 BCA *ms.*, Perinelli; Bertoldi, 1818, p. 34.

25 Malvasia, II, pp. 125–6.

26 ASV, *Avvisi*, 9, July 1623 (doc. 198) and 2.9.1623; Baldinucci, IV, p. 483.

27 Malvasia, II, p. 261; Mahon, 1968, p. 133; Haskell, p. 42.

28 Malvasia, II, p. 291 and p. 318; Barozzi and Berchet, *Roma*, I, pp. 154–6; p. 214 and p. 235.

29 BCA *ms.*, Ubaldini, p. 115; BCA *ms.* Ameyden.

30 The Ubaldini *ms.* reproduces the document of 1.7.1628.

31 ASF, *Bentivoglio*, 132, 15.9.1627 (Leni) and 26.5.1628 (Magalotti); AAF, *Capitolo, Libro de Decreti*, 72, 7.8.1635.

32 Guarini and Borsetti, p. 232; Frizzi and Laderchi, p. 93; AAF, *Curia, Editti*.

33 Magalotti, pp. 1–6.

34 AAF, *Curia, Editti, Ordini da osservarsi nella comunione generale . . .*, 31 May; Libanori, p. 119.

35 AAF, *Curia, Editti*, 31, 6.4.1629; reissued, n. 112, 9.11.1635.

36 AAF, *Curia, Editti*, 99, *Della Processione del Corpus Domini*; 38; *Capi da osservarsi per l'occasione della quaranta hore nelle Parochie*.

37 AAF, *Curia, Visite*, 2, 1634, 47T, *De Sacris Imaginibus*; *Editti*, 45, 28.6.1636; Libanori, p. 119.

38 AAF, *Curia, Editti, Editto per la processione da farsi Sabbato prossimo . . .*, 7 October.

39 AAF, *Curia, Editti*, 14, *Lettera Circolare a tutti li Curati*; 15, *Lettere, o Instruttione a Rettori. . . .*

40 See Tonello, *passim.*, for a general summary, and AAF, *Curia, Visite*, 1628, T.I (city) and T.II (country). Leni had made a brief second Visit in January 1616 (his 'most desired return to this his Church', was noted in the description of Enzo Bentivoglio's production *Bradamente Gelosa* of 1616) and an even briefer third Visit in 1620.

41 AAF, *Curia, Visite*, 1628, T.I, p. 80 and p. 81 (S Carlo and Spirito Santo), p. 87 (Confraternity of S Gio. Battista), visit of 13.11.1628 to the Cathedral.

42 AAF, *Curia, Visite*, 1628, T.II, p. 528.

43 AAF, *Curia, Visite*, 1628, T.I, p. 26 and p. 55.

44 AAF, *Curia, Visite*, 1628, T.II, p. 556, p. 642 and p. 702.

45 AAF, *Curia, Visite*, 1628, T.1, p. 55; Tonello, p. 42.

46 AAF, *Curia, Visite*, 1628, T.I, p. 123; AAF, *Stimmate, Registro di mandati*, 1629–41, p. 36, p. 37 and p. 46 (payment to Guercino and for new altar, windows, etc.); Malvasia, II, p. 310.

47 Guarini and Borsetti, p. 198 (noting that the painting was damaged, removed in 1668 and replaced by a copy by Gennari); Malvasia, II, p. 314 and p. 341 (repairs of 1661).

48 Guarini and Borsetti, p. 235; Malvasia, II, pp. 312–13.

49 For example, AAF, *Curia, Visite*, 1628, T.II, p. 586 and p. 520.

50 AAF, *Curia, Visite*, 1628, T.II, p. 638 and p. 721.

51 AAF, *Curia, Visite*, 1628, T.I, p. 55 and T. II, p. 537.

52 Guarini and Borsetti, p. 215.

53 AAF, *Curia, Visite*, 1628, T.I., p. 81.

54 AAF, *Curia, Visite*, 1628, T.II, p. 638.

55 AAF, *Curia, Visite*, 1628, T.I, visit beginning on 13.11.1628, p.3v; p.7v and p.4 and 4v.

56 AAF, *Curia, Catastro alfabetico . . .*, note of the relics brought from Sant'Antonio di Viena, near Naples; *Capitolo, Inventario della R.do Sacristia fato dell'anno 1638*, p. 62; Malvasia, II, p. 315 (the altarpiece was 'retouched' by Guercino in 1637).

57 AAF, *Capitolo*, 72, pp. 26–7, 17.6.1636 and 18.6.1636 and (note of safe return) 31.10.1636.

58 Libanori, p. 119.

59 BCA *ms.*, Perinelli; AAF, *Capitolo*, 72, p. 33, 3.11.1637 and pp. 46–7, 13.9.1638. Magalotti left to his heirs a legacy of *c.* 60,000 *scudi*, but debts of 20,000 (ASM, *Canc. Duc., Estero, Roma*, 196, 19.9.1637).

60 AAF, *Capitolo, Inventario della supelettile sacra lasciate alla Capella di S.to Lorenzo dall'Em.mo Sig. Card. Magalotti*, p. 44; BCA *ms.*, Scalabrini, n. 456. See also Cavicchi *et al.*, pp. 139–46 for other information concerning the altarpiece.

61 BCA *ms.*, Perinelli; Libanori, p. 119.

62 Malvasia, II, p. 308 nd p. 314.

63 Biblioteca dell'Ospedale Maggiore di Milano, *Rub. I, Origine e Dotazione, Cap. VIII, Eredità, Legati, ecc., Cesare Monti, Cardinale Arciv.o di Milano, 15.6.1650*. I am grateful to Dr Peter Cannon-Brookes for the use of this information concerning the estate of the Cardinal Monti. See ASM, *Canc. Duc., Estero, Roma*, 196, 19.9.1637 for Magalotti's protégés.

64 M. Heimburger-Ravalli, *Architettura, scultura e arti minori nel Barocco. Ricerche nell'Archivio Spada*, Florence, 1977, pp. 158–88.

65 Frizzi and Laderchi, p. 94.

66 BCA *ms.*, Perinelli; Libanori, p. 121; Bertoldi, 1818, p. 34.

67 AAF, *Curia, Editti*, 21.8.1647; ASM, *Canc. Duc., Estero, Roma*, 198, 1.11.1642.

68 Libanori, p. 123 and p. 125; Bertoldi, 1818, p. 35 and p. 37; BCA *ms.*, Perinelli; Guarini and Borsetti, p. 215.

69 Haskell, p. 221; L. Meluzzi, *Gli Arcivescovi di Ferrara*, Bologna, 1970, p. 21.

70 Guarini and Borsetti, p. 215; Frizzi and Laderchi, p. 130.

71 Guarini and Borsetti, p. 160.

72 Guarini and Borsetti, p. 41.

73 Guarini and Borsetti, p. 105 and p. 117.

74 Guarini and Borsetti, p. 30.

75 ASV, *Ferrara*, 18, 23.10.1641 (and see Passeri, ed. 1934, p. 230 for the palace at Velletri designed by Martino Longhi).

76 AAF, *Catastro alfabetico*, including contract with Danese of 14.10.1627 and his advice on foundations of 24.10.1627 and on the fabric of 19.1.1632; and undated note referring to architects Maruscelli and Nicolo Sebregondi. See also Guarini and Borsetti, p. 125.

77 Cavicchi *et al.*, p. 173; A. Sutherland Harris, *Andrea Sacchi*, Oxford, 1977, pp. 98–9; AAF, *Catastro alfabetico* ...; Malvasia, II, p. 320. (Guarini-Borsetti, p. 256, lists the Scannaroli among the nine families to settle in Ferrara.)

78 Malvasia, II, p. 335; Guarini and Borsetti, p. 125.

79 Guarini and Borsetti, p. 128; Baruffaldi, II, p. 209.

80 Penna, 1663, pp. 11–12.

6. The Papal Legation

1 BCA, *Antonelli, ms.*, 19. The claim was made Renato Cato.

2 BCA *ms.*, Ubaldini, p. 121; ASV, *Ferrara*, 6, 6.7.1630. The Costaguti was one of the nine new families settling in post-devolution Ferrara; see Guarini and Borsetti, p. 256.

3 ASV, *Ferrara*, 22, 14.11.1646 and 17.11.1646.

4 ASV, *Ferrara*, 17, 7.6.1636.

5 See G. Gaeta Bertelà, *Incisori Bolognesi ed Emiliani del sec. XVII*, Bologna, 1973 for many examples. Lodovico Carracci made a drawing of the Aldobrandini arms (Albertina, Vienna) which was then etched by Francesco Brizio.

6 ASF, *Storico, Cancelleria* (these privileges were granted, for example, to the Cardinals Franzone, Ginnetti (1664), Buonvisi (1665) and Bernardino Spada (who was, however, never Ferrara's Legate) and to the Cardinal Donghi's nephews); Baruffaldi, II, p. 198. Guido Reni's portrait of the Cardinal Bernardino Spada when Legate to Bologna (Galleria Spada, Rome), with his pigeon-holes of filing behind him, may stand representative of all Cardinal Legates.

7 ASM, *Canc. Duc., Estero, Roma*, 199, 22.3.1645 (with reference to Alderano Cibò, more 'needy' than some).

8 This cartouche may date from Spinola's period as Vice-Legate to Bologna immediately before appointment to Ferrara. Giovan. Valesio dedicated his *Primi elementi del disegno* to Spinola (A. Bartsch, *Le Peintre-Graveur*, Leipzig, 1870, vol. 18, p. 225).

9 BCA *ms.*, Ubaldini, p. 58 and p. 82. (Spinola was reappointed for a further three years in 1609 and presumably 1612.)

10 BCA *ms.*, Mussi for the history of the Fortress. Imperiale's visits, which may point up the changing character of Ferrara in the eyes of the world, are described in diaries reproduced in A. G. Barrili, 'Viaggi di Gian. Vincenzo Imperiale', *Atti della Società Ligure di Storia Patria*, XXIX, Genoa, 1898.

11 Orbaan, p. 303, 2.6.1609; Herz.

12 Barozzi and Berchet, *Roma*, I, p. 363; ASV, *Ferrara*, 13, 5.10.1633.

13 Penna, 1663, p. 13. It had long been accepted that the city was weak at that point, even by Cesare d'Este, who planned defences there (ASV, *Ferrara*, 1, 3.12.1597 and doc. 224, undated).

14 Coffin, 1962; BCA *ms.*, Mussi; Bonasera (with reference to Aleotti's letter of 25.2.1605 to Francesco Borghese on the necessity of choosing that site but providing alternative plans for diverting the waters); ASM, *Cam. Duc., Ferrara*, 9, 2.7.1604 (with reference to Aleotti's concern at

the Reno diversion); Cavicchi *et al.*, p. 103, 12.7.1608, letter from the Cardinal Caetani to the Cardinal Borghese recommending that Aleotti be excluded. Aleotti's *Porta Reno* of 1612 still stands in Ferrara.

15 BCA *ms.*, Mussi, p. 6; Orbaan, pp. 113–14, 5.7.1608 and p. 82, 27.6.1607; Baglione, p. 329 for Targone's career.

16 BCA *ms.*, Ubaldini, p. 44 and p. 85; Maestri, pp. 210–11. Spernazzati was perhaps in Ferrara in 1606, when payments were made to him and to architects sent to Bologna for reasons of water management (Orbaan, p. 297).

17 See A. Bartsch, *Le Peintre-Graveur*, Leipzig, 1870, v. 18, p. 227.

18 ASV, *Avvisi*, 4, 31.12.1611 and 9, 26.8.1623; R. S. Magurn, *The Letters of P. P. Rubens*, Cambridge, Mass., 1955, p. 41; L. Tagliaferro, 'Di Rubens e di alcuni genovesi' in *Rubens e Genova*, catalogue, Genoa, 1978, p. 54, n. 58.

19 Malvasia, II, p. 258; Mahon, 1968, p. 5, p. 75, p. 84, p. 91 and p. 93; Mahon, 1981. Sir Denis Mahon is, of course, responsible for tracing the paintings which can with almost complete certainty be identified with Serra's collection. Of those not reproduced here, the *St Sebastian* is in the Pinacoteca Nazionale, Bologna, and the *Elijah* and the *Jacob* are in the Mahon collection.

20 Malvasia, II, pp. 16–19; D. S. Pepper, 'Guido Reni's Roman account book', I, *The Burlington Magazine*, 1971, CXIII, p. 309.

21 Chiappini *et al.*, pp. 181–3 (the inventory of Canonici's collection of 'curios').

22 ASV, *Ferrara*, 17, 10.3.1638.

23 Frizzi and Laderchi, p. 69 and p. 75; Ubaldini, p. 84. Such of Serra's letters to the Commune as survive are in ASF, *Storico, Corrispondenza, Cardinali*, Serra, 11.

24 BCA *ms.*, Ubaldini, p. 94. ASF, *Storico, Corrispondenza, Cardinali, Sacrati*, 2, 19.5.1621 from Commune to Cardinal Sacrati refers to Serra's agreement to the creation of the Ghetto.

25 BCA, Antonelli *ms.*, Anonimo. BCA *ms.*, Ubaldini, p. 84, considered, however, that the scheme was foolish.

26 BCA, Antonelli *ms.*, Anonimo. Bread supplies may well have been in Serra's mind when Guercino painted the *Elijah fed by ravens*.

27 Bellini, p. 246.

28 Frizzi and Laderchi, p. 68; Penna, p. 12.

29 ASV, *Ferrara*, 8, promulgation of 20.11.1620.

30 BCA *ms.*, Mussi; Chiappini *et al.*, pp. 90–3.

31 BCA *ms.*, Ubaldini, p. 96; Bellini, pp. 255–7; Chiappini *et al.*, p. 203.

32 ASF, *Storico, Corrispondenza, Cardinali*, Serra, 11, August, 1623.

33 ASV, *Avvisi*, 9, 26.8.1623.

34 Mahon, 1968, p. 93, with reference to Serra's *Jacob blessing the sons of Joseph*, possibly acquired by the Legate Sacchetti and given by him to Juan Alfonso Enríquez de Cabrera, Admiral of Castile, in Rome in 1646.

35 Frizzi and Laderchi, pp. 77–8; ASV, *Ferrara*, 8, 13.6.1625; Malvasia, II, p. 261; BCA *ms.*, Ubaldini, p. 109.

36 Justi, p. 291; Malvasia, II, p. 261; Chiappini *et al.*, p. 183.

37 BCA, Antonelli *ms.*, Anonimo. (For Cortona, see N. Fabbrini, *Vita del Cav. Pietro da Cortona*, Cortona, 1896.)

38 BCA *ms.*, Ubaldini, p. 111 and p. 150; ASF, *Storico, Corrispondenza, Cardinali, Sacchetti*, 1, 12.9.1634, 20.9.1634 and 4.10.1634. In the same source is a letter of 27.7.1630 revealing that thanks to Sacchetti's intervention the Pope will allow Ferrara to raise a loan of 30,000 *scudi*.

39 ASV, *Ferrara*, 8, 16.4.1631.

40 BCA *ms.*, Ubaldini, p. 176; ASV, *Ferrara*, 12, 22.6.1633.

41 ASV, *Ferrara*, 12, letters of May and June 1633; BCA *ms.*, Ubaldini, p. 205. (Estense-Tassoni was accused of not only influencing elections but also embezzling some 7,000 *scudi* from the *Abbondanza* funds during his term as *Giudice* in 1629.)

42 ASV, *Ferrara*, 8, 24.12.1631.

43 BCA *ms.*, Mussi; ASV, *Avvisi*, 97, 28.10.1645.

44 F. Sansovino (con aggiunta . . . da D. Giustiniano Martinioni), *Venetia Città Nobilissima*, v. II, Venice, 1663, ed. 1968, pp. 666–7; ASV, *Ferrara*, 8, 11.12.1631. See Barozzi and Berchet, *Roma*, I, pp. 269, 344 and 363 and II, p. 31 for the Venetian Ambassadors' views of Pallotta's courageous, if somewhat forthright character and, less favourably, his aggressive policy towards Venice when Legate to Ferrara.

45 ASV, *Ferrara*, 9, 5.2.1632 and *Ferrara*, 11, 6.11.1632.

46 ASV, *Ferrara*, 8, 22.11.1631 and *Ferrara*, 14, 15.3.1634.

47 BCA *ms.*, Ubaldini, p. 173 (quoting 72,363 *scudi da paolo* as the cost); ASV, *Ferrara*, 10, 31.3.1632 and *Ferrara*, 14, 17.12.1633.

48 BCA, Antonelli *ms.*, Anonimo; ASV, *Ferrara*, 11, 6.11.1632.

49 ASV, *Ferrara*, 9, 2.6.1632; *Ferrara*, 13, 3.8.1633 and 20.8.1633; *Ferrara* 12, 30.7.1633; BCA *ms.*, Ubaldini, p. 198.

50 ASV, *Ferrara*, 9, 12.12.1632 and *Ferrara*, 10, 19.2.1632.

51 ASV, *Ferrara*, 9, 2.6.1632; *Ferrara*, 8, 11.12.1631; *Ferrara*, 14, 17.12.1633.

52 ASV, *Ferrara*, 12, 27.7.1633; *Ferrara*, 11, 27.10.1632; BCA *ms.*, Ubaldini, p. 163. Among other problems, on 16.10.1632 Pallotta reported that losses due to fraud in the Commune finances were estimated at some 30,000 *scudi* (ASV, *Ferrara*, 11).

53 ASV, *Ferrara*, 14, 5.2.1634 and *Ferrara*, 15, 24.6.1634.

54 M. Heimburger-Ravalli, *Architettura, scultura e arti minori nel Barocco Italiano*, Florence, 1977, p. 210. Pallotta had been appointed to the committee for the building works at St Peter's in 1631.

55 ASV, *Ferrara*, 12, 29.6.1633. (The Order in question was the Servite Order, some of whose members in Ferrara were controlled from Venice and therefore, since Paolo Sarpi had been a Venetian Servite, were suspected of spying by Pallotta. The Palazzo dei Diamanti and a Rossetti palace had been suggested when the need to rehouse the friars arose.)

56 Frizzi and Laderchi, p. 89; Bellini, p. 263.

57 BCA *ms.*, Ubaldini, p. 153; ASV, *Ferrara*, 12, 6.7.1633 and *Ferrara*, 14, 5.4.1634.

58 ASV, *Ferrara*, 14, 10.5.1634; ASF, *Bentivoglio, Repertorio de' Stabili*, 7.1.1634.

59 ASV, *Avvisi*, 96, 9.7.1644.

60 ASV, *Ferrara*, 12, 2.3.1633.

61 BCA *ms.*, Ubaldini, pp. 175–6.

62 Malvasia, II, p. 135 and pp. 262–3.

63 Malvasia, II, p. 313 and p. 317, account book of Guercino showing that Francesco I paid for the 1634 picture and that a copy owned by Pallotta was repaired in 1638. For the *Damon*, see N. Turner, *Italian Baroque Drawings*, London, 1980, p. 108, with reference to Mahon's identification of the British Museum drawing as a sketch for Pallotta's picture.

64 ASV, *Ferrara*, 15, 24.6.1634.

65 ASV, *Ferrara*, 14, 11.11.1634.

66 ASV, *Ferrara*, 14, 1.7.1634.

67 Testi, *Lettere*, I, p. 490, 28.11.1633.

68 ASV, *Ferrara*, 14, 28.6.1634.

69 ASV, *Ferrara*, 14, 7.3.1635 and 28.2.1635.

70 ASV, *Ferrara*, 14, 1.8.1635. Durazzo also took over from the Commune the services of Gnoli when Danese needed assistance in making plans of Reno flood damage in 1635 and protecting land north of the Po from an Adige flood in 1636.

71 ASV, *Ferrara*, 14, 11.11.1634.

72 ASV, *Ferrara*, 14, 2.5.1635. Guitti had been in Rome since January 1633 and Durazzo had been awaiting his return in August 1634.

73 ASV, *Ferrara*, 17, 12.8.1637.

74 ASV, *Ferrara*, 14, 21.2.1635, 28.2.1635 and 4.4.1635. See P. Bagni, *Il Guercino e il suo falsario*, Bologna, 1985, p. 143, for discussion of the drawing.

75 Testi, *Lettere*, II, p. 15, 11.1.1634.

76 ASV, *Ferrara*, 14, 6.12.1634; BCA, Antonelli *ms.*, Anonimo.

77 ASV, *Ferrara*, 17, 23.4.1636.

78 ASV, *Ferrara*, 17, 16.5.1637.

79 ASM, *Canc. Duc., Estero, Roma*, 197, 5.11.1639; BCA, Antonelli *ms.*, Anonimo; Barozzi and Berchet, *Roma*, I, p. 363.

80 Malvasia, II, pp. 263–4 and p. 313, p. 314 and p. 315; *Testamento dell'Illustrissimo Emmanuele Brignole, fondatore dell'Albergo dei Poveri, Ristauratore del Rifugio*, Genoa, 1776.

81 L. Alfonso, 'Stefano Durazzo Arcivescovo', *Atti della Società Ligure di Storia Patria*, Genoa, 1972. (For Reni, see Malvasia, II, p. 39.)

82 See Chapter 5, n. 63 above.

83 ASM, *Canc. Duc., Estero, Roma*, 196, 22.4.1637.

84 ASF, *Bentivoglio*, 252, 23.6.1640; ASV, *Ferrara*, 18, 30.6.1640.

85 Testi, *Lettere*, II, p. 285, 15.7.1634; BCA *ms.*, Ameyden; ASV, *Avvisi,*. 99, 17.2.1646.

86 ASV, *Avvisi*, 99, 13.1.1646 and 24.1.1646.

87 Malvasia, II, p. 264 and pp. 317–18.

88 ASV, *Ferrara*, 17, 16.6.1638.

89 ASV, *Ferrara*, 17, 10.3.1638.

90 ASF, *Storico, Allegrezze, Arrivo di Personaggi Illustri*, 19.5.1640.

91 ASF, *Bentivoglio*, 252, 23.5.1640.

92 ASV, *Ferrara*, 28, doc. 109–110; BCA, Aleotti, *Idrologia*, Chapter III.

93 ASV, *Ferrara*, 18, 7.11.1640; *Ferrara*, 19, 3.11.1640.

94 Penna, 1663, p. 62; ASV, *Ferrara*, 18, 24.1.1641.

95 ASV, *Ferrara*, 10.4.1641; 13.3.1641 and 15.5.1641. Danese had been sent to Rome to report.

96 ASV, *Ferrara*, 18, 11.12.1641. Danese's cover while spying on the Venetian Polisella site was that he needed a drink at a nearby *hostaria*.

97 ASV, *Ferrara*, 18, 30.10.1641.

98 ASV, *Ferrara*, 18, 6.11.1641.

99 For example, Malvasia, II, p. 30.

100 Malvasia, II, p. 265 and p. 322. (See also Mahon, 1968, p. 103 for paintings by Guercino which Ginnetti may have collected.)

101 Frizzi and Laderchi, p. 98; BCA, Antonelli *ms.*, Anonimo; ASF, *Bentivoglio, Lib.* 144, 29, academy held on 4 June 1642.

102 ASF, *Storico, Allegrezze, Spettacoli*, January 1642.

103 ASF, *Storico, Allegrezze, Arrivo di Personaggi Illustri*, payments of 6.11.1641 (Leonello Bononi), 7.11.1641 (painters including Antonio Casoli), 12.11.1641 (carpenter and painters), 12.1.1641 (Bononi).

104 ASV, *Ferrara*, 22, doc. 86–89 (peace treaty); ASV, *Avvisi*, 96, July 1644; Malvasia, II, p. 324.

105 ASM, *Canc. Duc.*, CSCPE, 225, 19.9.1644.

106 ASV, *Ferrara*, 23, doc. 554 and 18.9.1647.

107 ASM, *Canc. Duc., Particolari*, 852, 18.11.1647 (from the musician Marco Uccellini to Geminiano Poggi).

108 BCA, Antonelli *ms.*, Anonimo.

109 Penna, 1663, p. 52; Maestri.

110 Penna, 1663, p. 16; Frizzi and Laderchi, p. 113; ASM, *Canc. Duc.*, CSCPE, 103, 25.3.1646.

111 Penna, 1663, p. 16.

112 Evelyn, ed. 1850, p. 98 and p. 195; ASV, *Ferrara*, 23, 5.6.1647, 9.2.1647; *Ferrara*, 22, 5.12.1646.

113 ASF, *Bentivoglio, Lib.* 164, 68, 13.9.1663.

114 BCA *ms.*, Ubaldini, p. 82.

115 Bentivoglio, 1648, p. 14.

116 Ferri, p. 473.

117 BCA, Antonelli *ms.*, Anonimo; Ferri, p. 493.

118 Ferri, p. 496.
119 BCA, Antonelli *ms.*, Anonimo; Ferri, p. 497.
120 ASV, *Ferrara*, 14, 16.5.1634.
121 ASV, *Ferrara*, 9, 10.9.1632; T. Scalesse, 'Il canale Pallotta a Comacchio', *L'Ambiente Storico*, 1983–4, 6/7, p. 14.
122 ASV, *Ferrara*, 15, 12.2.1634.
123 ASV, *Ferrara*, 14, 28.7.1635; *Ferrara*, 17, 16.2.1636.
124 ASV, *Ferrara*, 19, 5.11.1642 and 19.11.1642; Ferri, p. 504.
125 BCA, Antonelli *ms.*, Anonimo; Ferri, p. 506.
126 Malvasia, II, p. 327.
127 ASV, *Ferrara*, 23, 3.4.1647.
128 ASV, *Ferrara*, 23, 1.5.1647.
129 ASV, *Ferrara*, 23, 10.8.1647.
130 BCA, Antonelli *ms.*, Anonimo.
131 ASV, *Ferrara*, 11, 6.11.1632. (Francesco Guitti had brought the plan of Comacchio to Rome for the information of the Barberini.)
132 ASV, *Ferrara*, 17, 16.2.1636.
133 Penna, 1663, p. 43.
134 Chiappini *et al.*, p. 59–60.
135 BCA, Antonelli *ms.*, Anonimo; Frizzi, p. 131.
136 ASV, *Ferrara*, 28, letters of January to March 1652; Maestri, p. 138. Like others before him, Cibò hoped to establish a regular fund for flood precautions; ASV, *Ferrara*, 27, 9.12.1651.
137 Guarini and Borsetti, p. 47.
138 Frizzi, p. 130 and Frizzi and Laderchi, pp. 125–6. The statue, attributed to Lorenzo Caprioli, was moved in 1675 and was placed on the column in the Piazza Nuova which had survived from the days of the Este (and still stands today, supporting a nineteenth-century statue of Ariosto). It was destroyed in 1796.
139 ASV, *Ferrara*, 35, 7.1.1660.
140 ASV, *Ferrara*, 47, 1.6.1673.

7. The Ferrarese nobility

1 ASV, *Ferrara*, 2, *Copia della scrittura del Rondinelli, Relatione sopra la città et stato di Ferrara*.
2 Spaccini, 20.7.1606.
3 Letter of 1.7.1628 reproduced in Ubaldini's *ms.* (see bibliography); see Guarini and Borsetti, p. 254 for the names of families and branches which had become extinct by the 1670s; ASV, *Ferrara*, 19, 17.12.1639 and 8.2.1640.
4 ASV, *Ferrara*, 12, 23.2.1633 and 9.3.1633.
5 ASM, *Canc. Duc., Estero, Roma*, 196, 23.9.1637.
6 ASV, *Ferrara*, 22, 17.2.1646 (letter from Donghi, noting as an exception Mario Calcagnini, Francesco d'Este's former Captain of Horseguards who had switched to the papal side in the war of Castro but by 1646 had returned to his 'old service' with the Este).
7 Cavicchi *et al.*, pp. 178–9; ASM, *Cam. Duc., Ferrara*, 13, 3.11.1609.
8 Borghini *passim*; Chiappini *et al.*, p. 154.
9 BCA *ms.*, Ubaldini, p. 83; Chiappini *et al.*, p. 60; Libanori, III, p. 106.
10 BCA *ms.*, Ubaldini, p. 200.
11 ASF, *Bentivoglio, Lib.* 176, 14, will of 24.2.1688. See also Frizzi and Laderchi, p. 68 for educational initiatives earlier in the century.
12 Guarini and Borsetti, p. 51.
13 Guarini and Borsetti, p. 13; ASV, *Ferrara*, 18, 21.6.1642; Maestri.

14 Frizzi and Laderchi, pp. 122–23; Libanori, p. 123; G. Gualdo Priorato, *Scena d'Huomini Illustri d'Italia*, Venice, 1659; Baruffaldi, II, p. 223 and pp. 234–9. For the collection of Canonici, to whom Superbi had dedicated his *Apparato* of 1620, see Campori, 1870, pp. 104–38 (paintings and drawings) and Chiappini *et al.*, pp. 181–3 (sculpture, curios, etc.).

15 See Leandro Alberti, *Descrittione di tutta Italia*, Venice, 1588, pp. 338–9 for a reference to the fable of Ferat.

16 F. Berni, *L'Academie raunatasi nel Castello di Ferrara il dì 16 giugno 1645* (copy in BCA, Ferrara).

17 BCA *ms.*, Ubaldini, pp. 165–6 (and Magalotti's letter of 1.7.1628); ASV, *Ferrara*, 9, 24.3.1632.

18 ASV, *Ferrara*, 22, 10.2.1646; Guarini and Borsetti, p. 221.

19 Guarini and Borsetti, p. 221; Libanori, III, p. 278 for the funeral of 16.10.1649.

20 Guarini and Borsetti, p. 221 and p. 41.

21 Malvasia, I, p. 106.

22 Superbi, p. 105.

23 BCA *ms.*, Pio.

24 The other participants in this imaginary symposium were Galeazzo Gualengo (who had died some time before), Annibale Manfredi and Tommaso Giannini, the 'Varro of Ferrara'.

25 Cavicchi *et al*; p. 167, n. 1; Reiner, citing letter of 17.8.1627.

26 Guitti's descriptions preceding the text of this and other productions for which he had worked follow the convention of a spectator's account. Guitti was a poet as well as an architect and could thus combine the functions fulfilled separately once by Aleotti and Alessandro Guarini.

27 Berni, introduction to the *festa Le Pretensioni del Tebro e del Po*, p. 17, comparing Pio to Diogenes and Alexander.

28 See Chapter 6, note 103. Other painters to whom payments were recorded in the 1630s for feast-day decorations include Antonio Mesi (1633), Nicolo Latta (1636 and 1640), Ercole Volpati and Francesco di Fagnani (1639). See ASF, *Storico, Allegrezze, Spettacoli*.

29 F. Baldinucci, *Vita di Bernini*, ed. 1948, Milan, p. 151.

30 ASF, *Bentivoglio*, 252, 25.9.1640.

31 Guitti had died in May 1640 (ASF, *Bentivoglio*, 252, 15.5.1640 and 19.5.1640). A Count Andrea Zani, writing to Cornelio II Bentivoglio from Venice then Mantua (ASF, *Bentivoglio*, 253, 5.11.1640 and 254, 10.1.1641), was involved in the search for a painter, engineer and architect. In Berni's introduction to *Le Pretensioni*, Burnacini is named as the designer of scenes and machines and would have been in Ferrara in, perhaps, late 1641 and early 1642.

32 Berni, *Cataio, passim.*; Malvasia, II, pp. 308–9.

33 ASV, *Ferrara*, 12, 12.3.1633 and 27.4.1633.

34 ASF, *Bentivoglio*, 84, 23.4.1616.

35 Povoledo, p. 173.

36 D. Lenzi, *Architettura, scenografia, pittura di paesaggio*, catalogue, *L'Arte del '700 emiliano*, Bologna, 1980, p. 105.

37 ASV, *Ferrara*, 28, 15.5.1652 (reporting the connection with Mantua); Berni.

38 Povoledo, p. 173.

39 Berni; Baruffaldi, II, p. 279.

40 Frizzi and Laderchi, p. 126; ASF, *Bentivoglio*, 331, 7.1.1660 and 8.1.1660; *Bentivoglio, Misc.I.I.*, 46, *Vendita fatta dal S. Duca di Modena . . .*, 1.2.1661.

41 ASF, *Bentivoglio*, 331, 7.2.1660.

42 Libanori, III, p. 229.

43 Baruffaldi, II, p. 266.

44 Libanori, III, p. 229.

45 Reiner, citing letter of 26.1.1627.

46 BCA *ms.*, *Elenco* (Imperiale). That the splendour of the festive theatre in Ferrara was a sham is the view advanced by C. Cavaliere Toschi in the article 'La magnifica menzogna', Chiappini *et al.*, pp. 136–41.

47 See Chiappini *et al.*, p. 144–51, for a tentative calendar of festive performances from 1598 to 1699.

48 ASV, *Ferrara*, 28, 15.5.1652; ASM, *Canc. Duc., Particolari*, 1040, 12.5.1652, letter from Superchi. 'I saw no reason to refuse permission' was Cibò's explanation to Rome, for which rather lukewarm support he perhaps earned the reputation for encouraging the arts in Ferrara he was given in G. Gualdo Priorato, *Scena d'Huomini Illustri d'Italia*, Venice, 1659.

49 ASF, *Bentivoglio*, Misc. I.I., 46: ASF, *Storico, Allegrezze, Spettacoli*, payments of, for example, 28.6.1688 and March 1700. Payments for seats in the *Sala delle Commedie* in January 1642 and the *Teatro di Cortile* in February 1668 were presumably due to the leaseholders then owners, the Bentivoglio.

50 *Discordia Confusa*, 1646, description by G. Bascarini.

51 Libanori, p. 229.

52 In *Le Pretensioni del Tebro e del Po*, for example, settings representing the Roman Campagna alternated with others of a Po landscape, and in Pasetti's settings for Berni's *La Palma d'Amore* (*Teatro degli Obizzi*, 1650), two scenes represented the city of Ferrara and another the Po landscape.

Conclusion

1 Mancini, I, p. 244; Cavicchi *et al.*, pp. 113–28.

2 Baruffaldi, II, p. 5.

3 Baruffaldi, p. 24; Riccomini, p. 25.

4 See, for example, Baruffaldi, II, p. 31 (Giulio Cromer) and p. 37 (Francesco Naselli).

5 Novelli, p. 25; BCA *ms.*, Ubaldini, p. 43.

6 Baruffaldi, II, p. 209 and Riccomini, p. 41 (Caletti); Baruffaldi, II, p. 222–3 and Riccomini, p. 47 (Catanio); Baruffaldi, II, p. 37 and Riccomini, p. 27 (Naselli).

7 AAF, *Stimmate, Filza delli Ordini . . .*, payments of 30.3.1624; Baruffaldi, II, p. 188 (Chenda completed, for example, the group of paintings in the presbytery of Sta Maria in Vado begun by Carlo Bononi, of whom he had been a pupil).

8 Baruffaldi, II, p. 279 and Riccomini, p. 53.

9 Guarini and Borsetti, p. 205; Chiappini *et al.*, pp. 90–111.

10 ASV, *Ferrara*, 34, 7.5.1659 and 10.5.1659. The Milanese was sent to Rome.

11 Frizzi, p. 130.

12 Libanori, III, p. 71. Frizzi, p. 132, also attributes Pasetti's education in geometry to Cabeo but his knowledge of hydrostatics to Guitti, and it was to Guitti that Pasetti referred in his application of 1628 to the Commune for the post of inspector of the *argini* or dykes. See also Maestri for Pasetti's career.

13 Maestri.

14 Libanori, III, p. 71.

15 Testi, *Lettere*, I, p. 415, 16.1.1633.

16 A. Lugli, 'Erudizione e pittura alla corte estense: il caso di Sigismondo Caula', *Prospettiva*, 21, 1980, pp. 57–74; Tiraboschi, VI, p. 542.

17 Malvasia, II, p. 258.

18 ASF, *Bentivoglio*, Misc. I.I., 24; Bagni, p. 241; Mahon, 1968, p. 14.

19 Passeri, ed. 1934, p. 350.

20 Passeri, ed. 1772, p. 379.

21 Malvasia, II, pp. 309–10.

22 Malvasia, II, p. 266, p. 325 and p. 327; Mahon, 1969, p. 227; Scannelli, p. 287 and p. 291.

23 ASV, *Ferrara*, 12, 2.3.1633.

24 Malvasia, II, p. 265 and p. 322 for a *St Joseph* for Obizzo d'Este.

25 ASM, *Canc. Duc., Estero, Torino*, 8, *Ragguaglio del il Co. Girolamo Graziani del suo viaggio fino a Torino*. The protégé was not named.

26 Malvasia, II, p. 263.

27 ASM, *Cam. Duc., Fabbriche, Sassuolo*, 14, *Carteggi e recapiti*, inventory of *c.* 1680. Also in the Room of Dreams was the *Tamar and Amnon* (now Galleria Estense, Modena) and a *Semiramis* (see D. Mahon, 'Guercino's paintings of Semiramis', *Art Bulletin*, XXXI, 1949).

28 Malvasia, II, p. 263; ASM, *Canc. Duc., Pittori*, 13/1, *Barbieri, Giovan. Francesco detto Guercino*, undated draft letter, probably 1641 (it refers to a *Madonna* recently painted for G. B. Tartaglione, and this is recorded in the account book under 1641).

29 Malvasia, II, p. 270 and p. 338 (Imperiale) and p. 332 (Cibò).

30 Malvasia, II, p. 314, p. 315 and p. 317 (Benaduccio, 1636–8); p. 317, p. 318 and p. 319 (Pellegrini, 1638–40); p. 32 (Argoli, 1640). The Apostolic Chamber architect Luca Danese might be added here; in the 1640s he represented the authorities of the church of S Romualdo in Ravenna (designed by him in the 1630s) in the ordering of an altarpiece from Guercino (Malvasia, II, p. 319).

31 Passeri, ed. 1934, p. 346, *Guercino* (this collector might, perhaps, have been Antonio Scannaroli, Governor of Cento in the 1630s); Malvasia, II, p. 322 (Barberini, 1642); p. 328 (Mattei, 1648); p. 339, p. 340, p. 341 and p. 342 (Gabrieli).

32 See Chapter 4. Mazarin owned 14 paintings attributed to Guercino according to the inventory of 31.3.1661; de Cosnac, p. 277.

33 Malvasia, II, p. 327; ASM, *Canc. Duc., CSCPE*, 105, 9.7.1648 and 235, 12.7.1648.

34 Malvasia, II, p. 318, p. 320, p. 324, p. 327 and p. 338 (1639 to 1658); Baruffaldi, II, p. 205 (Lana); Campori, 1855, p. 45. In 1658 Tartaglione brought Alfonso d'Este a gift of Lelio Orsi's drawings from the Count of Novellara (ASM, *Canc. Duc., Pittori*, 15/3, *Orsi, Lelio*, 27.3.1658).

35 Scannelli, p. 114. For an extensive discussion of Guercino's style, see Mahon, 1947.

36 ASM, *Canc. Duc., Pittori*, 13/1, *Barbieri, Giovan. Francesco detto Guercino*, undated letter, *c.* 1641. There is no further word of this commission (it is not listed in the account book, though in 1641 the Vice-Legate to Ferrara did order a *St Jerome*) but Guercino's drawing of *St Jerome* in the Ashmolean Collection (Mahon and Ekserdjian, p. 37) may suggest the type Francesco had in mind.

37 Malvasia, II, p. 269; Campori, 1870, p. 174, citing letter of 10.10.1651 from Francesco Mirogli in Perugia.

38 Seignelay, pp. 210–13.

39 Penna, 1671.

40 Caylus, pp. 135–6; Wright, p. 104.

41 A. Lazzari, *Attraverso la storia di Ferrara*, Rovigo, 1953, p. 385; Young, p. 267.

42 Baruffaldi, I, p. 258; Fava, p. 167.

43 *Histoire Anecdote*, Utrecht, 1723, p. 90.

44 Armandi *et al.*, p. 245.

45 Fava, p. 170.

46 Venturi, pp. 353–60 (inventory of 1743 in which the paintings sold to Dresden are indicated); Bonsanti, noting among others the addition to the gallery of the legacy from the Marchese Tommaso degli Obizzi of Cataio (pp. 32–3).

47 Caylus, pp. 44–5.

48 Young, p. 292.

Select Bibliography

Listed here are the full details of the principal and most frequently consulted sources. Details of sources consulted incidentally are given in the notes to the next.

ARCHIVES

(Archive titles are followed in the notes by series title, *busta*, *mazza* or volume number and date (or number) of the document.)

ARCHIVIO DI STATO, FERRARA (ASF)

Archivo Storico (*Storico*)
 Allegrezze e Commemorazioni, Sec. XVII (*Allegrezze*)
 Spettacoli
 Arrivo di Personaggi Illustri
 Cancelleria e Stampe (*Cancelleria*)
Archivio Bentivoglio (*Bentivoglio*)
 Libri dei contratti, stabili, etc.
 Lettere sciolte

ARCHIVIO DI STATO, FIRENZE (ASFIRENZE)

Ambasciatori, Spagna (*Spagna*)
 Cart. Med. 4963 (1637–July 1638)
 Cart. Med. 4964 (August 1638–)

ARCHIVIO DI STATO, MODENA (ASM)

Camera Ducale (*Cam. Duc.*)
 Amministrazione Patrimoniale dei Principi (*Amministrazione*)
 Agenzia in Ferrara (*Ferrara*)
 Fabbriche e Villeggiature (*Fabbriche*)
Cancelleria Ducale (*Canc. Duc.*)
 Archivi per Materie, Arti Belle

182

Architetti
Pittori
Scultori
Archivi per Materie, Galleria e Museo Estense (*Galleria*)
Archivi per Materie, Ingegneri (*Ingegneri*)
Carteggi di Referendari, Consiglieri, Cancellieri e Segretari (*Segretari*)
Casa e Stato
 Carteggi fra Principe Estensi; Lettere (*CSCPE*)
 Documenti spettanti a Principi Estensi (*Documenti*)
 Storie e notizie particolari di Principi Estensi (*Storie*)
Estero, Ambasciatori (*Estero*)
 Firenze, Milano, Parma, Roma, Spagna, Torino and Venezia
Lettere di Particolari (*Particolari*)

ARCHIVIO SEGRETO VATICANO (ASV)

Segreteria di Stato
 Legazione di Ferrara (*Ferrara*)
 Lettere del Nunzio e Inter.o di Fiandra dall'1607 all'1706 (*Nunzio*)
 Lettere di Mo.r Nuntio in Firenze (*Nunzio, Firenze*)
 Avvisi da Roma (*Avvisi*)
Fondo Pio (*Pio*)
 Scelta di Lettere del Sig.r Cardinal Bentivoglio scritte a diversi . . . (*Scelta di Lettere*)
 Registro di Lettere scritte da Mons.r Guido Bentivoglio sopra la fuga di Francia del Principe di Condé
 (*Registro di Lettere*)

ARCHIVIO ARCIVESCOVILE, FERRARA (AAF)

Archivio della Curia (*Curia*)
Editti e Notificazioni dei Vescovi, 1590–1667 (*Editti*)
Visite delle Chiese (*Visite*)
Miscellaneous: Catastro alfabetico della scriture . . . esistenti nell'Archivio della Casa di Sta Maria della
 Pietà (*Catastro alfabetico*)
Archivio del Capitolo (*Capitolo*)
Archivio della Compagnia delle Stimmate (*Stimmate*)

PUBLIC RECORD OFFICE, LONDON (PRO)

State Papers Foreign, Italian States (SP85)
State Papers Foreign, Spain (SP94)

MANUSCRIPTS (BIBLIOTECA COMUNALE ARIOSTEA, FERRARA (BCA))

Aleotti, Gio. Battista d'Argenta, *Dell'Idrologia overo della scienza et arte di ben regolar acqua. Libri Quattro
 Intieri a fragmenti copiata dal suo originale manoscritto che app.o di me si conserva da me Alberto Penna
 l'anno 1666, ms.* C1.I, no. 748.

Ameyden, Theodor, *Compendium vitae diversorum cardinali*, ms. C1.11, no. 276.

Anonimo, *Relazione di quanto hanno operato pel bene di Ferrara gli Em.i Cardinali Legati dalla devoluzione dell Stato fino al 1676*, Collezione Antonelli, ms. 166.

Mussi, Don Guilio, *Storia o sieno Memorie della Fortezza di Ferrara*, ms. C1.I, no. 281.

Perinelli, F, *Catena d'oro d'anella . . . Figurati ne Vescovi di Ferrara, 1658*, ms. C1.I, no. 425.

Pio di Savoia, Ascanio, *Precetti, consiglij et avertimenti . . . dedicati all' Ill.mo Sig.re D. Carlo suo Figluolo*, ms. C1.I, no. 42.

Scalabrini, G. A., *Le rendite e le spese della Sacrestia della Metropolitana di Ferrara*, ms. C1.1, no. 456.

Ubaldini, Cesare, *Storia di Ferrara dall' anno 1597 a tutto l'anno 1633*, Collezione Antonelli, ms. 264.

Elenco di famiglie ferraresi, ms. C1.I, no. 662.

PUBLISHED SOURCES

C. Acidini Luchat, L. Serchia, V. Vandelli, *Restauri a Sassuolo*, Sassuolo, 1982.

G. Agnelli, 'Relazione dello Stato di Ferrara di Orazio della Rena', *Atti della Deputazione Ferrarese di Storia Patria*, III, 1896.

L. Amorth, *Modena capitale*, Modena, 1967.

L. Amorth, G. Boccolari, C. Roli Guidetti, *Residenze Estensi*, Modena, 1973.

M. Armandi, M. Canova, E. Bertozzi Desco, C. Ghelfi, V. Vandelli, *Natura e cultura urbana a Modena*, exhibition catalogue, Modena, 1983.

N. Artioli and E. Monducci, *Gli Affreschi della Ghiara in Reggio*, Milan, 1970.

G. Baglione, *Le Vite de' pittori, scultori et architetti dal pontificato di Gregorio XIII fino a tutto quello d'Urbano VIII*, Rome, 1649.

P. Bagni, *Guercino a Cento*, Bologna, 1984.

F. Baldinucci, *Notizie dei professori del disegno da Cimabue in qua*, Florence, vol. IV, ed. 1846; vol. V, ed. 1974; vol. VI, ed. 1975 with appendix by P. Barocchi.

W. Barnes, 'The Bentivoglios of Gualtieri', *Country Life*, 1981, CLXIX, p. 1130.

N. Barozzi and G. Berchet, *Le Relazioni degli stati europei lette al Senato dagli ambasciatori Veneziani, Relazione di Roma*, vols I and II, Venice, 1877.

G. Baruffaldi, *Vite de' pittori e scultori ferraresi*, Ferrara, vol. I, ed. 1844; vol. II, ed. 1846.

A. Baschet, 'Négociation d'oeuvres de tapisseries de Flandre et de France', *Gazette des Beaux-Arts*, 1861, I, p. 406 and 1862, II, p. 32.

G. L. Basini, *L'Uomo e il pane*, Milan, 1970.

V. Bellini, *Delle monete di Ferrara*, Ferrara, 1761.

G. P. Bellori, *Le Vite de' pittori, scultori et architetti moderni* (Rome, 1672), ed. E. Borea, Turin, 1976.

G. Bentivoglio, *Raccolte di lettere scritte dal Cardinal Bentivoglio in tempo delle sue nuntiature di Fiandra, e di Francia*, Cologne, 1631.

G. Bentivoglio, *Relatione del Cardinal Bentivoglio*, Cologne, 1646.

G. Bentivoglio, *Memorie del Cardinale Bentivoglio con le quali descrive la sua vita*, Venice, 1648.

G. Bentivoglio, *La Nunziatura di Francia*, ed. L. de Steffani, Florence, vol. I, 1863; vol. II, 1865; vol. II, 1867; and vol. IV, 1870.

G. Bentivoglio, *Memorie e lettere*, ed. C. Panigada, Bari, 1934.

F. Berni, *Descrizione del Cataio, luogo del Marchese Pio Enea degli Obizzi* (incorporating description of 1572 by G. Betussi), Ferrara, 1669.

F. L. Bertoldi, *Vescovi ed Arcivescovi di Ferrara*, Ferrara, 1818.

Q. Bigi, 'Camillo e Siro da Correggio', *Atti e Memorie delle RR Deputazioni di Storia Patria per le provincie Modenese e Parmense*, 1870, V, pp. 77–107.

F. Bonasera, *Forma veteris urbis Ferrariae*, Florence, 1965.

G. Bonsanti, *Galleria Estense*, Modena, 1977.

G. Borghini, *Memorie dell' inclita famiglia dell' Signori Marchesi Villa*, Ferrara, 1680.

F. Bravi, *Il Principe Frate*, Bolzano, 1972.

M. Brunori, 'Spigolature in margine al Del Cairo', *Pantheon*, 1967, XXV, p. 105.

G. Campori, *Gli artisti italiani e stranieri negli stati estensi*, Modena, 1855.

G. Campori, 'Notizie inedite di Raffaello da Urbino', *Atti e Memorie delle RR Deputazioni di Storia Patria per le provincie Modenese e Parmense*, 1863, I, pp. 111–47.

G. Campori, *Lettere artistiche inedite*, Modena, 1866.

G. Campori, *Raccolta di cataloghi ed inventarii inediti*, Modena, 1870.

A Cavicchi, J. Bentini, G. degli Esposti, G. Marcon, S. Maddalo, G. Marcolini, L. Spezzaferro, *Frescobaldi e il suo tempo*, exhibition catalogue, Ferrara, pub. Marsilio Editori, Venice, 1983.

Caylus, Comte de, *Voyage d'Italie*, ed. A-A. Pons, Paris, 1914.

A. Chiappini, C. Cavaliere Toschi, B. Giovannucci Vigi, M. T. Gulinelli, S. Savino Bettini, A. M. Visser Travagli, *La Chiesa di S Giovanni Battista e la cultura ferrarese del seicento*, exhibition catalogue, Ferrara, pub. Electa, Milan, 1981.

D. Coffin, *The Villa d'Este at Tivoli*, Princeton, 1960.

D. Coffin, 'Some architectural drawings of Giovanni Battista Aleotti', *Journal of the Society of Architectural Historians*, XXI, 1962, p. 116.

Cosnac, Comte Gabriel Jules de, *Les Richesses du Palais Mazarin*, Paris, 1884.

G. Dethan, *The Young Mazarin*, (Paris, 1968), Eng. trans. by Stanley Baron, London, 1977.

Dizionario biografico degli italiani, Rome 1966, vol. 8; T. Ascari, pp. 610–12 (Enzo Bentivoglio); A. Merola, pp. 634–8 (Guido Bentivoglio).

U. Donati, 'Tre fontane berniniane', *L'Urbe*, 1941, VI, pp. 11–13.

A. Dondi, *Notizie storiche ed artistiche del Duomo di Modena*, Modena, 1896.

G. F. Erri, *Dell'origine di Cento e di sua Pieve*, (Bologna, 1769), ed. Cento, 1973.

J. Evelyn, *Diary and correspondence*, London, ed. 1850 and 1908.

P. L. Fantelli, 'Nicolo Ranieri. Pittore Fiamengo', *Saggi e Memorie*, 1974, p. 77.

F. Fasolo, *L'Opera di Hieronimo e Carlo Rainaldi*, Rome, 1960.

D. Fava, *La Biblioteca Estense*, Modena, 1925.

E. Feinblatt, 'A Note on Bianchi-Monti', *The Burlington Magazine*, 1972, CXIV, pp. 17–22.

G. F. Ferri, *Istoria dell'antica città di Comacchio*, (Ferrara, 1701), ed. Cologne, 1970.

S. Fraschetti, *Il Bernini*, Milan, 1900.

W. Friedlaender, *Caravaggio Studies*, Princeton, 1955.

A. Frizzi, *Memorie per la storia di Ferrara*, vol. V, Ferrara, 1809.

A. Frizzi and C. Laderchi, *Memorie per la storia di Ferrara*, vol. V, Ferrara, 1848.

D. Gamberti, *Corona funerale*, Modena, 1659.

D. Gamberti, *L'Idea d'un prencipe et eroe Christiano in Francesco I . . .*, Modena, 1659.

E. L. Goldberg, *Patterns in Late Medici Art Patronage*, Princeton, 1983.

D. Goodgal, 'The Camerino of Alfonso I d'Este', *Art History*, 1978, I, 2, pp. 162–90.

C. Gould, *The Paintings of Correggio*, London, 1976.

E. Grandi, *Armi e nozze alla corte di Francesco I d'Este*, Alessandria, 1907.

M. A. Guarini and A. Borsetti, *Compendio Historico dell'origine, accrescimento, e prerogative delle chiese, e luoghi pij della città e diocese di Ferrara*, Ferrara, 1621, and *Supplemento*, Ferrara, 1670.

F. Haskell, *Patrons and painters; a study in the relations between Italian art and society in the age of the Baroque*, New Haven and London, ed. 1980.

A. Herz, 'The Sixtine and Pauline Tombs: Documents of the Counter-Reformation', *Storia dell'Arte*, 1981, 42, p. 241.

C. Hope, 'The Camerino d'Alabastro of Alfonso d'Este', *The Burlington Magazine*, 1971, CXIII, p. 649.

K. Justi, *Velázquez e il suo tempo*, Bonn, 1888, Italian translation, Florence, 1958.

M. Kitson, 'Claude's earliest coast scene with the *Rape of Europa*', *The Burlington Magazine*, 1973, CXV, pp. 775–9.

I. Lavin, 'Lettres de Parme . . .', *Le lieu théatral à la Renaissance*, ed. J. Jacquot, CNRS, Paris, 1964, p. 105.

A. Libanori, *Ferrara d'oro imbrunito*, Ferrara, 1665 and Part III, *c*. 1675.

R. Lightbown, 'Princely pressures 2: Francesco I d'Este and Correggio', *Apollo*, Sept 1963, p. 193–9.

A. G. Lodi, *Bartolomeo Schedoni, Notizie e Documenti*, Modena, 1978.

D. Maestri, *Goro e il Delta del Po*, Rome, 1981.

L. Magalotti, *Avvertimenti a predicatori della sua diocese*, Ferrara, 1637.

O. Magnanini, *Del Convito*, Ferrara, 1639.

D. Mahon, *Studies in seicento art and theory*, London, 1947.

D. Mahon, 'The author of a false Liss – an Englishman', *The Burlington Magazine*, 1950, XCII, p. 98–102.

D. Mahon, *Il Guercino. Catalogo critico dei dipinti*, Bologna, 1968.

D. Mahon, *Il Guercino. Catalogue critico dei disegni*, Bologna, 1969.

D. Mahon, 'Guercino and the Cardinal Serra. A newly discovered masterpiece', *Apollo*, Sept, 1981, pp. 172–3.

D. Mahon and d. Ekserdjian, *Guercino drawings from the collections of Denis Mahon and the Ashmolean Museum*, The Burlington Magazine/Ashmolean Museum, 1986.

Malvasia, *Felsina Pittrice. Vite de' pittori Bolognesi del Conte Carlo Cesare Malvasia con aggiunti . . . di Giampietro Zanotti*, vols. I and II, Bologna, 1841.

G. Mancini, *Considerazioni sulla Pittura, pubblicate per la prima volta da Adriana Marucchi con il commento da Luigi Salerno*, vols. I and II, Rome, 1956.

R. Marchioni Ascione, 'Sante Peranda alla Mirandola e a Modena', *Arte Veneta*, 1958, XII, p. 126.

G. B. Marino, *La Galeria*, ed. M. Pieri, Padua, 1979.

E. Massano, *La Vita di Fulvio Testi*, Florence, 1900.

A. Mezzetti, 'Le storie di Enea del Dosso nel Camerino d'Alabastro di Alfonso I d'Este', *Paragone*, 1965, 189, pp. 71–84.

A. Mezzetti, *Il Dosso e Battista Ferraresi*, Milan, 1965.

M. V. Mazza Monti, *Le Duchesse di Modena*, Reggio Emilia, 1977.

C. G. Mor and P. di Pietro, *Storia dell'Università di Modena*, vol. I., Florence, 1975.

F. Moryson, ed. C. Hughes, *Shakespeare's Europe*, London, 1903.

L. A. Muratori, *Delle Antichità Estensi*, vols. I and II, Modena, 1717 and 1740.

A. Namias, *Storia di Modena e dei paesi circostanti dall'origine sino al 1860*, Modena, 1894.

M. A. Novelli, *Lo Scarsellino*, Ferrara, 1964.

C. d'Onofrio, 'Inventario dei dipinti del Cardinal Pietro Aldobrandini compilato da G. B. Agucchi nel 1603', *Palatino*, 1964, VIII, pp. 15–20, 158–62, 202–11.

J. A. F. Orbaan, *Documenti sul Barocco in Roma*, Rome, 1920.

G. B. Passeri, *Vite de' pittori, scultori ed architetti che hanno lavorato in Roma*, Rome, 1772 and ed. J. Hess, Leipzig, 1934.

L. von Pastor, *Storia dei Papi*, XI, ed. Rome, 1958; *History of the Popes*, XXIV and XXV, ed. London, 1933 and 1952.

A. Penna, *Compendiosa descrittione dello stato di Ferrara in generale, e due sue parti in particolar*, Ferrara, 1663.

A. Penna, *Descrittione dalla Porta di S Benedetto della Città di Ferrara*, Padua, 1671.

P. della Pergola, *Galleria Borghese*, vols. I and II, Rome, 1959.

E. Peverada, 'La predicazione nelle indicazione pastorali del vescovo di Ferrara Giovanni Fontana' and 'Ricordi di S Carlo Borromeo a Ferrara', *Analecta Pomposiana*, 1984, IX, p. 295 and p. 319.

M. Pirondini, *Giovanni Boulanger. Un pittor francese nel ducato di Modena*, Modena, 1969.

G. Poggi, 'Cambi di quadri fra Firenze e Modena nel secolo XVII', *Rivista d'Arte*, 1912, VIII, pp. 45–51.

E. Povoledo, *Enciclopedia dello spettacolo*, V, Milan, 1958, pp. 175–86.

V. Prinzivalli, 'La devoluzione di Ferrara alla S Sede secondo una relazione inedita di Camillo Capilupi', *Atti della Deputazione Ferrarese di Storia Patria*, 1898, X, pp. 121–332.

T. Pugliatti, *Agostino Tassi tra conformismo e libertà*, Rome, 1977.

L. Pungileoni, *Memorie istoriche di Antonio Allegri detto il Correggio*, Parma, 1817–21.

D. Posner, *Annibale Carracci*, London, 1971.

S. Reiner, 'Preparations in Parma', *The Music Review*, 1964, p. 271.

E. Riccomini, *Il Seicento Ferrarese*, Milan, 1969.

C. Ridolfi, *Le Maraviglie dell'Arte*, 2 vols., Venice, 1648 and ed. Padua, 1837 and ed. D. V. Hadeln, Berlin, 1914–24.

G. Rouchès, *Inventarie des lettres et papiers manuscrits de Gaspare, Carlo et Lodovico Vigarani*, Paris, 1913.

H. Diane Russell, *Claude Lorrain*, exhibition catalogue, New York, 1982.

L. Salerno, *Salvator Rosa*, Milan, 1963.

T. Sandonnini, 'Il Padre Guarino Guarini Modenese', *Atti e Memorie delle RR Deputazioni di Storia Patria per le provincie Modenese e Parmense*, S.III, 1888, V, pp. 483–534.

F. Scannelli, *Il Microcosmo della Pittura*, Cesena, 1657, ed. G. Giubbini, Milan, 1966.

M. Schenetti, *Storia di Sassuolo*, Modena, 1966.

F. Scoto, *Itinerario d'Italia*, ed. Padua, 1659.

Seignelay, Marquis de, ed. P. Clement, *L'Italie en 1671; relation d'un voyage du Marquis de Seignelay*, Paris, 1869.

I. Senesi, *Raimondo Montecuccoli*, Turin, 1933.

G. Serra, *La Peste dell'anno 1630 nel ducato di Modena*, Modena, 1959.

G. Silingardi, *Modena nei secoli*, Modena, 1970.

G. Soli, *Le Chiese di Modena*, vols. I-III, ed. G. Bertuzzi, Modena, 1974.

F. Sossaj, *Descrizione della città di Modena nell'anno 1833*, Modena, 1833.

G. B. Spaccini, 'Cronaca', *Monumenti di Storia Patria delle Provincie Modenesi, Serie delle Cronache*, Modena, vol. XVII, 1919 and vol. XVIII, 1936. (The remainder of the chronicle, up to 1636, was in 1984 in course of publication by Edizione Panini for the Deputazione di Storia Patria di Modena.)

A. Superbi, *Apparato de gli huomini illustri della città di Ferrara*, Ferrara, 1620.

A. Tassoni, *Dieci libri di pensieri diversi . . .*, ed. Venice (M. A. Brogiolo), 1636.

F. Testi, *Poesie liriche et Alcina Tragedia*, ed. Naples (G. Dom Montanaro), 1637.

F. Testi, *Poesie*, Modena, 1663.

F. Testi, *Opere scelte*, Modena, 1817.

F. Testi, *Lettere*, vols. I-III, ed. M. L. Doglio, Bari, 1967.

N. Tessin the Younger, ed. O. Siren, *Studievesor*, Stockholm, 1914.

G. Tiraboschi, *Biblioteca Modenese*, Modena, vol. III, 1783; vol. V, 1785; vol. VI, 1789.

E. Tonello, *La Diocesi di Ferrara negli Atti della Visita Pastorale (1628–32) del Vescovo Lorenzo Magalotti*, unpublished thesis, Università degli Studi, Bologna, 1976.

A. F. Trotti, 'Le Delizie di Belvedere Illustrate', *Atti della Ferrarese Deputazione di Storia Patria*, II, 1889, pp. 3–32.

L. Vedriani, *Raccolta de' pittori, scultori et architetti Modonesi più celebre*, (Modena, 1662), facsimile edition, Bologna, 1970.

L. Vedriani, *Dottori Modenesi*, Modena, 1665.

L. Vedriani, *Historia dell'antichissima città di Modena*, Modena, vol. I, 1666; vol. II, 1668.

A. Venturi, *La R Galleria Estense in Modena*, Modena, 1882.

A. de Vesme and P. D. Massar, *Stefano della Bella*, New York, 1971.

H. E. Wethey, *The Paintings of Titian*, vols. I-III, London, 1971.

E. Wright, *Some observations made in travelling through France, Italy etc. in the years 1720, 1721 and 1722*, London, 1730.

A. Young, *Travels in France and Italy (1787–89)*, ed. T. Okey, London (Everyman).

L. Zanugg, 'Il Palazzo Ducale di Modena. Il problema della sua costruzione', *Rivista del R Istituto di Archeologia e Storia dell'Arte*, 1942, IX, pp. 212–52.

R. Zapperi, 'L'Inventario di Annibale Carracci', *Antologia di Belle Arti*, 3/4, 1979–80, pp. 62–7.

FESTE

La Gara delle Stagioni. Torneo a cavallo, G. Graziani, Modena, 1652.

Giostra del Saracino: Relazione della famosa festa fatta in Roma alli 25 di Febbraio MDCXXXIV sotto gli auspicij dell'Eminentissimo Sig. Cardinale Antonio Barberini descritta dal Card. Bentivoglio, Rome, 1654.

TEAGENE. Del Campo Aperto mantenuto in Ferrara l'Anno MDCX la Notte di Carnovale dall'Illustriss. Signore

Enzo Bentivoglio, Mantenitore della querela, pubblicata nella disfida da un Araldo, a suon di tromba, il dì 6 febraio, su'l Corso, pieno di tutta le Città mascherate, A. Guarini, Ferrara, 1610.

Intramezzi dell'Idalba Tragedia fatta rappresentare dall'Ill.mo Sig. Enzo Bentivoglio, E. Bentivoglio, M. Venieri and G. Prete, Ferrara, 1614.

L'Acina Maga. Il Torneo a Piedi e l'Inventione ed Allegoria colla quale il Sig. Borso Bonacossi comparì a mantenirli. E l'Alcina Maga favola pescatoria, Sebastiano Martini, Ferrara, 1631.

La Contesa. Torneo fatta in Ferrara per le Nozze dell'Illustrissimo Signor Gio. Francesco Sacchetti coll' Illustrissima Signora Donna Beatrice Estense Tassona, Ferrara, 1632.

Discordia Superata. Torneo Combattuta in Ferrara il carnevale dell'anno 1635, A. Pio di Savoia, Ferrara, 1636.

L'Andromeda di D Ascanio Pio di Savoia. Cantata e combattuta in Ferrara, il Carnevale dell'anno 1638, Ferrara, 1639.

L'Amore trionfante dello Sdegno, A. Pio di Savoia, Ferrara, 1642.

Le Pretensioni del Tebro e del Po cantate e combattute in Ferrara nella venuta dell'Eccell. Sig. Principe Don Taddeo Barberini, Prefetto di Roma, Generaliss. dell'Armi di S Chiesa, A. Pio di Savoia, Ferrara, 1642.

La Discordia Confusa. Rappresentata con macchine e musica e combattuta in Ferrara nel Pallaggio della Ser.ma Anna de' Medici, A. Pio di Savoia, Ferrara, 1646.

Ferrara Trionfante per la Coronazione della B.ma Vergine del Rosario celebrata l'Anno 1638, A. Pio di Savoia, Ferrara, 1662.

La Palma d'Amore, favoletta dramatica, F. Berni, Ferrara, 1650.

Gli Sforzi del Desiderio. Ricreazione dramatica musicale, F. Berni, Ferrara, 1652.

La Dafne, favola da recitarsi in musica nella venuta dell' Eminentissimo Signor Card. Fransone alla Legazione di Ferrara, D. Azzio Epibenio (Pio Enea II degli Obizzi), Ferrara, 1660.

L'Achille in Sciro, favola dramatica, M. Colombo (Ippolito II Bentivoglio), Venice, 1663.

Index